LUXURY TOYS

edited by Anja Llorella Oriol

LUXURY TOYS

edited by Anja Llorella Oriol

teNeues

Editor and texts: Anja Llorella Oriol

Art Director: Mireia Casanovas Soley

Copyediting: Raquel Vicente Durán

Layout: Ignasi Gracia Blanco

Translations: Robert Nusbaum (English)
Marion Westerhoff (French)
Eva Dallo (Spanish)
Sara Tonelli (Italian)

Produced by Loft Publications
www.loftpublications.com

Published by teNeues Publishing Group

teNeues Publishing Company
16 West 22nd Street, New York, NY 10010, USA
Tel.: 001-212-627-9090, Fax: 001-212-627-9511

teNeues Book Division
Kaistraße 18
40221 Düsseldorf, Germany
Tel.: 0049-(0)211-994597-0, Fax: 0049-(0)211-994597-40

teNeues Publishing UK Ltd.
P.O. Box 402
West Byfleet
KT14 7ZF, Great Britain
Tel.: 0044-1932-403509, Fax: 0044-1932-403514

teNeues France S.A.R.L.
4, rue de Valence
75005 Paris, France
Tel.: 0033-1-55766205, Fax: 0033-1-55766419

www.teneues.com

ISBN: 3-8238-4591-8

© 2004 teNeues Verlag GmbH + Co. KG, Kempen

Printed in Italy

Bibliographic information published by
Die Deutsche Bibliothek. Die Deutsche Bibliothek lists
this publication in the Deutsche Nationalbibliografie;
detailed bibliographic data is available in the Internet
at http://dnb.ddb.de

Summary

Luxury—or how to get the most out of life

When we think of luxury, we tend to think of magnificence, living it up, la dolce vita—in short everything outside the realm of basic food, clothing and shelter. But luxury can also have quite different meanings for various individuals depending on their cultural origin, personal experience or age. Luxury can, for example, simply mean a fondness for a particular kind of food or the desire to drive a fast car or spend a totally relaxing day at a wellness hotel, or purchasing a technologically advanced timepiece. Luxury goods exceed a product's actual purpose. In aesthetic, qualitative and technical terms, they are high-value products.

But in affluent western societies, and particularly for people in the highest income brackets, one important commodity is becoming so scarce that it has taken on luxury status: time. As a result, products that save us time or enable us to spend our time more flexibly and efficiently are gaining in importance. Such products include cars and private jets that double as offices, or, for example, helicopter taxis in São Paulo that circumvent heavy traffic and enable passengers to reach their destination in the shortest possible time.

People acquire luxury items to reward themselves, as gifts for their friends or loved ones, or simply for prestige. The need to rise higher in the social hierarchy and differentiate oneself from one's fellows is deeply rooted in all of us. Apart from conferring prestige, people purchase luxury items because they bring pleasure, are of high quality and because they are not run of the mill. But in addition to purchasers of such goods, who mainly do so to gain attention by presenting themselves to the outside world in a particular way, there are also people who unostentatiously enjoy luxury goods in private and appreciate the unusually high quality of such products, or who simply like the idea of acquiring the image of uniqueness that such products confer, since many are available in limited quantities only.

Since truly superlative luxury goods are out of reach for all but a selected few, such goods tend to create envious feelings in those not fortunate enough to own them. Some people regard luxury as unnecessary or superfluous, although it is precisely these products that most accurately reflect the technological vistas of our time.

Even in an era of mass produced goods that the vast majority of the population can afford, automakers such as Rolls Royce still produce hand crafted cars, most of which are customized, outfitted with cutting edge technology and executed with impeccable attention to detail.

This book contains photos of cars, yachts, and private jets—products that most people associate with luxury. But these products are more than just consumer goods, for many are used for special purposes—for example as mobile offices or for the opportunity they afford their owners to hold business meetings in a unique venue. However, along with these special uses, such products also provide extraordinary levels of comfort and are made with the highest quality materials and most advanced technologies available. And they all share one attribute: they are the nearest thing to timelessness. Such products create in people who see but do not own them a mixture of envy and amazement—on account of their beauty and the shining promise they hold out of a better life.

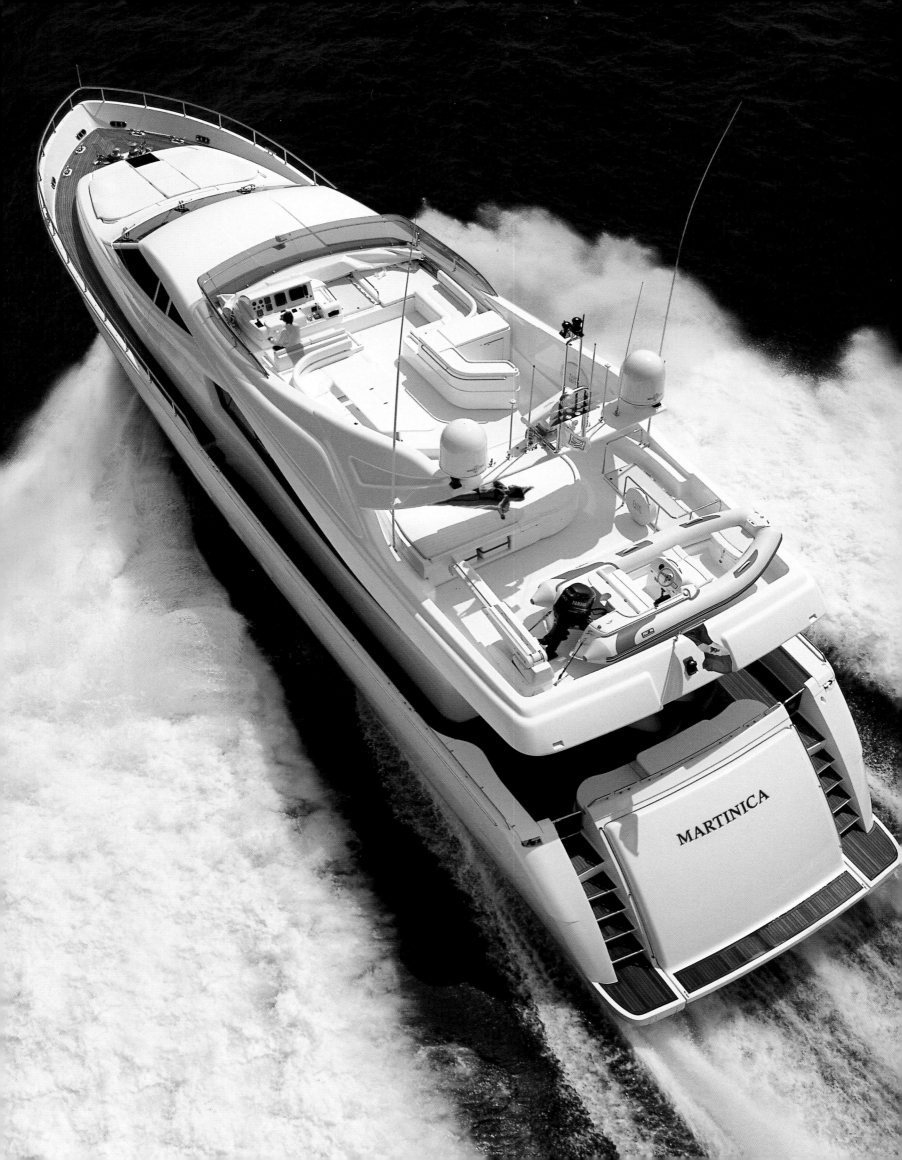

Luxus – das Mehr für's Leben

Luxus bedeutet gemeinhin Pracht, Ausschweifung und all das, was über das zum Leben Notwendige und Essentielle hinausgeht. Allerdings kann Luxus für jeden einzelnen Menschen je nach Herkunft, persönlicher Erfahrung und Lebensalter etwas ganz anderes bedeuten. Das kann die Leidenschaft für ein besonderes Essen sein, aber auch die befriedigende Lust, ein schnelles Auto zu fahren, einen entspannenden Verwöhntag in einem Wellness-Hotel zu verbringen oder auch der Kauf einer extravaganten Uhr. Luxusgüter übersteigen den eigentlichen Zweck eines Gutes. Es sind ästhetisch, qualitativ und technisch hochwertige Produkte.

Allerdings wird in der westlichen, vom Wohlstand geprägten Gesellschaft gerade für die besser verdienende Elite ein Gut immer mehr zum bestimmenden Luxus, von dem sie immer weniger besitzt: die Zeit. So erlangen zunehmend Güter an Bedeutung, die es ermöglichen, Zeit zu sparen oder über die Zeit selbst flexibler zu entscheiden und die kostbare Zeit effektiver zu nutzen: Autos und Privatjets als mobile Büros, Helikopter-Taxis in São Paulo, die es ermöglichen, Verkehrsstaus zu entfliehen und in kürzester Zeit an den gewünschten Zielort zu gelangen.

Luxusgüter erwirbt man als persönliche Belohnung, um sich oder anderen Freude zu bereiten oder auch aus Sozialprestige. Denn das Bedürfnis nach sozialer Abhebung und Unterscheidung bzw. Abgrenzung ist tief im menschlichen Denken und Verhalten verankert. Außer Sozialprestige bieten Luxusgüter auch den Appeal von Vergnügen, Qualität und Einmaligkeit. Neben den Käufern von Luxusgütern, denen es hauptsächlich um den aufmerksamkeitsstarken Außenauftritt geht, gibt es die stillen Genießer im Verborgenen, die die besondere Qualität des Produktes schätzen, oder auch die, die das Image der Einmaligkeit erwerben, da bestimmte Waren nur begrenzt zur Verfügung stehen.

Da prunkvoller Luxus nur sehr wenigen Menschen zugänglich ist, ist er auch immer von einem Hauch von Neid umgeben. Manche Menschen betrachten Luxus oft auch als unnötig oder überflüssig, jedoch sind es gerade auch diese Produkte, die das technisch Mögliche ihrer Zeit widerspiegeln.

Gerade in Zeiten der mehrheitsfähigen Massenproduktion werden Automobile wie Rolls-Royce in klassisch-konventioneller Handarbeit gefertigt, meist individuell auf die Kundenwünsche hin weiter entwickelt, mit modernster Spitzentechnologie und sehr viel Liebe zum Detail.

Dieses Buch stellt eine Reihe von Luxusgütern vor, die die meisten Menschen mit Luxus assoziieren: Autos, Yachten und Privatflugzeuge. Allerdings sind die hier vorgestellten Produkte nicht nur Güter, bei denen es um den reinen Konsumgenuss geht – viele haben einen speziellen Gebrauchswert, z.B. als mobiles Büro, oder sie ermöglichen, Geschäfts-termine individuell zu planen. Dieser funktionale Gebrauchswert schließt jedoch den Genuss eines außergewöhnlichen Komforts und die Verwendung wertvollster Materialien und modernster Technologien nicht aus. Ihnen allen gemein ist eine nahezu zeitlose Aura: Sie hinterlassen in den Augen der Betrachter neidvolles Staunen – wegen ihres ästhetisch schönen Scheins höherer, funkelnder Lebensqualität.

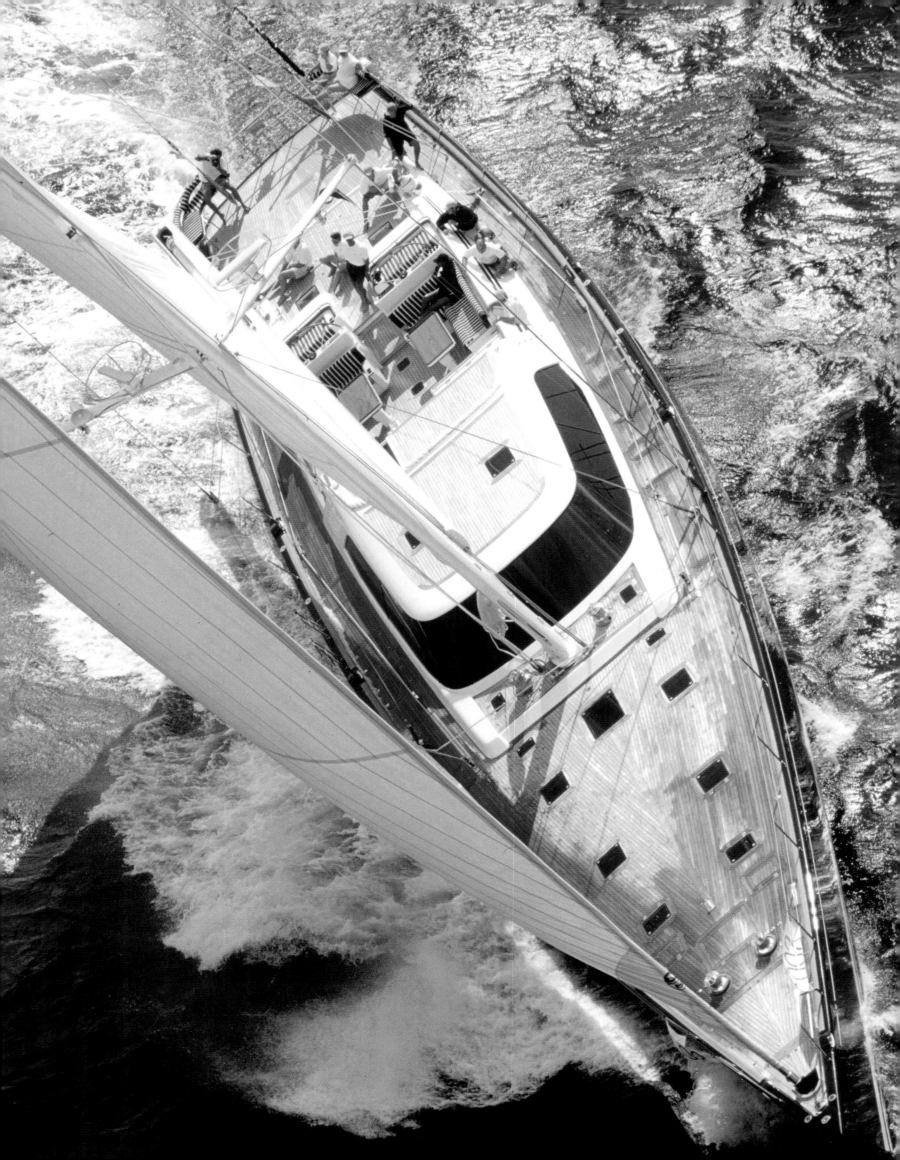

Luxe – les petits plus de la vie

Le luxe est souvent synonyme de faste, d'excès, de ce qui n'est pas indispensable ni nécessaire pour vivre. Mais la notion de luxe diffère totalement selon les individus, l'origine, l'expérience personnelle et l'âge. Car le luxe c'est aussi se passionner pour les plaisirs de la table, conduire une voiture rapide, s'offrir une journée de détente dans un hôtel de remise en forme ou s'acheter une montre extravagante. Les biens de luxe ne se définissent pas uniquement par leur fonction. Bien plus que cela, ils sont esthétiques, de grande qualité et à la pointe de la technique.

Toutefois, la société occidentale de consommation, surtout l'élite des nantis, est en quête d'un bien devenu un luxe de plus en plus rare, à savoir le temps. C'est ce qui explique l'importance croissante des biens qui permettent de gagner du temps, d'en disposer à sa guise ou de mieux l'utiliser, car il est devenu précieux : autos ou jets privés transformés en bureaux mobiles, hélicoptères-taxis de São Paulo, tous permettent d'éviter les embouteillages et d'arriver à destination en temps et en heure.

Acquérir un bien de luxe, c'est en quelque sorte se récompenser soi-même, se faire plaisir ou faire plaisir à autrui. C'est aussi tout simplement une question de prestige social. Car le besoin de s'élever socialement, de se différencier ou de se détacher des autres est profondément ancré dans la pensée et le comportement de l'homme. Mais en plus du prestige social, ces objets de luxe sont synonymes de plaisirs, d'une certaine qualité de vie et de ce qui est unique. A côté des consommateurs de biens de luxe, uniquement axés sur l'apparence et le besoin d'attirer l'attention, il y a ceux qui savourent tranquillement, à l'abri des regards, la qualité du bien dont ils connaissent la valeur. Souvent produits en nombre limité, ils deviennent l'apanage de ceux qui sont attirés par l'image de marque de la pièce unique.

Le luxe fastueux n'est accessible qu'à un tout petit nombre de privilégiés. De ce fait, où qu'il soit, il suscite un brin d'envie. D'aucuns considèrent que les biens de luxe sont inutiles et superflus. Et pourtant, ces biens reflètent les performances techniques de leur époque.

Et c'est justement à cette époque de la production de masse générale, que des ateliers comme Rolls-Royce produisent encore des automobiles fabriquées de manière traditionnelle à la main, sur mesure pour le client, alliant technologie de pointe et amour du détail.

Ce livre offre une panoplie de biens somptueux que la plupart des gens associent au luxe: autos, yachts et avions privés. Toutefois, les objets présentés ici ne se limitent pas uniquement au plaisir de les posséder – un grand nombre d'entre eux ont une utilité spécifique. Ce sont soit des bureaux mobiles – soit ils offrent la possibilité de planifier ses rendez-vous d'affaires à sa convenance personnelle. Cette valeur accordée au fonctionnel et à l'utilitaire n'exclut en rien le plaisir de savourer le confort extraordinaire et d'évoluer dans des espaces qui déclinent noblesse des matériaux et technologies de pointes.
Ces biens de luxe ont tous en commun une aura quasi intemporelle : à leur vue, les regards s'emplissent d'émerveillement mêlé d'envie – car ils sont le miroir d'une qualité de vie aux reflets scintillants d'esthétisme et de beauté.

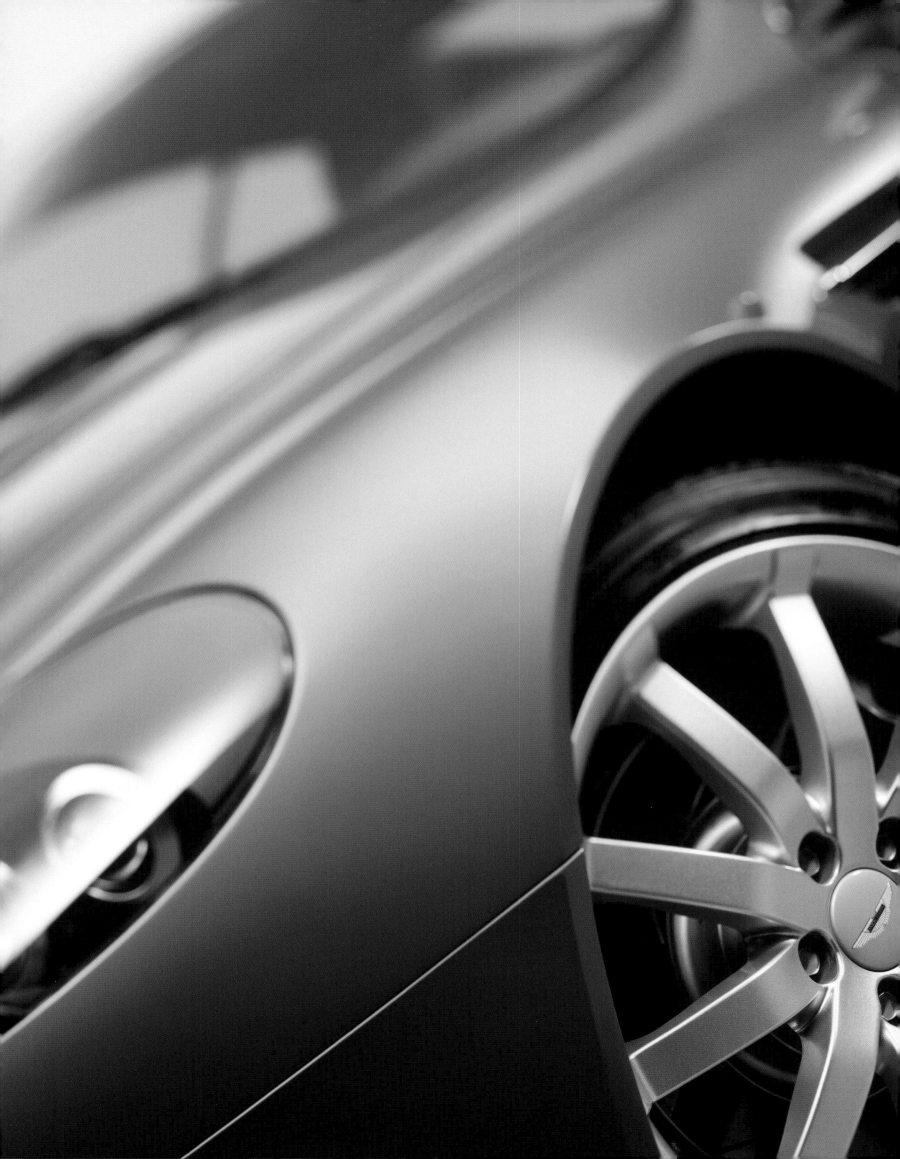

Lujo – el súmmum de la vida

La palabra lujo encierra definiciones como encanto, exceso y todo aquello que va más allá de lo esencial y necesario para vivir. Sin embargo, estos significados pueden variar mucho dependiendo de cada persona, su origen, experiencia personal y edad. Podemos entender por lujo la pasión por una comida especial, el gratificante deseo de conducir un coche rápido, disfrutar de los servicios de balneoterapia que ofrecen algunos hoteles durante un día, e incluso, comprarse un reloj extravagante. Los bienes de lujo no se definen únicamente por su función, sino que son objetos muy valiosos desde un punto de vista estético, de calidad y técnico.

Pero en las sociedades occidentales, sobre todo entre las élites de un alto poder adquisitivo, existe un bien preciado del que cada vez se dispone menos y del que se considera ya todo un lujo: el tiempo. En consecuencia, cobran cada vez mayor valor aquellos productos que permiten ahorrar tiempo o decidir sobre él de forma más flexible y optimizar su aprovechamiento: automóviles y jets privados transformables en despachos móviles o taxis-helicóptero en São Paulo, que hacen posible escapar de los atascos para llegar en el menor tiempo posible al lugar de destino.

Los bienes de lujo se entienden como una recompensa, bien sea para uno mismo o para otros. Pero también son una cuestión de prestigio, ya que la necesidad de ascender en la sociedad, diferenciarse y establecer fronteras está profundamente arraigado en el pensamiento y comportamiento humanos. Pero además del prestigio social, el patrimonio de lujo es sinónimo de placer, calidad de vida y exclusividad. Junto con los compradores de este tipo de objetos, que buscan llamar poderosamente la atención, existen también seres anónimos, discretos, que disfrutan en la intimidad de estas piezas exclusivas y aprecian sus especiales cualidades, o aquellos que, simplemente, desean transmitir una imagen de exclusividad al adquirir bienes disponibles de forma limitada.

El lujo suntuoso sólo está a alcance de unos pocos, y esto provoca que esté rodeado siempre de cierto halo de envidia. Calificado por algunos de innecesario y superficial, lo cierto es que son precisamente estos productos los que reflejan las posibilidades técnicas de su época.

En estos tiempos de la producción en serie, fabricantes como Rolls-Royce apuestan por una manufactura tradicional, acorde con el cliente, aunando tecnología punta con una gran devoción por el detalle.

Este libro presenta una serie de objetos que suelen ser catalogados por la mayoría de las personas como artículos de lujo: automóviles, yates y aviones privados. En cualquier caso, el placer que produce su consumo no representa ni mucho menos su único valor –muchos tienen una utilidad específica, como las oficinas móviles, que están a disposición de su propietario para planificar y celebrar reuniones de negocios. La funcionalidad no excluye el placer de disfrutar de una comodidad fuera de lo normal, de materiales de primera calidad y de la más avanzada tecnología. A todos ellos les es común un aura que permanece en el tiempo: su visión provoca miradas de asombro acompañado de cierta envidia, ya que, inevitablemente, el esplendor de su hermosa apariencia evoca una más elevada y chispeante calidad de vida.

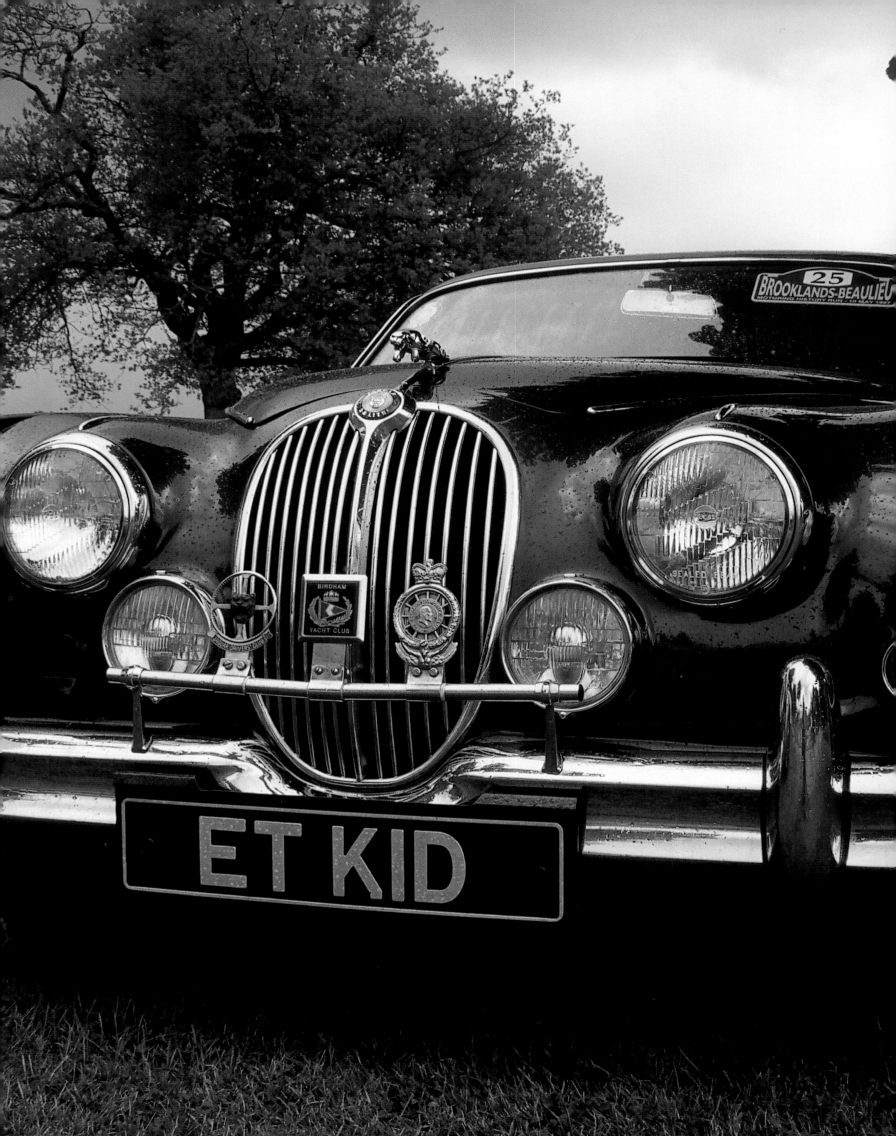

Lusso – quel tocco in più per la vita

Lusso significa generalmente sfarzo, sontuosità e tutto ciò che prescinde dal necessario e dall'essenziale. Ciò nonostante, il lusso può significare anche qualcosa di profondamente diverso per ogni persona, a seconda delle esperienze vissute, della provenienza e dell'età. Lusso può essere per esempio la passione per il cibo, oppure il piacere appagante di guidare un'auto veloce, trascorrere una giornata tutta per sé in un Centro Benessere, o comprarsi un orologio stravagante. Il significato dei beni di lusso va oltre il fine effettivo di un bene e si distingue per l'alto valore estetico, qualitativo e tecnico.

Nelle società Occidentali caratterizzate dal benessere, esiste però un bene che si sta imponendo come un lusso reale difficile da possedere, soprattutto per l'élite economica: il tempo. Per questo, acquisiscono un'importanza sempre maggiore i beni che consentono di risparmiare tempo, che permettono di disporne in modo più flessibile oppure di impiegarlo con efficienza: automobili e jet privati come uffici mobili, taxi-elicotteri a São Paulo che consentono di raggiungere in poco tempo la propria destinazione senza restare intrappolati nel traffico.

I beni di lusso si acquistano come riconoscimento personale, per rendere felici se stessi e gli altri o per il prestigio sociale che ne deriva, poiché il desiderio di distinguersi e riconoscersi socialmente è profondamente radicato nel pensiero e nel comportamento umano. Oltre al prestigio sociale, i beni di lusso offrono anche il fascino del piacere, della qualità e dell'unicità. Accanto agli acquirenti classici di beni di lusso, che cercano principalmente di suscitare attenzione e ammirazione, esistono anche gli intenditori silenziosi, che sanno apprezzare la particolare qualità del prodotto, oppure quelli interessati più all'unicità dell'immagine, visto che alcuni beni sono disponibili solo in serie limitata.

Dato che il lusso sfarzoso è accessibile solo per pochi privilegiati, esso è generalmente circondato da un velo d'invidia. Alcune persone lo considerano inutile e superfluo, anche se proprio questi prodotti riflettono le potenzialità tecniche del proprio tempo. Non a caso, nell'era della produzione di massa, si costruiscono auto come le Rolls-Royce con il procedimento artigianale classico, adattandole ai desideri individuali dei clienti e arricchendole delle tecnologie più moderne e di un'attenzione assoluta per il dettaglio.

Questo libro presenta una serie di beni di lusso secondo la concezione più tradizionale del termine: auto, yacht e aerei privati. Ciò nonostante, i prodotti presentati di seguito non sono semplici beni da consumare – molti di essi possiedono uno speciale valore d'uso, pensiamo per esempio all'ufficio mobile e alla possibilità di programmare autonomamente appuntamenti di lavoro. Questo valore d'uso funzionale non esclude comunque il piacere di un comfort eccezionale, l'impiego dei materiali più pregiati e la tecnologia più moderna. Il risultato è un'aura quasi senza tempo: questi beni lasciano negli occhi di chi guarda uno stupore velato d'invidia, trasmettendo l'immagine esteticamente piacevole di una qualità di vita sfavillante e superiore.

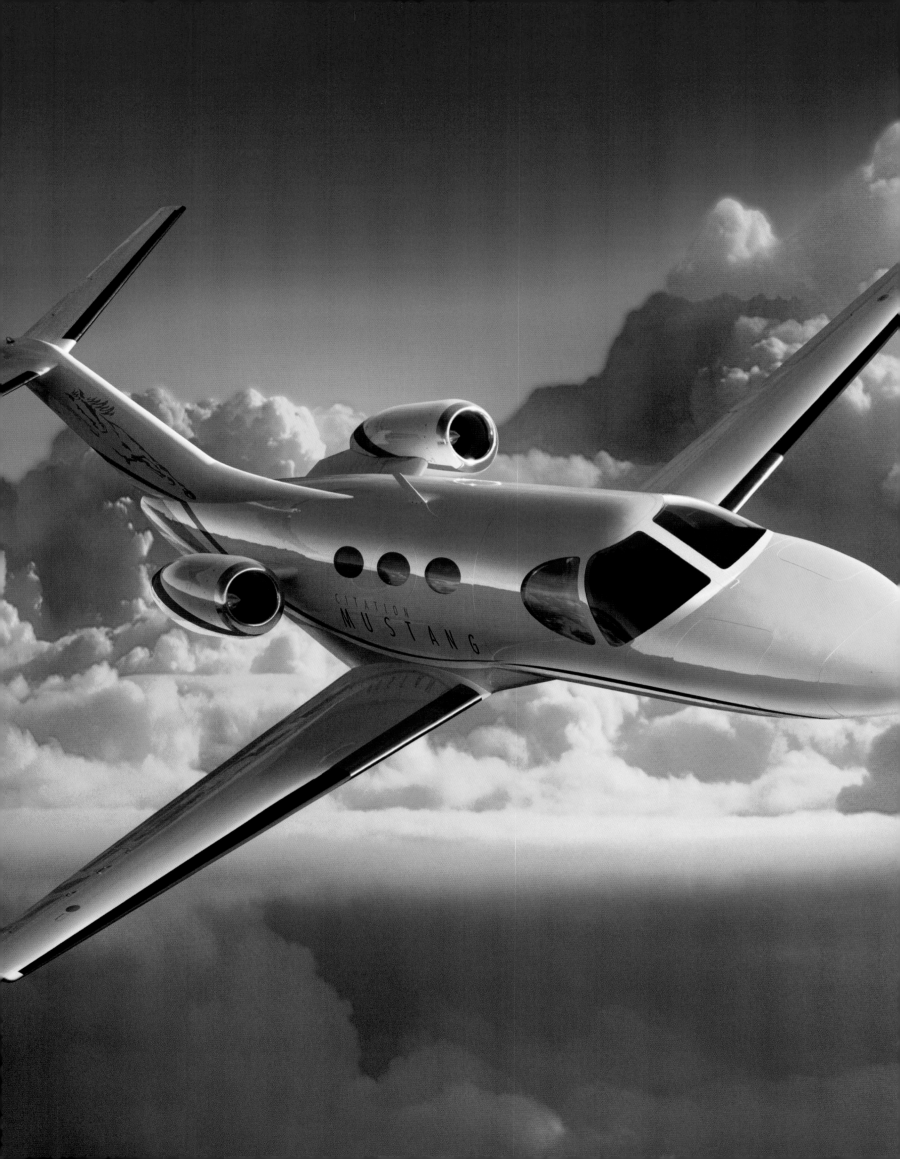

Motor yachts

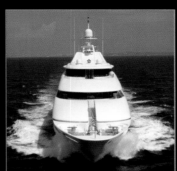

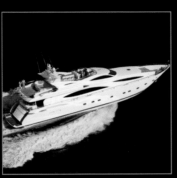

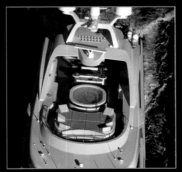

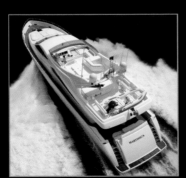

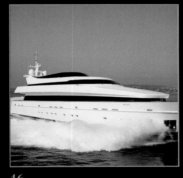

Wally Wallypower 118'

This futuristic yacht with razor sharp edges and a dark, shiny skin does 120 km/h, making it the world's fastest motor yacht.
In addition to its astonishing performance in the water, the ship also offers all the amenities you would expect in a luxury yacht. A glass-sided deckhouse accommodates a spacious, white-upholstered living room and a dining room with a carbon fiber dining table. The Wallypower offers sleeping space for 12 people, and each stateroom has its own bathroom and dressing room.

Diese futuristische Motoryacht mit rasiermesserscharfen Kanten und dunklen metallisch glänzenden Oberflächen ist mit 120 km/h die derzeit schnellste Motoryacht der Welt.
Neben den unglaublichen Fahrleistungen bietet das Schiff auch den Komfort einer Luxusyacht. Das mit Glasflächen versehene Deck beherbergt einen großzügigen Salon mit weißer Polsterung und ein Esszimmer mit einem aus Karbonfaser gefertigtem Tisch. Die Schlafkabinen verfügen über ein eigenes Bad und Ankleidezimmer. 12 Personen haben auf der Wallypower Platz.

Ce yacht futuriste aux lignes effilées, pures et franches étincelant dans sa robe sombre métallisée, doté d'une puissance de 120km/h, est actuellement le yacht à moteur le plus rapide du monde.
Ce bateau allie une vitesse de pointe incroyable au confort d'un yacht de luxe. Les grandes baies vitrées du pont abritent un salon spacieux capitonné de blanc et une salle à manger dotée d'une table en fibre de carbone. Chaque cabine couchette à sa propre salle de bains et son dressing. Le Wallypower peut accueillir 12 personnes.

Este futurista yate a motor con aristas afiladas como cuchillas de afeitar y oscuras y brillantes superficies metalizadas es, a sus 120 km/h, el yate a motor más rápido del mundo.
Junto a las increíbles prestaciones de velocidad, la embarcación ofrece la comodidad de un yate de lujo. La cubierta con superficies acristaladas alberga un generoso salón con asientos acolchados blancos y un comedor con una mesa de fibra de carbono. Los camarotes disponen de baño y vestidor propios. El Wallypower da cabida a 12 personas.

Questo motoryacht futuristico con spigoli vivi e superfici scure e metalliche è il più veloce del mondo con i suoi 120 km/h.
Accanto alle eccezionali prestazioni, l'imbarcazione offre il comfort di uno yacht di lusso. Il ponte dotato di superfici in vetro nasconde un ampio salone con imbottiture bianche e una sala da pranzo con tavolo in fibra di carbonio. Le cabine dispongono di un bagno privato e di uno spogliatoio. La Wallypower può ospitare fino a 12 persone.

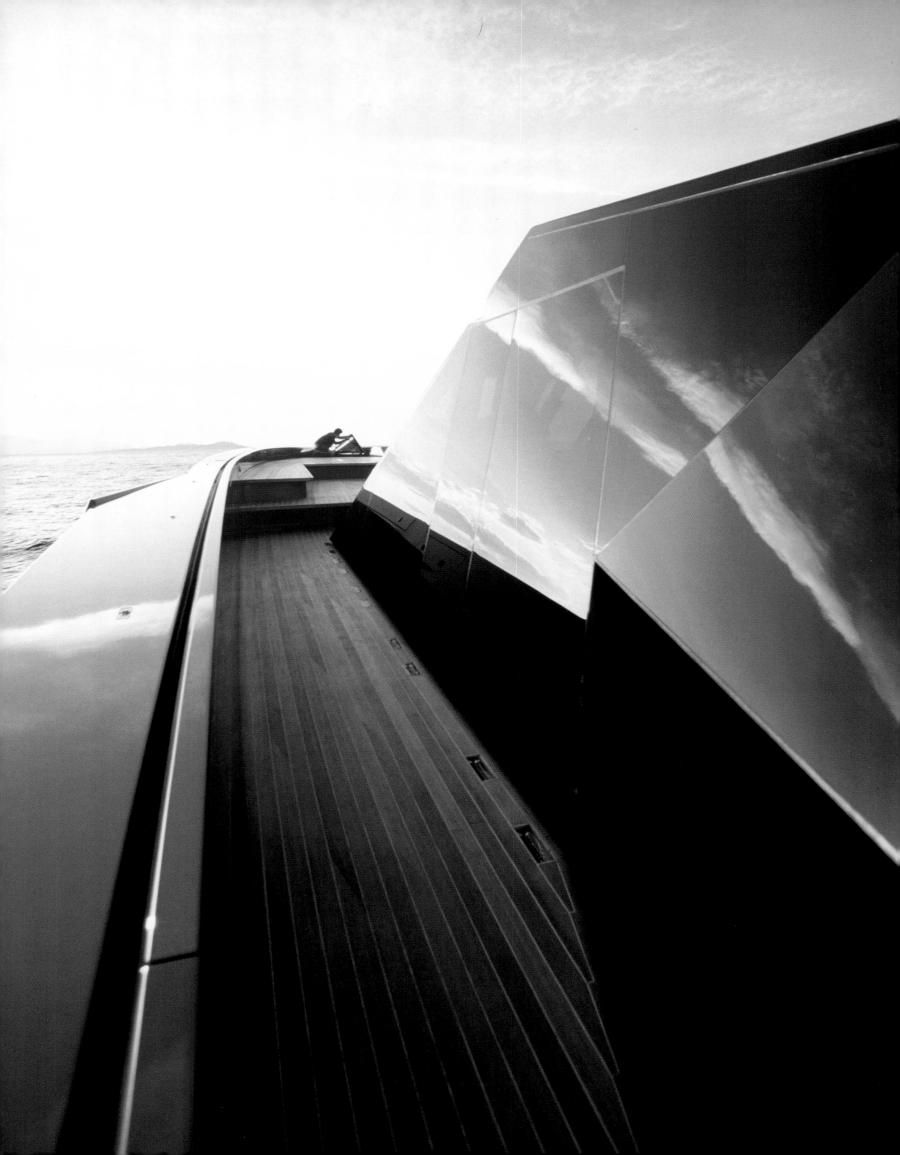

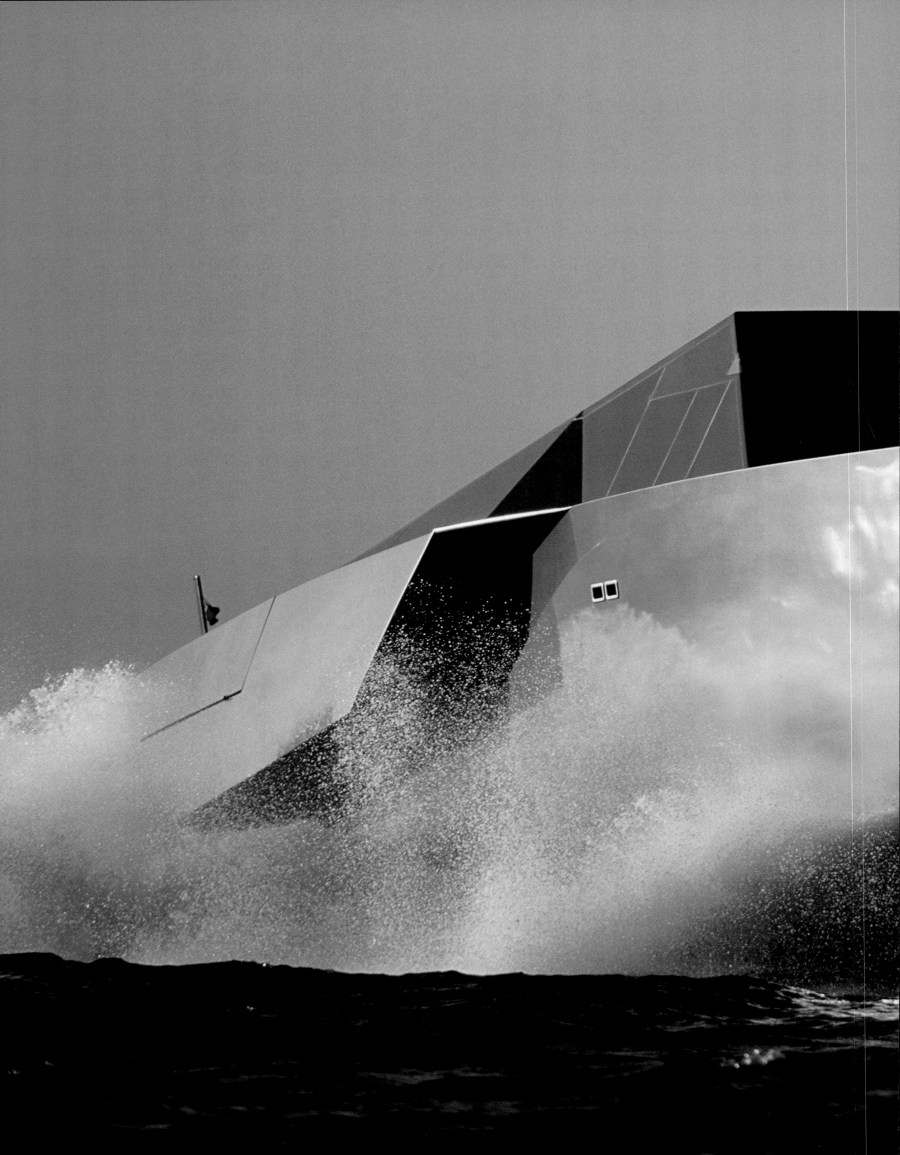

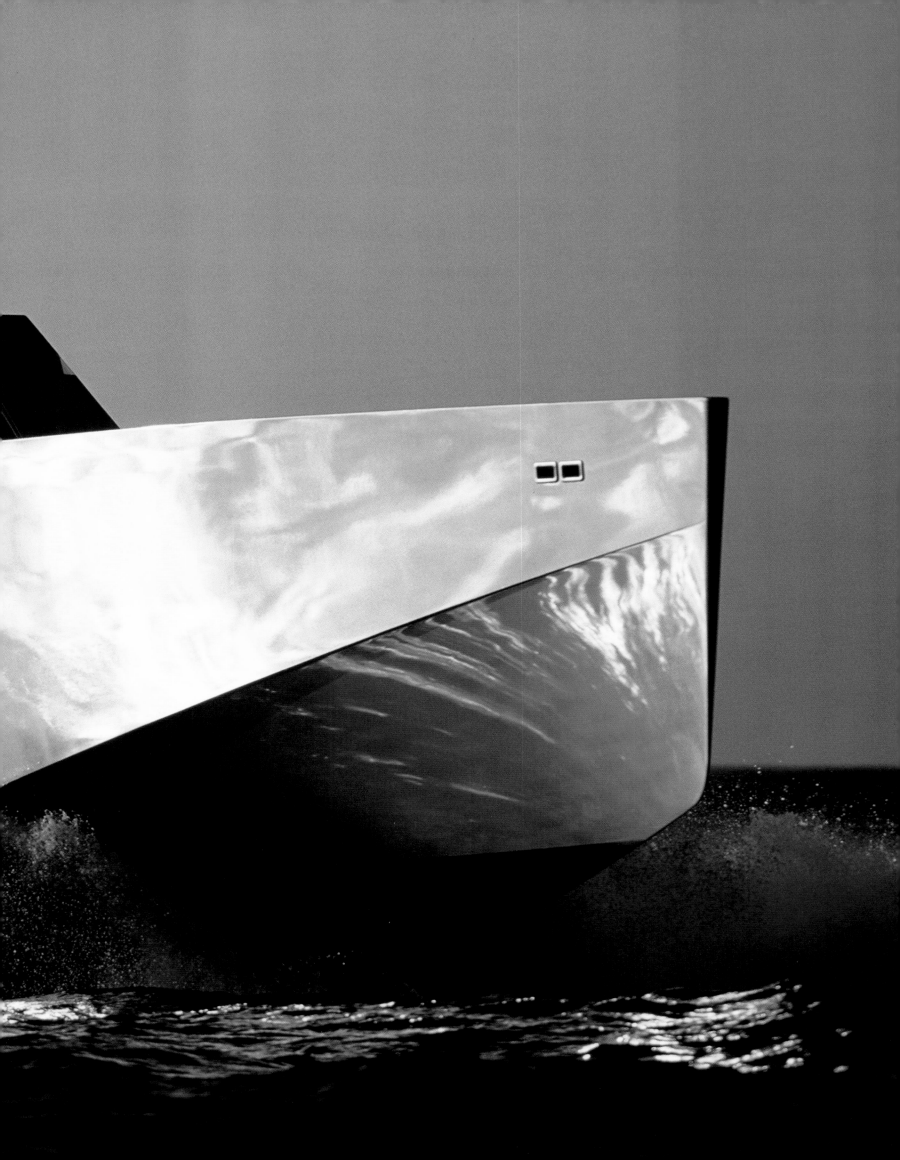

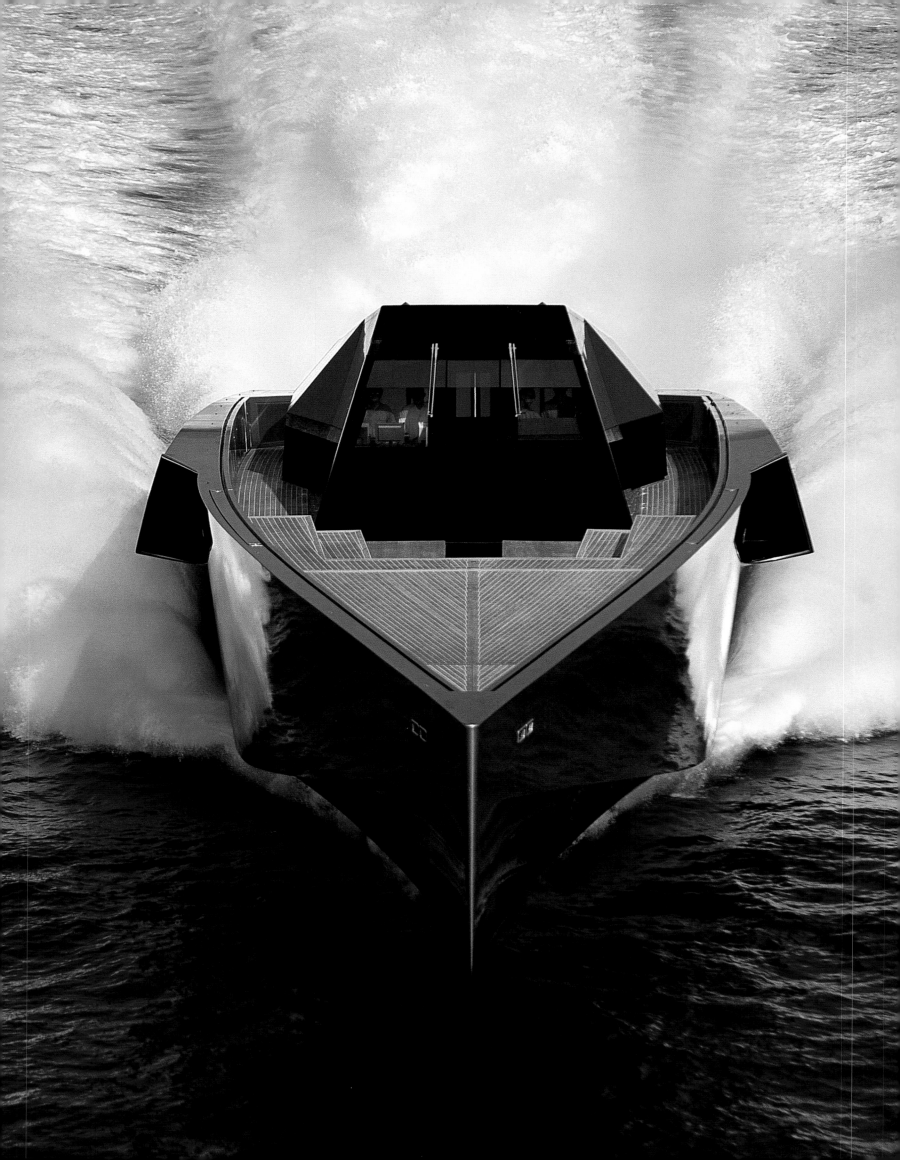

This kind of seagoing idyll comes at price: 14 to 21 million euro, depending on the engine. And it isn't cheap to run either: a full tank of fuel costs 20,000 euro.

Der maritime Superlativ hat seinen Preis: 14 bis 21 Millionen Euro – je nach Ausbaustufe des Antriebs. Und auch den Unterhalt muss man sich leisten können, denn einmal voll tanken kostet 20.000 Euro.

Cette diva maritime coûte un certain prix : de 14 à 21 millions d'Euros – selon la puissance du moteur. L'entretien n'est pas non plus à la portée de toutes les bourses. En effet, faire le plein coûte 20 000 euro.

Este gigante marítimo tiene precio: de 14 a 21 millones de euros, según el grado de potencia. Tampoco el mantenimiento está al alcance de cualquiera, ya que sólo llenar una vez el depósito cuesta 20 000 euros.

Questo superlativo marittimo ha anche un prezzo: da 14 a 21 milioni di Euro – a seconda della potenza del motore. E anche i costi di funzionamento non sono alla portata di tutti; fare il pieno costa infatti 20 000 euro.

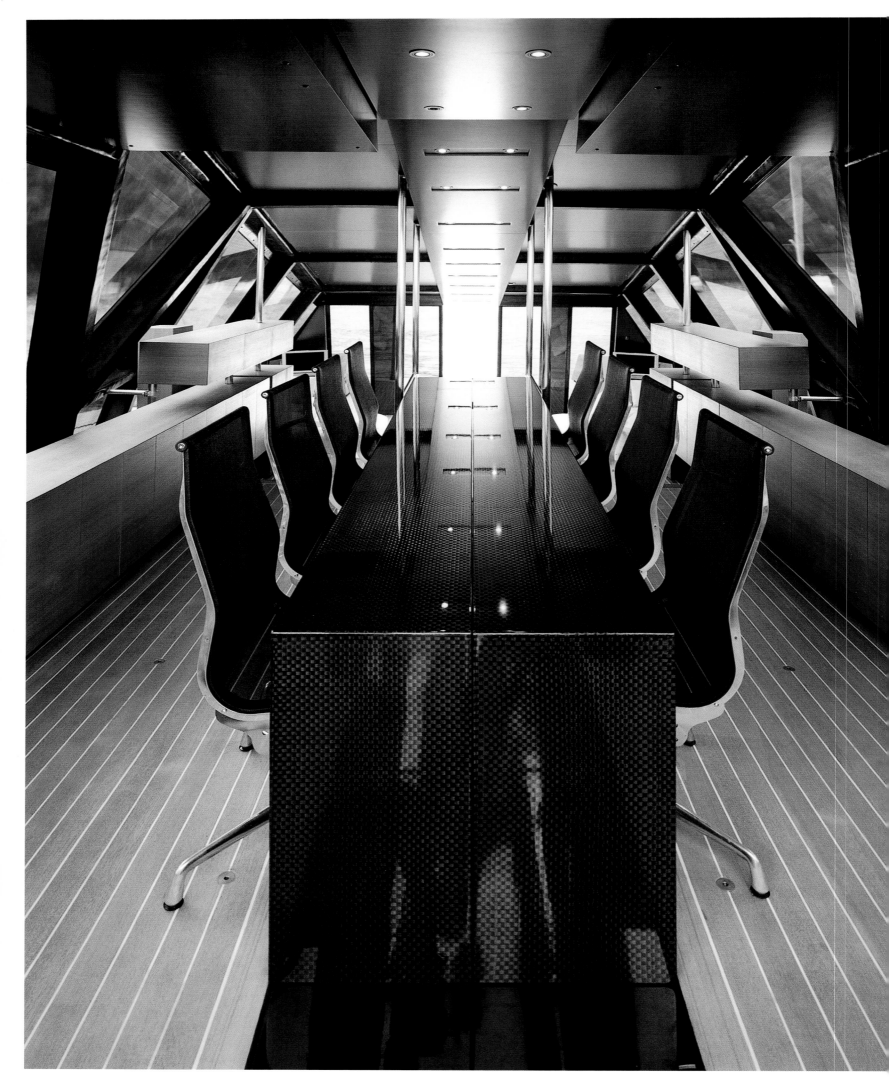

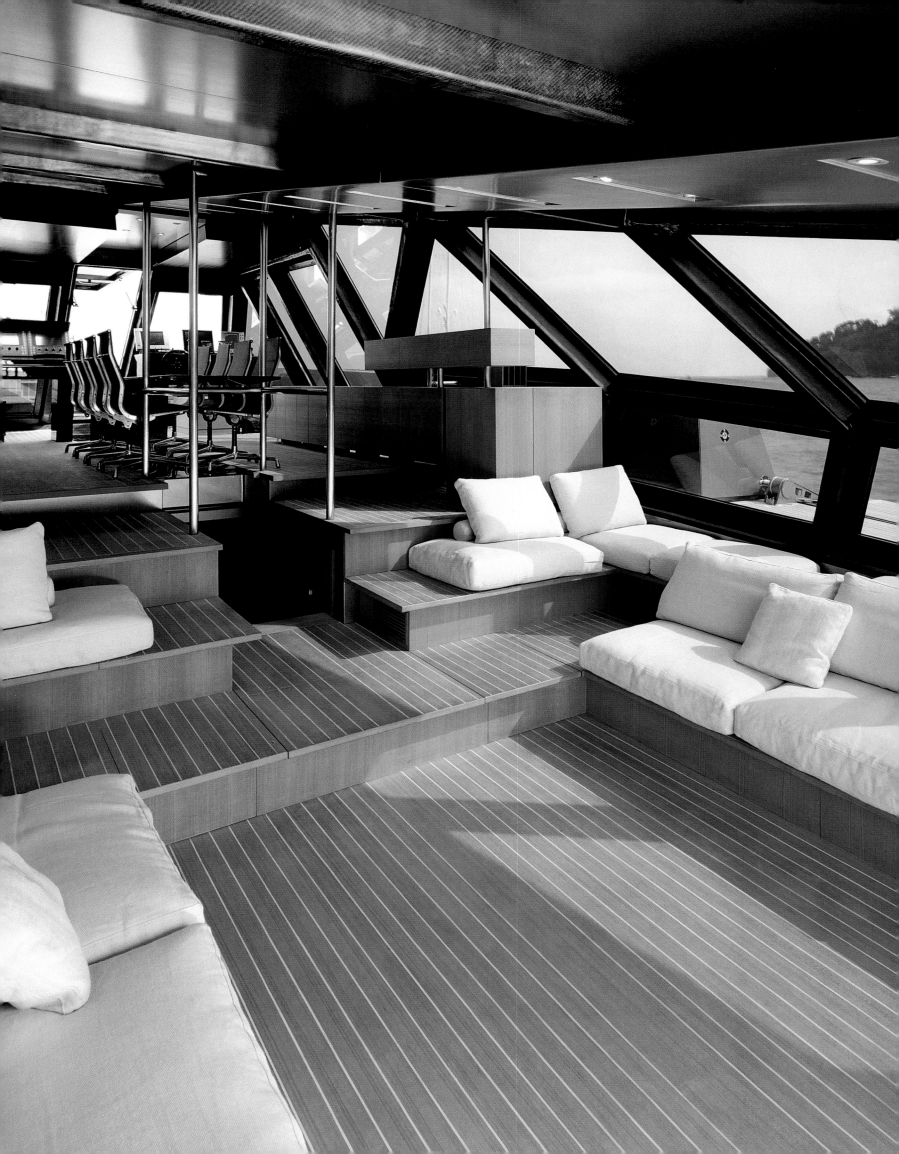

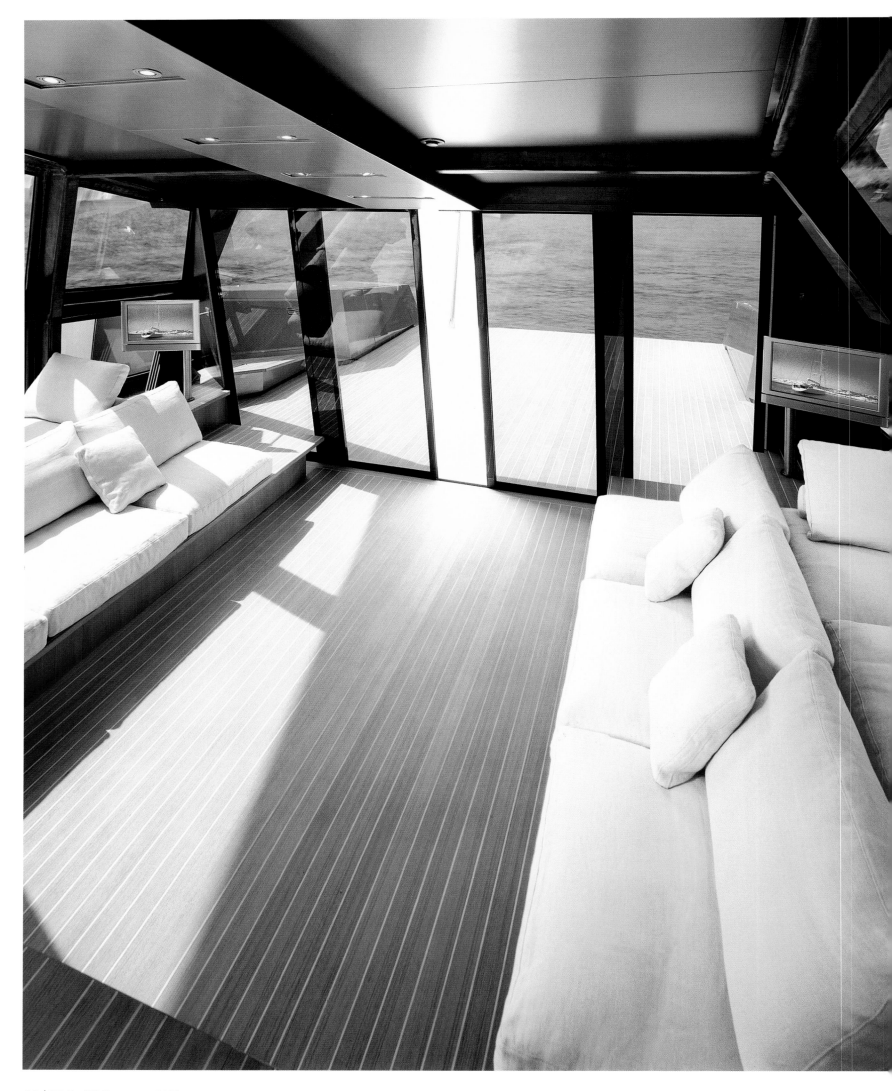

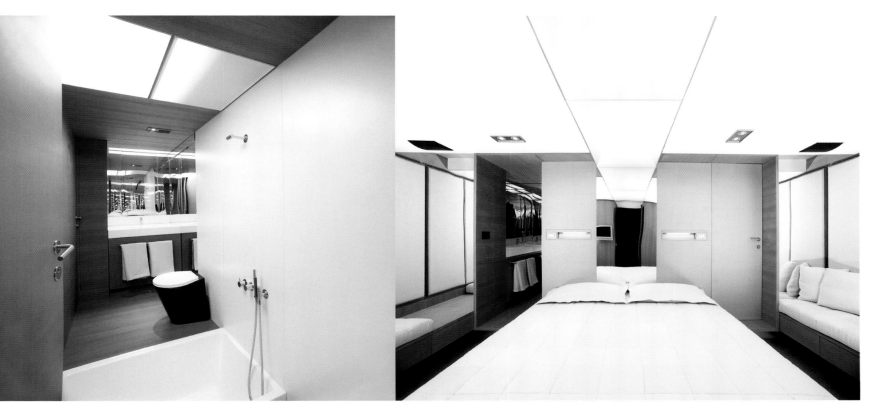

Photos: © Gilles Martin-Raget

TECHNICAL SPECIFICATIONS

Builder	Wally, Intermarine Italy
Price	$ 25,000,000 / € 21,000,000
Naval Architecture	Wally, Lazzarini & Pickering Architects
Design	Wally, Lazzarini & Pickering Architects
Contact	www.wally.com
Engine	3 x DDC TF50 gas Turbines
	2 x Cummins 370 hp
Displacement	95 tons
Cruising Speed	60 knots
Fuel capacity	22,000 l
Water capacity	1,200 l
LOA , BEAM , DRAFT	118 ft, 26 ft, 4.3 ft
Classification	RINA - DNV
Range	1,500 nm
Material	Polyester and carbon fiber

Lürssen Capri

This special-ordered 192-foot motor yacht was built by Lürssen Yachts in 2003. The Capri offers its passengers exquisite comfort on all five decks. In addition to an owner's cabin which has an onyx ensuite bathroom, the ship also features a library, an office, two VIP cabins and four guest cabins, plus a jacuzzi, a fitness center, and a sun deck on the upper deck, which doubles as a helicopter landing pad. The customer also had Lürssen build a recording studio on the motor yacht. The "Skylounge" with its bar and various lounge seating areas is an ideal venue for stargazing.

2003 wurde diese 192 Fuß große, auf Kundenwunsch gebaute Motoryacht aus dem Hause Lürssen vom Stapel gelassen. Capri bietet Komfort auf fünf Decks. Neben einer Eignerkabine mit einem Onyxbadezimmer, einer Bibliothek, einem Büro und zwei Vip-Kabinen sowie vier Gästekabinen ist diese Luxusyacht mit einem Whirlpool, einem Fitnessstudio und einem Sonnendeck auf dem Oberdeck ausgestattet. Das Sonnendeck kann auch als Helikopterlandeplatz genutzt werden. Auf Kundenwunsch wurde ein professionelles Musikstudio installiert. In der „Skylounge" mit eingebauter Bar und diversen Sitzecken kann man dann die Sterne am Abendhimmel genießen.

Ce motor-yacht de 192 pieds construit par la maison Lürssen, selon les désirs du client, a été lancé en 2003. Le Capri offre le confort sur cinq niveaux. Fort d'une cabine dotée d'une salle de bains en onyx, d'une bibliothèque, d'un bureau, de deux cabines V.I.P. et de quatre cabines d'invités, ce yacht luxueux est aussi équipé d'un bain à remous, d'un studio de remise en forme et d'une plate-forme bain de soleil sur le pont supérieur. Ce dernier sert aussi de piste d'atterrissage pour hélicoptères. A la demande du client, un studio de musique professionnel a été installé. Le « Skylounge » équipé d'un bar intégré et de bancs d'angle et fauteuils assortis permet de contempler la nuit étoilée.

Este yate a motor de 192 pies fue construido por encargo por Lürssen de Stapel en el año 2003. Capri ofrece comodidad en cinco cubiertas. Además, junto al camarote del propietario que contien un baño en onyx, este yate de lujo cuenta con una biblioteca, un despacho y dos camarotes vip, así como cuatro camarotes para invitados, un yacuzzi, un pequeño gimnasio y un solárium en la cubierta superior. El solárium se puede utilizar también como pista de aterrizaje para helicópteros. Por petición del cliente se instaló un estudio de grabación de música. En el "skylounge" con bar empotrado y diversos asientos en ángulo se puede disfrutar durante la noche del cielo estrellado.

Questo motoryacht 192 piedi, costruito su ordinazione secondo i desideri dell'armatore, è uscito dai cantieri Lürssen nel 2003 e offre un comfort totale distribuito su cinque ponti. Oltre alla cabina armatoriale con un bagno in onice, una biblioteca e un ufficio, due cabine VIP e quattro cabine per gli ospiti, sul ponte di coperta di questo yacht di lusso sono disponibili un idromassaggio, una palestra e una zona prendisole, che può fungere anche da pista di atterraggio per elicotteri. Su richiesta del cliente, nello yacht è stato installato anche uno studio di registrazione professionale. Nella „Skylounge" fornito di bar e diversi angoli per la conversazione è possibile ammirare il cielo stellato.

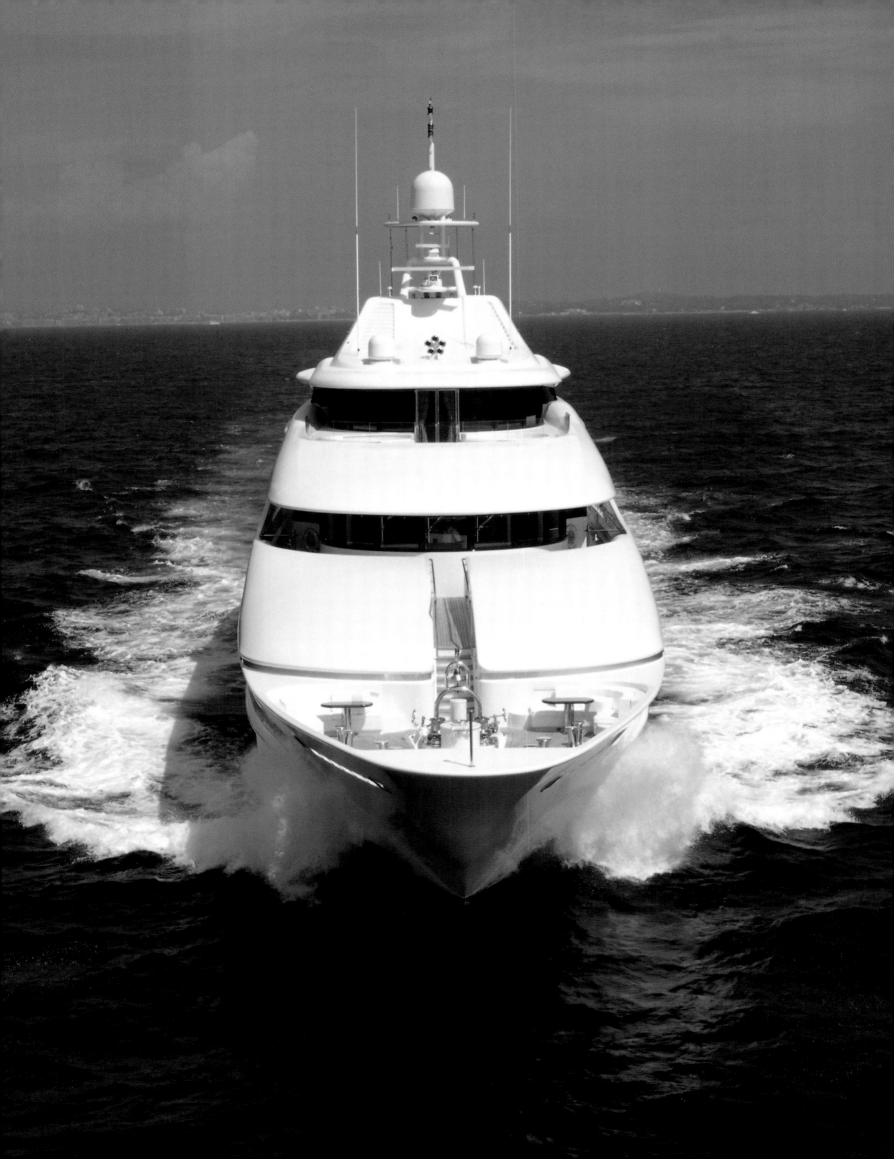

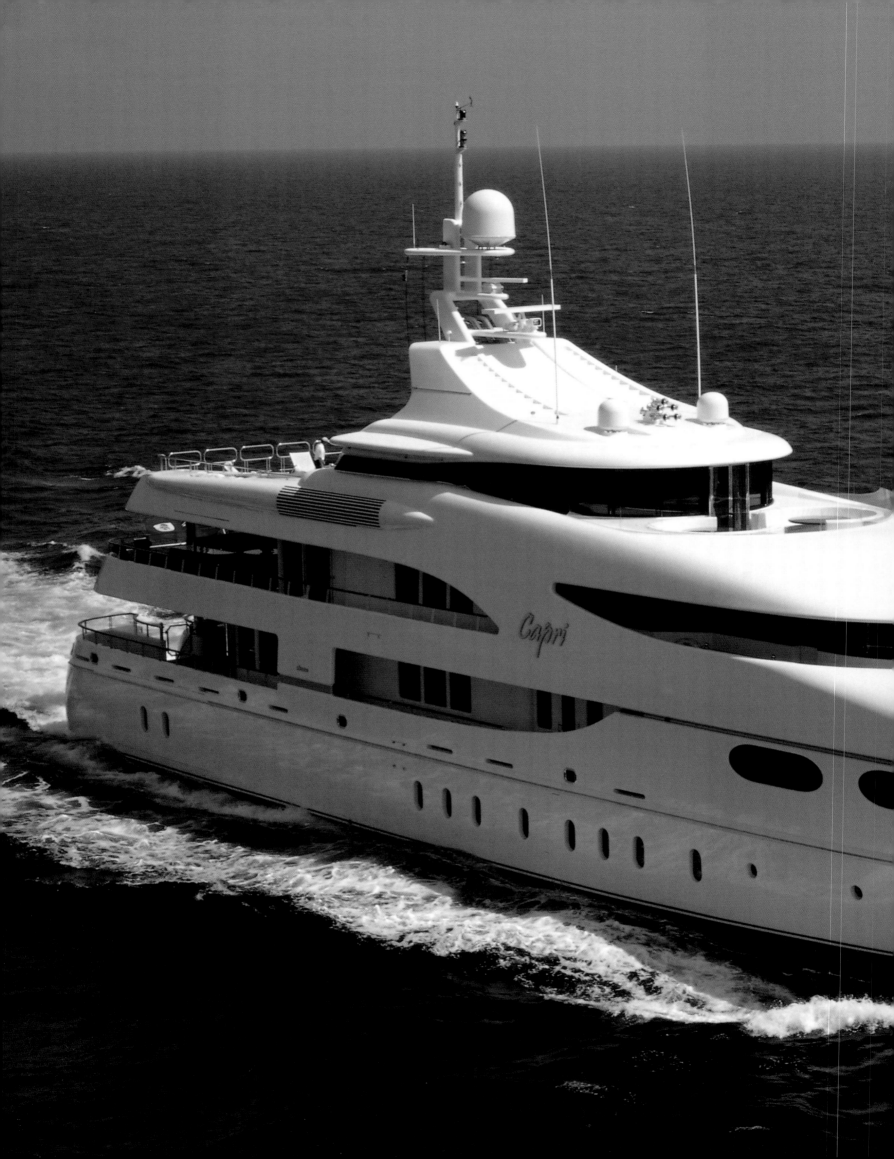

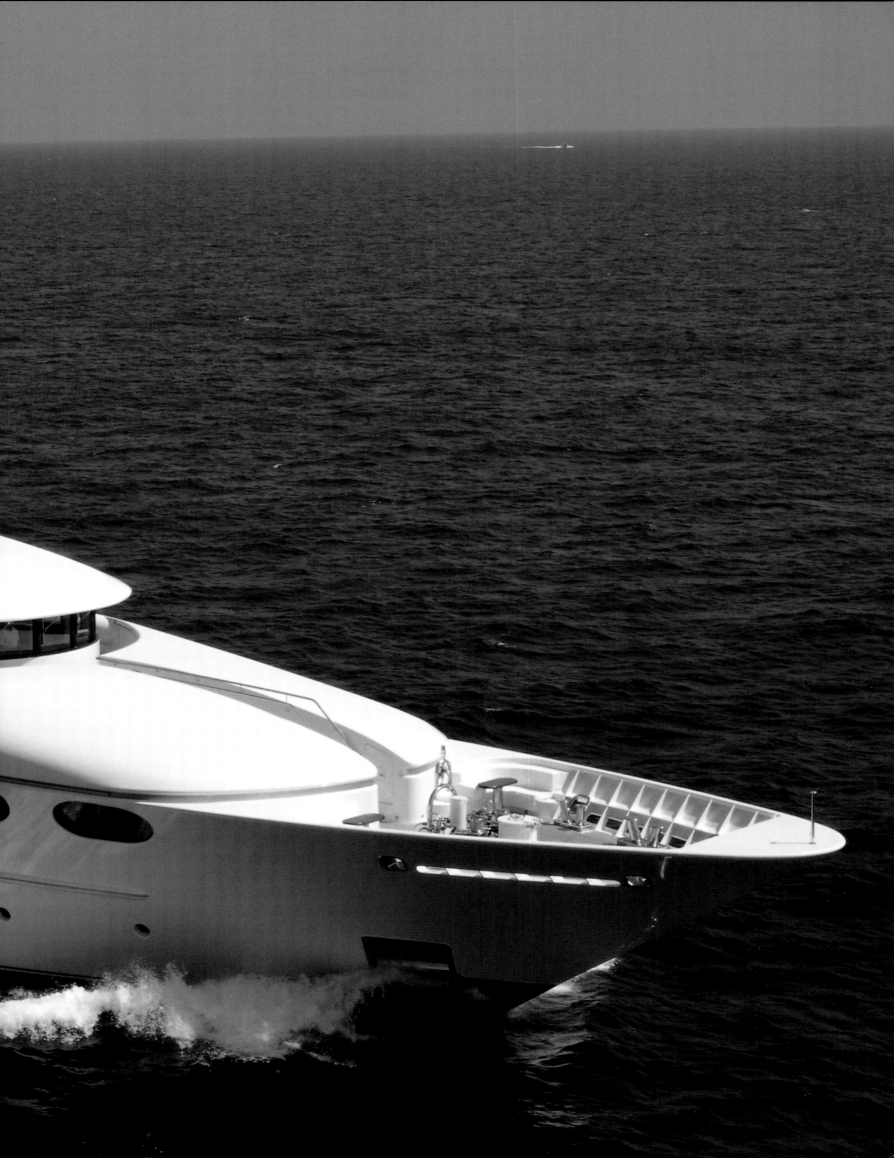

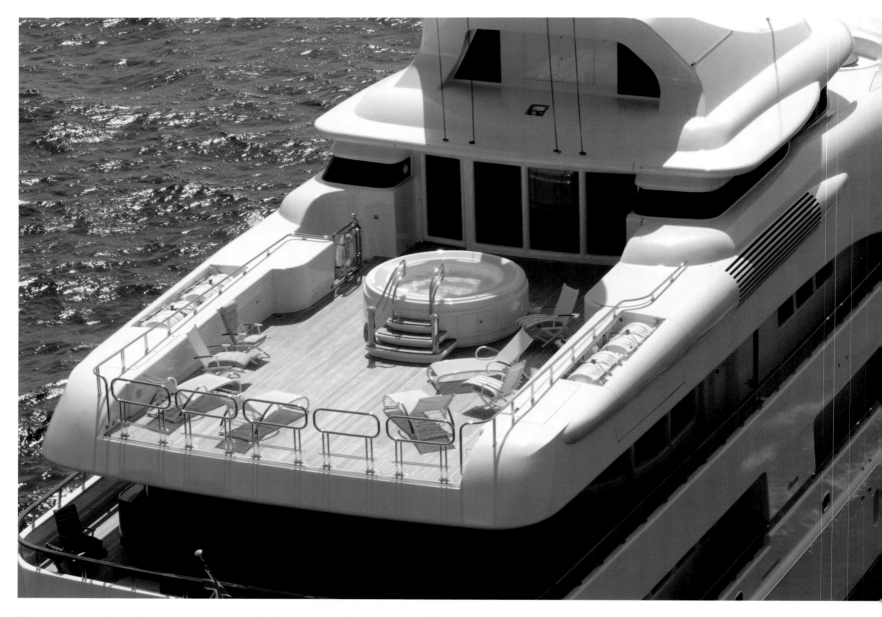

Passengers seeking distraction have at their disposal the aforementioned fitness center and a 62 inch plasma TV screen in the Skylounge. The garage, which is outfitted with hydraulic doors, accommodates outdoor equipment such as kayaks and bicycles.

Für Unterhaltung sorgt neben dem Fitnessstudio auch der 62 Zoll Plasmabildschirm in der „Skylounge". In der mit Hydrauliktüren versehenen Garage befinden sich zudem entsprechende Sportgeräte, wie z.B. Kajaks und Fahrräder.

Le studio de remise en forme et l'écran plasma de 62 pouces du « Skylounge » assurent détente et divertissement. Le garage muni de portes hydrauliques abrite aussi des articles de sport, notamment des kayacs et des vélos.

El entretenimiento está garantizado, ya que, además del gimnasio, el barco cuenta con una pantalla de plasma de 62 pulgadas en el "Skylounge". En el garaje provisto de puertas hidráulicas se almacena el material deportivo, como kajaks y bicicletas.

Per il tempo libero gli ospiti hanno a disposizione una stanza per il fitness ma anche uno schermo al plasma 62 pollici nella "Skylounge". Nel garage dotato di porte idrauliche si trovano diverse attrezzature per lo sport come i kajak e le biciclette.

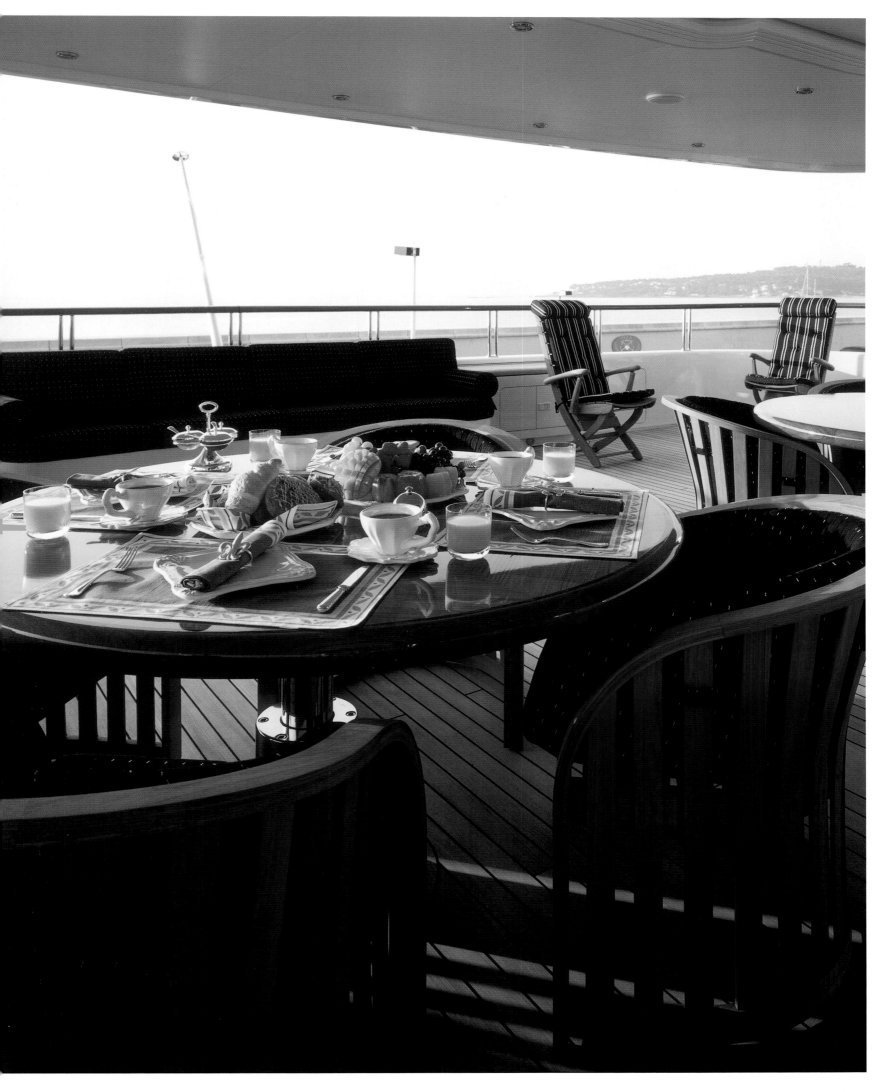

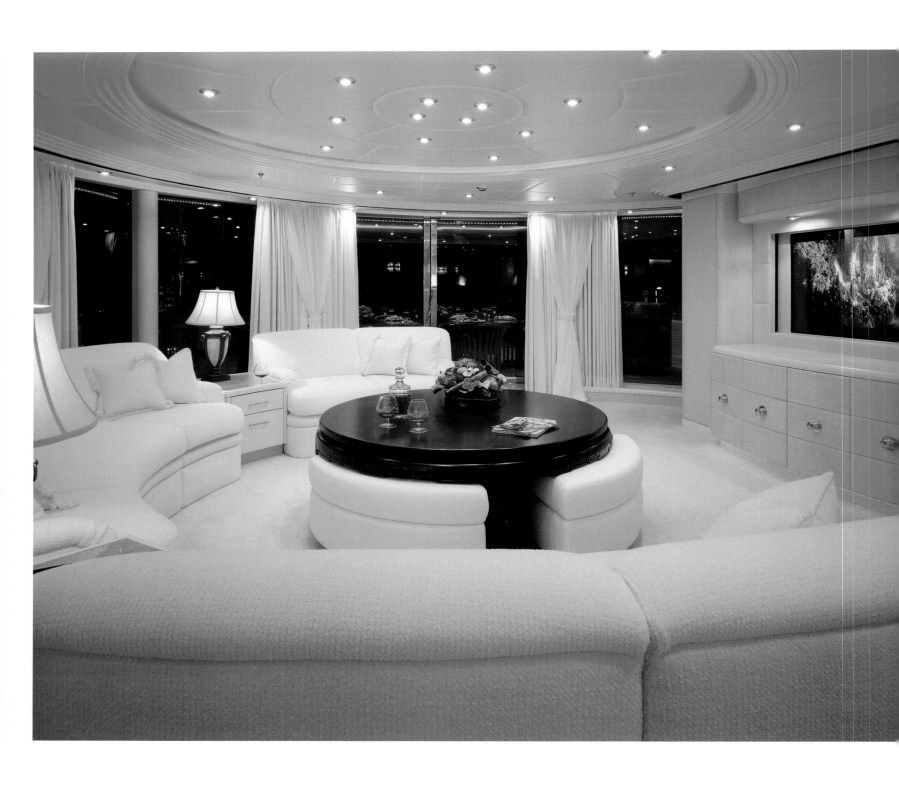

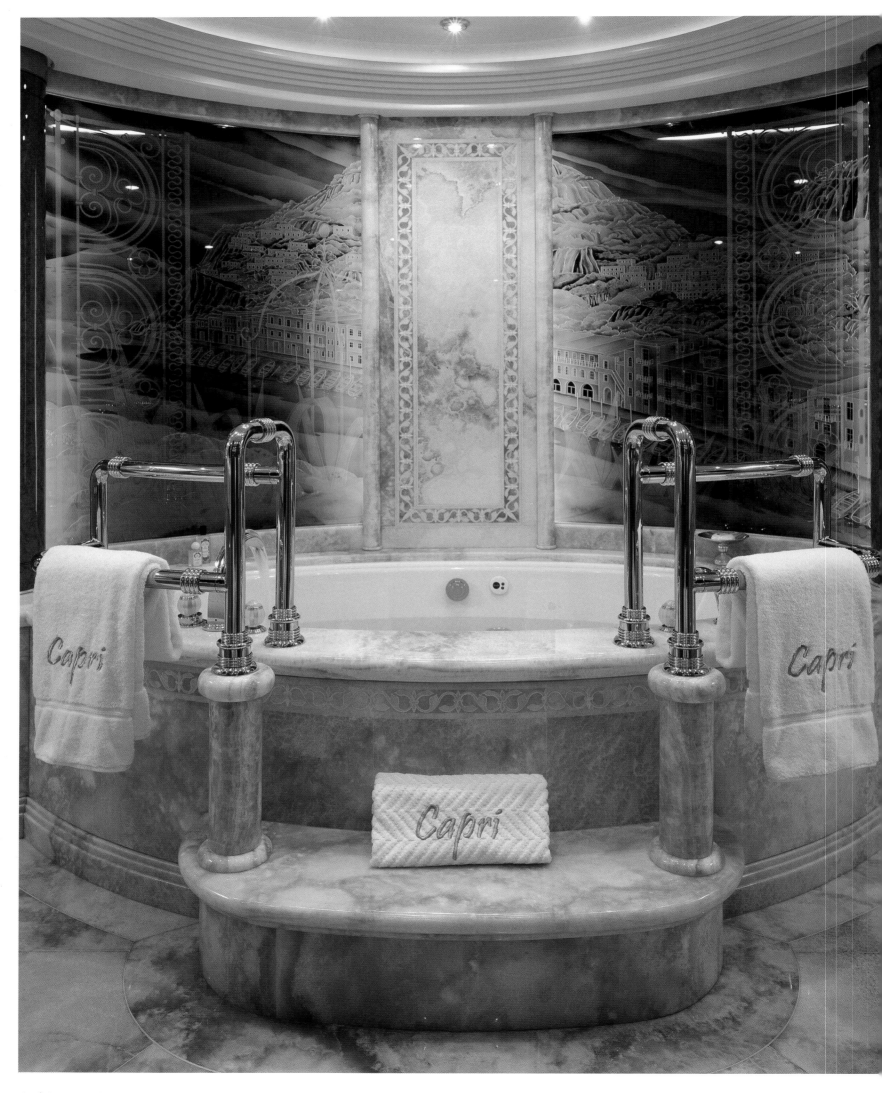

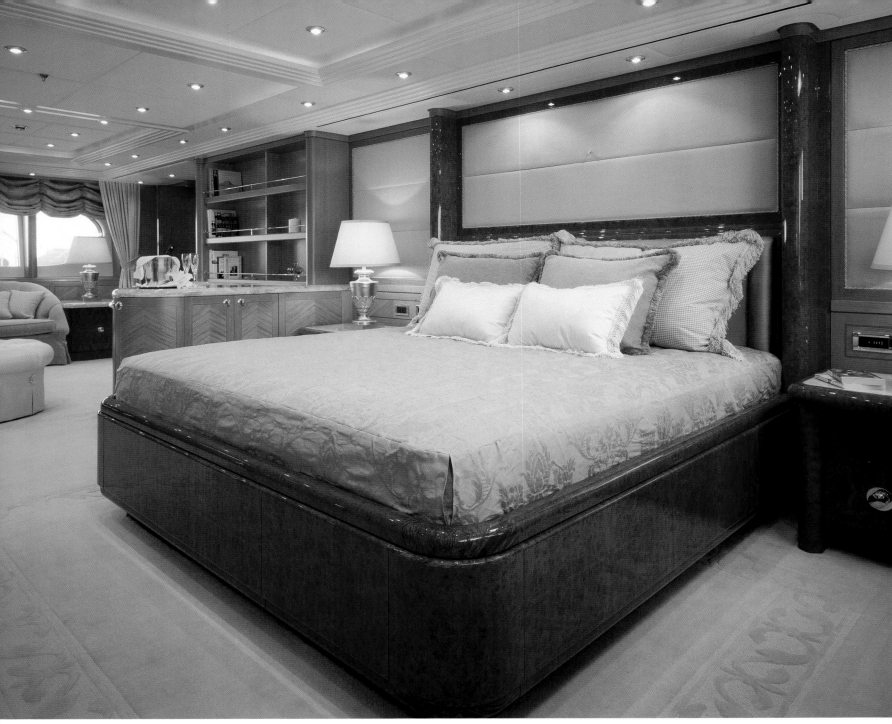

TECHNICAL SPECIFICATIONS

Builder	Lürssen
Price	Price on request
Naval Architecture	Lürssen
Design	Glade Johnson Design
Contact	www.lurssen.com
Engine	Twin Caterpillar 3512B Diesels
Displacement	1,226 tons
Top Speed	16.1 knots
Fuel capacity	150,000 l
Water capacity	28,000 l
LOA , BEAM , DRAFT	192 ft, 37.6 ft, 11.6 ft
Classification	Lloyd's X 100A1, SSC Yacht Mono, LMC CCS, G6 UMS; MCA certificate
Range	5,000 nm
Material	steel hull, aluminum superstructure

Sunseeker 105

Winner of the Superyacht Design Award, the Sunseeker 105 enables each owner to specify their own choice of layout, fittings and finishes for this 105-foot yacht.
To make the craft even more customizable, the Sunseeker has various changes to the basic specification including a triple-level owner's suite forward. The stateroom, which is on the upper deck, features a panoramic view and an oversize bed. A marble bathroom with a jacuzzi can be accessed from the dressing room via a spiral staircase.

Diese Superyacht, die den internationalen Superyacht-Design-Award erhalten hat, kombiniert die ausgereifte Konstruktion eines Serienmodells mit der Möglichkeit individuelle Kundenwünsche umzusetzen. So entsteht jede Sunseeker 105 ganz neu und immer auf die Bedürfnisse des Eigners angepasst.
Um bei der Gestaltung keinerlei Grenzen unterworfen zu sein, ist die Eigner-Suite auf verschiedenen Ebenen angeordnet. Auf der oberen Ebene befindet sich das Schlafzimmer mit Panoramablick und einem übergroßen Bett. Das mit Spiegeln ausgelegte Ankleidezimmer ist über eine Wendeltreppe mit einem Marmorbad inklusive Whirlpool verbunden.

Ce super yacht qui a reçu la récompense internationale Superyacht Design Award, permet de décliner toutes les volontés personnelles du client sur la base d'une construction en série très au point. Chaque nouveau Sunseeker 105 peut être modulé selon les désirs du propriétaire.
C'est ainsi que la suite personnelle est prévue sur plusieurs niveaux pour laisser le choix libre au client lors de la conception finale. Le dernier niveau s'ouvre sur la chambre à coucher avec vue panoramique et un lit surdimensionné. Le dressing agrémenté de miroirs est relié par un escalier en colimaçon à une salle de bains de marbre dotée des bains à remous.

Este superyate, galardonado con el premio Superyacht Design Award, combina la madurada construcción de un modelo de serie con la posibilidad de realizar modificaciones por encargo del cliente. De esta forma cada Sunseeker 105 es un yate perfectamente nuevo que se adapta a las necesidades del propietario.
La suite del propietario se encuentra distribuida en diferentes niveles para no limitar el diseño. La planta superior acoge el dormitorio con excelentes vistas panorámicas y una cama de grandes dimensiones. El vestidor, decorado con espejos, comunica con un baño de mármol con jacuzzi por medio de una escalera de caracol.

Questo superyacht, che ha ricevuto il premio Superyacht Design Award, coniuga in sé l'affidabilità del modello di serie con la possibilità di soddisfare i desideri individuali dei clienti. Per questo, ogni Sunseeker 105 nasce come un'imbarcazione unica adatta alle esigenze dell'acquirente.
Non a caso, la suite armatoriale è suddivisa su diversi livelli, per non sottostare a limiti di nessun genere in fase di progettazione. Sul livello superiore si trova la stanza da letto con vista panoramica e un letto immenso. Lo spogliatoio rivestito di specchi è collegato tramite una scala a chiocciola ad un bagno in marmo con idromassaggio.

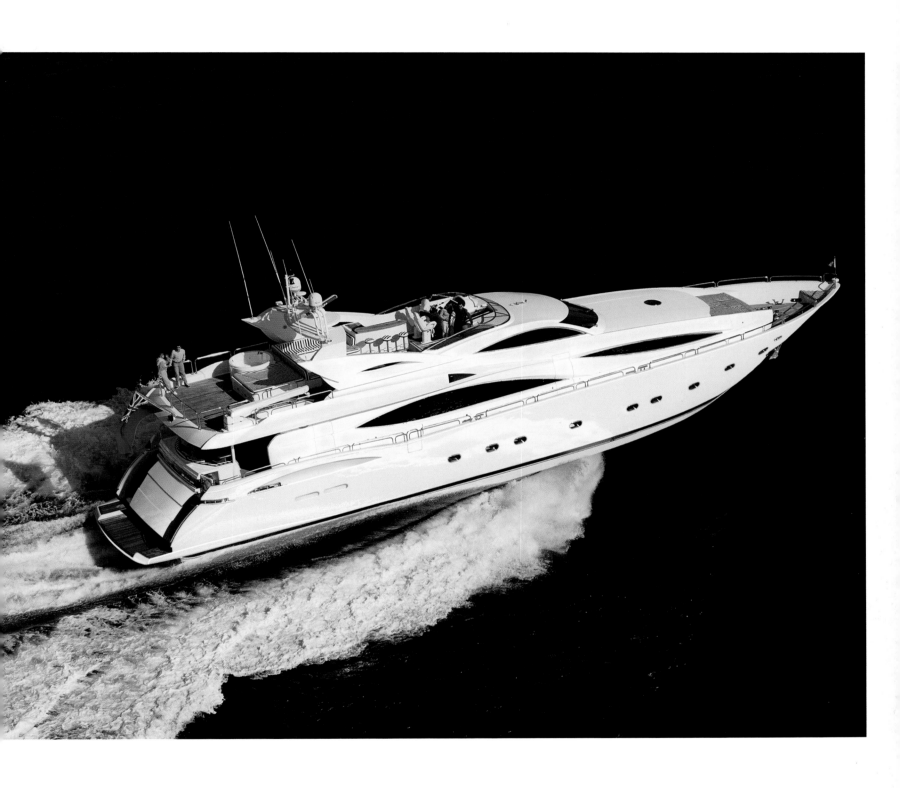

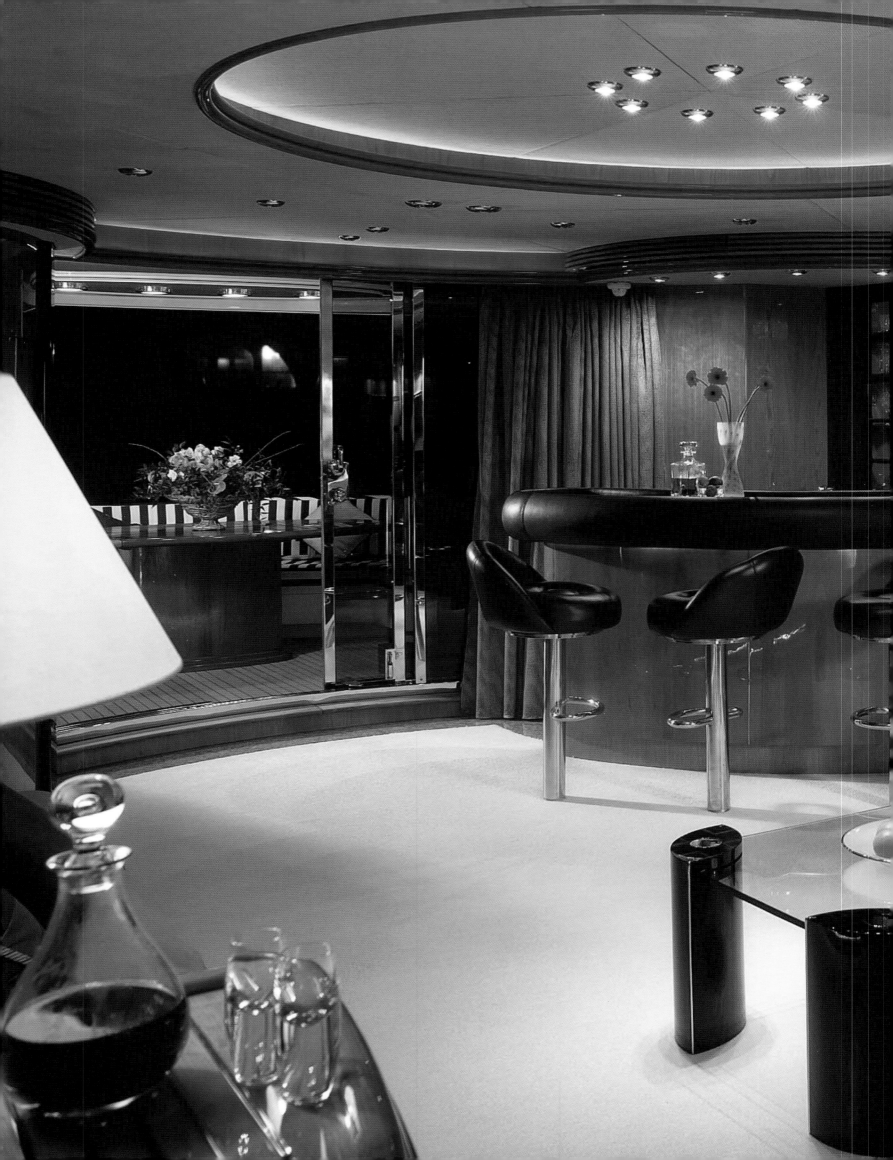

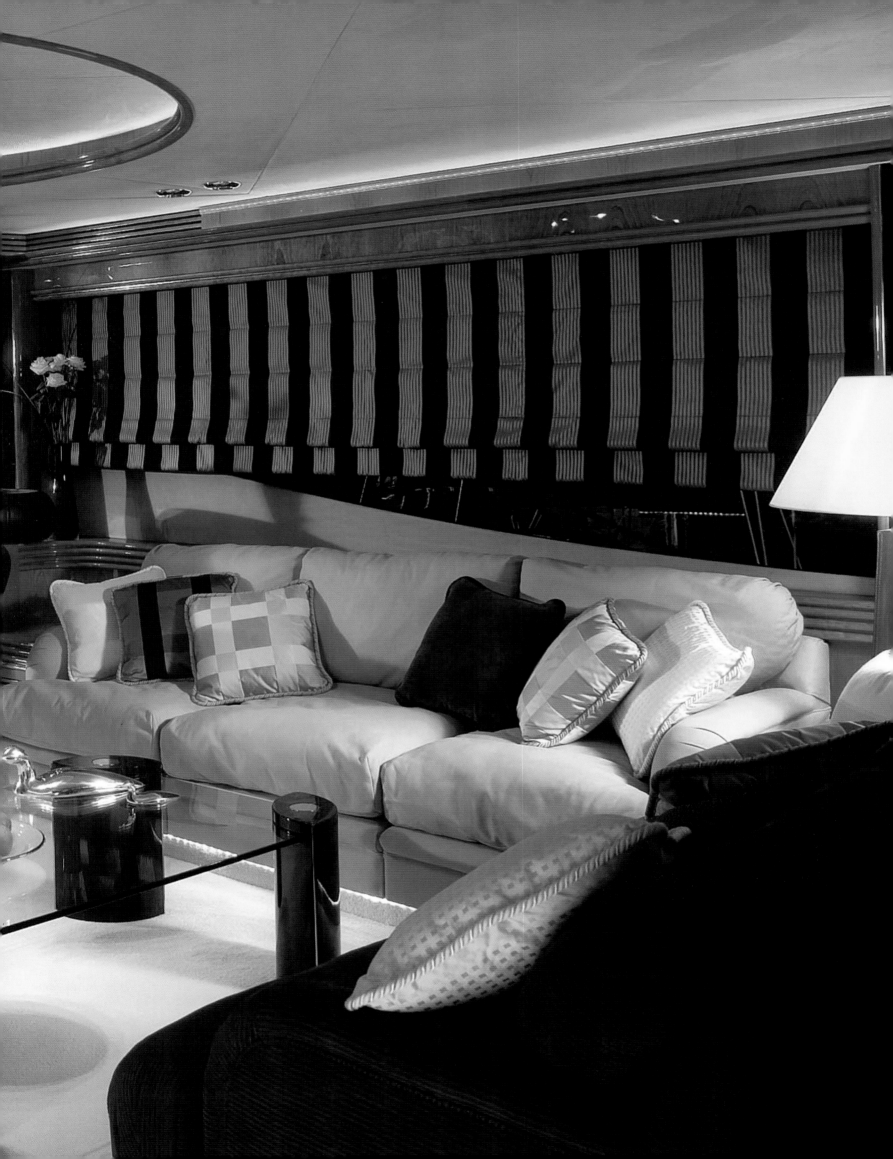

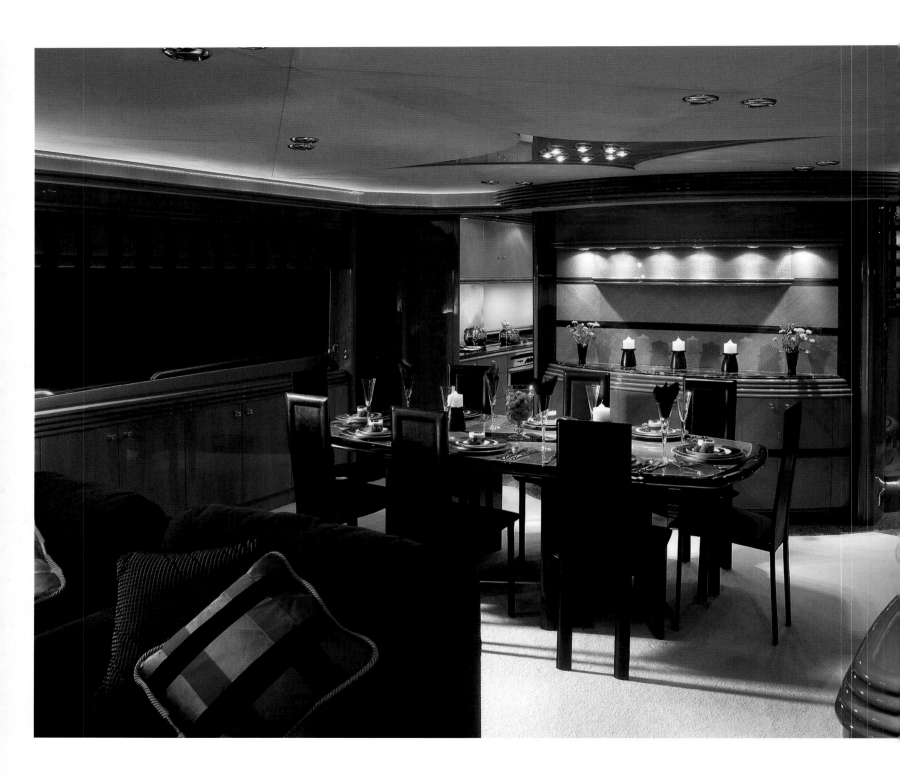

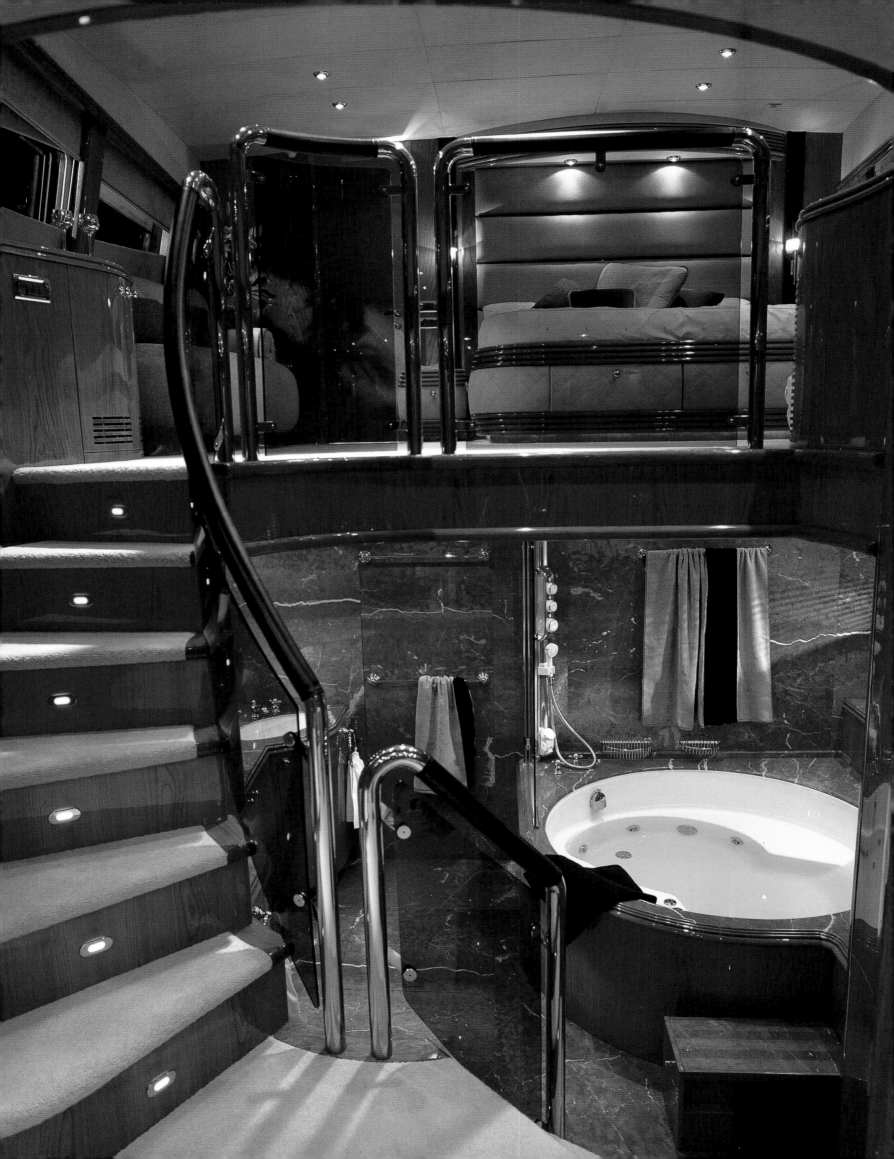

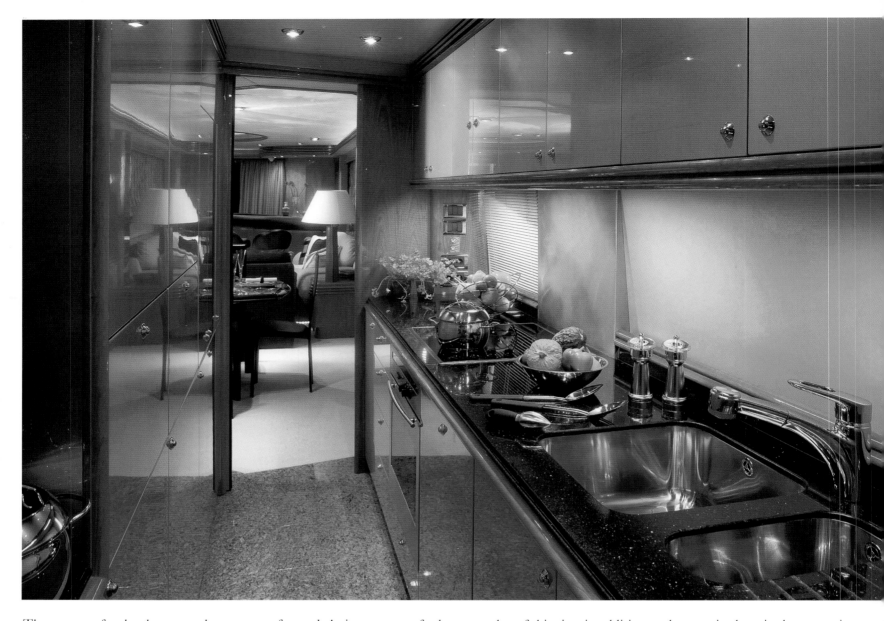

The quarters for the three-member crew are forward. As is customary for luxury yachts of this size, in addition to the captain there is also an engineer on board who looks after the ship's navigation and other equipment as well as its highly sophisticated entertainment systems.

Für die dreiköpfige Crew sind die Wohnräume im Vorschiff untergebracht. Wie bei Luxusyachten dieser Größe üblich, gibt es neben einem Kapitän auch einen Ingenieur an Bord. Er ist für die moderne Schiffs- und Navigationstechnik, aber auch für die hochwertige Unterhaltungselektronik zuständig.

Les trois membres de l'équipage ont leurs pièces à vivre à l'aplomb du bateau. Il est d'usage que les yachts de luxe de cette taille aient en plus du capitaine un ingénieur à bord, responsable de la technique de navigation maritime moderne mais aussi de tout le système électronique de pointe des appareils de loisirs.

Los habitáculos de los tres miembros de la tripulación se han construido en la proa del barco. Como es habitual en los yates de lujo de este tamaño, junto al capitán se encuentra a bordo un ingeniero. Este es reponsable de las modernas técnicas de navegación y de funcionamiento de la embarcación, pero también de todos los valiosos aparatos electrónicos de entretenimiento.

Gli spazi abitativi per l'equipaggio di tre persone si trovano a prua. Come di consueto, in yacht di lusso di queste dimensioni accanto al capitano si affianca sempre un ingegnere a bordo, che è il responsabile tecnico dell'imbarcazione e della navigazione ma anche della sofisticata apparecchiatura elettronica.

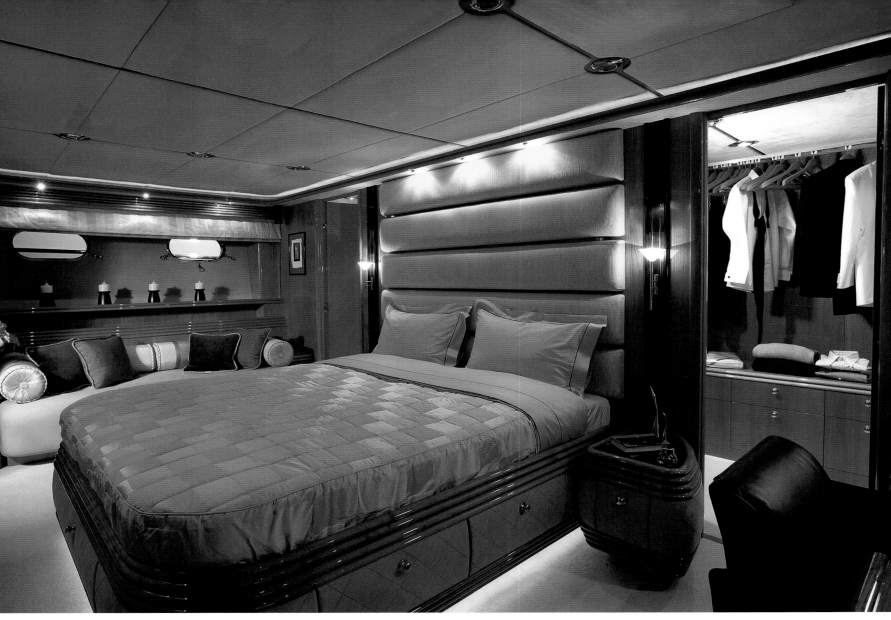

TECHNICAL SPECIFICATIONS

Builder	Sunseeker International
Price	Price on request
Naval architecture	Don Shead (hull only), John Braithwaite, and Sunseeker Design Team
Design	Ken Freivokh Design
Contact	www.sunseeker.com
Engine	2 x MTU 2000 V16 1826ps
	2 x MTU 2000 V16 2000ps
Displacement	89 tons
Top Speed	31 knots
Fuel capacity	14,780 l
Water capacity	2,500 l
LOA , BEAM , DRAFT	101.1 ft, 20.8 ft, n. i.
Classification	Rina 100 A1
Range	n. i.
Material	FRP w/vinylester resin, balsa-cored topsides, stitched multiaxial cloth, marine plywood bulkhead floors and soles

Cantieri di Pisa Akhir 140 Element

The Akhir 140 Element is the largest motor yacht Cantieri di Pisa has ever built. The interior was designed by the shipyard's design department in collaboration with the ship holder's designer Frédéric Mechiche. The designer took his inspiration from the work of Jean-Michel Franks, a French artist of the 1930s. This luxury yacht contains five staterooms on the lower deck, a suite, a spacious living room and kitchen on the main deck and on the upper deck the wheel house, the captain's cabin and a panoramic sitting room. The sundeck provides the perfect, roomy venue for rest and relaxation.

Akhir 140 Element ist die bisher größte Motoryacht, die Cantieri di Pisa gebaut hat. Die Innenräume wurden von der Designabteilung der Werft unter Mitarbeit von Frédéric Mechiche, dem Designer des Reeders, entworfen. Die Designer ließen sich von den Werken Jean-Michel Franks, einem Pariser Architekten der dreißiger Jahre, inspirieren. Die Luxusyacht verfügt über fünf Gästekabinen im Unterdeck, einer Suite, einem geräumigen Salon und der Küche auf dem Hauptdeck sowie das Steuerhaus mit der Kapitänskabine und dem Aussichtssalon auf dem Oberdeck. Ein Sonnendeck bietet eine geräumige Fläche, um sich ideal zu erholen.

L' Akhir 140 Element est jusqu'à présent le plus grand des yachts construits par Cantieri di Pisa. L'espace intérieur a été conçu par le département de design du chantier naval en collaboration avec Frédéric Mechiche, le designer de l'armateur. Les designers se sont inspirés des œuvres de Jean-Michel Franks, architecte parisien des années trente. Ce yacht de luxe possède plus de cinq cabines d'invités sur le pont inférieur, une suite, un salon spacieux et la cuisine sur le pont principal. Sur le pont supérieur se trouve aussi la salle des commandes, la cabine du capitaine et le salon panoramique. Un large bain de soleil spacieux offre un espace idéal pour se reposer.

El Akhir 140 Element es en la actualidad el mayor yate a motor construido por Cantieri di Pisa. Los interiores son obra del departamento de diseño de los astilleros en colaboración con Frédéric Mechiche, diseñador del armador. Los diseñadores se inspiraron en las obras de Jean-Michel Franks, arquitecto francés de la década de 1930. Este yate de lujo dispone bajo la cubierta de cinco camarotes para invitados, una suite y un amplio salón; sobre la principal está instalada la cocina, y sobre la cubierta superior la cabina de mandos, el camarote del capitán y el salón panorámico. Una amplia superficie permite relajarse de manera ideal y disfrutar del sol.

Akhir 140 Element è il motoryacht più grande costruito fino ad ora dai Cantieri di Pisa. Gli spazi interni sono stati progettati dal gruppo di designer dei cantieri con la collaborazione di Frédéric Mechiche, il designer scelto dall'armatore. I progettisti si sono ispirati ai lavori di Jean-Michel Franks, un architetto parigino degli anni trenta. Lo yacht di lusso dispone di cinque cabine per gli ospiti in sottocoperta, di una suite, di un ampio salone, di una cucina sul primo ponte e di una timoneria, con la cabina del capitano e il salone panoramico sul ponte superiore. Una zona prendisole offre uno spazio ideale per rilassarsi.

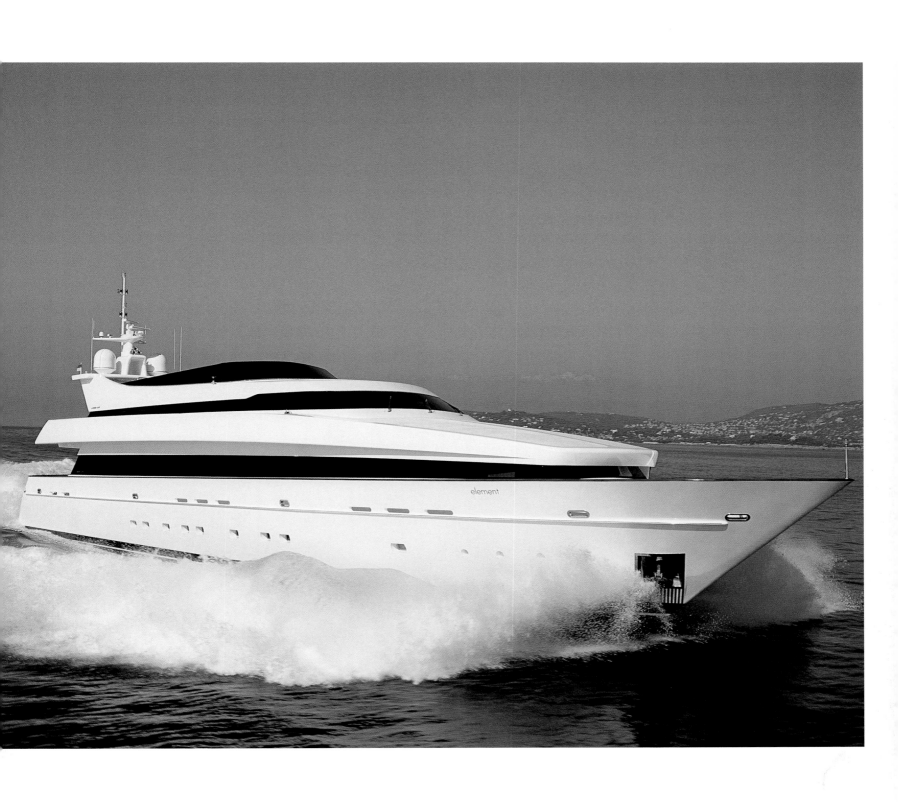

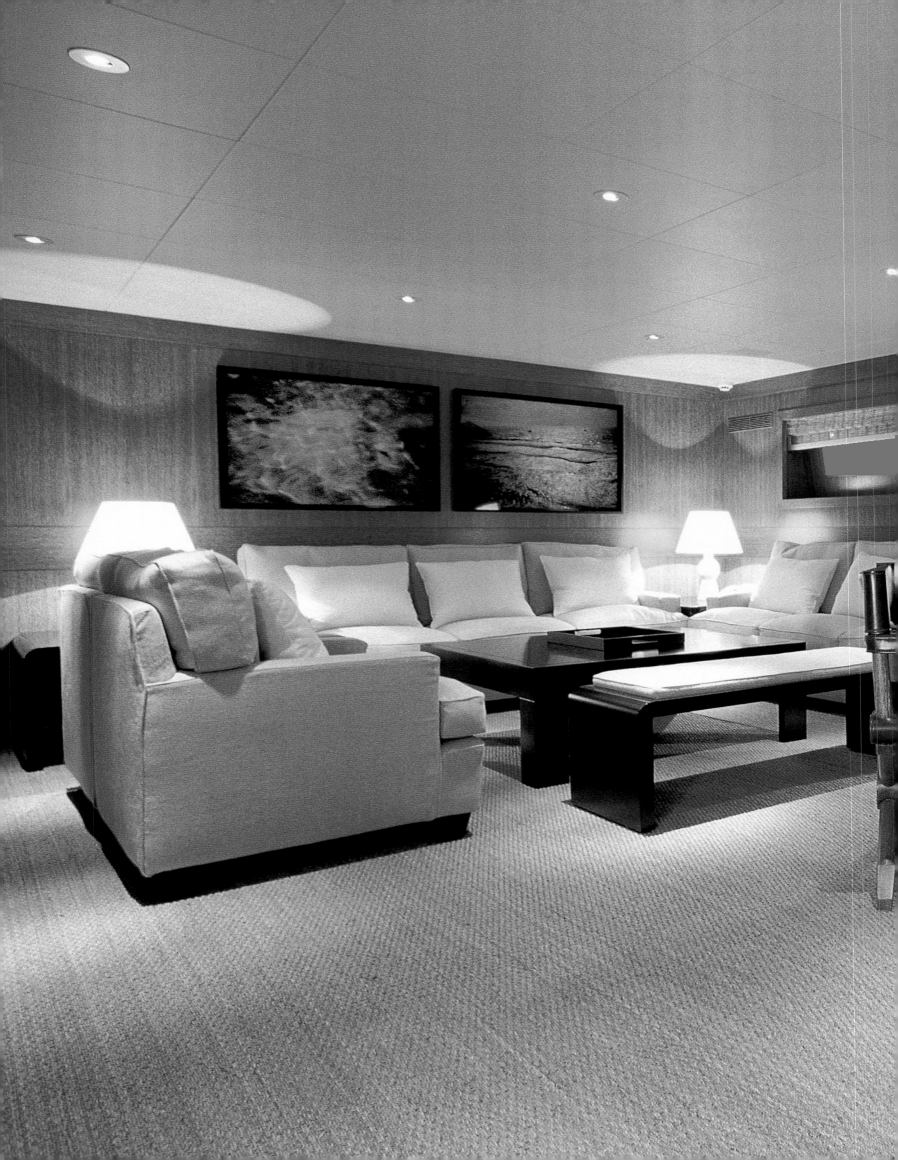

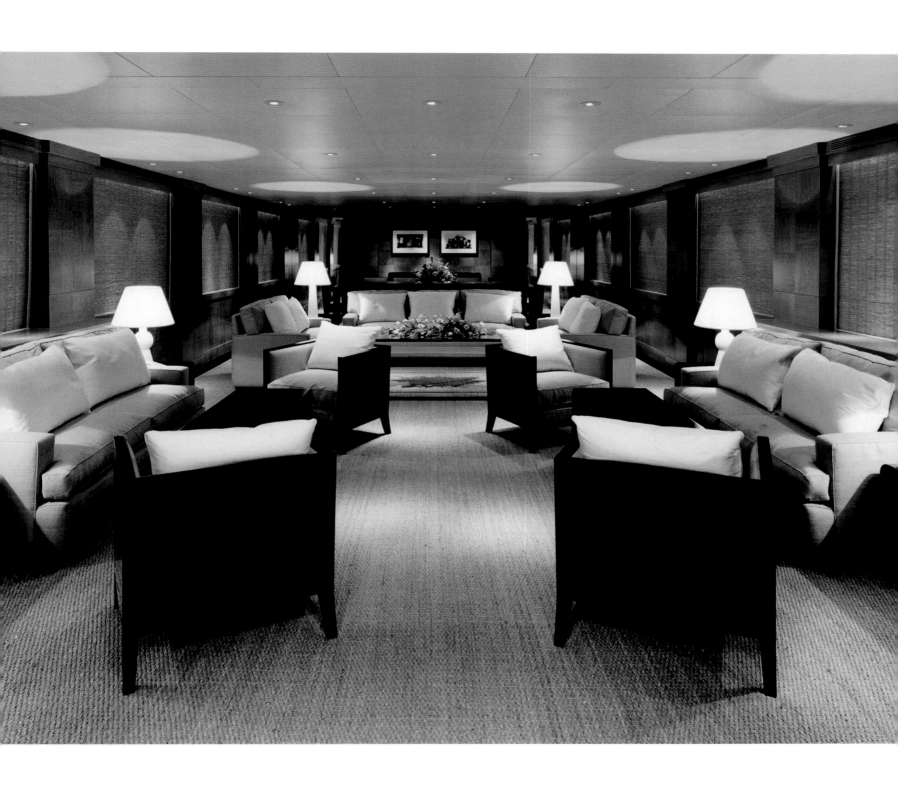

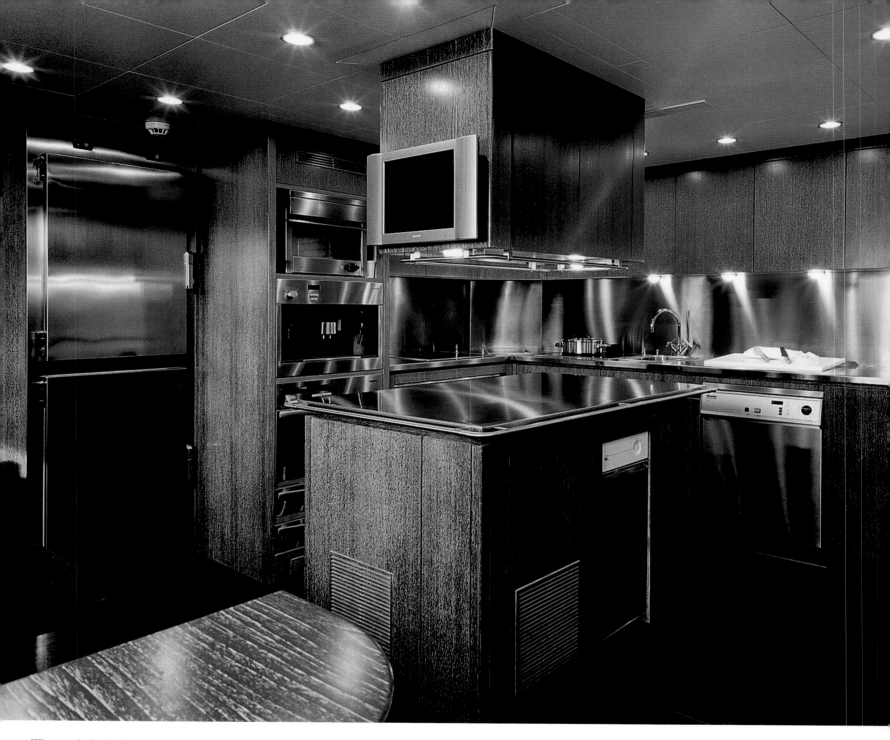

The yacht's chairs, armchairs, tables and other furnishings are made of black stained pear wood. All of the bathrooms have travertine floors and countertops, and the showers are tiled in natural travertine mosaics.

Die Möbel, wie z.B. Stühle, Sessel und Tische sind aus schwarz gefärbtem Birnbaum gefertigt. Alle Badezimmer haben Fußböden und Spülbeckenflächen aus Travertin und die Duschen sind mit natürlichem Travertinmosaik ausgekleidet.

Les meubles, à l'instar des sièges, des fauteuils et de la table sont fabriqués en poirier teint noir. Tous les sols et lavabos des salles de bain sont en travertin. Les douches sont revêtues de mosaïques de travertin naturel.

El mobiliario, como sillas, asientos y mesas, está fabricado en madera de peral tintada en negro. Todos los baños poseen las superficies y los suelos de Travertin y las duchas están revestidas con mosaicos naturales, también de la misma firma.

Le sedie, le poltrone e i tavoli sono in legno di pero laccato nero. Il pavimento e i lavandini in tutti i bagni sono in travertino mentre le docce sono rivestite di mosaici, sempre in travertino naturale.

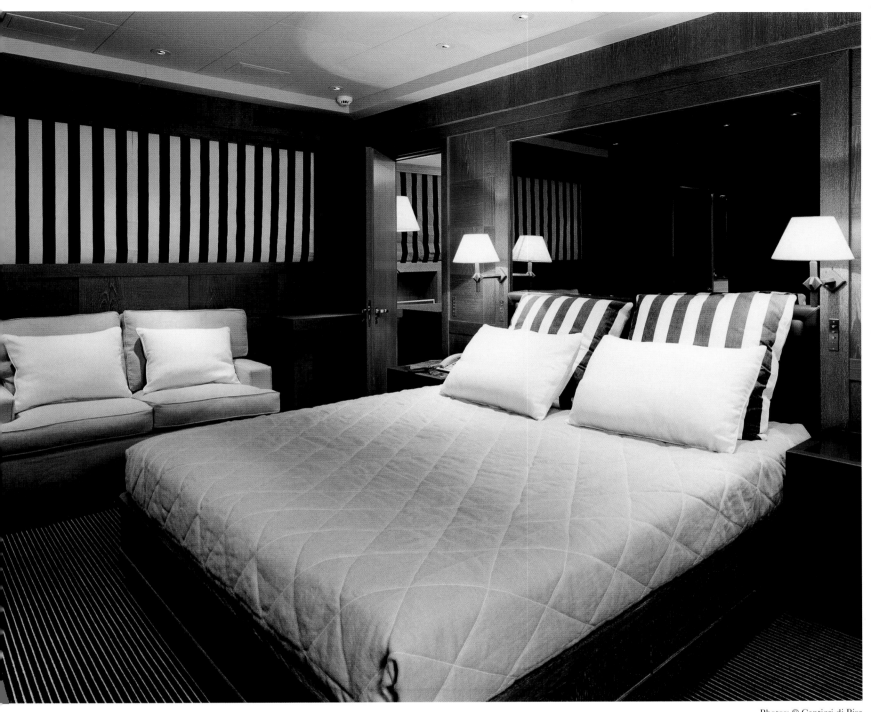

TECHNICAL SPECIFICATIONS

Builder	Cantieri di Pisa
Price	Price on request
Naval architecture	Cantieri di Pisa
Design	Cantieri di Pisa
Contact	www.cantieridipisa.it
Engine	2 x 3 700 HP MTU
Displacement	60/62 tons
Top Speed	28 knots
Fuel capacity	35,000 l
Water capacity	5,000 l
LOA, BEAM, DRAFT	n. i.
Classification	n. i.
Range	2,000 miles
Material	n. i.

Ferretti 880

The Ferretti development team worked closely with the design firm of Zuccon International Project to come up with a yacht that combines classic Ferretti features with innovative design elements.
The sleeping deck harbors a whole series of pleasant surprises for the owner and his guests. The lower deck has four comfortably furnished cabins and five bathrooms and can easily accommodate up to eight people. The spacious owner's cabin is amidships and the roomy VIP cabin occupies the forward part of the ship.

In der Entwicklung der 880 hat das Team von Ferretti eng mit dem Designstudio Zuccon International Project zusammengearbeitet, um ein eigenständiges Modell zu entwerfen, in dem sich klassische Ferretti-Eigenschaften mit innovativem Yachtdesign verbinden.
Das Schlafdeck der Yacht hält eine Reihe positiver Überraschungen für den Eigner und seine Gäste bereit. Unter Deck bieten vier komfortabel ausgestattete Kabinen mit fünf Badezimmern viel Raum für acht Personen. Die großzügig bemessene Eignerkabine liegt mittschiffs, während die geräumige Vip-Kabine das Vorschiff ausfüllt.

Le 880, modèle unique en son genre, alliant la tradition classique de Ferretti au design de yacht innovant, est le fruit de l'étroite collaboration entre le bureau d'études de Ferretti et le studio de design Zuccon International Project.
Le pont du yacht réservé au couchage offre mille et une surprises à son propriétaire et à ses convives. Le pont inférieur, doté de quatre cabines très confortables avec cinq salles de bains, offre suffisamment d'espace pour huit personnes. La cabine du propriétaire, aux dimensions généreuses, est située au milieu du bateau, alors que la cabine V.I.P. occupe l'aplomb du yacht.

En la creación del 880, el equipo de desarrollo de Ferretti ha trabajado estrechamente con el estudio de diseño Zuccon International Project para idear un modelo único, en el que se combinaran las características clásicas de Ferretti con el diseño más innovador de yates. La zona dormitorio del yate reserva entre sus paredes unas cuantas sorpresas para el propietario y sus invitados. Bajo la cubierta, cuatro camarotes confortablemente equipados con cinco baños ofrecen espacio más que suficiente para ocho personas. El camarote del propietario, de generosas proporciones, se sitúa en la parte central del barco, mientras que el también amplio camarote vip ocupa la proa.

Durante lo sviluppo della 880, l'ufficio di progettazione della Ferretti ha collaborato intensamente con lo studio di design Zuccon International Project, per proporre un modello originale che coniugasse le caratteristiche classiche della Ferretti con un design innovativo.
La zona notte dello yacht riserva una serie di sorprese per l'armatore e i suoi ospiti. Sottocoperta, quattro cabine confortevoli con cinque stanze da bagno possono ospitare fino a otto persone. La cabina armatoriale estremamente spaziosa si trova in centro alla nave, mentre la cabina VIP, anch'essa estremamente ampia, occupa la prua.

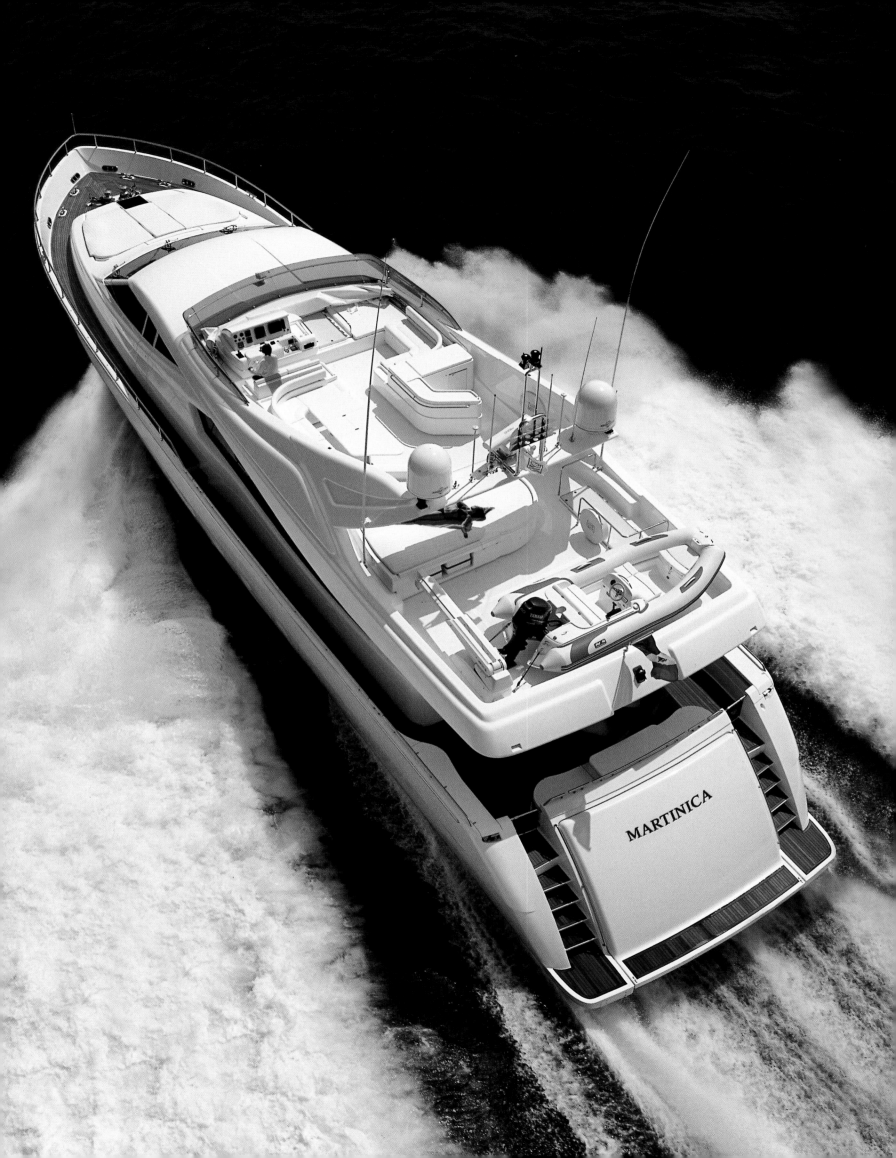

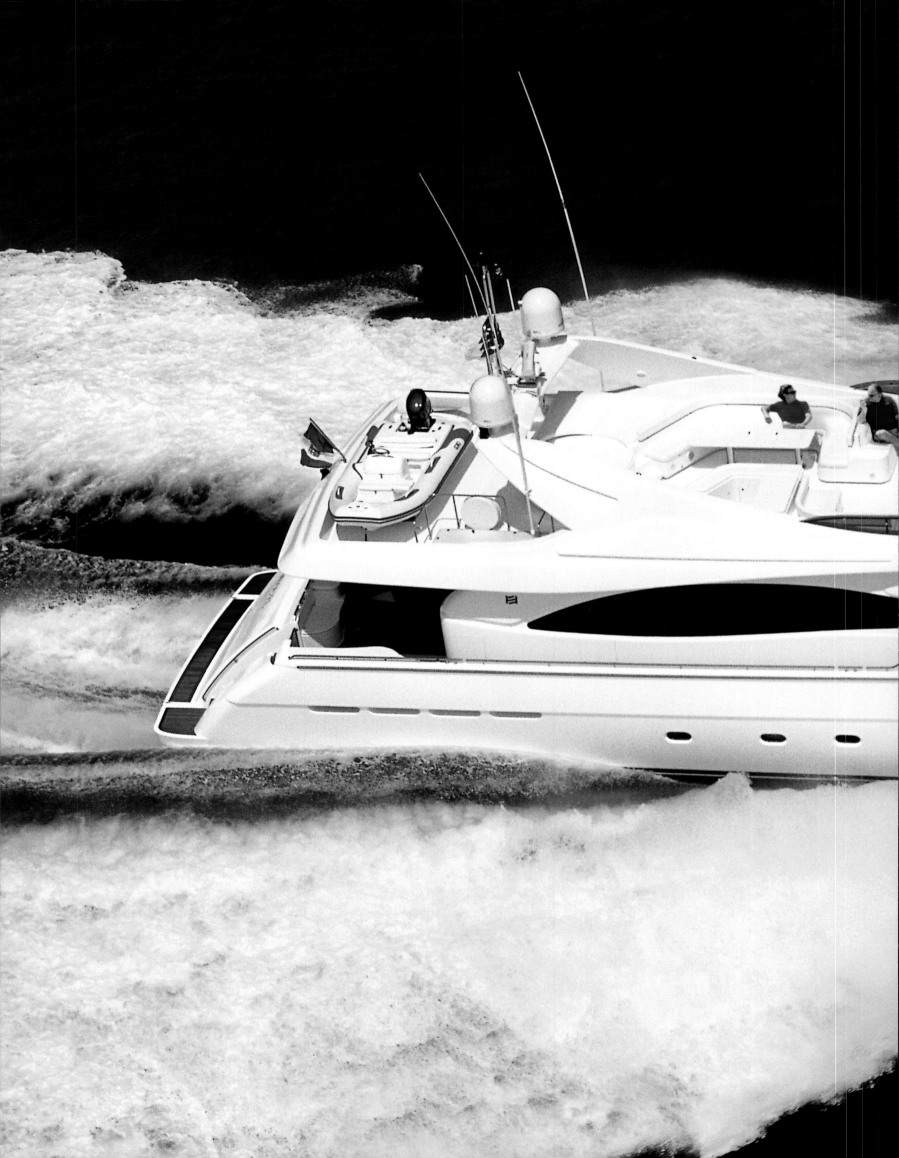

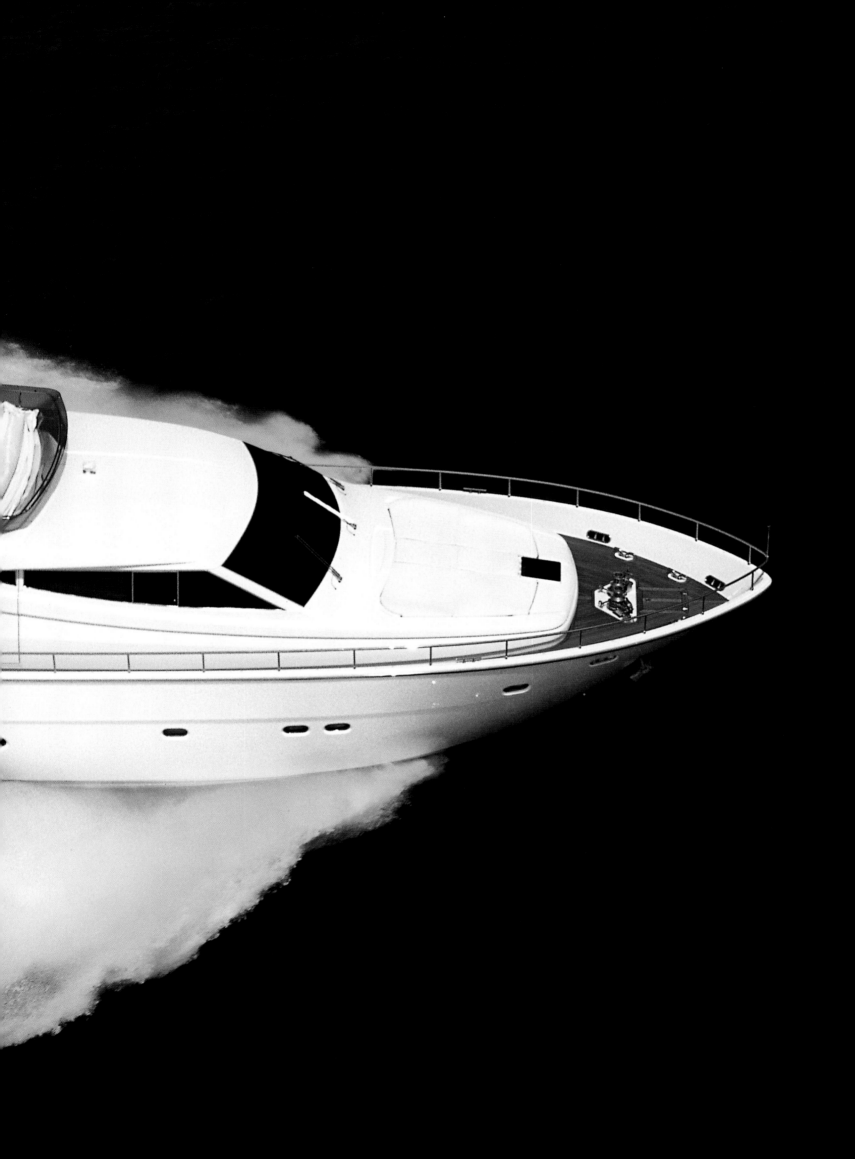

The yacht is amply powered by two MTU 2000 engines that enable the 880 to reach a speed of 30 knots.

Für die angemessene Leistung der Yacht sorgen zwei MTU 2000 Maschinen. Mit diesem Antrieb erreicht die 880 eine Geschwindigkeit von 30 Knoten.

Grâce à la puissance de deux moteurs MTU 2000, le yacht 880 développe une vitesse de 30 nœuds.

Gracias a dos máquinas MTU 2000, que se encargan de proporcionar la potencia adecuada al yate, el 880 alcanza una velocidad de 30 nudos.

Le prestazioni ottimali dello yacht sono assicurate da due motori MTU 2000. Con questa potenza, l'880 può raggiungere una velocità di 30 nodi.

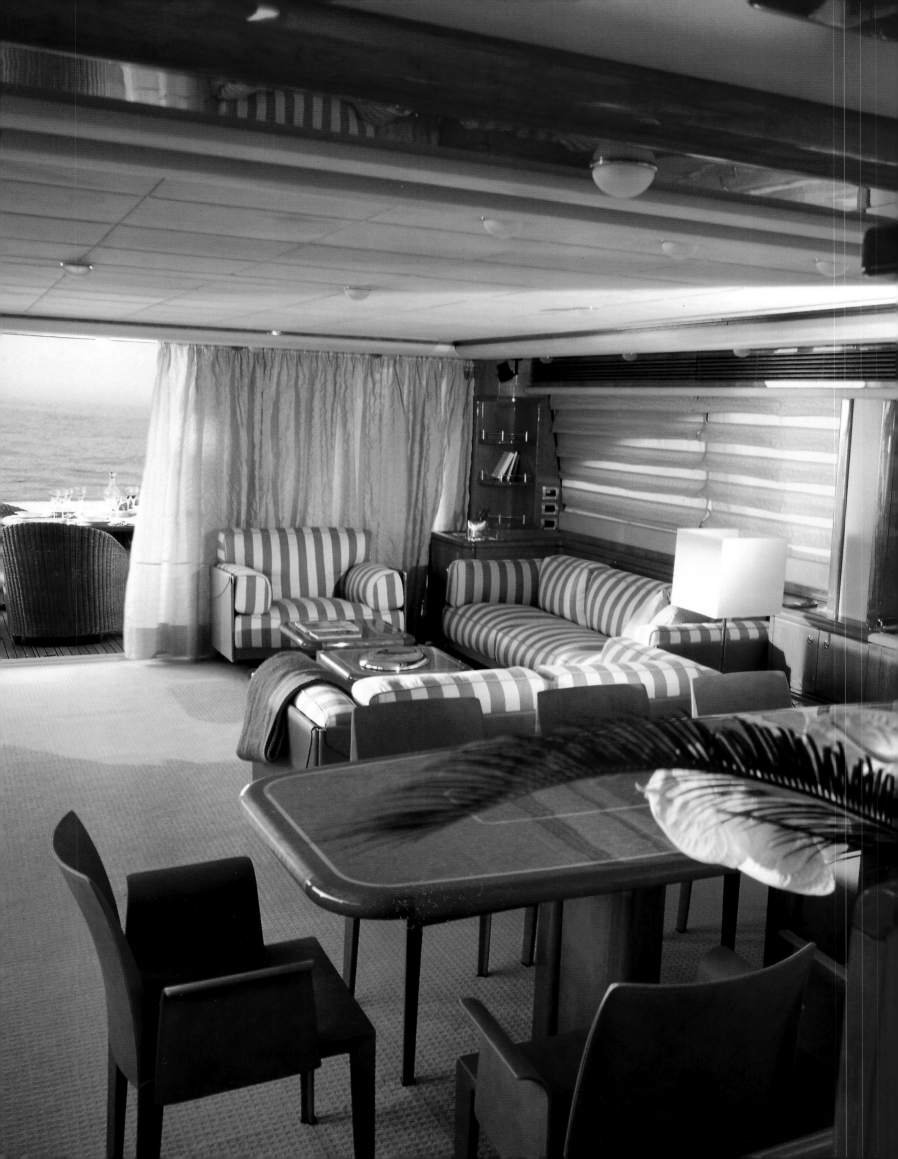

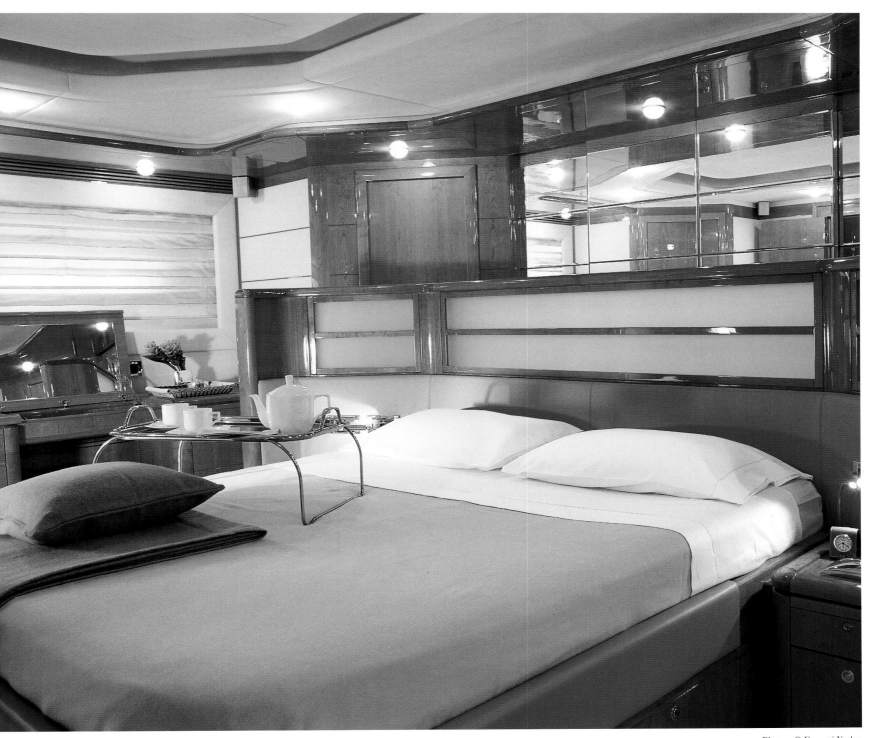

Photos: © Ferretti Yachts

TECHNICAL SPECIFICATIONS

Builder	Ferretti Yachts
Price	Price on request
Naval architecture	Zuccon International Project Studio
Design	Ferretti Yachts
Contact	www.ferretti-yacht.com
Engine	2 x MTU 16 V 2.000 M 91
Displacement	70 tons
Top speed	31 knots
Fuel capacity	9,000 l
Water capacity	1,200 l
LOA, BEAM, DRAFT	88.8 ft, 22.1 ft, 6.3 ft
Classification	n. i.
Range	n. i.
Material	n. i.

Benetti Amnesia

This yacht, which was commissioned by a British customer, is in keeping with the Benetti tradition of building legendary superyachts.
The most striking difference between the Amnesia and most yachts is the saloon, which connects to the dining room. This layout makes the space feel quite large, while the decor of the various areas around the ship creates a cozy atmosphere.
Two large seating areas are clustered in the center of the saloon, where the owner and his guests can have relaxed conversation or watch a movie on TV.

Diese auf Wunsch ihres englischen Eigners gefertigte Yacht führt die Tradition Benettis beim Bau von legendären Superyachten fort.
Der auffälligste Unterschied zu den meisten Yachten ist der Salon, der mit dem Essbereich verbunden ist. Diese Aufteilung vermittelt ein großzügiges Raumgefühl und die unterschiedlichen Dekorationen in den verschiedenen Nutzungsbereichen schaffen eine gemütliche Atmosphäre.
Zwei große Sitzecken werden zusammen mitten im Salon gruppiert und ermöglichen es dem Inhaber und seinen Gästen, sich entspannt zu unterhalten oder einen Film auf dem Fernsehbildschirm zu verfolgen.

Ce yacht, réalisé spécialement pour un anglais, est dans la lignée de la tradition Benetti, constructeur de yachts légendaires.
Ce qui le distingue de la plupart des yachts, c'est le salon relié à la salle à manger. Cette distribution des pièces donne une impression d'espace. La variété des décorations dans les espaces utilitaires crée une atmosphère conviviale et chaleureuse.
Deux grands bancs d'angle sont regroupés au cœur du salon permettant au propriétaire et à ses convives de s'entretenir facilement dans un esprit de détente ou de suivre un film sur l'écran de télévision.

El Amnesia, construido por encargo para un cliente inglés, perpetúa la tradición Benetti en la construcción de los superyates.
La diferencia más perceptible respecto a la mayoría de estas embarcaciones es su salón, que comunica con el área del comedor. Esta distribución proporciona una sensación de amplitud, y las distintas decoraciones en las diversas zonas logran dotar el espacio de una atmósfera agradable.
Dos grandes asientos en ángulo se agrupan en el centro del salón y permiten al propietario y a sus invitados conversar relajadamente o visualizar alguna película en la pantalla de televisión.

Questo yacht fabbricato su desiderio di un armatore inglese ribadisce la vocazione di Benetti nella costruzione di superyacht leggendari.
La differenza più evidente rispetto agli altri yacht è rappresentata dal salone, collegato alla sala da pranzo. Questa suddivisione trasmette un'idea di spazio senza riserve e le diverse decorazioni degli ambienti creano un'atmosfera accogliente.
Due grandi angoli conversazione sono accostati in mezzo al salone in modo da consentire al proprietario e ai suoi ospiti di conversare in tutto relax o di guardare un film.

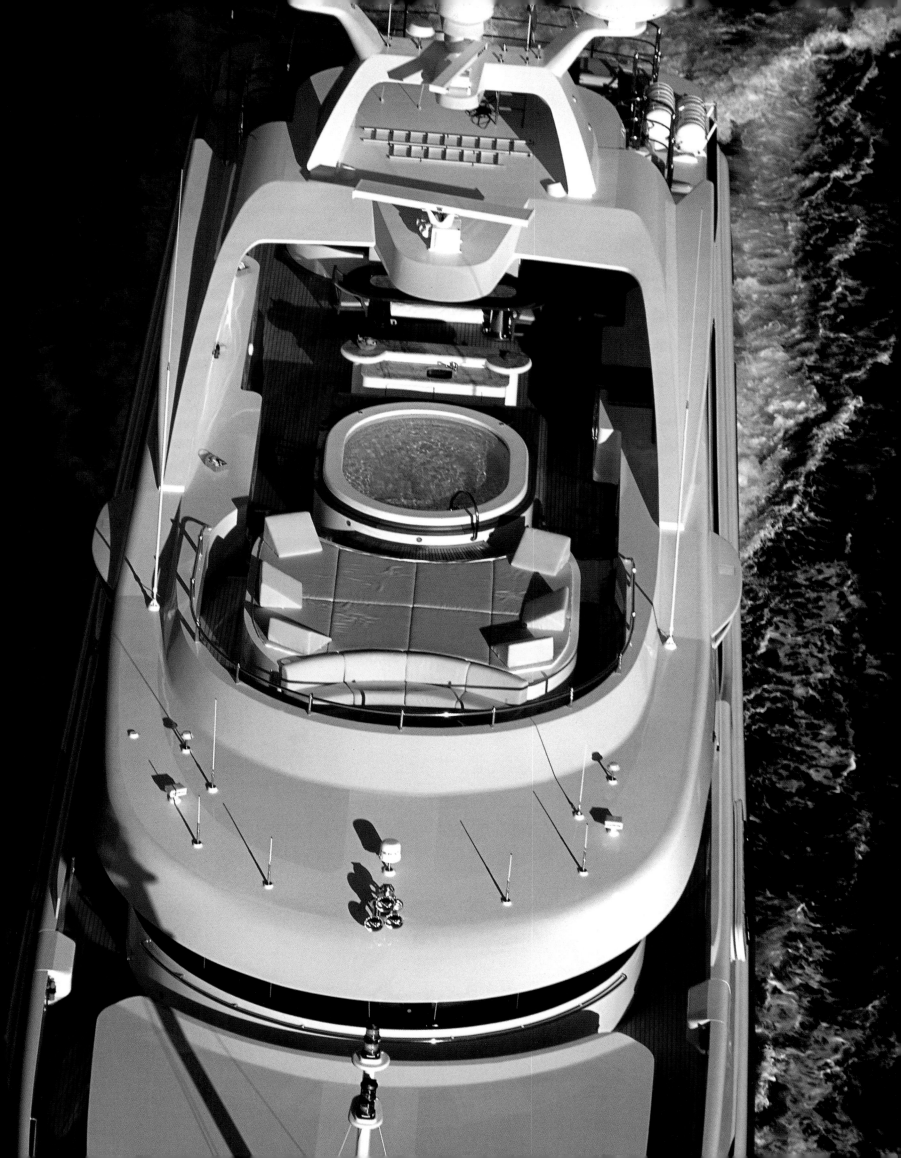

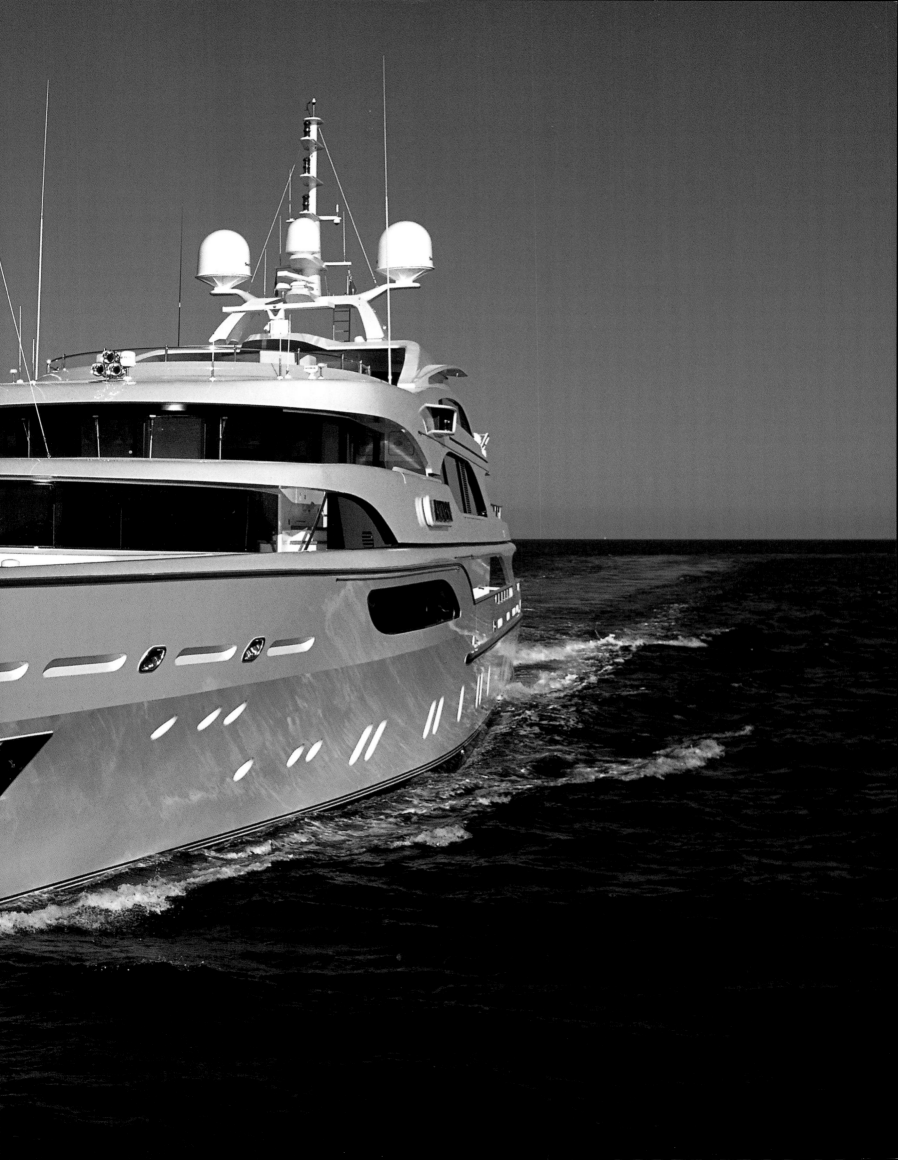

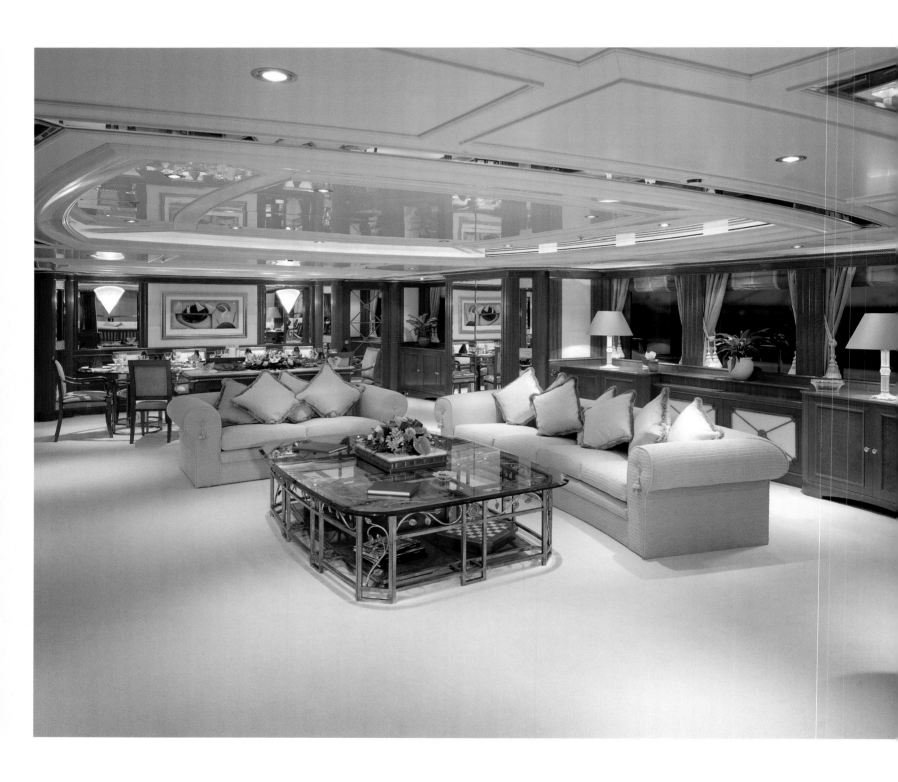

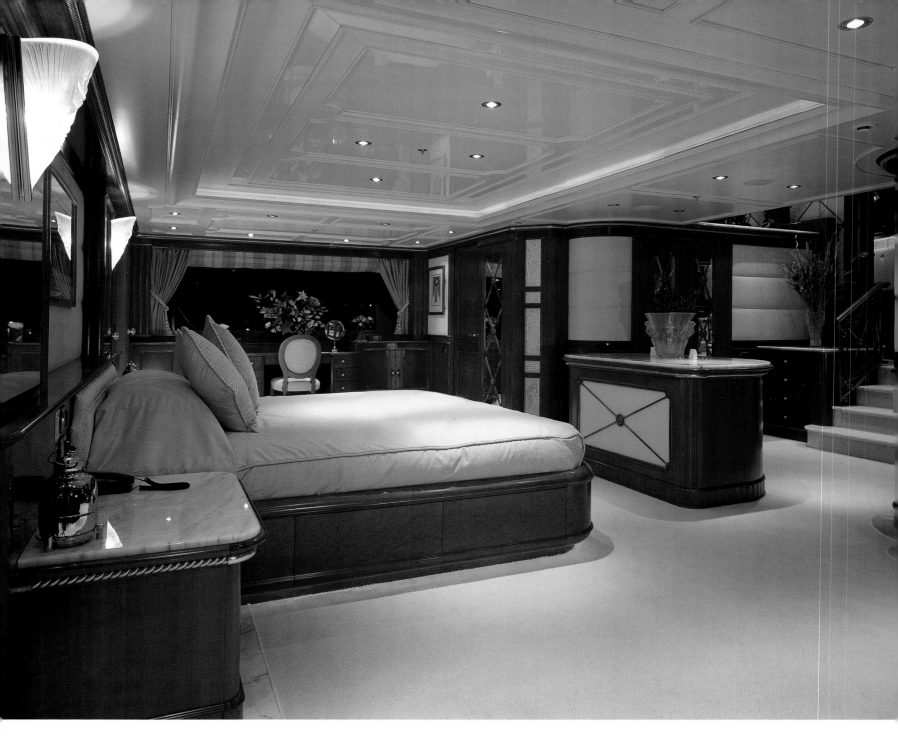

After sunbathing on the sundeck, which doubles as a helicopter landing pad, guests can enjoy a restorative seance in the jacuzzi.

Möchte man sich nach dem Sonnenbaden auf dem Sonnendeck, das auch als Helikopterlandeplatz genutzt werden kann, erfrischen, so kann man im separaten Whirlpool entspannen.

Après une séance de bronzage sur la plate-forme bain de soleil, qui sert à la fois de piste d'atterrissage pour hélicoptère, on peut se rafraîchir et se détendre dans le bains à remous, installé en retrait.

Después de un baño de sol en la cubierta-solárium, utilizada también como pista de aterrizaje de helicópteros, nada mejor que el jacuzzi individual para refrescarse.

Se ci si vuole rinfrescare dopo un bagno di sole sul ponte che funge anche da pista per gli elicotteri, è possibile rilassarsi nell'idromassaggio separato.

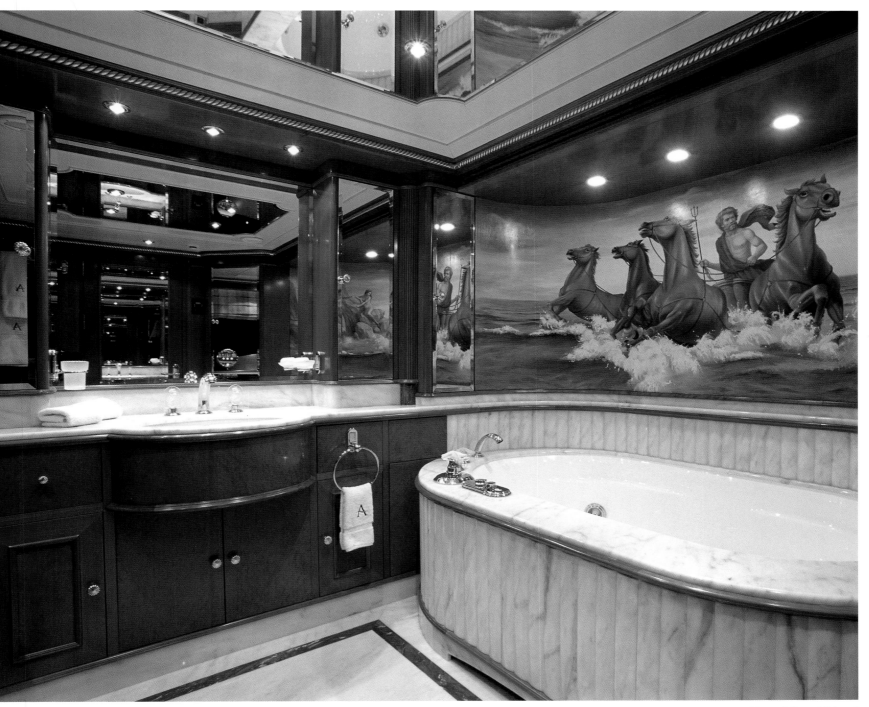

Photos: © Benetti Shipyard

TECHNICAL SPECIFICATIONS

Builder	Benetti Shipyard
Price	Price on request
Naval architecture	Benetti Shipyard
Design	Stefano Natucci
Contact	www.benettiyachts.it
Engine	2 x Caterpillar 3512
Displacement	680 tons
Top speed	16 knots
Fuel capacity	140,000 l
Water capacity	12,000 l
LOA, BEAM, DRAFT	180.4 ft, 33.45 ft, 9.84 ft
Classification	Lloyds register of shipping – MCA compliant
Range	5,000 nm approx.
Material	Steel hull and aluminum superstructure

YAC

Sail yachts

72

80

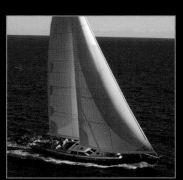

86

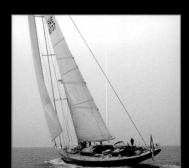

94

Wally B

This 107-foot sailing yacht was built by the legendary Italian yacht builder Wally. The Wally B is an updated version of the highly successful Nariida.
The interior design by the architects Lazzarini & Pickering echoes the natural, oval form of the hull and makes optimal use of the available space. Future owners can choose between a range of furnishing configurations, e.g. a multi-component sofa that can also be used as a chaise longue or armchair.
The main saloon can accommodate up to 14 persons for a gathering or meal.

Die 107 Fuß große Segelyacht wurde vom legendären italienischen Yachtbauer Wally konstruiert. Hierbei handelt es sich um eine Weiterentwicklung der bereits erfolgreichen Nariida.
Das vom Architekturbüro Lazzarini & Pickering entworfene Innendesign nimmt die natürliche, ovale Form des Rumpfes auf und schafft so eine optimale Raumausnutzung. Der künftige Besitzer kann zwischen verschiedenen Layoutaufteilungen wählen. So bietet das Sofa die Möglichkeit, es als Chaiselongue, Sessel oder auch Couch zu benutzen.
Der Hauptsalon kann entweder als Aufenthalts- oder als Essbereich für 14 Personen genutzt werden.

Le yacht à voiles de 107 pieds a été construit par Wally, le légendaire constructeur italien de yacht. Ce modèle est une évolution du Nariida déjà très réussi.
Le design intérieur conçu et réalisé par les architectes Lazzarini & Pickering suit la forme ovale naturelle de la coque parvenant ainsi à une utilisation optimale de l'espace intérieur. Le futur propriétaire a le choix entre diverses solutions de distribution intérieure. A titre d'exemple, le sofa modulable se transforme en chaise longue, fauteuil ou canapé.
Le salon principal peut être pièce à vivre ou coin repas pour 14 personnes.

Este velero de 107 pies de eslora es obra del legendario constructor de yates Wally. Wally B es una evolución del famoso Nariida.
El diseño interior, fruto de los arquitectos italianos Lazzarini & Pickering, adopta la forma oval del casco y obtiene un aprovechamiento óptimo del espacio. El comprador puede elegir entre diferentes configuraciones de mobiliario. El sofá, por ejemplo, se transforma en una chaise-longue, un sillón o tresillo.
El salón principal se puede utilizar como zona de ocio o comedor para 14 personas.

Questo yacht a vela 107 piedi, prodotto dal leggendario costruttore di yacht italiano Wally, rappresenta una successivo sviluppo del famoso Nariida.
Il design degli interni, curato dall'architetto Lazzarini & Pickering, riprende la forma naturale ovale dello scafo e consente lo sfruttamento ottimale dello spazio. Il futuro proprietario può scegliere tra diverse possibili variazioni dell'arredamento. Il sofa per esempio può trasformarsi in chaise-longue, poltrona o divano.
Il salone principale può fungere da salotto per la conversazione o zona pranzo per 14 persone.

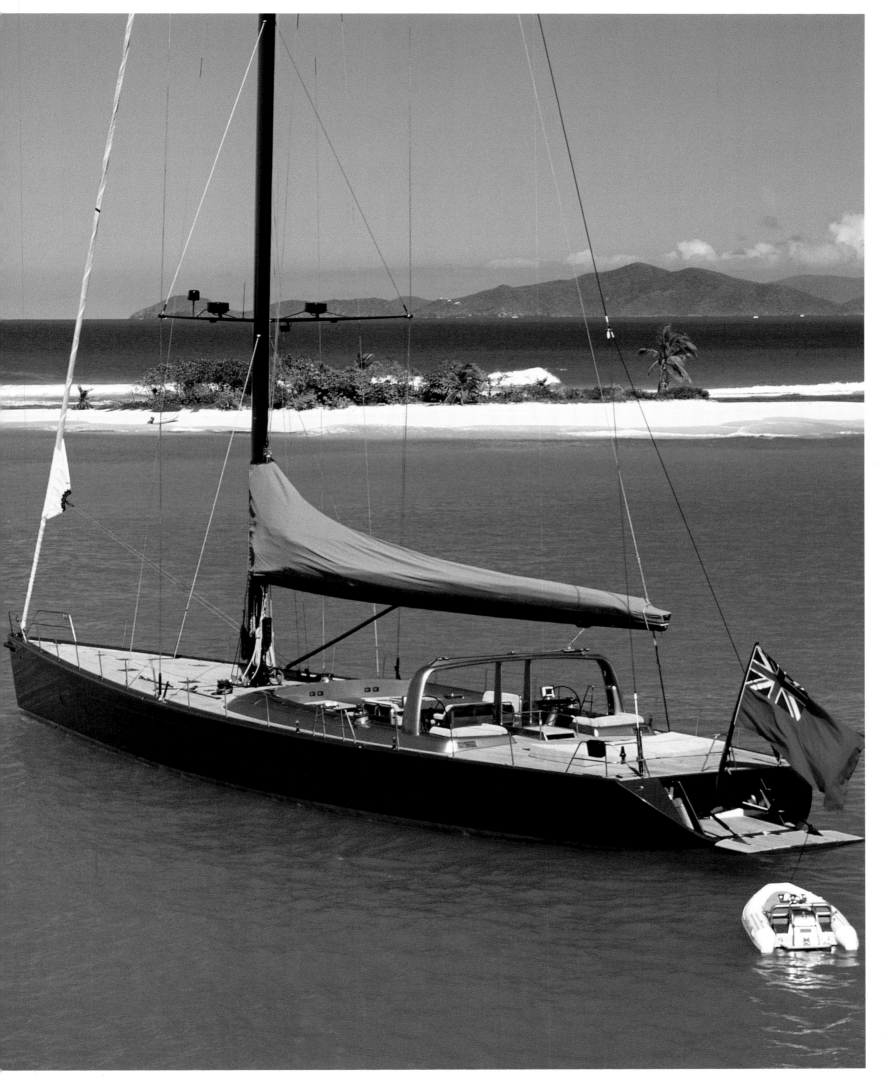

The yacht's decor combines high tech with natural materials. In lieu of light switches, the yacht has small control buttons that allow for adjustment of the air conditioning, stereo volume, and audiovisual devices such as a plasma screen, which is used for projecting video-art when the TV is not switched on.

Die Innengestaltung verbindet Hightech mit ausgewählten natürlichen Materialien. So gibt es keine Lichtschalter, sondern kleine Kontrollflächen, mit denen man die Klimaanlage, Musik und audiovisuelle Geräte, wie z.B. einen Plasmabildschirm, steuern kann. Der Plasma-bildschirm projiziert Video-Kunst, wenn das Fernsehprogramm nicht aktiviert ist.

L'architecture intérieure allie technique de pointe à des matériaux nobles naturels. Citons les interrupteurs remplacés par des touches de contrôles qui commandent la climatisation, la musique et les appareils audiovisuels dont un écran plasma qui projette des vidéos d'art lorsque le programme de télévision n'est pas en marche.

La decoración interior combina la alta tecnología con una selección de materiales naturales. De esta manera, no hay interruptores para la luz, sino pequeñas placas con las que se controla el climatizador y los equipos audiovisuales y musicales, como una pantalla de plasma, por ejemplo. Esta pantalla proyecta videoarte cuando no hay ningún programa de televisión activado.

La disposizione degli interni coniuga hi-tech con materiali naturali scelti con cura. Non ci sono interruttori della luce, bensì piccoli pannelli di controllo per regolare l'aria condizionata, la musica e gli apparecchi audiovisivi come lo schermo al plasma. Quando il televisore non è acceso, lo schermo proietta filmati artistici.

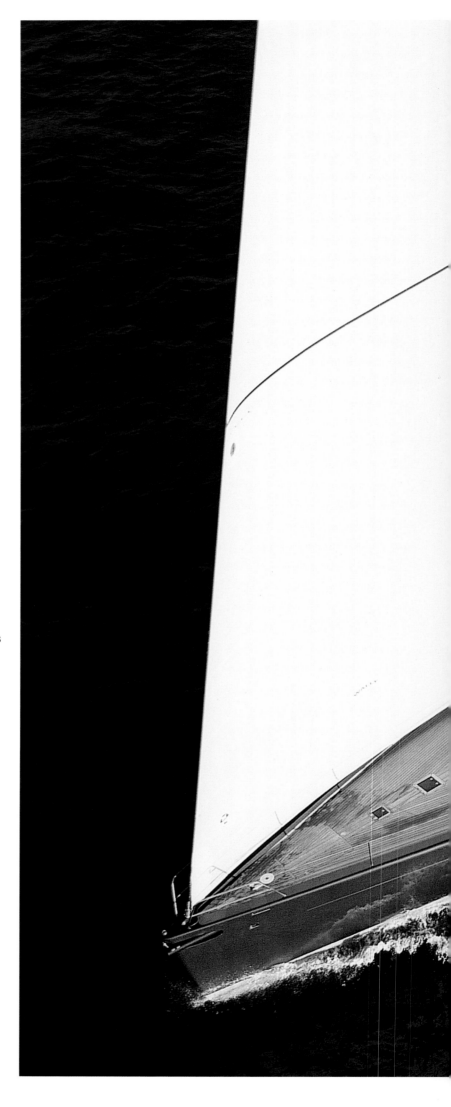

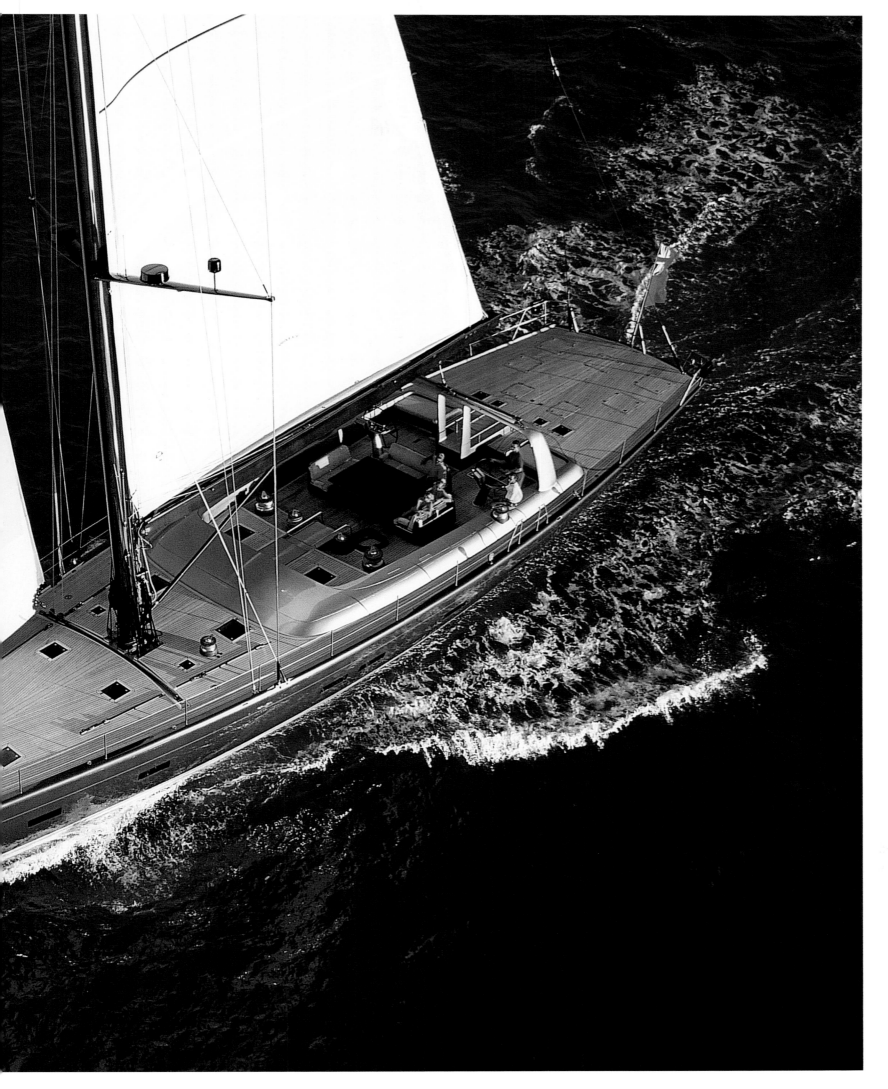

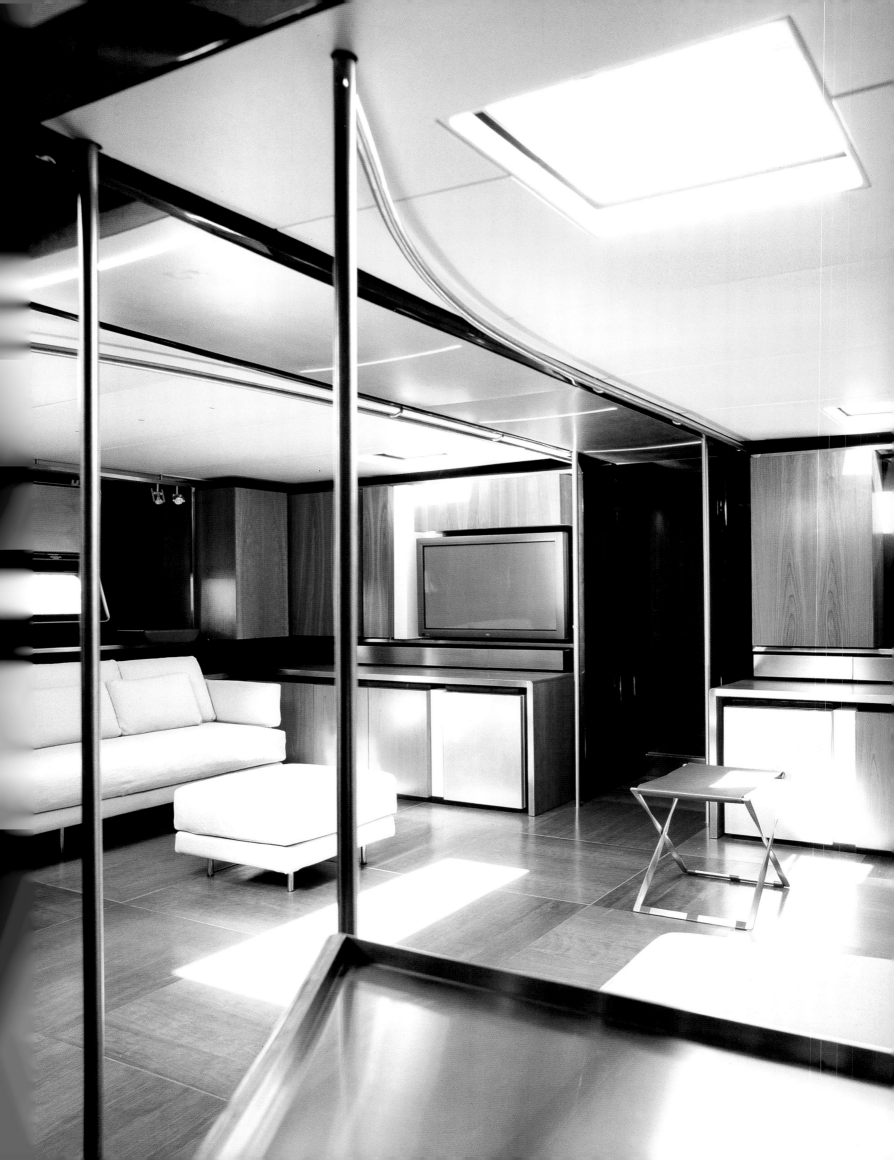

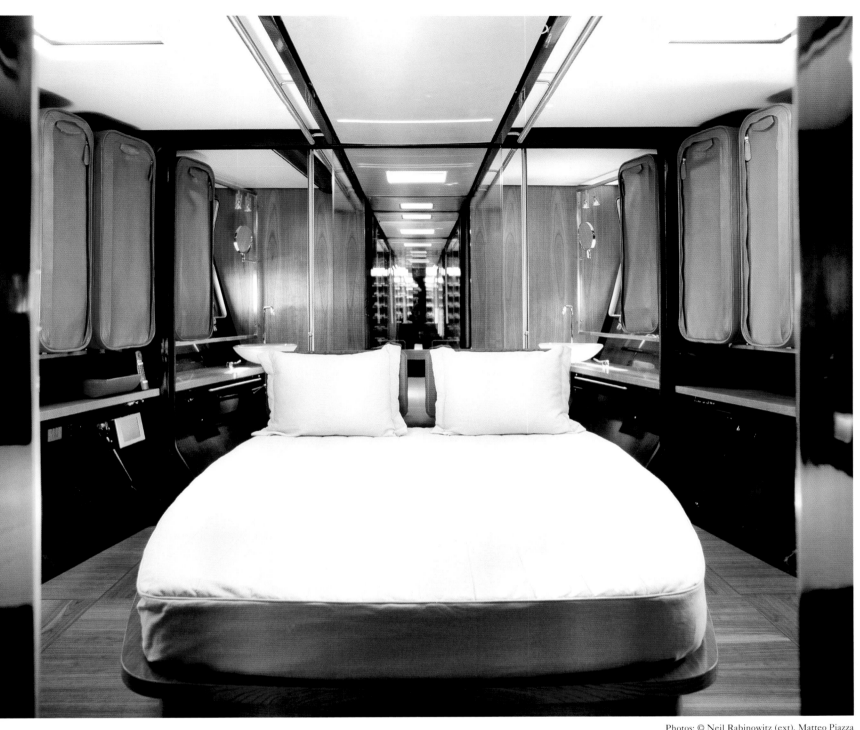

Photos: © Neil Rabinowitz (ext), Matteo Piazza

TECHNICAL SPECIFICATIONS

Builder	Wally
Price	Price on request
Naval architecture	Lazzarini & Pickering Architects
	Luca Brenta & Co. Design
Design	Luca Brenta & Co. Design
Contact	www.wally.com
Type	Cruising yacht
LOA, BEAM, DRAFT	107.4 ft, 26 ft, 15.9 ft
Sail area	507.6 sq.m.
Engine	Caterpillar KTP 312 G
Displacement	75.4 tons
Top speed	12.00 knots (Engine)
Fuel capacity	4,300 l
Water capacity	2,500 l
Material	Advanced Composites

Wally B | 79

Nautor's Swan 112

This is the first megayacht to have been built by the prestigious yacht builder Nautor's Swan. The Swan 112 integrates the classic Nautor's Swan values with a concept that combines outstanding sailing performance with world class comfort.
Using this concept as a starting point, each Swan 112 is customized for the owner on the basis of a seemingly endless range of options. In this way, a yacht is created that enables its owner to sail the seven seas in the lap of luxury and with optimal safety. This concept is reflected in the materials used—for example the 39 m high carbon fiber mast.

Dies ist die erste Megayacht, die vom prestigeträchtigen Segelyachtenbauer Nautor's Swan gebaut wurde. Dabei wurden die traditionellen Werte der Werft mit einem Konzept umgesetzt, das herausragende Segeleigenschaften mit angenehmstem Komfort verbindet. Jede Swan 112 wird auf dieser Basis mit schier unendlichen Möglichkeiten der individuellen Gestaltung für den Eigner maßgeschneidert. Es galt, eine Yacht zu schaffen, die es dem Eigner gestattet, die Welt mit angenehmstem Komfort und großer Sicherheit zu umsegeln. Diese Idee spiegelt sich auch in den verwendeten Materialien wider, so ist der 39 m hohe Mast vollständig aus Karbonfaser gefertigt.

C'est le premier méga yacht construit par Nautor's Swan, le prestigieux constructeur de yacht à voiles. Pour ce faire, il a su allier les valeurs traditionnelles du chantier naval à une conception qui unit les hautes performances du voilier au confort le plus agréable.
En partant de cette idée de base, chaque Swan 112 est construit sur mesure, proposant au propriétaire toute une palette de conceptions modulables. La priorité est de construire un yacht qui permette au propriétaire de faire le tour du monde en voilier avec un maximum de confort et de sécurité. Cette idée se reflète ici dans les matériaux employés, tel le mât de 39 m de haut entièrement réalisé en fibres de carbone.

El 112 es el primer megayate construido por el prestigioso fabricante de veleros Nautor's Swan. En su realización, los valores tradicionales del astillero se adaptaron a un concepto que combina las mejores cualidades para la navegación con el más alto confort.
El diseño de cada Swan 112 se hace a la medida y se adapta totalmente a los deseos personales del comprador. Se perseguía el objetivo de conseguir un yate que permitiera a su inquilino navegar alrededor del mundo con la máxima seguridad y comodidades. Esta idea se refleja también en los materiales utilizados, como el mástil de 39 m fabricado completamente en fibra de carbono.

Si tratta del primo megayacht costruito dal prestigioso costruttore di yacht a vela Nautor´s Swan, in cui i valori tradizionali del cantiere sono concettualmente modificati per coniugare le eccezionali prestazioni da vela con il massimo comfort.
Ogni Swan 112 è costruito su misura, scegliendo tra infinite possibilità secondo le esigenze di ogni singolo armatore. In altre parole, si offre la possibilità all'armatore di solcare i mari di tutto il mondo con il massimo comfort e in tutta sicurezza. Questa idea si riscontra anche nei materiali impiegati, come l'albero di 39 m completamente in fibra di carbonio.

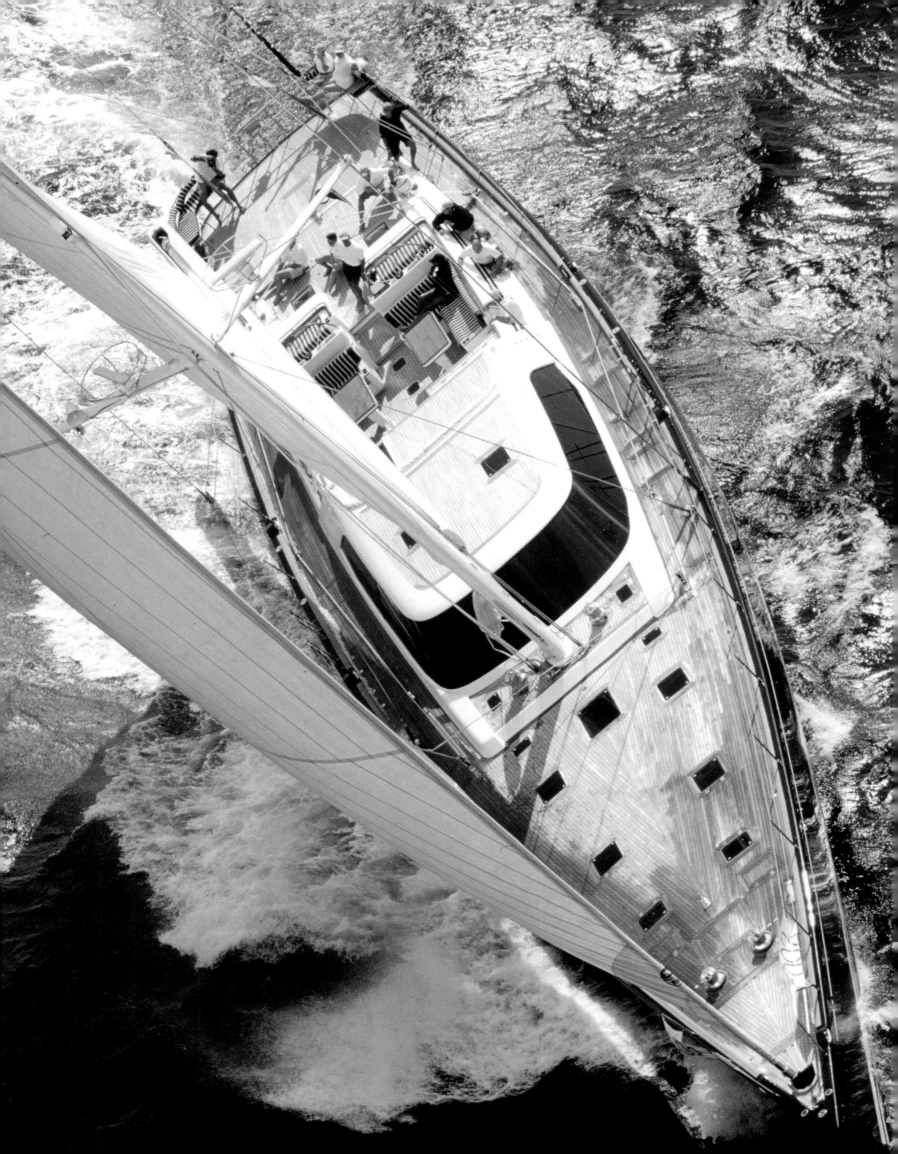

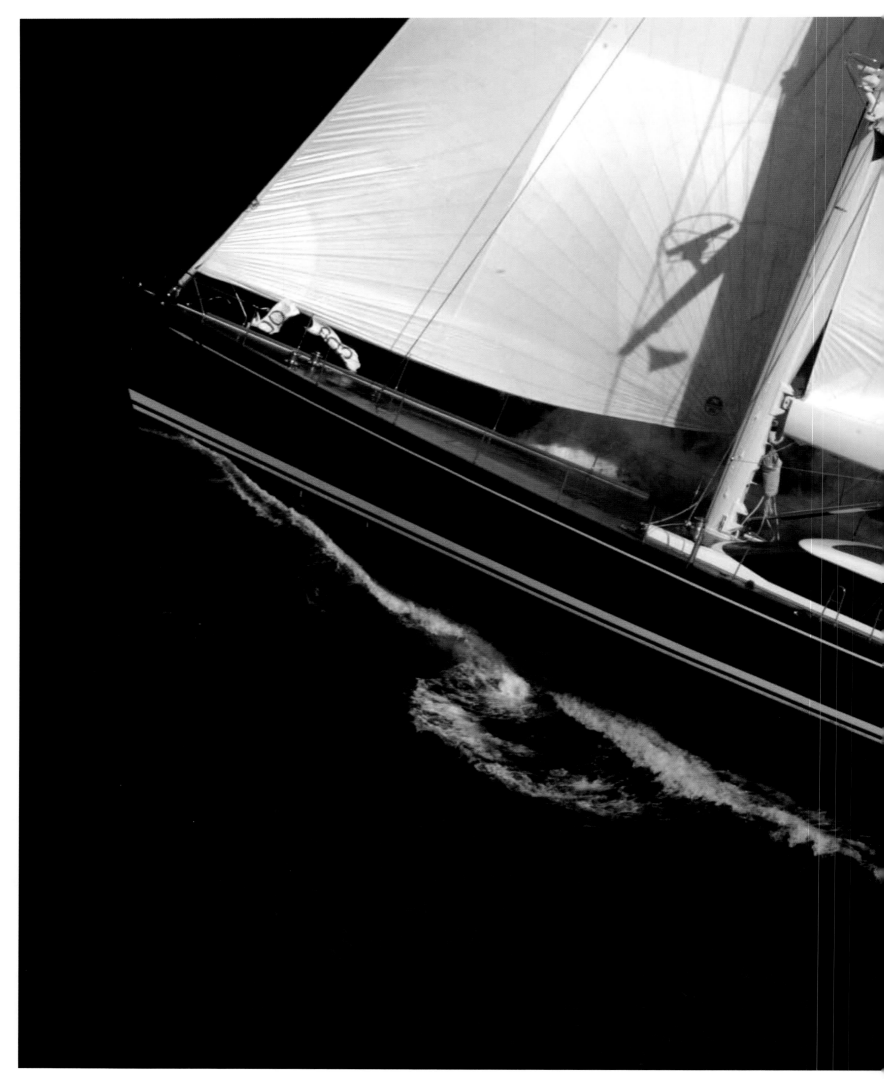

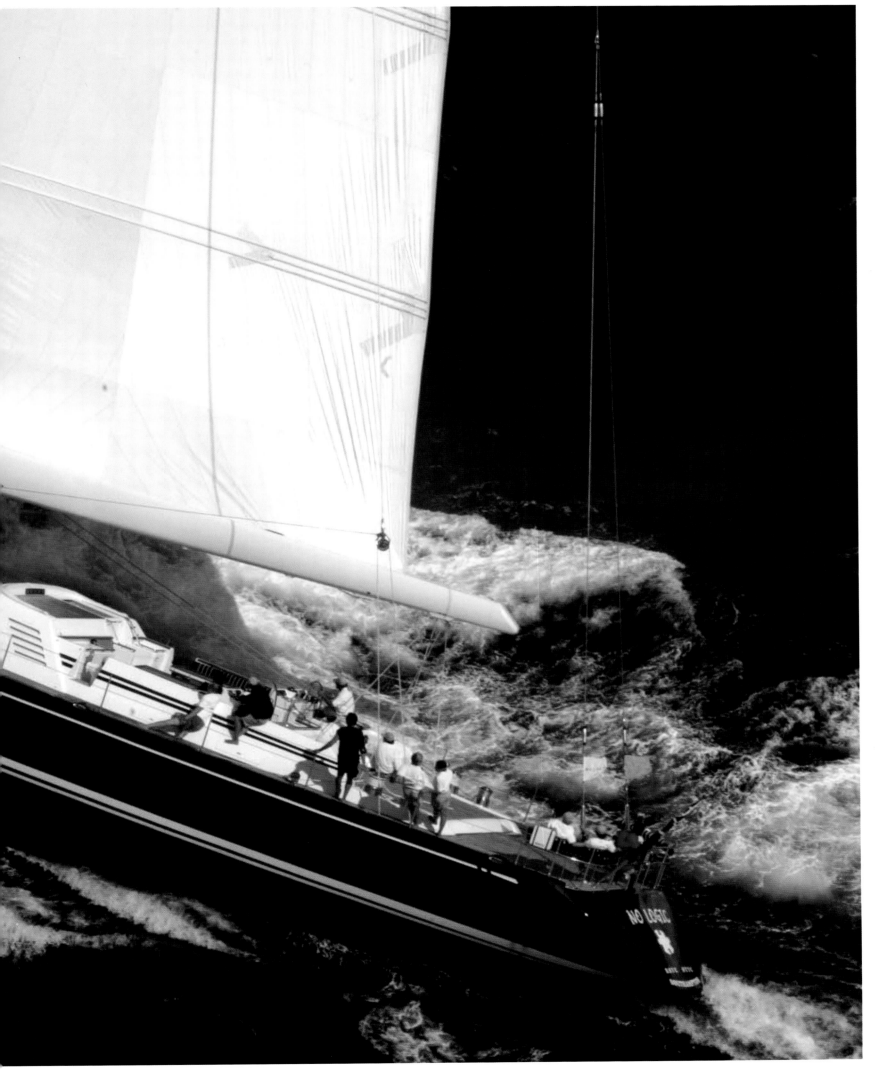

The 112 was designed to be sailed with only a four member crew. Toward this end, a great deal of emphasis was placed on creating ergonomic decks so that maneuvers could be carried out in complete safety.

Die 112 ist für eine nur vierköpfige Crew entwickelt. Daher wurde auch bei der Gestaltung des Decks viel Wert auf ergonomische Formen gelegt, um die Manöver mit totaler Sicherheit ausführen zu können.

Le 112 a été réalisé pour un équipage de quatre personnes seulement. C'est pourquoi, les constructeurs ont accordé une grande valeur aux formes ergonomiques dans la conception du pont, afin d'effectuer les manœuvres en toute sécurité.

El Swan 112 está diseñado para una tripulación de cuatro personas. Por ello cobró gran relevancia la ergonomía de las formas en el diseño de la cubierta para así poder ejecutar las maniobras con total seguridad.

Il 112 è stato concepito per un equipaggio di quattro persone. Nella progettazione del ponte, le forme sono state accuratamente concepite in modo ergonomico, per eseguire le manovre in tutta sicurezza.

Photos: © Nautor's Swan

TECHNICAL SPECIFICATIONS

Builder	Nautor's Swan
Price	Price on request
Naval architecture	Nautor's Swan, German Frers
Design	Nautor's Swan
Contact	www.nautorgroup.com
Type	Cruising Yacht
LOA, BEAM, DRAFT	112.66 ft, 24.34 ft, 14.44 ft
Sail area	583.3 sq.m.
Engine	1 x 414 HP MTU
Displacement	110 tons
Top speed	n. i.
Fuel capacity	6,500 l
Water capacity	3,000 l
Material	Glass fibre, carbon-fibre mast

Holland Jachtbouw Whisper

Holland Jachtbouw, well known for its construction of fine classic and modern sailing yachts, has scored yet another success with its 116.3-foot aluminum sloop Whisper. The Whisper is the first Holland Jachtbouw launch to be built in collaboration with the American Ted Hood Design Group. She is also the first Holland Jachtbouw project with interior styling by the renowned English firm of Andrew Winch Design. The Whisper was conceived by her owners for both family cruising and chartering purposes. Her luxurious configuration therefore consists of a full-width master suite with a private entry, marbled ensuite bath, and a convenient U-shaped office, plus three double guest cabins.

Die für die Konstruktion von klassischen und modernen Segelyachten bekannte Werft Holland Jachtbouw präsentierte mit Whisper eine 116,3 Fuß große Aluminium-Rumpf-Yacht. Whisper ist die erste Yacht, die in Zusammenarbeit mit der amerikanischen Ted Hood Design Group verwirklicht wurde. Das Innendesign wurde vom renommierten englischen Designstudio Andrew Winch Design ausgeführt. Der Wunsch des Eigners war es, eine Segelyacht zu konstruieren, die zum einen für den persönlichen Gebrauch und zum anderen als Charteryacht genutzt werden konnte. Dazu entstand eine großzügige Eignerkabine mit privatem Zugang, mit marmorverkleidetem Bad und einem U-förmig angeordneten Büro. Des Weiteren gibt es drei Doppelbettgästekabinen.

Le chantier naval Holland Jachtbouw, réputé pour la construction de yacht à voiles à la fois classiques et modernes, présente avec le Whisper un yacht à coque d'aluminium de 116.3 pieds. Whisper est le premier yacht, réalisé en collaboration avec le bureau de design américain Ted Hood Design Group. Le design intérieur est l'œuvre du studio de design anglais renommé Andrew Winch Design. Le souhait du propriétaire était de construire un voilier à usage privé et utilisable aussi comme yacht charter. A cet effet, la cabine du propriétaire, très spacieuse, a un accès privé . Elle est dotée d'une salle de bains plaquée de marbre et d'un bureau en forme de fer à cheval. Le yacht est également équipé de trois cabines doubles.

Holland Jachtbouw, el conocido astillero de veleros clásicos y modernos, presentó Whisper, un yate construido con casco de aluminio y de 116.3 pies de eslora. Este yate es el primero realizado juntamente con el americano Ted Hood Design Group. El diseño interior es obra del renombrado studio de diseño ingles Andrew Winch Design. La idea partía de concebir un velero para uso privado y como yate chárter. Para ello se ideó, por un lado, una amplia y lujosa suite con acceso privado, un baño revestido en mármol y un despacho en forma de U para el propietario; y por otro, tres camarotes dobles para los invitados.

Il cantiere Holland Jachtbouw, noto per la costruzione di yacht a vela classici e moderni, ha presentato con il Whisper uno yacht 116.3 piedi con scafo in alluminio. Whisper è il primo yacht realizzato in collaborazione con il studio americano Ted Hood Design Group, mentre il design degli interni è stato progettato insieme al rinomato studio inglese Andrew Winch Design. Il proprietario desiderava costruire uno yacht a vela che potesse servire per uso privato ma anche come yacht charter. Per questo è stata realizzata una spaziosa cabina armatoriale con accesso privato, bagno rivestito in marmo e ufficio annesso con forma a U. Inoltre, sono disponibili tre cabine doppie per gli ospiti.

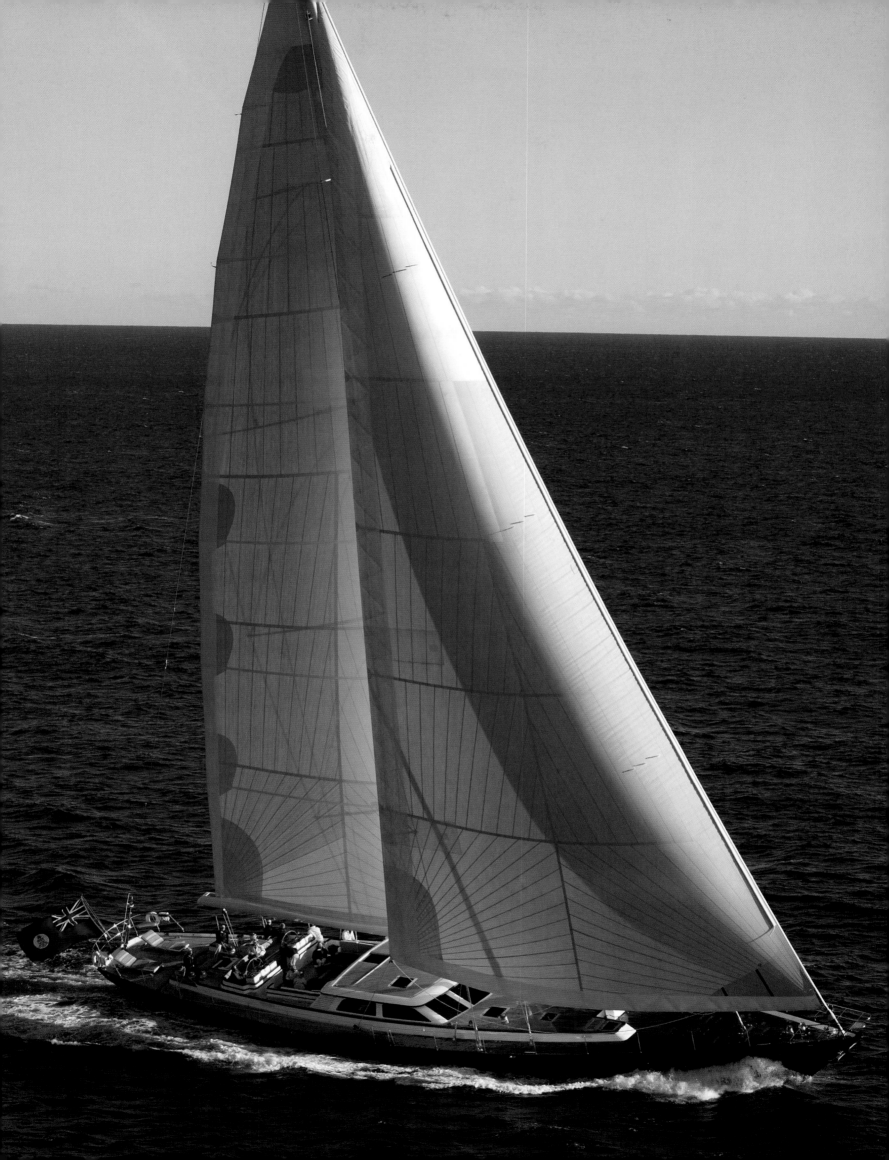

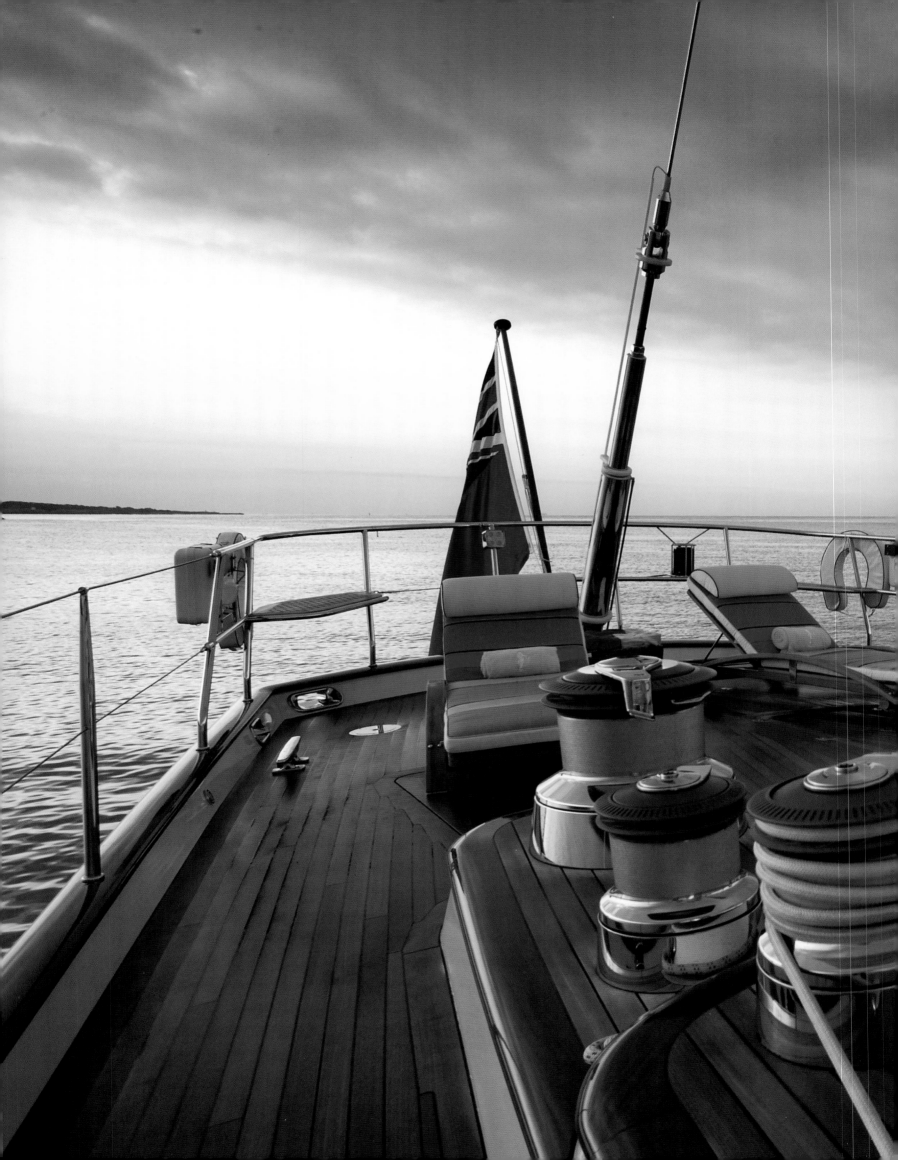

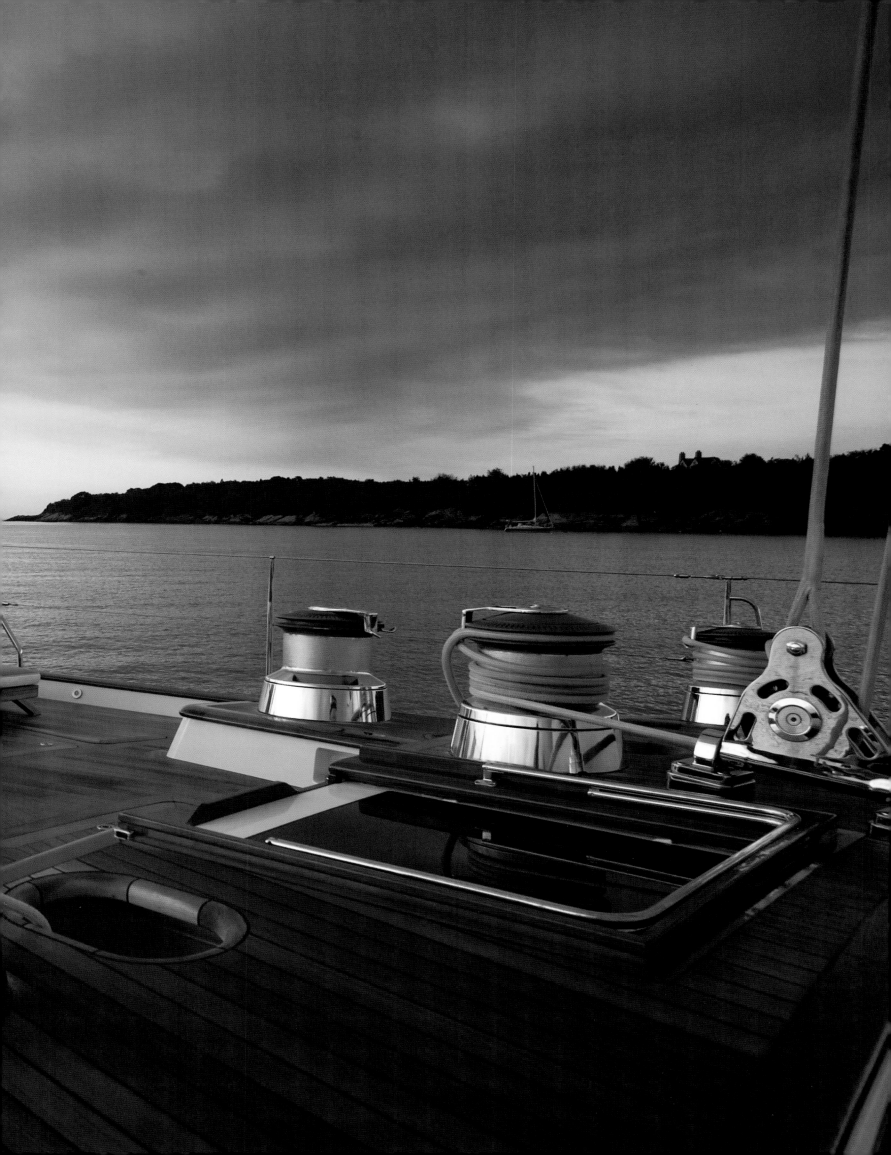

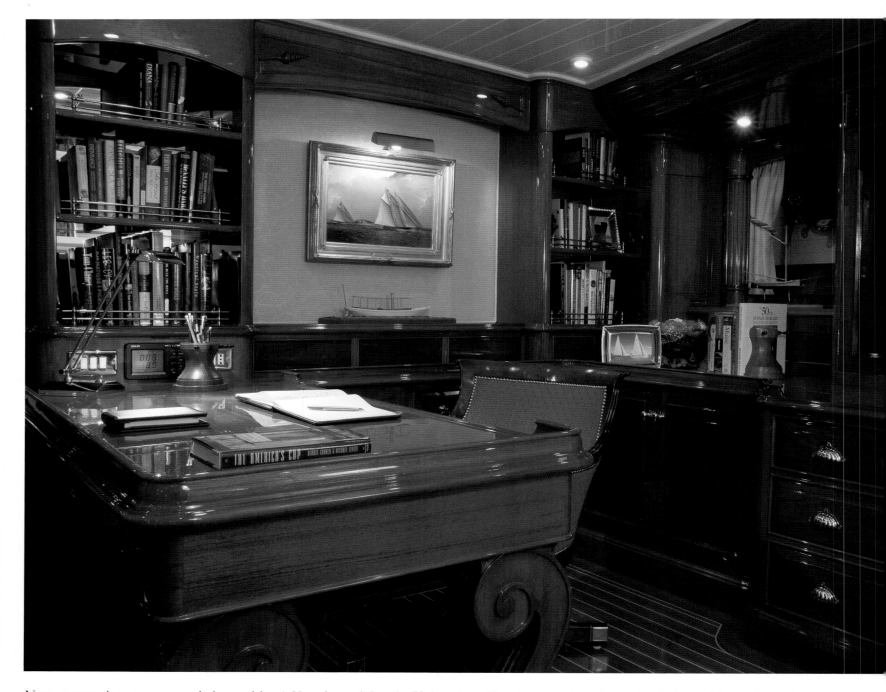

Numerous tank tests were carried out with a 1:20 scale model at the University of Southampton in order to check the craft's aerodynamic responses. And thus it is no surprise that it took five years to design and build the Whisper—which was well worth the wait.

Um ein optimales aerodynamisches Verhalten der Whisper zu erreichen, wurden zahlreiche Tests mit 1:20 Modellen an der University of Southampton durchgeführt. Und so ist es auch nicht erstaunlich, dass von der Designphase bis zur Fertigstellung fünf Jahre vergingen. Das Warten hat sich gelohnt.

Pour que l'aérodynamisme du Whisper soit optimal, l'université de Southampton a réalisé d'innombrables tests sur 1:20 modèles. Ce n'est donc pas étonnant que cinq ans se soient écoulés entre la phase du design et la fin de la construction. Cela valait la peine d'attendre !

Para conseguir que el Whisper fuero lo más aerodinámico posible, se realizaron numerosos pruebas con modelos a escala 1:20 en la Universidad de Southampton. Por este motivo no sorprende que pasaran cinco años desde la fase del diseño hasta su construcción; pero la espera ha merecido la pena.

Per ottenere una forma aerodinamica ottimale, sono stati effettuati numerosi test con modelli 1:20 all'Università di Southampton. Non stupisce quindi che siano passati cinque anni dalla fase di progettazione alla realizzazione definitiva. Valeva la pena di aspettare.

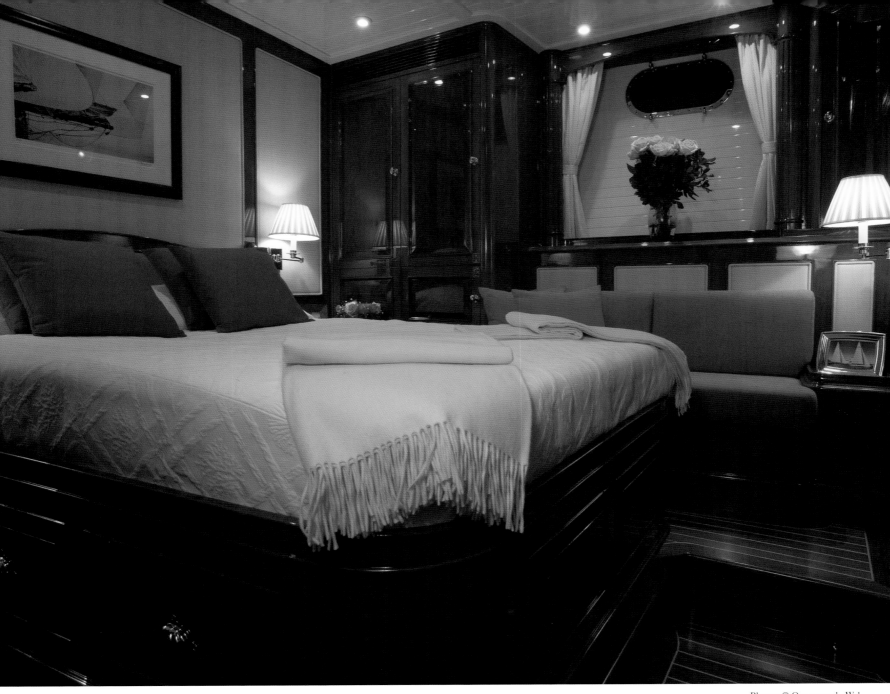

TECHNICAL SPECIFICATIONS

Builder	Holland Jachtbouw
Price	Price on request
Naval architecture	Ted Hood Design Group
Design	Andrew Winch Design
Contact	www.hollandjachtbouw.nl
Type	Sloop
LOA, BEAM, DRAFT	116 ft, 27.2 ft, 19.9 ft
Sail area	565 sq.m.
Engine	2 x 300 HP Lugger
Displacement	170 tons
Top speed	14 knots
Fuel capacity	11,500 l
Water capacity	5,000 l
Material	Aluminum hull, carbon-fibre mast and boom

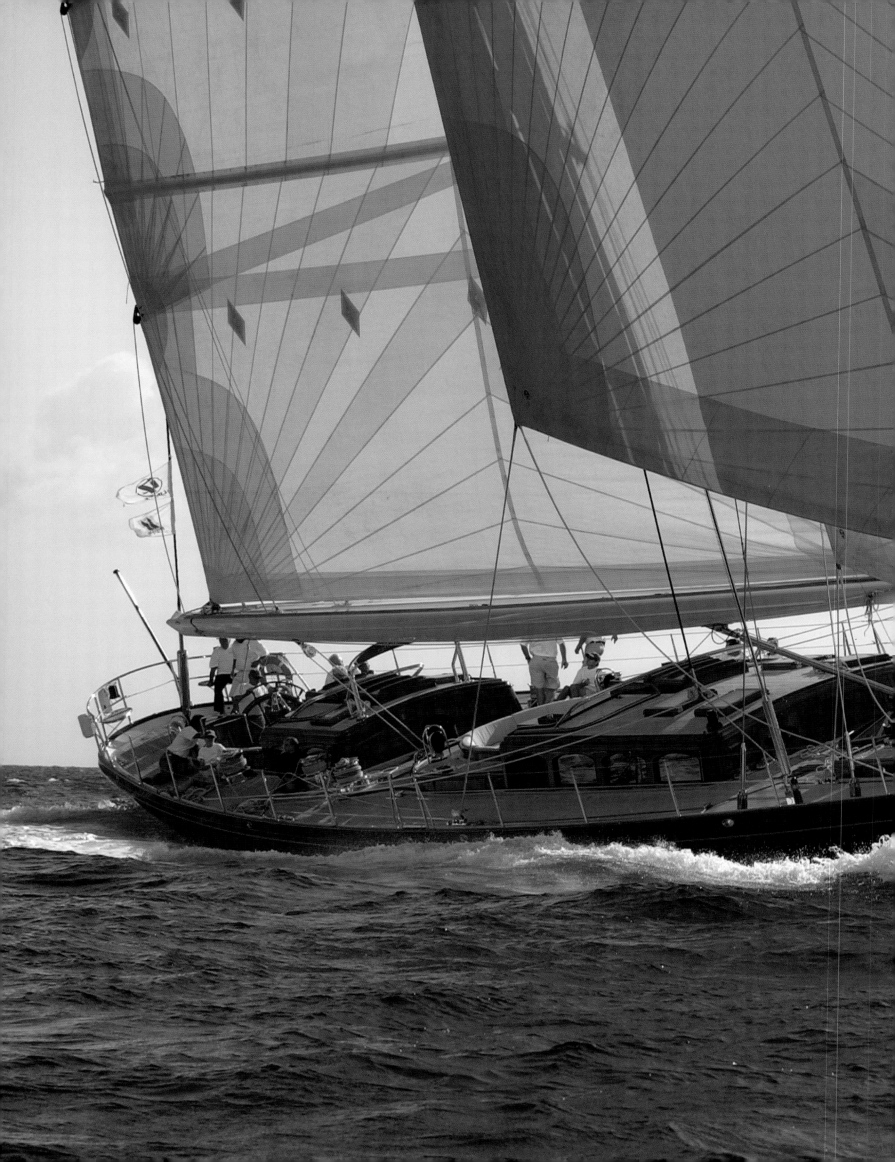

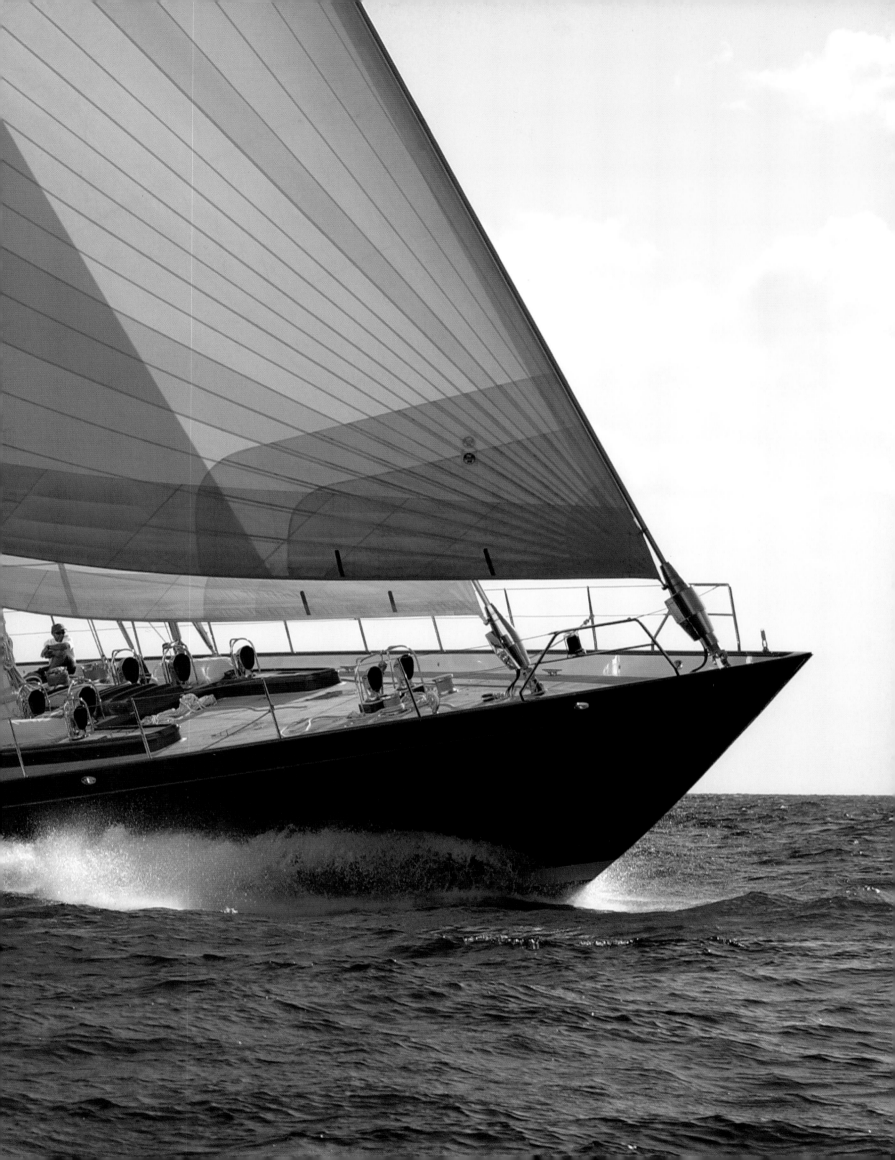

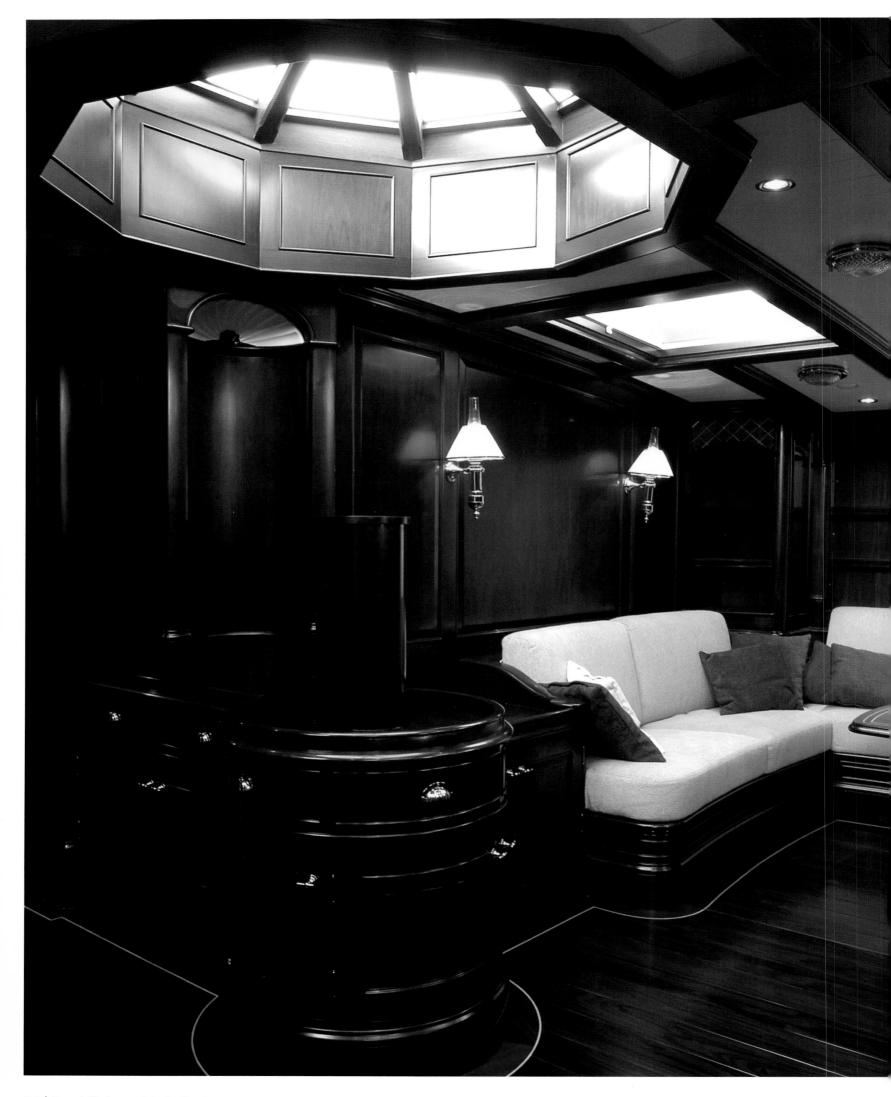

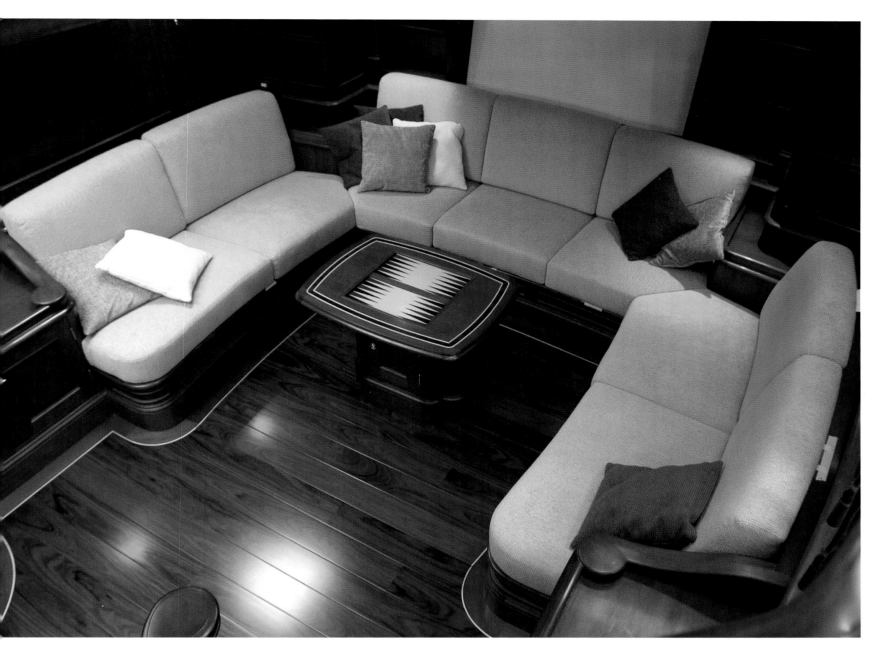

The mahogany paneling of the cabins conveys the feel of a modern classic. The interior design firm Dick Young Design created a cozy and classic ambience for the ship.

Die Kabinen sind mit dunklem Mahagoniholz ausgekleidet und vermitteln so die Idee eines modernen Klassikers. Anliegen des Designstudios Dick Young Design war es, ein gemütliches und klassisches Ambiente zu schaffen.

Le revêtement des cabines est en acajou foncé transmettant ainsi la notion d'un classique empreint de modernisme. L'idée maîtresse du studio de design Dick Young Design était de créer une ambiance chaleureuse, conviviale et d'esprit classique de marine d'autrefois.

Las cabinas están revestidas con madera oscura de Mahagoni lo que evoca la idea de clasicismo moderno. El objetivo del estudio de diseño Dick Young Design era el lograr un ambiente clásico y cómodo.

Le cabine sono rivestite in mogano scuro, ribadendo il concetto di classicità moderna. L'intenzione dello studio di progettazione Dick Young Design era proprio quella di creare un ambiente classico e accogliente.

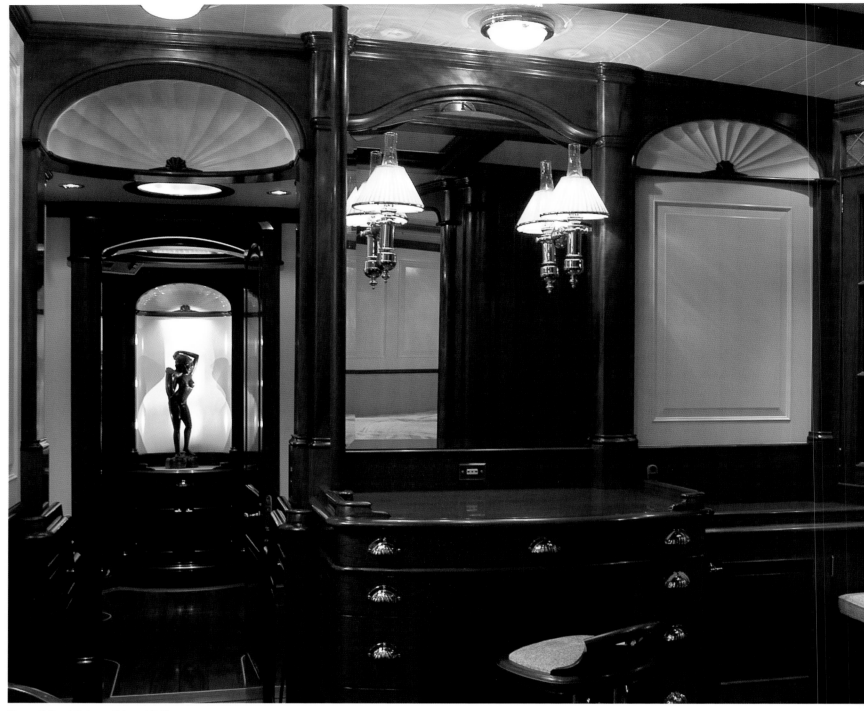

Photos: © Royal Huisman Shipyard B. V.

TECHNICAL SPECIFICATIONS

Builder	Royal Huisman Shipyard B. V.
Price	Price on request
Naval architecture	Bruce King Yacht Design
Design	Dick Young Design
Contact	www.royalhuisman.com
Type	Classic sloop rigged sailing yacht
LOA , BEAM , DRAFT	130.97 ft, 26.18 ft, 12.43 ft
Sail area	376 sq.m. (Main sail), 378 sq.m. (Yankee), 146 sq.m. (Stay sail)
Engine	1 x 640 HP MTU DDC 8V 2000 M70
Displacement	180 tons
Top speed	13.1 knots
Fuel capacity	11,550 l
Water capacity	4,035 l
Material	Aluminum, carbon fibre mast

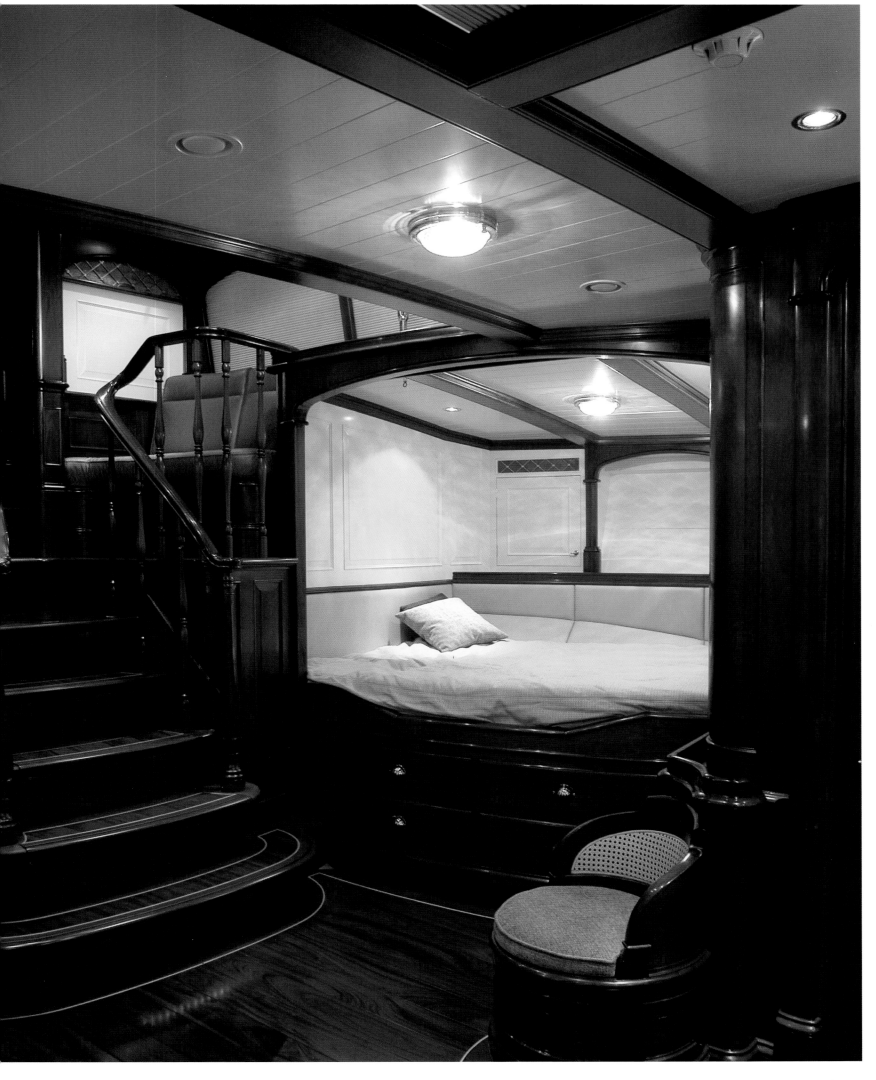

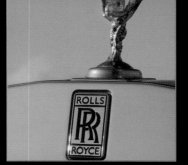

104

110

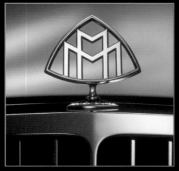

116

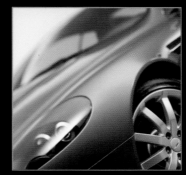

124

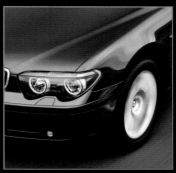

130

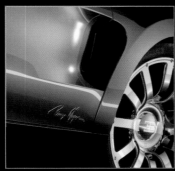

136

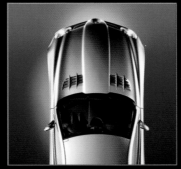

142

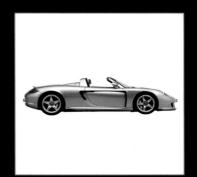

148

154

160

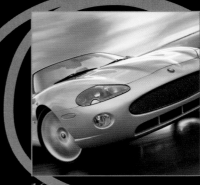

166

Rolls-Royce Phantom

The current model of the legendary Phantom luxury limousine combines classic Rolls-Royce design elements with modern lines and technological advances such as an aluminum spaceframe chassis—the largest such construction ever developed for a modern automobile.
A special feature of this 5.83 m long automobile is its rear doors that open toward the back, making the car particularly easy to enter and exit. The doors can also be closed from inside by pushing a button.

Das aktuelle Modell der legendären Luxuslimousine Phantom verbindet die Gestaltungs-elemente des klassischen Rolls-Royce mit einer moderneren Linienführung und Neuerungen, wie einer Aluminium-Spaceframe-Karosserie – die größte, im modernen Automobilbau entwickelte Rahmenstruktur ihrer Art.
Besonderes Charakteristikum des 5,83 m langen Fahrzeuges dürften jedoch die nach hinten öffnenden Fondstüren sein, die von innen per Knopfdruck geschlossen werden können. Dadurch wird ein müheloser Zustieg ermöglicht.

Le dernier modèle de la Phantom, berline de luxe légendaire, est l'alliance entre la conception traditionnelle de la Rolls-Royce classique et les lignes d'un modernisme aux techniques innovantes, comme un habitacle entouré d'une ceinture d'aluminium – la plus grande structure de carrosserie de ce genre développée par la construction automobile contemporaine.
Ce véhicule, long de 5.83 m présente des caractéristiques particulières, notamment l'ouverture par derrière des portes du fond, facilitant ainsi l'accès aux sièges arrière et la fermeture de l'intérieur par simple pression sur un bouton de commande.

El modelo actual de la ya legendaria limusina de lujo Phantom combina los clásicos elementos de diseño de Rolls-Royce con un trazado de líneas modernas e innovaciones tecnológicas, como la carrocería armada de aluminio, el mayor bastidor de este tipo construido hasta la fecha en la industria automovilística.
Las puertas posteriores con apertura hacia atrás son, sin embargo, las que imprimen especial carácter a este transporte de 5.83 m, que pueden ser cerradas desde el interior pulsando un botón, y facilitan la entrada y la salida del vehículo.

Il modello attuale della leggendaria limousine di lusso Phantom coniuga elementi strutturali delle Rolls-Royce classiche con una linea moderna e alcune innovazioni come il telaio spaceframe in alluminio – il più grande telaio di questo tipo mai sviluppato nel settore automobilistico.
Una caratteristica particolare di questo veicolo di 5.83 metri sono le portiere posteriori che possono essere chiuse dall'interno con un pulsante e che si aprono in senso opposto rispetto a quello convenzionale, consentendo di salire in auto senza problemi.

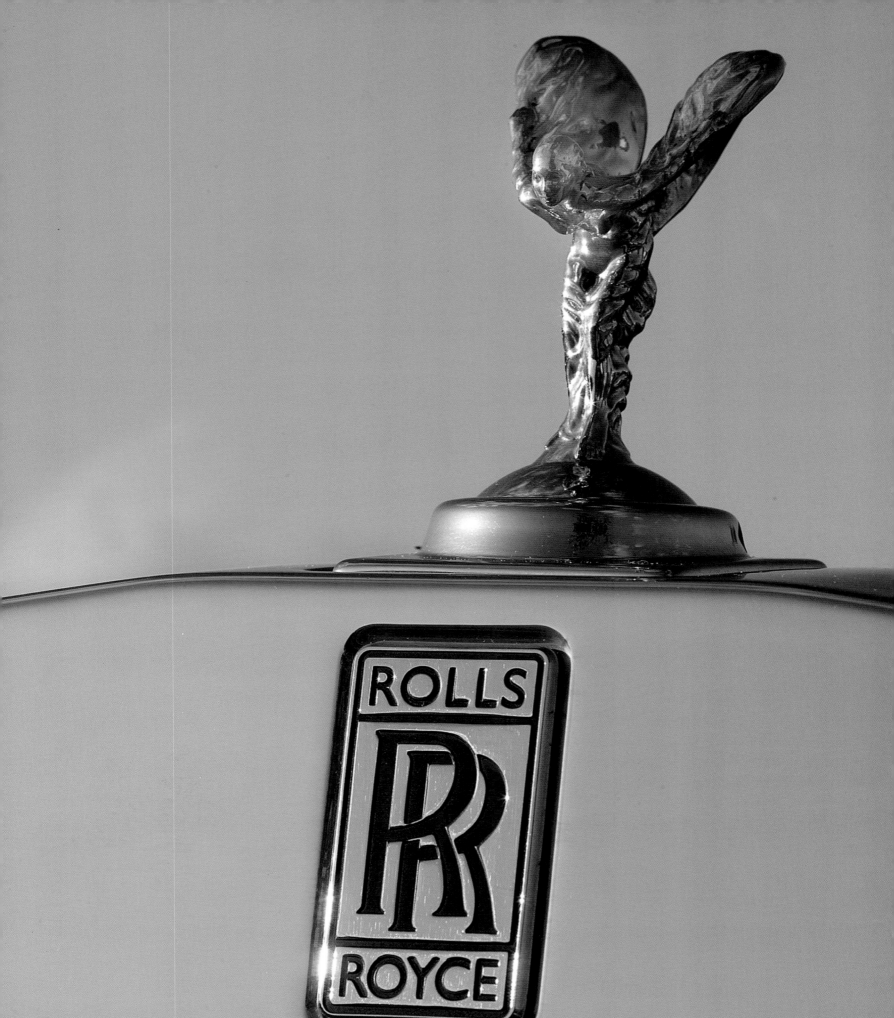

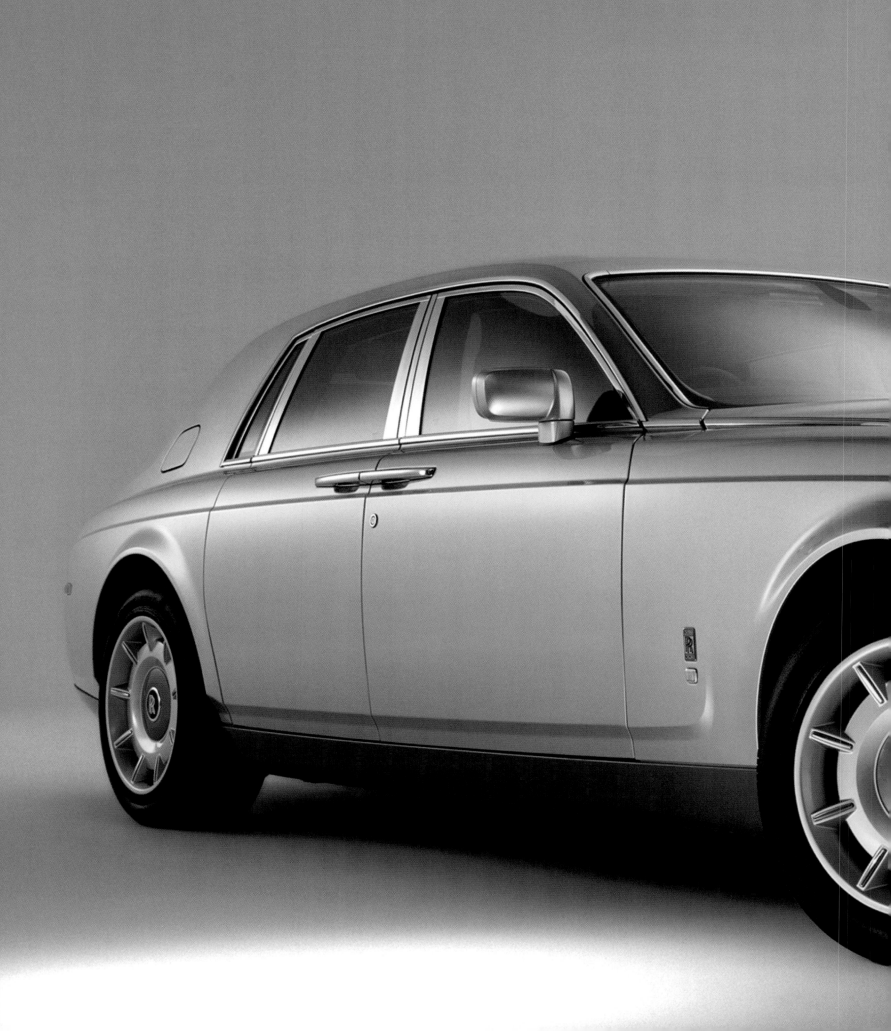

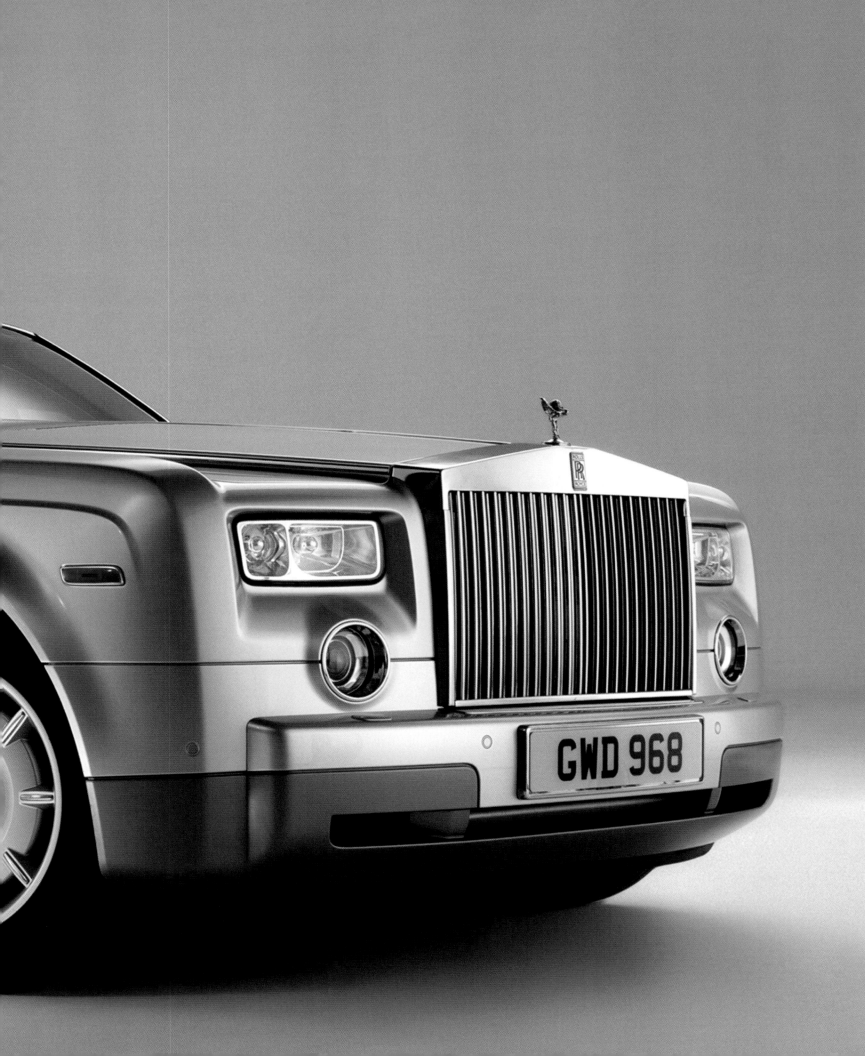

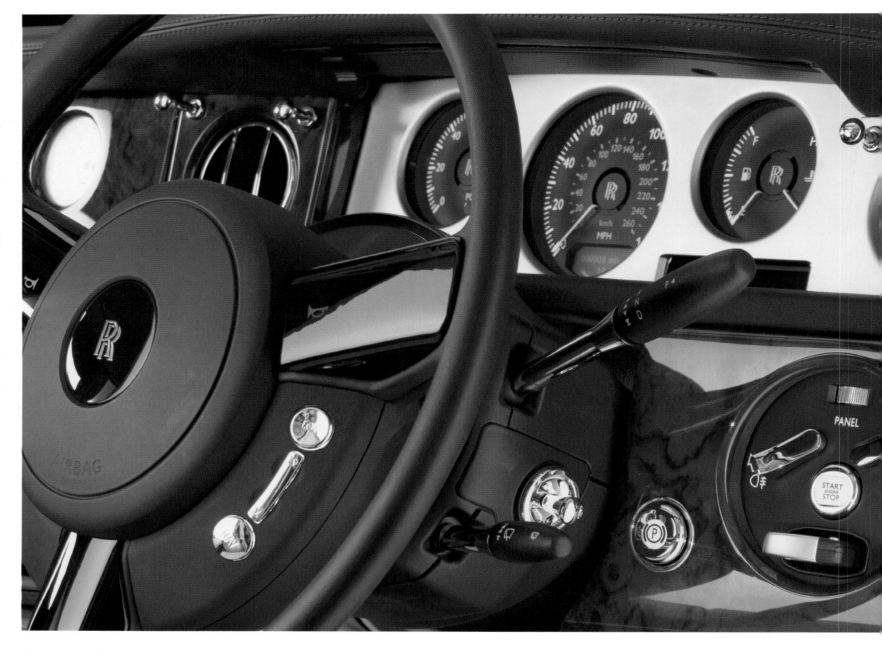

The interior, like the engine, is hand made and features carefully crafted wood with numerous layers of lacquer, close-stitched leather, chrome, and numerous elegant details such as the umbrella integrated into the rear door.

Der Innenraum ist, wie auch der Motor, in Handarbeit gefertigt: aufwändig verarbeitetes, mehrfach lackiertes Holz, eng vernähtes Leder sowie verchromtes Metall und liebevolle Details, wie zum Beispiel ein eingebauter Regenschirm in der Fondstür.

L'habitacle à l'instar du moteur, est réalisé à la main : bois richement travaillé et recouvert de plusieurs couches de laque, sellerie cousue à petits points, métal chromé et détails charmants, tel qu'un parapluie intégré dans la porte arrière.

Tanto el interior como el motor están fabricados a mano: madera lujosamente trabajada y barnizada varias veces, piel cosida sin aberturas y metal cromado, así como cuidados acabados, como por ejemplo un paraguas incorporado en la puerta posterior.

Lo spazio interno, come anche il motore, è fabbricato a mano: legno lavorato con cura e laccato diverse volte, pelle cucita con attenzione, metallo cromato e dettagli particolari, come un ombrello inserito nella portiera posteriore.

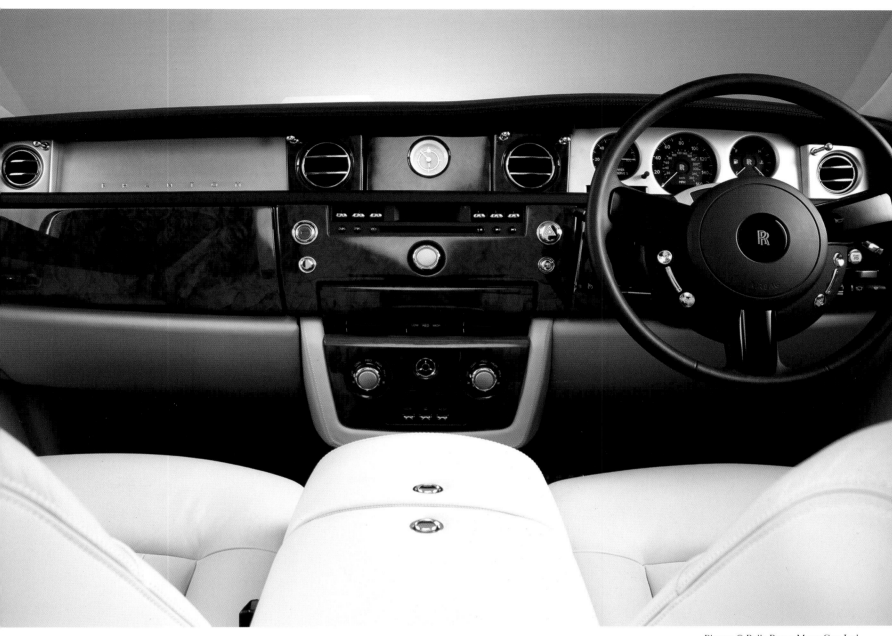

Photos: © Rolls-Royce Motor Cars Ltd.

TECHNICAL SPECIFICATIONS

Manufacturer	Rolls-Royce Motor Cars Ltd.
Price	€ 380,000
Contact	www.rolls-roycemotorcars.com
Engine/cylinders/valves per cylinder	V/12/4
Displacement	6.749 cc
Power output	460 hp
Top speed	240 km/h
Acceleration 0-100 km/h	5.9 sec
Dimensions length, width, height	5,834 mm, 1,990 mm, 1,632 mm
Wheelbase	3,750 mm
Unloaded weight	2,495 kg
Transmission	6-speed, automatic
Fuel management	Direct injection
Fuel consumption city	24.6 l / 100 km/h

Bentley Arnage RL Mulliner

The elegant Mulliner logo is the only outward sign of the extraordinary amount of talent and know-how that goes into making this chauffeur limosine. The unique feature of the Mulliner is that options are chosen not from an options portfolio but are instead left up to the customer, who can order anything his heart desires, from a classic interior to high-tech options including a TV and DVD—or out and out avant-garde interior elements.

Äußerlich verweist nur das feine Mulliner-Logo auf die besonderen Talente dieser Chauffeur-Limousine. Wer im Mulliner-Fond Platz nehmen möchte, und hier liegt das Einzigartige dieses Automobilkonzepts, muss nicht aus einer Liste von Merkmalen wählen, denn es gibt keine Ausstattungsliste.
Der Kunde entscheidet völlig frei, und die Spezialabteilung Mulliner setzt seine Wünsche um. Das Spektrum umfasst dabei Innenräume von klassischer Eleganz, Hightech-Ausstattungen inklusive TV- und DVD-Anlagen oder konsequent auf Avantgarde ausgerichtete Interieur-Elemente.

Seul la signature élégante Mulliner fait allusion aux talents cachés de cette berline de chauffeur. Celui qui prend place au fond de la Mulliner – et c'est là toute l'originalité unique de cette conception automobile – ne doit pas choisir les détails d'équipements sur une liste, car il n'y en a pas.
En effet, grâce au service spécial de Mulliner, les moindres désirs du client se transforment en réalité. Un kaléidoscope de possibilités lui est offert allant d'un habitacle à l'élégance classique, aux équipements High Tec avec TV et DVD – en passant par les détails intérieurs aux accents d'avant-guarde.

A primera vista sólo el discreto logo de Mulliner nos remite a las especiales características que puede albergar esta limusina de chófer. Y es que en un Mulliner Fond –y he aquí lo excepcional de este concepto de automóvil– no existe la lista tradicional de características de equipamiento.
El cliente decide libremente qué comodidas desear integrar en su vehículo, y el departamento especial de Mulliner convierte sus deseos en realidad. El espectro abarca interiores de elegancia clásica, sistemas de alta tecnología, incluso aparatos de DVD y televisión o detalles interiores de inspiración vanguardista.

Dall'esterno solo l'elegante logo Mulliner ci ricorda i particolari pregi di questa limousine di autista. I fortunati acquirenti di una Mulliner non devono scegliere da una lista di elementi costruttivi semplicemente perché tale lista non esiste – proprio qui risiede la peculiarità di questo concetto automobilistico unico.
Il cliente decide in totale libertà e il dipartimento speciale Mulliner realizza i suoi desideri. La scelta spazia dagli interni dall'eleganza classica, elementi high-tech come gli impianti TV e DVD oppure rifiniture in stile avantgarde.

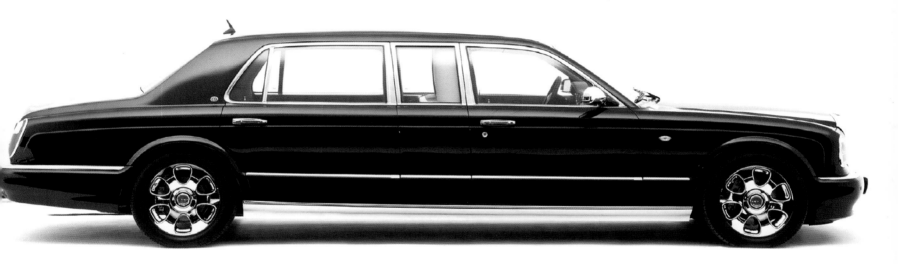

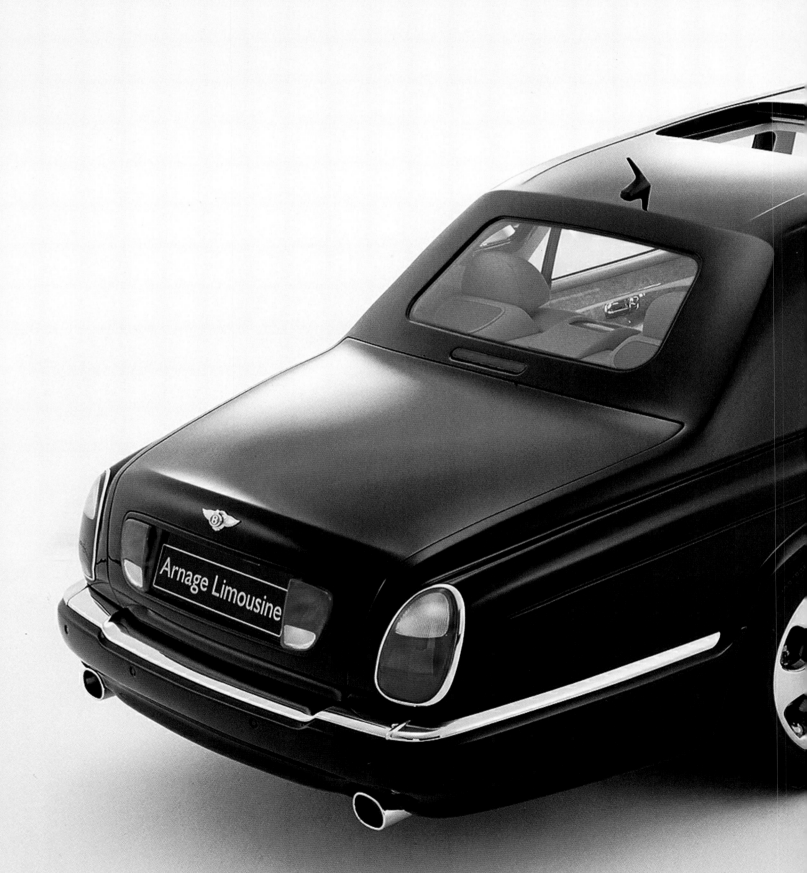

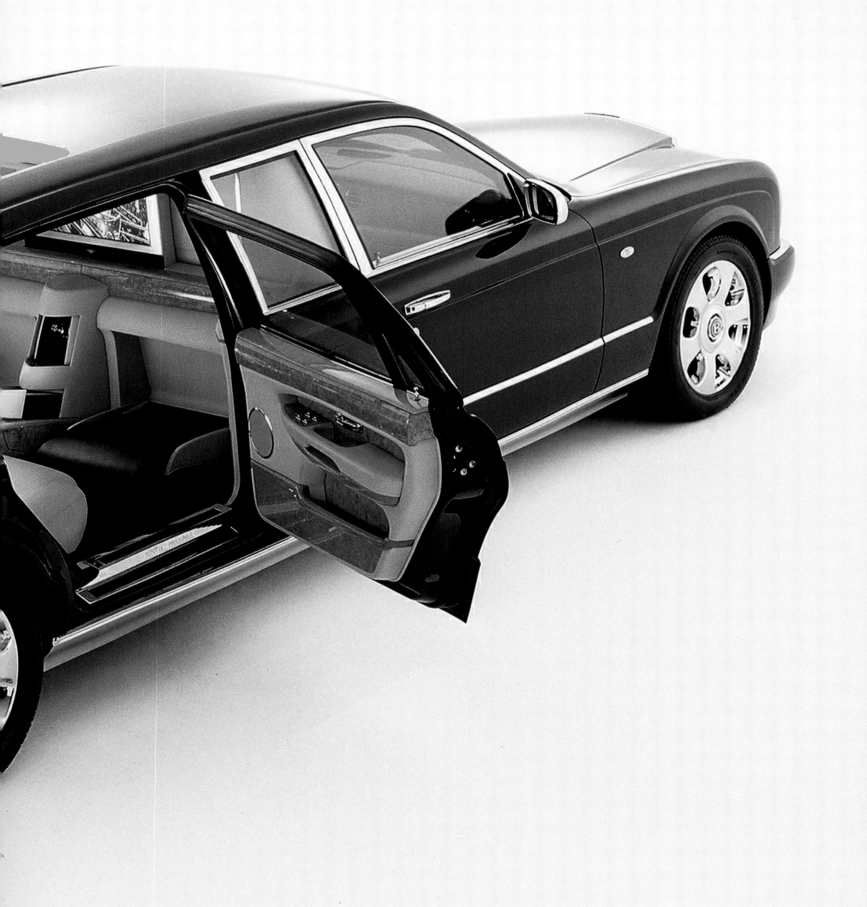

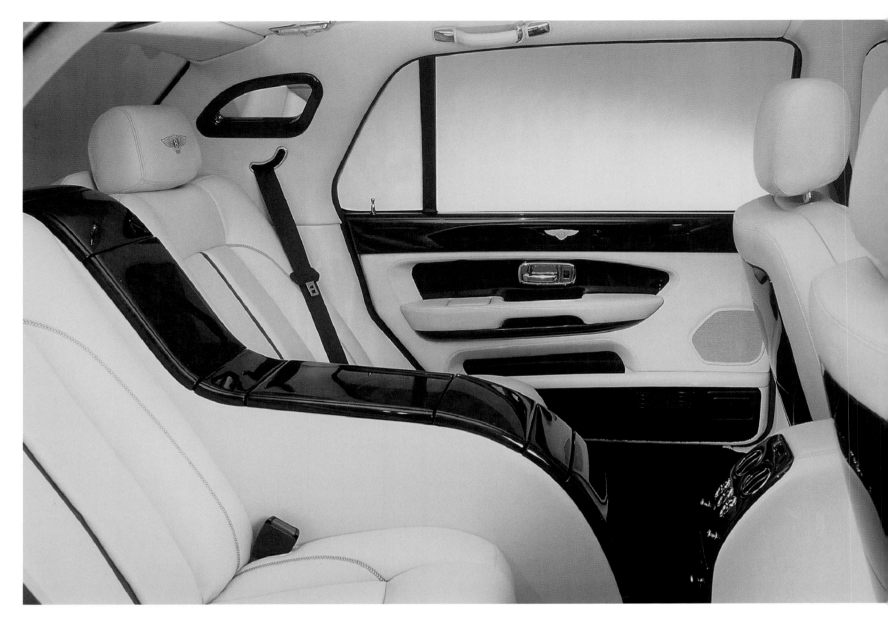

Whatever the customer chooses, approximately 130 Bentley Mulliner craftsmen and other specialists spend over 6,000 hours creating what no machine could ever produce: an automobile with a soul. For example, hand carving a wooden gear box takes approximately 12 hours, sewing a leather steering wheel is 18 hours of work and two weeks of labor go into the car's silk window curtains.

Rund 130 Mulliner-Spezialisten führen in mehr als 6.000 Arbeitsstunden aus, was keine Maschine vermag: dem Auto eine Seele einzuhauchen. So dauert das Schnitzen eines Schalthebels aus Vollholz rund 12 Stunden, ein Lederlenkrad zu nähen 18 Stunden, und für Fenstervorhänge aus Seide müssen zwei Wochen einkalkuliert werden.

Au prix de 6 000 heures de travail, 130 spécialistes Mulliner parviennent à ce qu'aucune machine n'est capable de faire : insuffler une âme à l'automobile. A titre d'exemple, il faut compter environ 12 heures pour tailler un levier de vitesse entièrement en bois, 18 heures pour coudre un volant en cuir et enfin deux semaines pour fabriquer les rideaux de soie des fenêtres.

Cerca de 130 especialistas de Mulliner trabajan más de 6 000 horas para dotar al vehículo de lo que ninguna otra máquina posee: alma. Por ejemplo, para el tallado de una palanca de cambios de madera maciza se necesitan unas 12 horas; para la costura de un volante de piel, 18 horas, y 14 días se tardan en la confección de unas cortinas de seda para las ventanas.

Circa 130 specialisti Mulliner riescono a realizzare in più di 6 000 ore lavorative ciò che risulta impossibile ad una macchina: conferire all'auto un'anima. Per questo, l'intaglio di una leva del cambio in legno può durare 12 ore, la cucitura di un volante in pelle 18 ore, e per le tende di seta ai finestrini si devono calcolare almeno due settimane di lavoro.

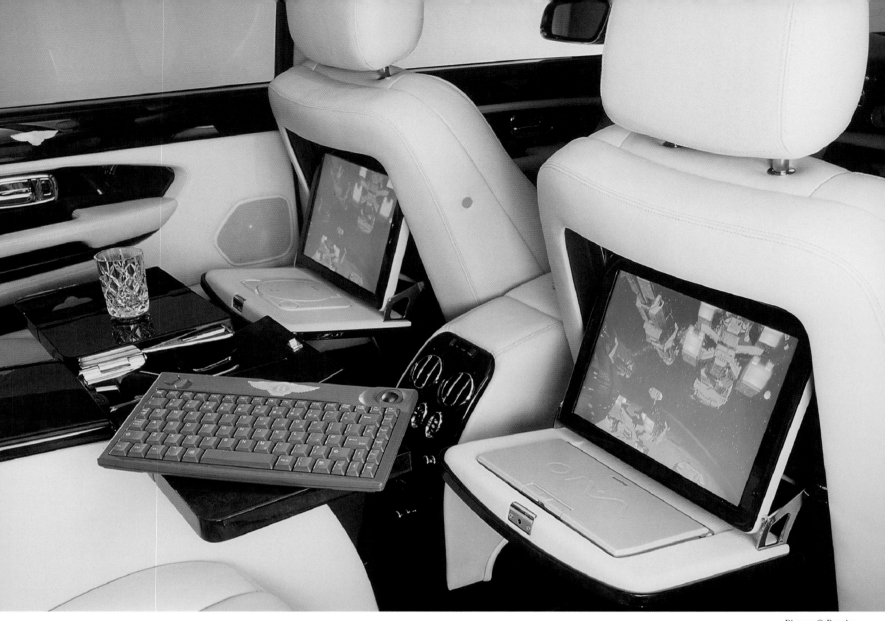

TECHNICAL SPECIFICATIONS

Manufacturer	Bentley
Price	Price on request
Contact	www.bentleymotors.com
Engine/cylinders/valves per cylinder	V/8/2
Displacement	6.750 cc
Power output	405 hp
Top speed	250 km/h
Acceleration 0-100 km/h	6.3 sec.
Dimensions length, width, height	5,640 mm, 1,932 mm, 1,515 mm
Wheelbase	3,366 mm
Unloaded weight	2,655 kg
Transmission	4-speed, automatic
Fuel feed	Direct injection
Fuel consumption city	30.7 l / 100 km/h

Maybach 62

The advent of the Maybach 62 luxury limousine marks the rebirth, after more than six decades of dormancy, of one of the world's most exquisite and sophisticated automobiles. The Maybach 62 follows in the noble footsteps of its predecessors—a luxury car that is in many respects pathbreaking.
With the press of a button, the individual seats can be converted to comfortable recliners that enable passengers to relax under the car's electro-transparent panoramic roof. A special holder for a silver water pitcher, champagne bottle, and flutes, as well as a refrigerator compartment, are all standard equipment.

Mit der Luxuslimousine Maybach 62 erwachte eine der nobelsten und anspruchsvollsten Automobilmarken der Welt nach über 60 Jahren zu neuem Leben. Mit dem Maybach 62 setzt die Marke ihre Tradition der geräumigen Limousinen fort und bietet einen Luxuswagen, der in vielerlei Hinsicht neue Dimensionen eröffnet.
Die Einzelsitze verwandeln sich per Knopfdruck in bequeme Liegesitze und ermöglichen es, unter dem transparenten Panoramadach zu entspannen. Spezielle Halter für silberne Wasserbecher, Champagnerkelche und -flaschen, sowie ein integrierter Kühlschrank sind Standard.

La berline de luxe Maybach 62, fait revivre une des plus nobles et prestigieuses marques automobiles mondiales qui existe depuis 60 ans. Avec la Maybach 62, ce grand nom de l'automobile reste fidèle à la tradition des berlines spacieuses en proposant une voiture de luxe dont certains aspects présentent de nouvelles dimensions.
Grâce à un bouton de commande, les sièges séparés se transforment en chaises longues confortables pour se détendre en regardant le paysage défiler au travers du toit de verre panoramique. La panoplie de base englobe supports spéciaux pour gobelet en argent, coupes et bouteilles de champagne ainsi qu'un réfrigérateur intégré.

La limusina de lujo Maybach 62 supuso el renacimiento de una de las más elegantes y exigentes firmas automovilísticas del mundo después de 60 años. Con la Maybach 62, esta gran marca perpetúa su tradición de amplias limusinas y ofrece un vehículo de lujo que abre nuevas dimensiones en numerosos aspectos.
Los asientos individuales se reclinan hasta la posición horizontal al presionar un botón y permite a sus ocupantes relajarse mientras contemplan el cielo a través del techo panorámico transparente. Contenedores especiales para vasos, copas y botellas de champán así como un frigorífico empotrado forman parte del equipamiento de serie.

Con la limousine di lusso Maybach 62 è tornato a rivivere uno dei marchi automobilistici più nobili ed esclusivi del mondo dopo più di 60 anni. Con il modello Maybach 62 il marchio ha ripreso la tradizione delle limousine spaziose e offre un veicolo di lusso che per molti aspetti scopre nuove dimensioni.
Con un semplice pulsante, i sedili singoli si trasformano in comodi sedili con schienali reclinabili e consentono di rilassarsi sotto il tettuccio panoramico trasparente. Nel modello standard sono presenti speciali sostegni per bicchieri in argento, calici e bottiglie da Champagne e un frigorifero integrato.

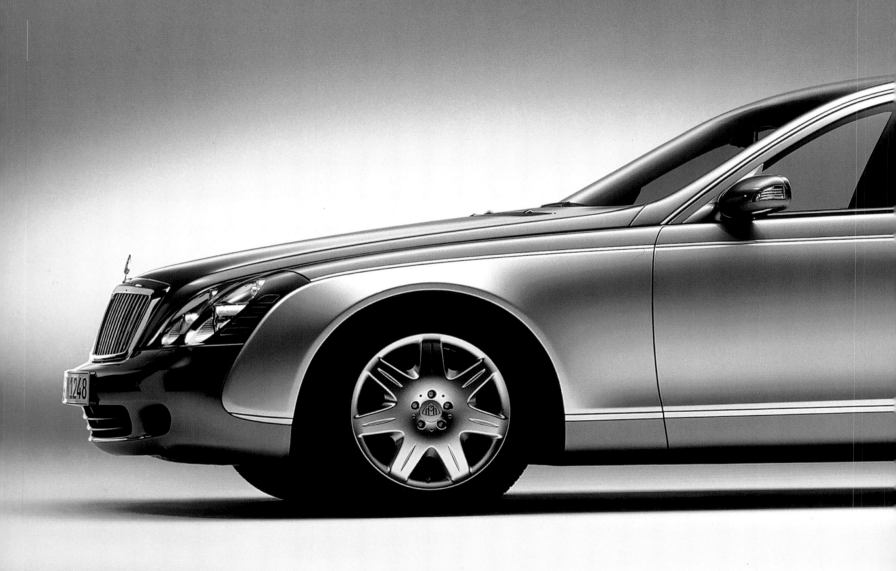

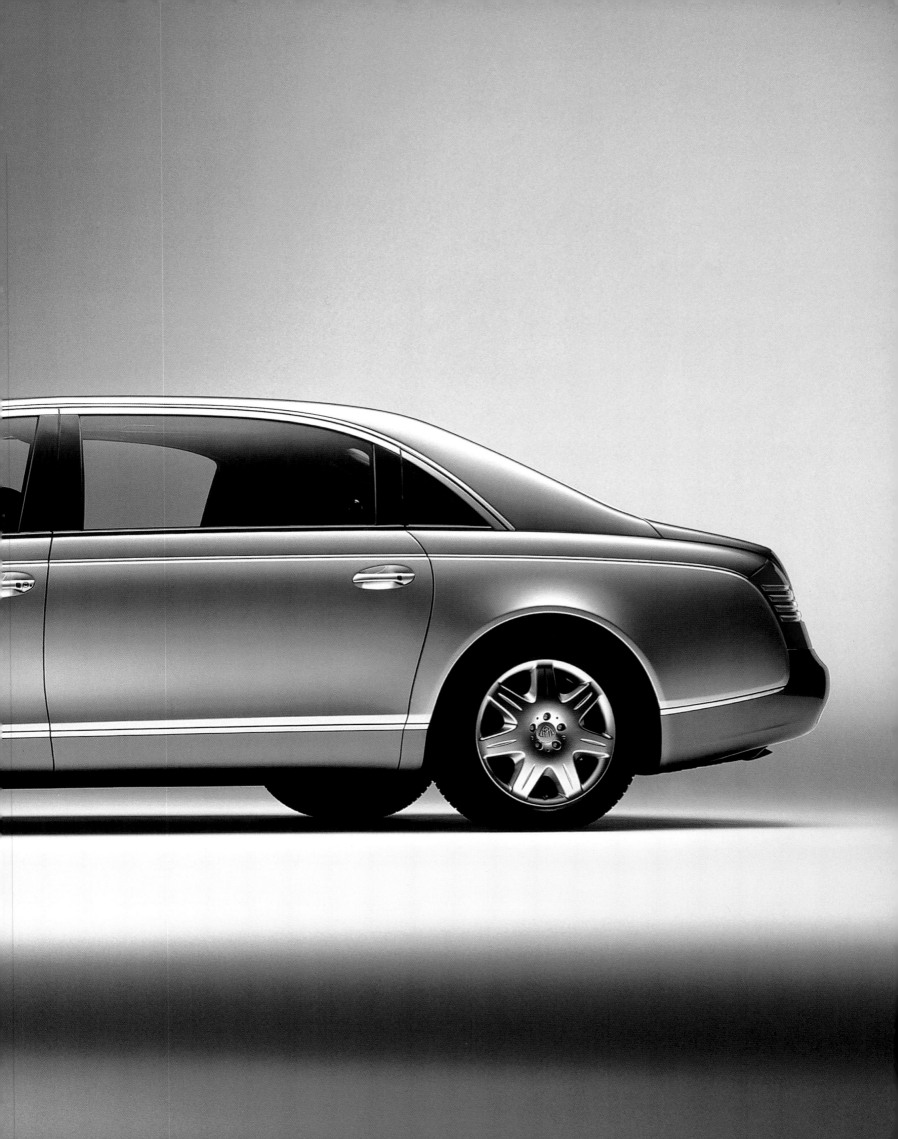

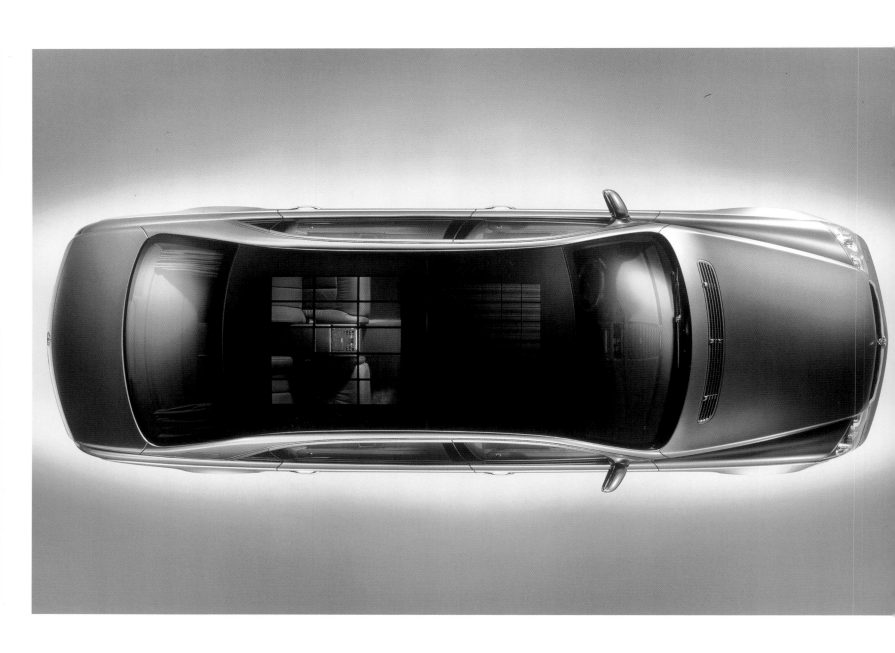

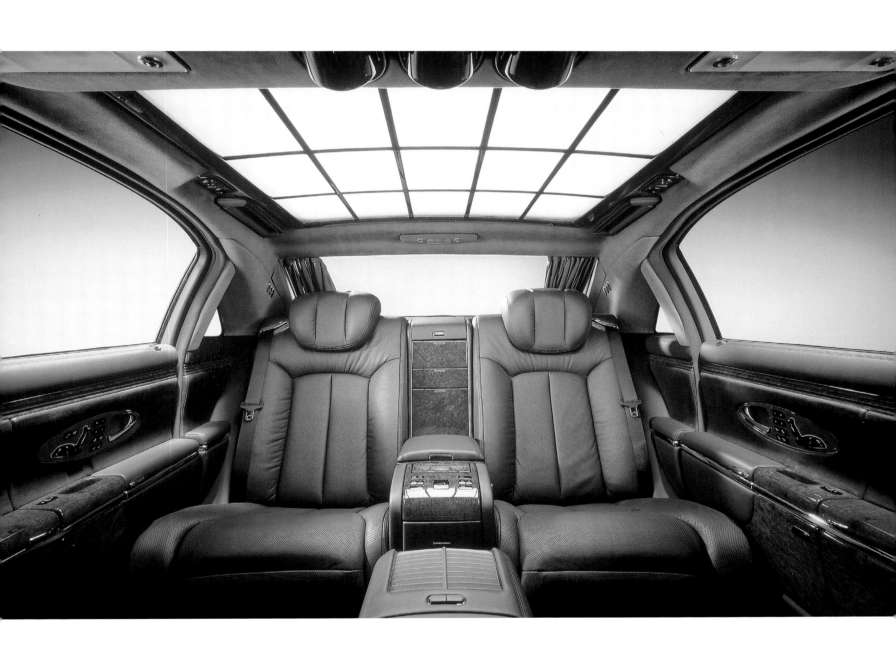

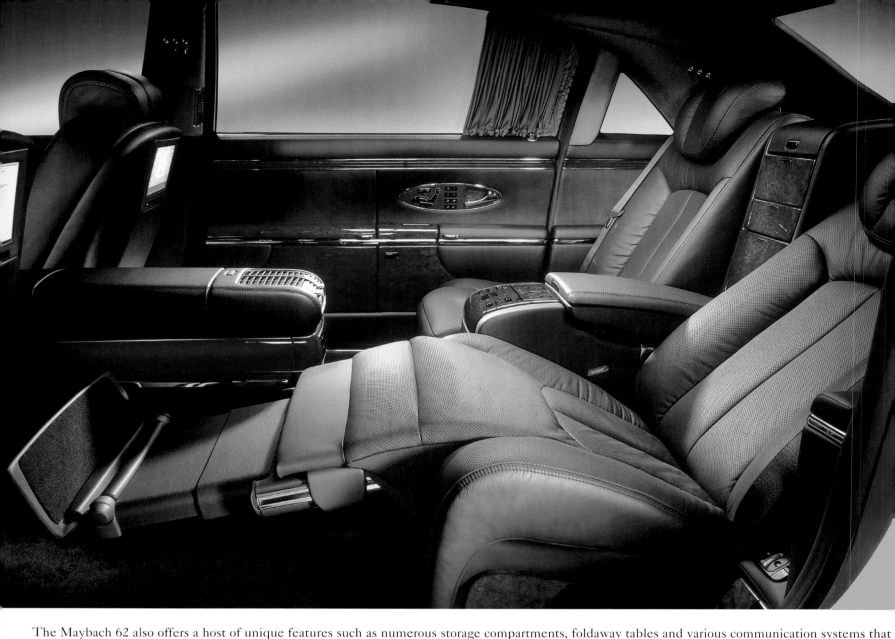

The Maybach 62 also offers a host of unique features such as numerous storage compartments, foldaway tables and various communication systems that allow the car to be used as a mobile office.

Wer das Außergewöhnliche, das Einmalige am Maybach sucht, wird spätestens in vielfältigen Ablagen, Arbeitstischen und diversen Kommunikations-systemen fündig, die den Maybach bei Bedarf in ein mobiles Büro verwandeln.

Avec sa palette de vide-poches, tablettes, plans de travail et divers systèmes de communication, la Maybach se métamorphose en un bureau mobile pour la plus grande satisfaction de l'amateur en quête d'exceptionnel et d'originalité.

Aquellos que buscan excepcionalidad, exclusividad, se verán sin duda recompensados con la extensa variedad de guanteras, mesas de trabajo y diversos sistemas de comunicación que transforman el Maybach 62, si fuera necesario, en una oficina móvil.

Coloro che sono alla ricerca di elementi particolari e unici nella Maybach potranno soddisfare i propri desideri con i diversi ripiani, scrivanie e sistemi per la comunicazione che possono trasformare la Maybach in un ufficio mobile.

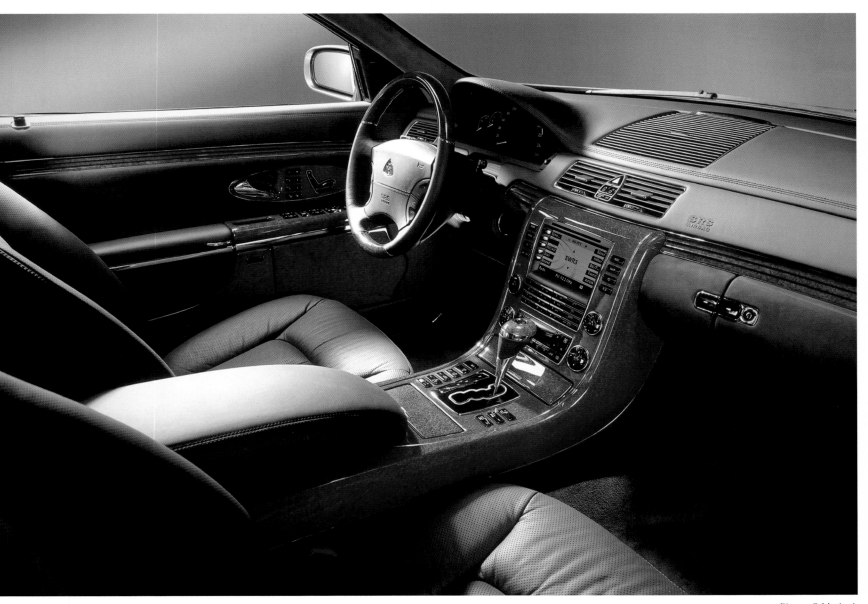

TECHNICAL SPECIFICATIONS

Manufacturer	Maybach
Price	€ 360,000
Contact	www.maybach-manufaktur.com
Engine/cylinders/valves per cylinder	V/12/3
Displacement	5.513 cc
Power output	550 hp
Top speed	250 km/h
Acceleration 0-100 km/h	5.4 sec.
Dimensions length, width, height	6,165 mm, 1,980 mm, 1,573 mm
Wheelbase	3,827 mm
Unloaded weight	2,855 kg
Transmission	5-speed, automatic
Fuel feed	Electronic fuel injection
Fuel consumption city	15.9 l / 100 km/h

Aston Martin DB9

The new Aston Martin DB9—the car currently used by James Bond—can best be described as a sportscar in a tuxedo.
Aston Martin plans to produce approximately 2,000 units annually. The coupe will be built in a new Land Rover plant near Gaydon using a radically innovative aluminum-bonded body frame and aluminum or composite panels. This lightweight construction allows for a total weight of only 1,710 kg with outstanding rigidity.

Sportlichkeit im seriösen Gewand, so lässt sich der neue DB9 Aston Martin – James Bonds neuer Dienstwagen – umschreiben.
Vom DB9 sind jährlich rund 2.000 Einheiten geplant. Das Coupé, das an einem neuen Standort in der Nähe des Land Rover-Sitzes „Gaydon" gebaut werden soll, besteht aus einer dreidimensionalen Struktur aus Strangpressprofilen und Aluminium-Blechen, die miteinander verklebt sind. Umhüllt wird dieses Gerüst von Aluminium- und Kunst-stoffteilen. Durch diese Leichtbauweise wird bei verbesserter Festigkeit ein Gesamtgewicht von nur 1.710 kg erreicht.

Sportive, drapée dans une livrée classique, c'est ainsi que l'on peut décrire la nouvelle Aston Martin DB9 – la nouvelle voiture de fonction de James Bond.
Le programme prévoit environ 2 000 unités de DB9 par an. Le Coupé, qui sera construit sur un nouveau site à proximité du siège de Land Rover « Gaydon », est constitué d'une structure en trois dimensions composée de profilés et d'aluminium collés ensemble. Cette structure est enrobée d'éléments en aluminium et fibres synthétiques. Grâce à cette construction légère et à une rigidité améliorée, la voiture a un poids minimal de 1 710 kg.

El nuevo Aston Martin DB9 –el último coche utilizado por James Bond– podría definirse como un deportivo con apariencia seria y formal.
La producción anual planificada de este modelo es de en torno a 2 000 unidades. El coupé, que se fabricará en una nueva planta en las proximidades de "Gaydon", la sede de Land Rover, está compuesto por tres estructuras tridimensionales de perfiles estrusionados y chapas de aluminio pegados entre sí. Esta estructura está a su vez revestida de piezas de aluminio y plástico. Gracias a la ligereza de esta construcción, el peso máximo del vehículo es de tan sólo 1 710 kg con una resistencia superior a la normal.

La sportività in veste seria, così si potrebbe definire la nuova DB9 della Aston Martin – l'auto ufficiale di James Bond.
Ogni anno si fabbricano circa 2 000 unità della DB9. Il coupé, che in futuro verrà costruito nelle vicinanze della sede "Gaydon" della Land Rover, è composto da una struttura tridimensionale in profilati estrusi e lamine d'alluminio ricoperta d'alluminio e materiale sintetico. Grazie a questa modalità costruttiva leggera, il veicolo raggiunge un peso totale di soli 1 720 kg con una resistenza superiore alla norma.

The roof retracts at the push of a button and stows in 17 seconds behind the rear seats beneath a hard tonneau cover that closes flush with the rear bodywork. The trunk has a capacity of 197 liters—plenty of space to stash golf bags and cases.

Das Verdeck lässt sich in rund 17 Sekunden elektrisch per Knopfdruck öffnen. Ansonsten verschwindet es hinter den beiden Notsitzen unter einer Klappe, die bündig und fast unsichtbar mit der Karosserie abschließt. Als Ladekapazität stehen noch 197 Liter Volumen für Golftasche und Aktentasche bereit.

Par simple pression sur un bouton électrique, la capote s'ouvre en 17 secondes. Elle disparaît ensuite derrière les deux sièges de secours sous un volet qui se fond dans la carrosserie. Le coffre dispose encore d'un volume de 197 litres pour le sac de golf et une mallette.

El techo se recoge eléctricamente al apretar un botón. En tan sólo 17 segundos este desaparece detrás de los dos asientos supletorios, bajo una tapa que se cierra y se ajusta perfectamente con el resto de la carrocería. El vehículo ofrece una capacidad de carga de 197 litros de volumen para la bolsa de golf y maletín.

Il tettuccio si apre elettricamente in 17 secondi premendo un pulsante, oppure scompare dietro i due seggiolini d'emergenza sotto uno sportello quasi invisibile che si chiude sulla carrozzeria. La capacità di carico ha un volume di 197 litri, perfetti per il borsone da golf e la valigetta.

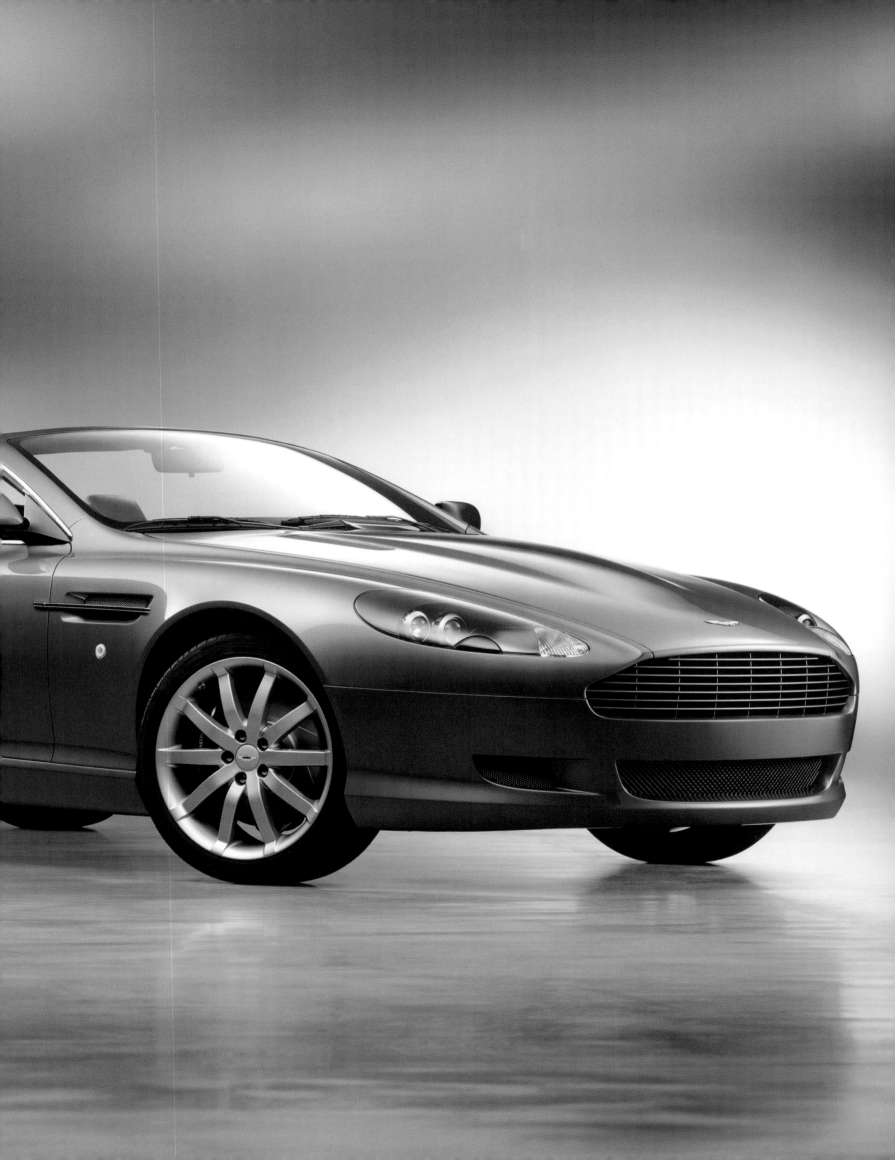

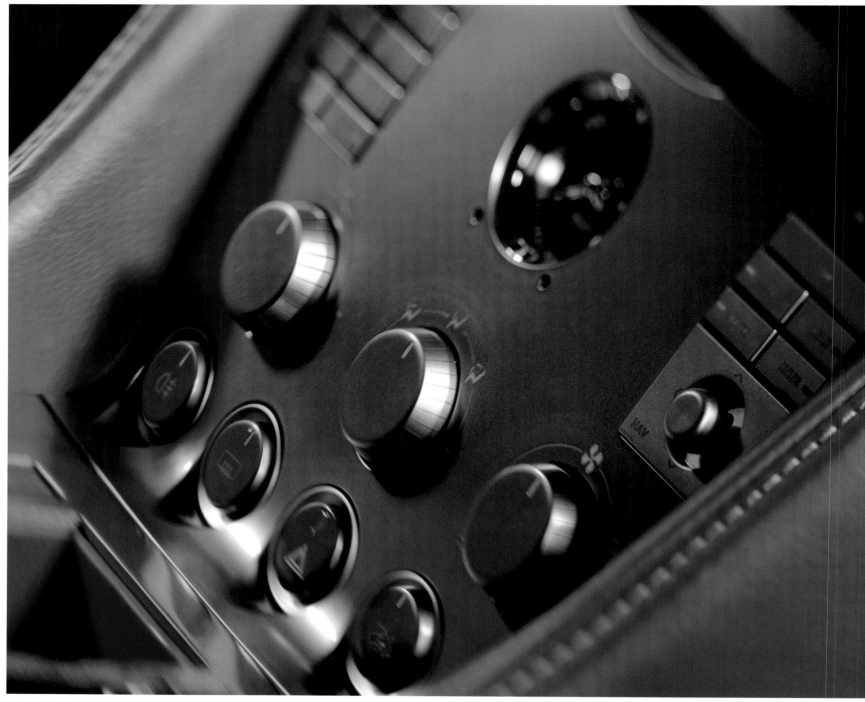

Photos: © Aston Martin

TECHNICAL SPECIFICATIONS

Manufacturer	Aston Martin
Price	€ 150,000
Contact	www.astonmartin.com
Engine/cylinders/valves per cylinder	V/12/4
Displacement	5.935 cc
Power output	450 hp
Top speed	300 km/h
Acceleration 0-100 km/h	4.9 sec.
Dimensions length, width, height	4,710 mm, 1,875 mm, 1,270 mm
Wheelbase	2,740 mm
Unloaded weight	1,710 kg
Transmission	6-speed, automatic
Fuel feed	Direct injection
Fuel consumption city	24.9 l / 100 km/h

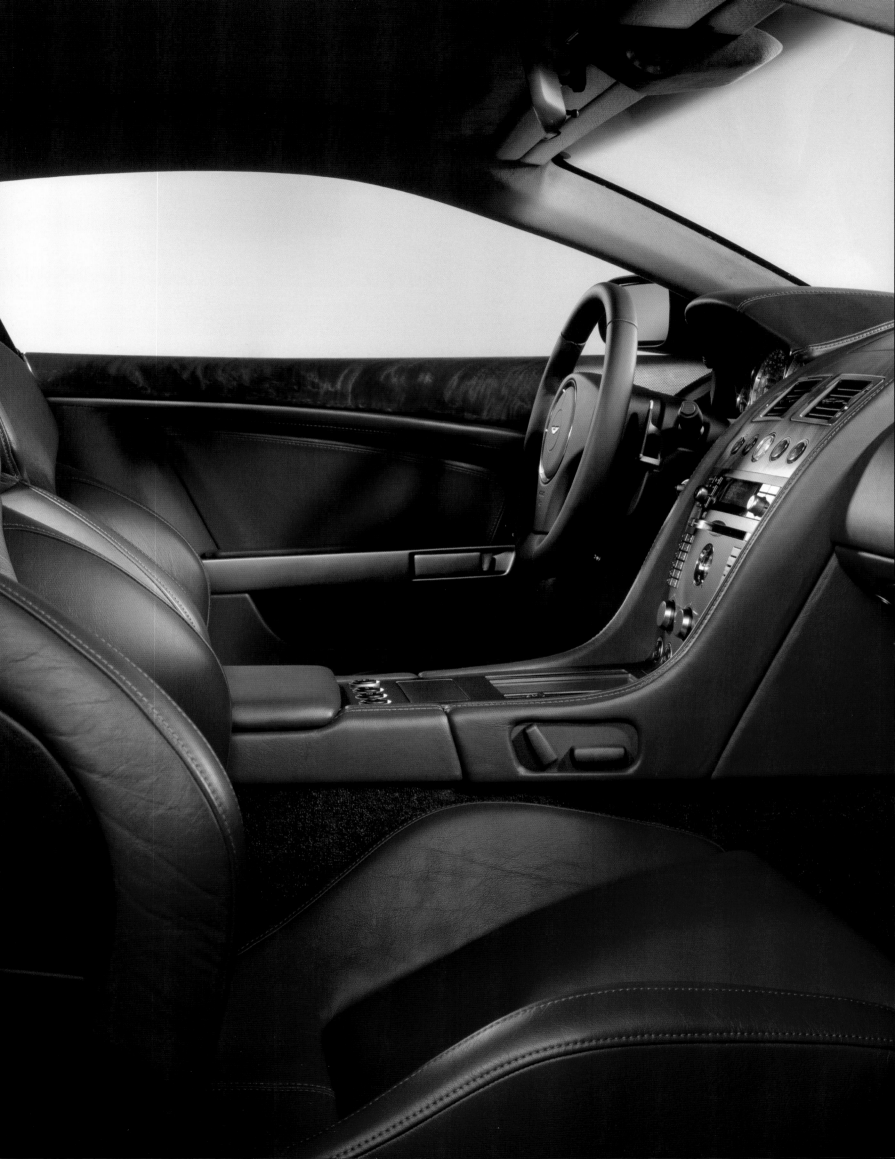

BMW 760 Li Yachtline

A yacht can take you anywhere on the high seas. But which limousine can be used to drive to the yacht? BMW Individual has answered this question with a new version of the BMW 760 Li. The interior is definitely the centerpiece of this yacht-like vehicle. The trim in the cockpit and rear is mahogany with maple stripes. Hand crafted inlays in the wood console and the Alcantara leather sun visors and headliner create a luxuriously elegant atmosphere that is accentuated by the compass card embroidered into the charcoal-grey floormats.

Mit der Yacht über alle Meere. Aber mit welcher Limousine zur Yacht? Diese Frage beantwortet BMW Individual mit einer Interpretation des BMW 760 Li. Im Zentrum dieser maritimen Komposition steht dabei das Interieur. Die Dekorleisten in Cockpit und Fond sind in Edelholz Mahagoni mit Ahornstreifen gehalten. Aufwändige Intarsienarbeiten in den Echtholz-Einlagen und mit Alcantara bespannte Sonnenblenden und Dachhimmel vervollständigen den Eindruck von luxuriöser Eleganz, der durch die eingestickten Kompassrosen in den anthrazitfarbenen Fußmatten zusätzlich betont wird.

Un yacht permet de naviguer sur tous les océans. Mais quelle berline trouver à quai pour prendre ce yacht ? Le département Individual de BMW détient la réponse avec la BMW 760 Li. L'habitacle est le centre de cette composition marine. Dans le cockpit et à l'arrière, les baguettes décoratives sont en bois précieux, acajou doté de fins inserts rayés d'érable. De superbes marqueteries dans les boiseries, des pare-soleil et un plafond en alcantara soulignent l'impression d'élégance luxueuse que parachèvent les roses des vents brodées dans la moquette couleur anthracite.

Con un yate se puede surcar los mares. ¿Pero que limunina puede utilizarse para ir al yate? La respuesta a esta pregunta la tiene BMW Individual con una reinterpretación del BMW 760 Li. El protagonista de esta composición marítima es el interior. Los listones decorativos en la zona del conductor y en la parte posterior son de madera maciza de mahagoni y se sujetan con piezas de madera de arce. Los elementos de madera maciza lucen una elegante marquetería que junto con los parasoles y el techo interior tapizados con alcántara completan la sensación de un lujosa elegancia, acentuada con las rosas de los vientos bordadas en las alfombrillas de color antracita.

Con lo yacht per tutti i mari. Ma con quale limousine si va allo yacht? BMW Individual risponde a questa domanda con una rivisitazione della BMW 760 Li. Al centro di questa composizione marittima troviamo lo spazio interno. Le rifiniture del cockpit e dei sedili posteriori sono in mogano mahagoni e in acero. I minuziosi lavori di intarsio negli inserti di vero legno, le alette parasole e l'interno del tettuccio rivestiti in alcantara ribadiscono l'immagine di un'eleganza lussuosa, evidenziata dalle rose dei venti ricamate sui tappetini color antracite.

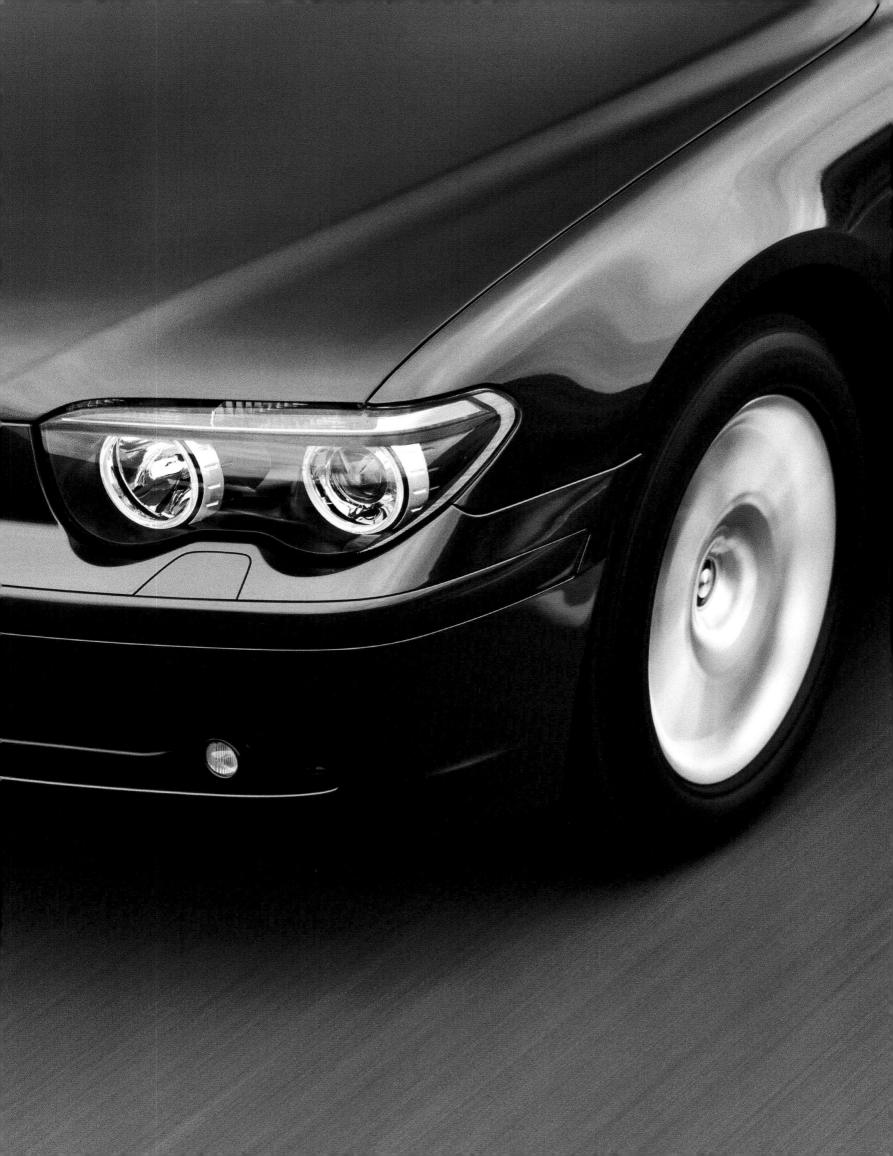

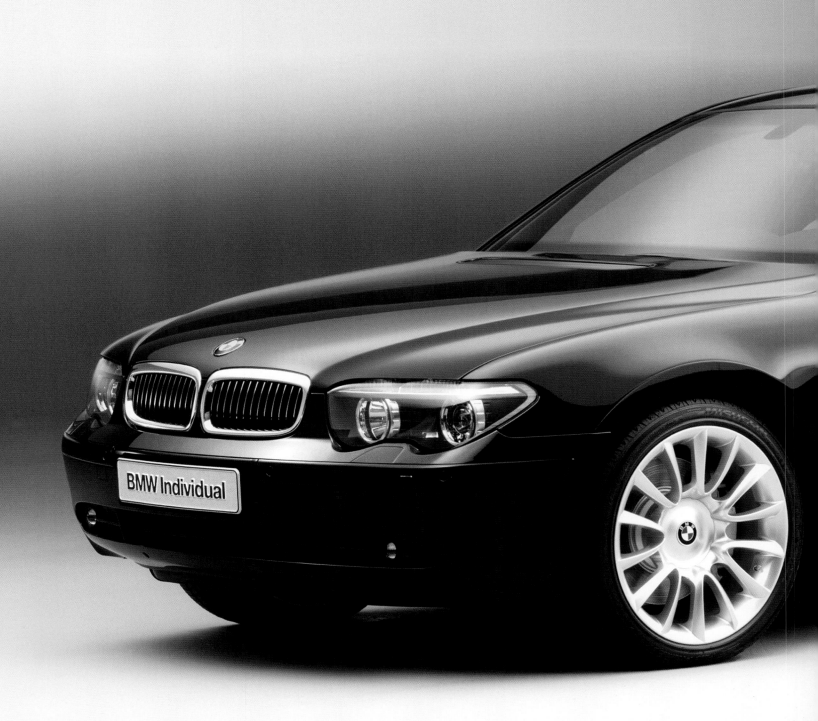

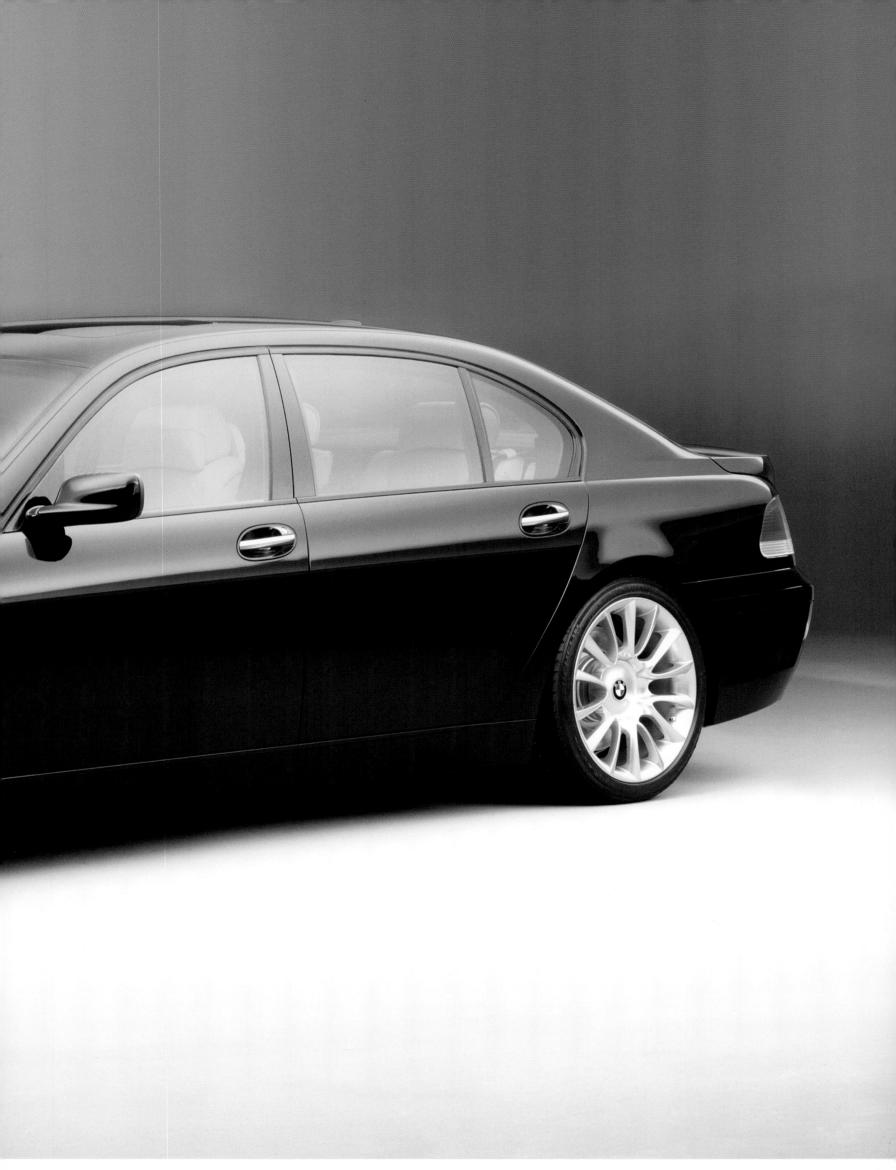

Bugatti Veyron EB 16,4

The new Veyron EB 16,4 luxury sportscar from the legendary automaker Bugatti is currently the world's fastest and highest priced sportscar. The 16 cylinder Veyron engine is engineered as if it were intended for a private jet, developing 1001 hp and reaching a top speed of over 400 km/h.
Like a Formula One racing car, the EB 16,4 has a self supporting carbon fiber composite chassis that provides optimal rigidity and stiffness with minimal weight. It is also one of the world's safest cars.

Der neue Luxussportwagen Veyron EB 16,4 der legendären Marke Bugatti ist der derzeit schnellste und teuerste Sportwagen der Welt. Der Bugatti Veyron ist ein Auto motorisiert wie ein Privatjet. Ausgestattet mit einem 1001 PS-Sechzehnzylindermotor erreicht er Spitzengeschwindigkeiten über 400 km/h.
Wie bei einem Formel-1-Auto wird das selbst tragende Chassis des EB 16,4 in Kohlefaser-Technologie (CFK) hergestellt. Diese Bauweise garantiert die höchstmögliche Festigkeit und Steifigkeit bei minimalem Gewicht und gewährleistet darüber hinaus optimale Sicherheit für die Passagiere.

La Veyron EB 16,4, la nouvelle sportive de luxe de Bugatti, marque légendaire s'il en est, est actuellement la voiture de sport la plus rapide et la plus chère du monde. La Bugatti Veyron est motorisée à l'instar d'un jet privé. Equipée d'un moteur de seize cylindres déployant une puissance de 1001 ch, elle peut atteindre la vitesse de 400 km/h.
Comme les formules 1, le châssis autoporteur de l'EB 16,4 est réalisé en fibres de carbones (CFK). Cette construction lui confère une grande rigidité et stabilité pour un poids minimal et un maximum de sécurité garantie pour les passagers.

El nuevo deportivo de lujo Veyron EB 16,4, de la legendaria firma Bugatti, es en la actualidad el vehículo más rápido y más caro del mundo. El Veyron, dotado con el motor de un jet privado, posee 1001 caballos de potencia y 16 cilindros y alcanza una velocidad máxima de más de 400 km/h.
Al igual que en los vehículos de la Fórmula 1, el chasis monocasco está fabricado con tecnología de fibra de carbono (CFK). Este tipo de construcción garantiza mayor estabilidad y rigidez con el peso mínimo y garantiza además una óptima seguridad para los ocupantes.

Il nuovo veicolo sportivo di lusso EB 16,4 del leggendario marchio Bugatti è attualmente l'auto sportiva più veloce e costosa del mondo. La Bugatti Veyron è un'auto motorizzata come un jet privato. Fornita di un motore a sedici cilindri con 1001 CV, l'auto raggiunge una velocità massima di oltre 400 km/h.
Come in un'auto di Formula 1, il telaio autoportante della EB 16,4 è costruito a base di fibra di carbonio (tecnologia CFK). Questa modalità costruttiva garantisce la maggiore solidità possibile e rigidità insieme a un peso minimo ed assicura perciò una sicurezza ottimale per i passeggeri.

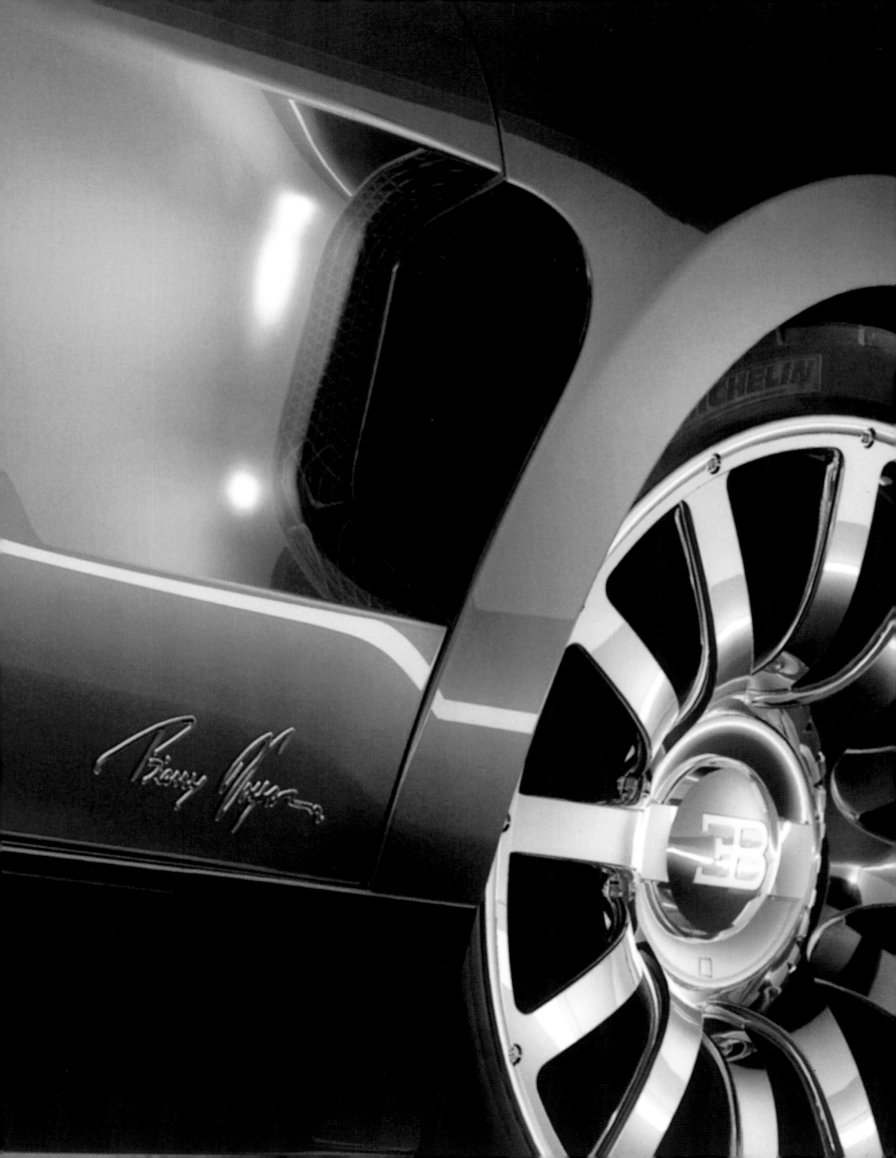

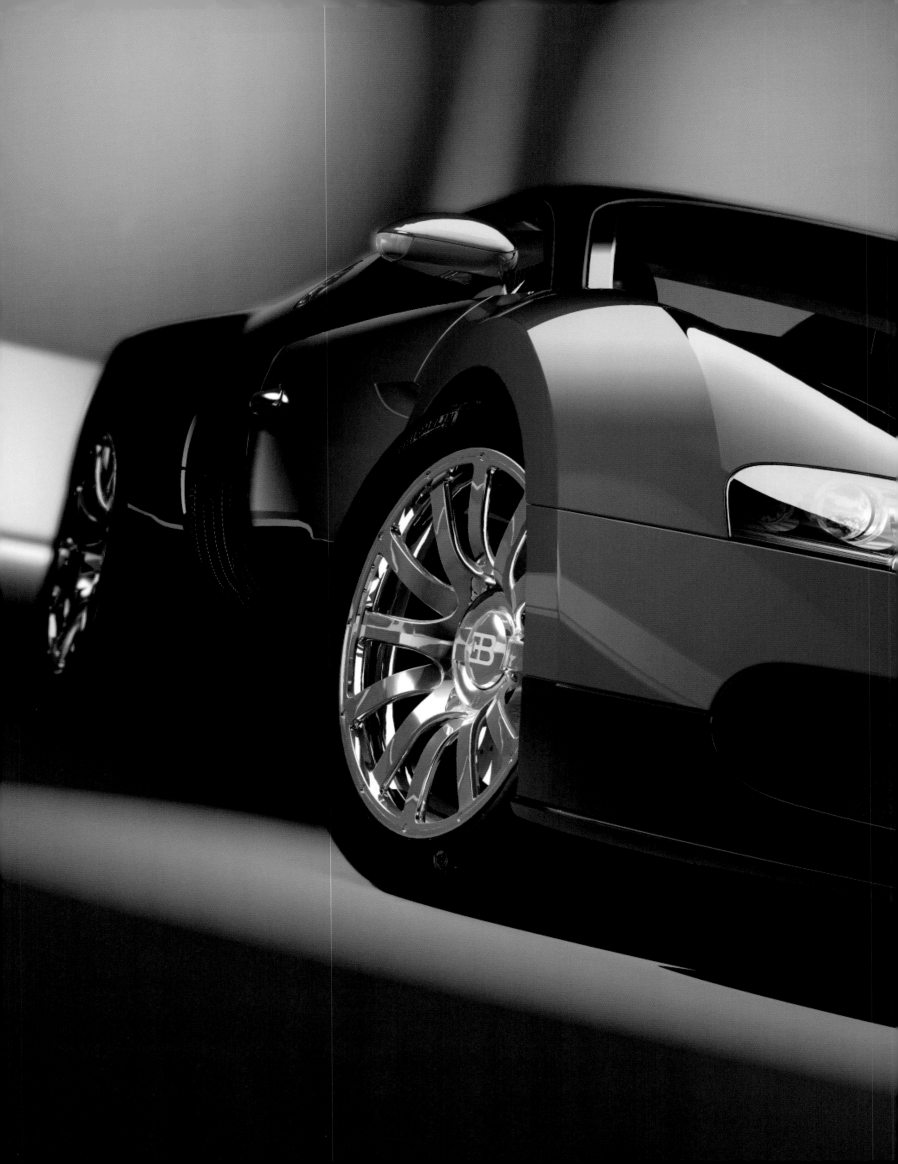

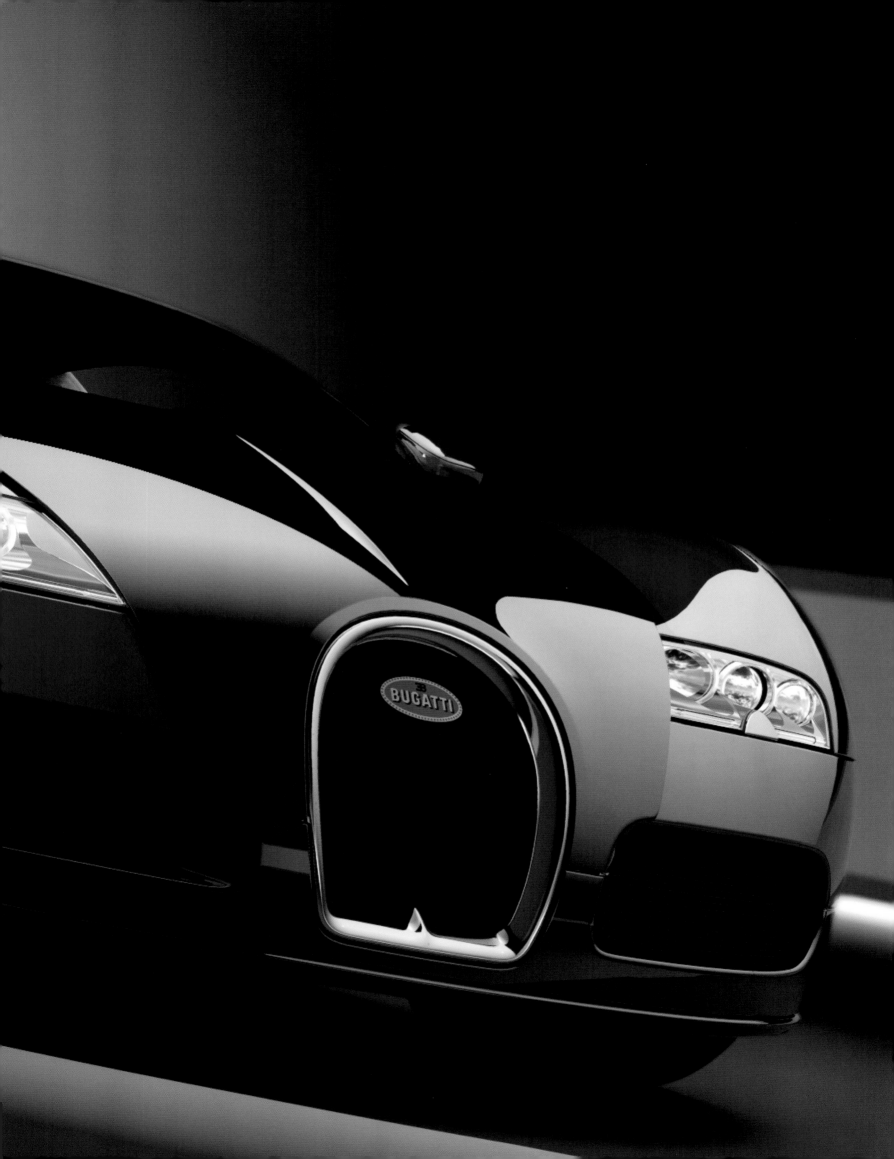

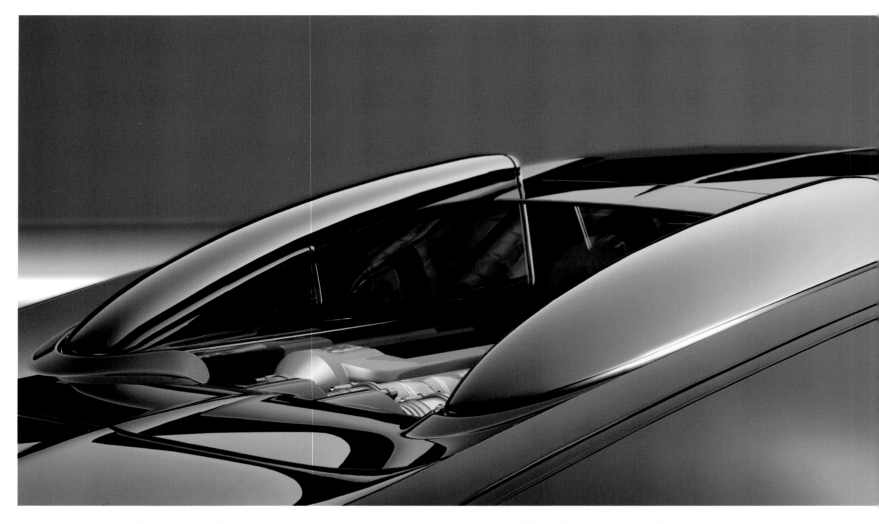

In order to produce effective downforce, the front and rear of the under carriage have a diffuser-like form. In addition, drivetrain performance is enhanced by a rear spoiler that extends automatically.

Um einen effektiven Abtrieb zu erzeugen, ist im Front- und im Heckbereich des Fahrzeuges, der Unterboden diffusorartig geformt. Positiv beeinflusst wird die Abtriebskomponente außerdem durch einen automatisch ausfahrenden Heckspoiler.

Pour parvenir à une portance efficace, le dessous de caisse est irrégulier à l'avant et à l'arrière du véhicule. Un béquet déclenché automatiquement agit positivement sur les coefficients de portance.

Para conseguir una propulsión efectiva, la estructura por debajo de la parte delantera y trasera del vehículo tiene forma difusora. Un alerón trasero desplegable automáticamente incide también positivamente en la propulsión.

Un sistema di diffusione nella zona ventrale aumenta la deportanza nella parte anteriore e posteriore del veicolo. La potenza è ottimizzata anche da uno spoiler posteriore estraibile.

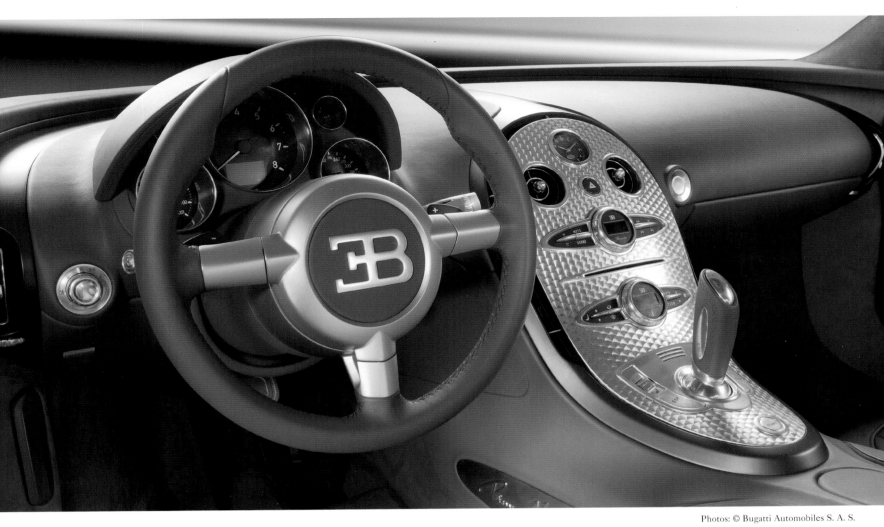

TECHNICAL SPECIFICATIONS

Manufacturer	Bugatti Automobiles S. A. S.
Price	€ 1,000,000
Contact	www.bugatti-cars.com
Engine/cylinders/valves per cylinder	W/16/4
Displacement	7.993 cc
Power output	1001 hp
Top speed	406 km/h
Acceleration 0-100 km/h	3 sec.
Dimensions length, width, height	4,470 mm, 1,990 mm, 1,210 mm
Wheelbase	2,700 mm
Unloaded weight	1,900 kg
Transmission	7-speed, manual
Fuel feed	Direct injection
Fuel consumption city	29.9 l / 100 km/h

Mercedes Benz SLR McLaren

The exciting design of this high performance sportscar was inspired by the legendary 300 SLR Coupe of the 1950s and the current Formula 1 Silver Arrow. The SlR McLaren is hand built by Mercedes' Formula 1 partner McLaren in Woking, England.
The newly developed 5.5 liter V8 supercharged engine delivers output of 626 hp and accelerates the car from 0 to 100 km/h in 3.8 seconds. The top speed is 334 km/h, making the SLR 8-cylinder among the most powerful engines currently available in a series-produced roadgoing sports car.

Das aufregende Design dieses Hochleistungs-Sportwagens wurde durch die SLR-Rennsportwagen aus den fünfziger Jahren und die aktuellen Formel-1-Silberpfeile inspiriert. Der SLR McLaren wird vom Mercedes Formel-1-Partner McLaren im englischen Woking in Handarbeit gebaut.
Der 5,5-Liter-V8-Motor mit Kompressoraufladung leistet 626 PS. In 3,8 Sekunden kommt der Sportwagen auf Tempo 100, bei 334 km/h hat er seine Höchstgeschwindigkeit erreicht. Damit zeichnet sich der SLR durch einen derzeit kraftvollsten Motoren für straßentaugliche Seriensportwagen aus.

Le design fascinant de cette sportive à hautes performances s'inspire en droite ligne de la voiture de course SLR des années cinquante et de l'actuelle formule-1-Flèche d'Argent. La SLR McLaren est fabriquée à la main dans des ateliers anglais à Woking, par McLaren, partenaire de la formule 1 de Mercedes.
Le moteur V8 de 5.5 litres suralimenté peut fournir une puissance de 626 ch. En 3.8 secondes cette voiture de sport monte à 100 pour atteindre une vitesse de pointe de 334 km/h. Equipée d'un des plus puissants moteurs de son temps, la SLR est homologuée comme sportive de série pour la route.

El interesante diseño de este vehículo de gran potencia está inspirado en el deportivo de carreras SLR de los años cincuenta así como en la actual Fórmula 1 Silver Arrow. El SLR McLaren se fabricó manualmente por McLaren, compañero de Fórmula 1 de Mercedes, en Woking, Inglaterra.
El motor de 5.5 litros y 8 válvulas con sobrecarga por compresor genera 626 caballos de potencia. En 3.8 segundos el deportivo alcanza los 100 km/h, llegando incluso a alcanzar una velocidad máxima de 334 km/h. El SLR despunta así gracias a su motor, uno de los más potentes para deportivos de serie de carretera del momento.

Il design eccezionale di questa auto sportiva dalle elevate prestazioni trae ispirazione dalle auto da corsa SLR degli anni cinquanta e dalle attuali "frecce d'argento" della Formula 1. La SLR McLaren viene costruita a mano dalla McLaren, partner della Mercedes nella Formula 1, nella sede inglese di Woking.
Il motore V8 5.5 litri con sovralimentazione con compressore ha una prestazione di 626 CV. L'auto sportiva raggiunge i 100 km/h in 3.8 secondi, mentre la sua velocità massima tocca i 334 km/h. Grazie a queste prestazioni, il motore della SLR si conferma uno dei più potenti del momento per auto sportive di serie da strada.

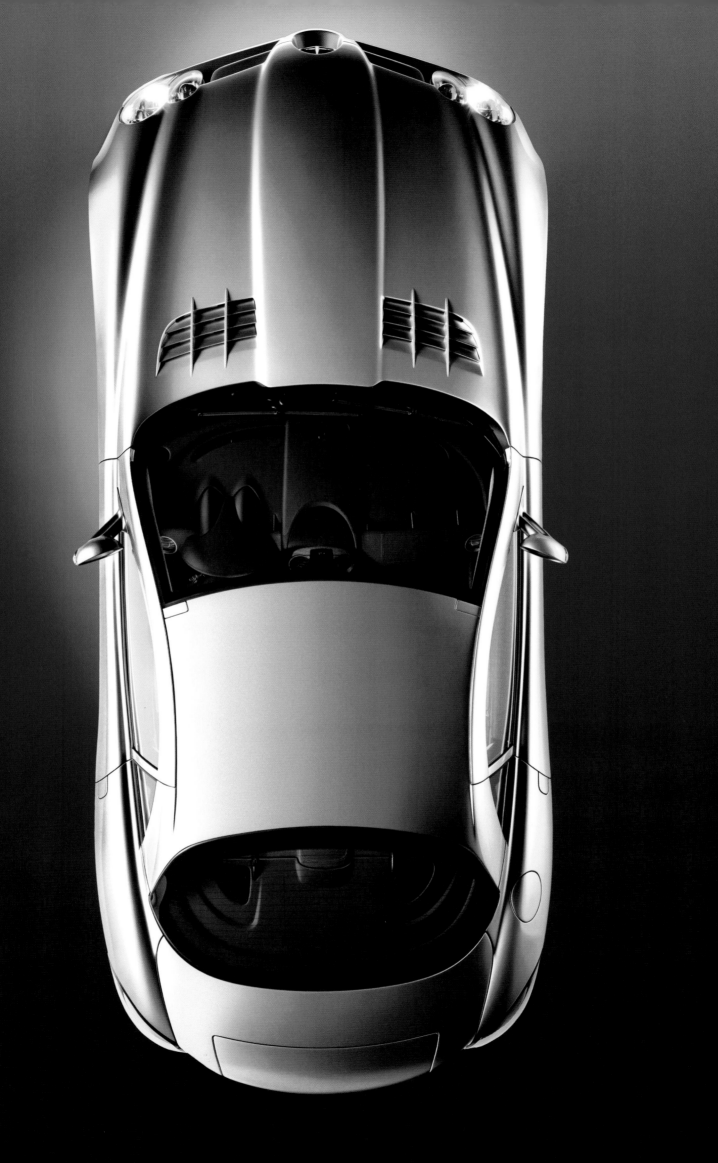

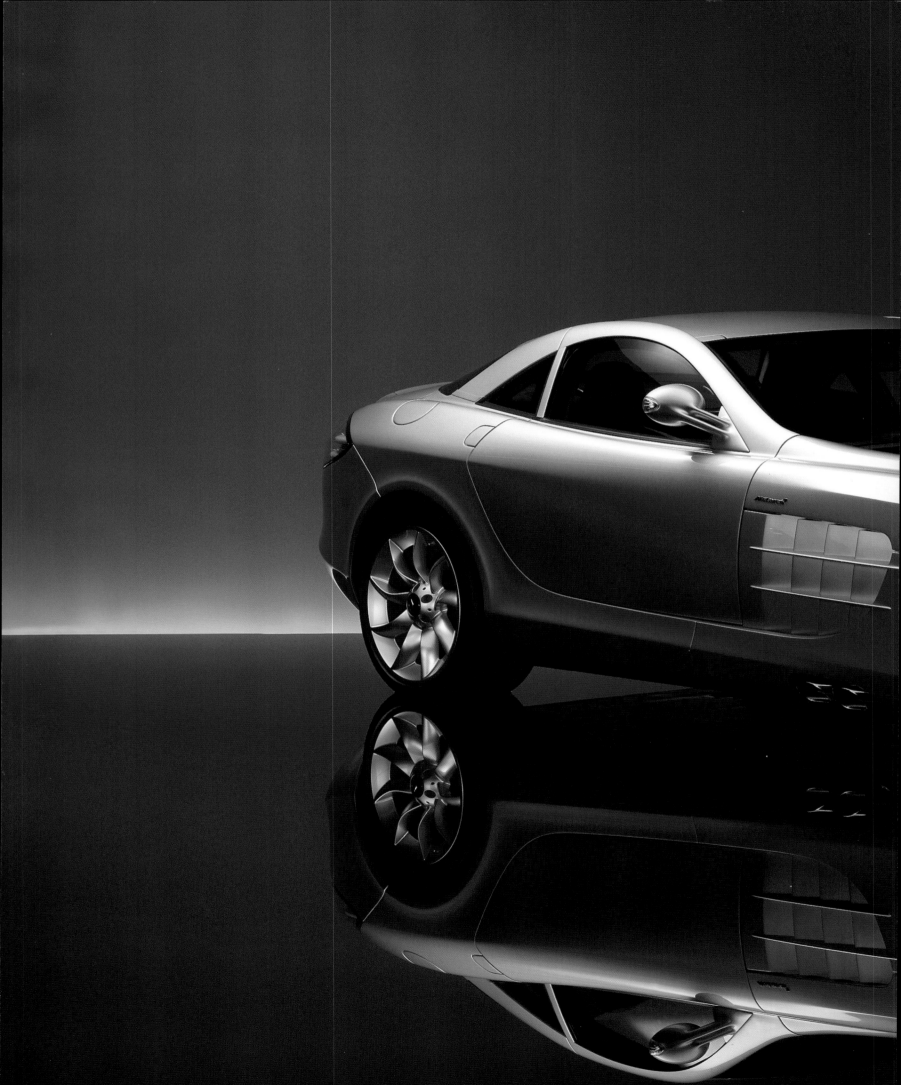

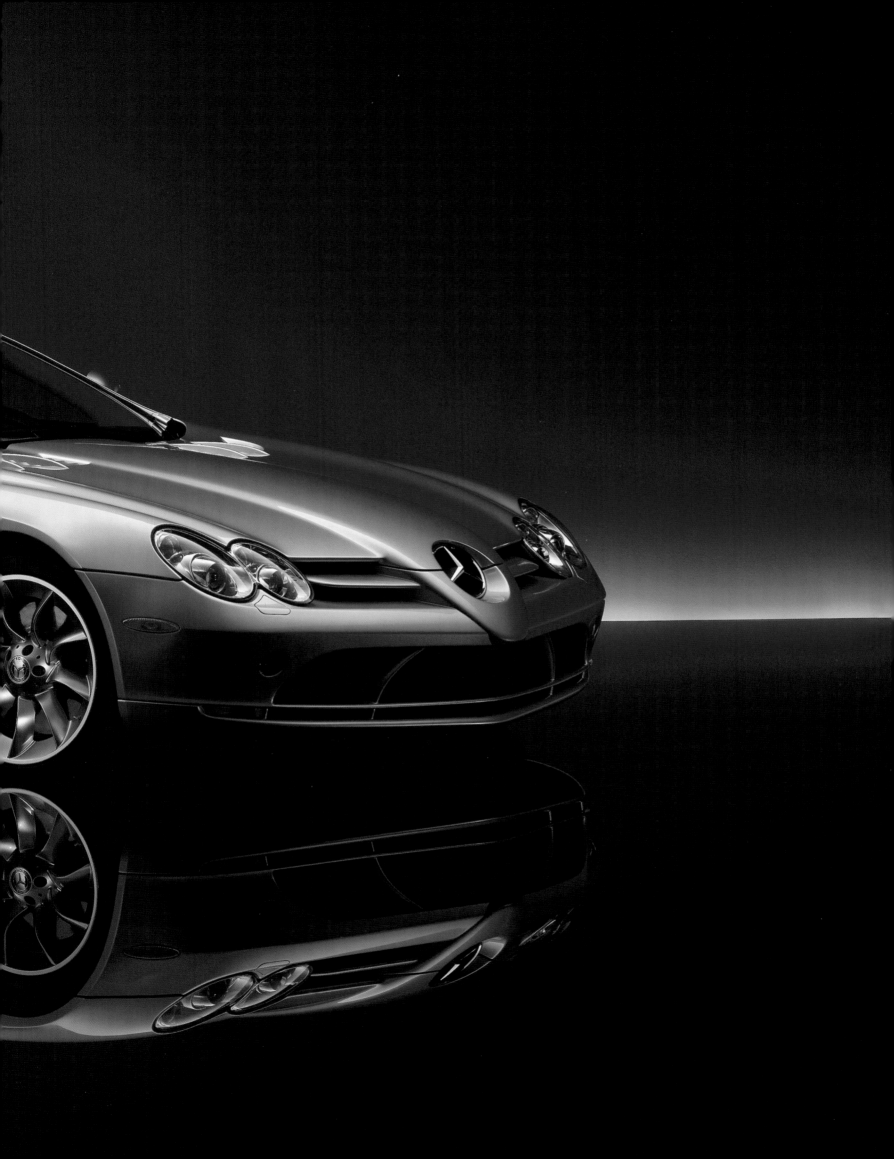

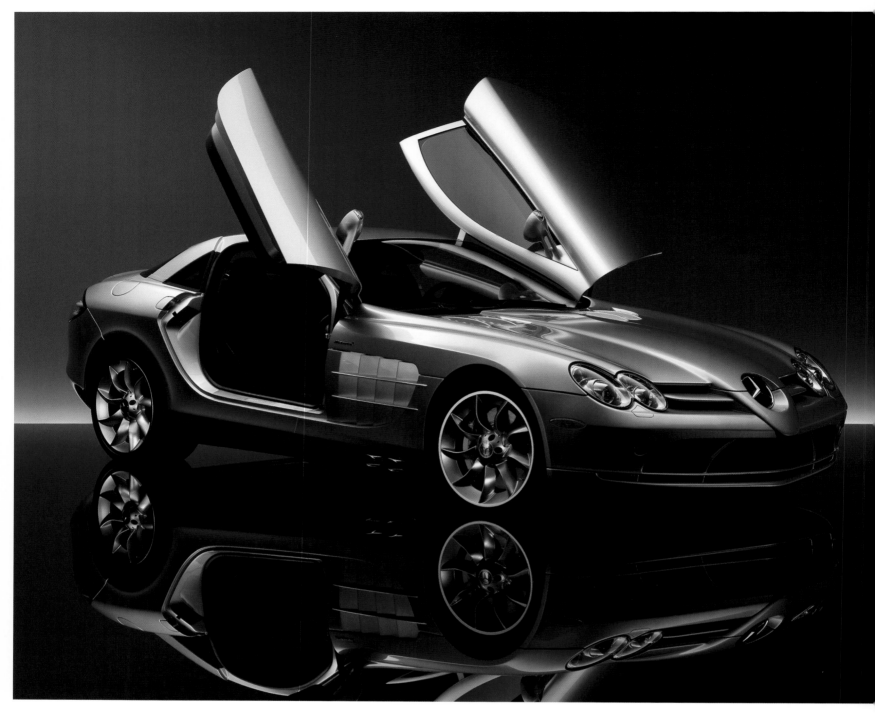

The engine owes its negative lift—or "downforce" as it is termed in Formula 1 circles—to racing car expertise. The SLR McLaren was given an aerodynamic underbody with a special six-channel diffuser under the rear and an adaptive spoiler that automatically extends from the rear of the car and doubles as an airbrake.

Aus dem Rennsport stammt auch das auf Abtrieb – die Formel-1-Fachleute sprechen von „Downforce" – basierende Aerodynamik-Prinzip mit Sechskanal-Diffusor am Unterboden und automatische ausfahrbaren Spoiler im Kofferraumdeckel, der auch als Luftbremse dient.

Les coefficients de portance négatifs proviennent également du concept de la course – les experts de la formule 1 parlent de « Downforce » – principe aérodynamique avec structure à diffuseur tubulaire de six tubes comme châssis et d'un béquet à commande automatique dans le capot du coffre comme aéro-frein.

El principio aerodinámico basado en la propulsión procede de la Fórmula 1 –los expertos lo denominan "downforce"– con una cámara de evacuación de seis canales en los bajos de la estructura del vehículo y un alerón desplegable automáticamente en la puerta del maletero que funciona también como freno aerodinámico.

Dal settore delle gare automobilistiche deriva anche il principio aerodinamico basato sulla presa di forza – i tecnici della Formula 1 lo chiamano "downforce" – con diffusore a sei canali e alettone posteriore estraibile dalla coda, che funge anche da freno aerodinamico.

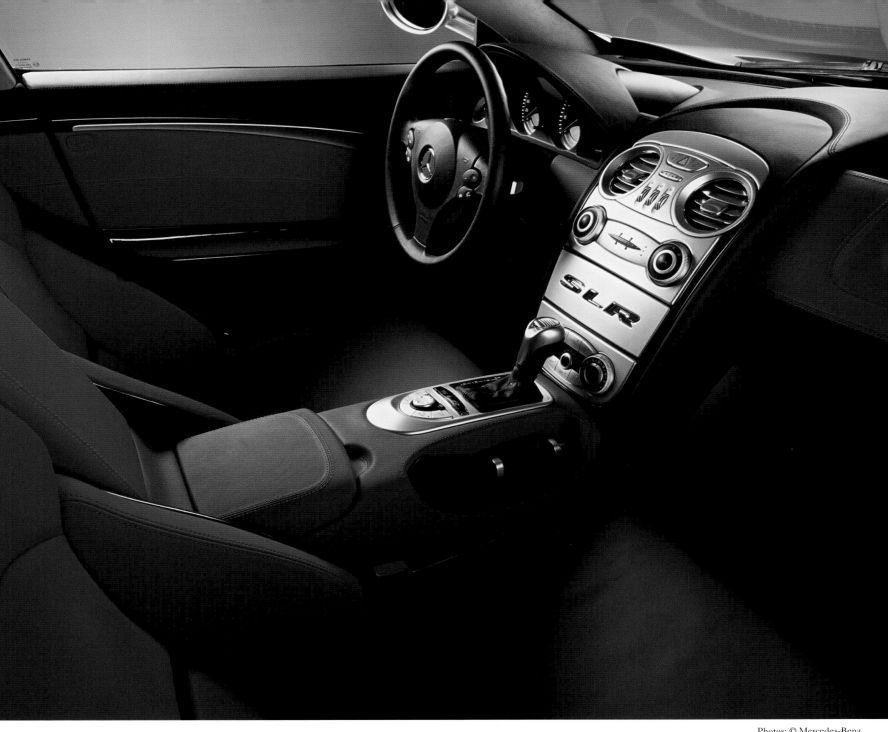

Photos: © Mercedes-Benz

TECHNICAL SPECIFICATIONS

Manufacturer	Mercedes-Benz
Price	$ 360,850 / € 435,000
Contact	www.mercedes-benz.com
Engine /cylinders/valves per cylinder	V/8/3
Displacement	5.439 cc
Power output	626 hp
Top speed	334 km/h
Acceleration 0-100 km/h	3.8 sec.
Dimensions length, width, height	4,656 mm, 1,908 mm, 1,261 mm
Wheelbase	2,700 mm
Unloaded weight	1,768 kg
Transmission	5-speed, manual
Fuel feed	Direct injection
Fuel consumption city	20.9 l / 100 km/h

Porsche Carrera GT

The Carrera GT is the minimalist among supercars. It eschews ESP, supercharging, an adjustable chassis, launch control, shift paddles and all wheel drive, and instead opts for the authentic feel of a race car.
This focus on the essentials is evident in the car's lightweight construction. At only 1,380 kg, the Carerra GT is an ideal featherweight, though the car offers the exceptional stability and balance that you would expect in a race car.

Der Carrera GT ist der Minimalist unter den Supersportwagen. Er verzichtet auf ESP, Aufladung, verstellbares Fahrwerk, Launch Control, Schaltpaddel und Allradantrieb und kultiviert damit den unverfälschten Charakter eines Rennfahrzeuges.
Diese Konzentration auf das Wesentliche macht sich auch im konsequenten Leichtbau bemerkbar. So kommt der Roadster auf ein ideales Leergewicht von 1.380 kg. Genau deswegen vermittelt der Porsche Carrera GT die Stabilität und die Ausgewogenheit, die man von einem reinen Rennsportwagen erwartet.

La Carrera GT est la plus minimaliste des super sportives. Elle renonce à l'ESP, à la suralimentation, au châssis réglable, au Launch Control, au pedale d'embrayage à la traction toutes roues motrices pour cultiver sa réputation de voiture de course.
La concentration sur l'essentiel se fait sentir dans la légèreté de la construction. Le Roadster atteint ainsi le poids idéal à vide de 1 380 kg. Mais la Porsche Carrera GT garde la stabilité et l'équilibre que l'on attend des voitures de course.

El carrera GT es el vehículo minimalista entre los superdeportivos. Prescinde de ESP, sobrealimentación, chasis regulable, control Launch, embrague y tracción a las cuatro ruedad y cultiva, de esta manera, el auténtico carácter del deportivo de carreras.
Esta concentración en lo esencial convierte a este vehículo en una construcción ligera que no excede de 1 380 kg. A pesar de ello, el Porsche Carrera GT transmite la estabilidad y el equilibrio que se espera de un coche de carreras.

La Carrera GT incarna il minimalismo tra le auto sportive di qualità superiore. Rinunciando a ESP, sovralimentazione, autotelaio regolabile, launch control, alette selettrici di marcia e trazione integrale, il veicolo coltiva il carattere autentico di un'auto da corsa.
L'attenzione per l'essenzialità è evidente anche nella costruzione estremamente leggera; la roadster raggiunge infatti il peso ideale a vuoto di 1 380 kg. Ciò nonostante, la Porsche Carrera GT garantisce la stabilità e l'equilibrio fondamentali per un'auto da corsa senza compromessi.

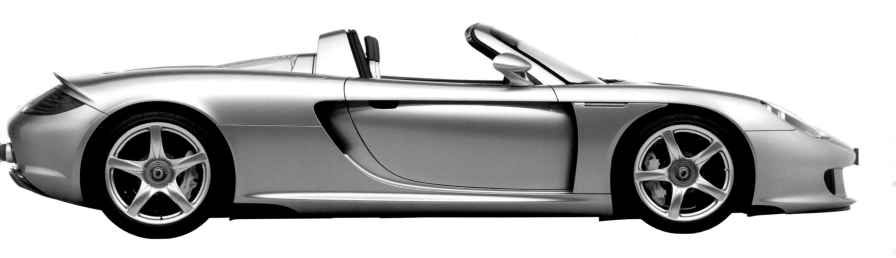

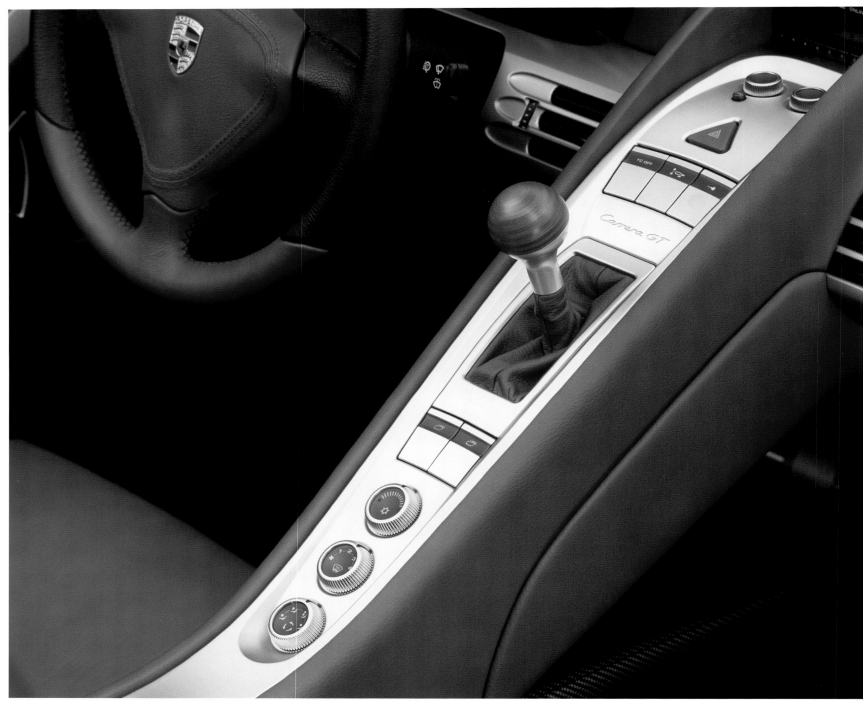

Photos: © Porsche

TECHNICAL SPECIFICATIONS

Manufacturer	Porsche
Price	$ 375,525 / € 452,690
Contact	www.porsche.com
Engine/cylinders/valves per cylinder	V/10/4
Displacement	5.733 cc
Power output	612 hp
Top speed	330 km/h
Acceleration 0-100 km/h	3.9 sec.
Dimensions length, width, height	4,613 mm, 1,921 mm, 1,166 mm
Wheelbase	2,730 mm
Unloaded weight	1,380 kg
Transmission	6-speed, manual
Fuel feed	Port injection
Fuel consumption city	17.8 l / 100 km/h

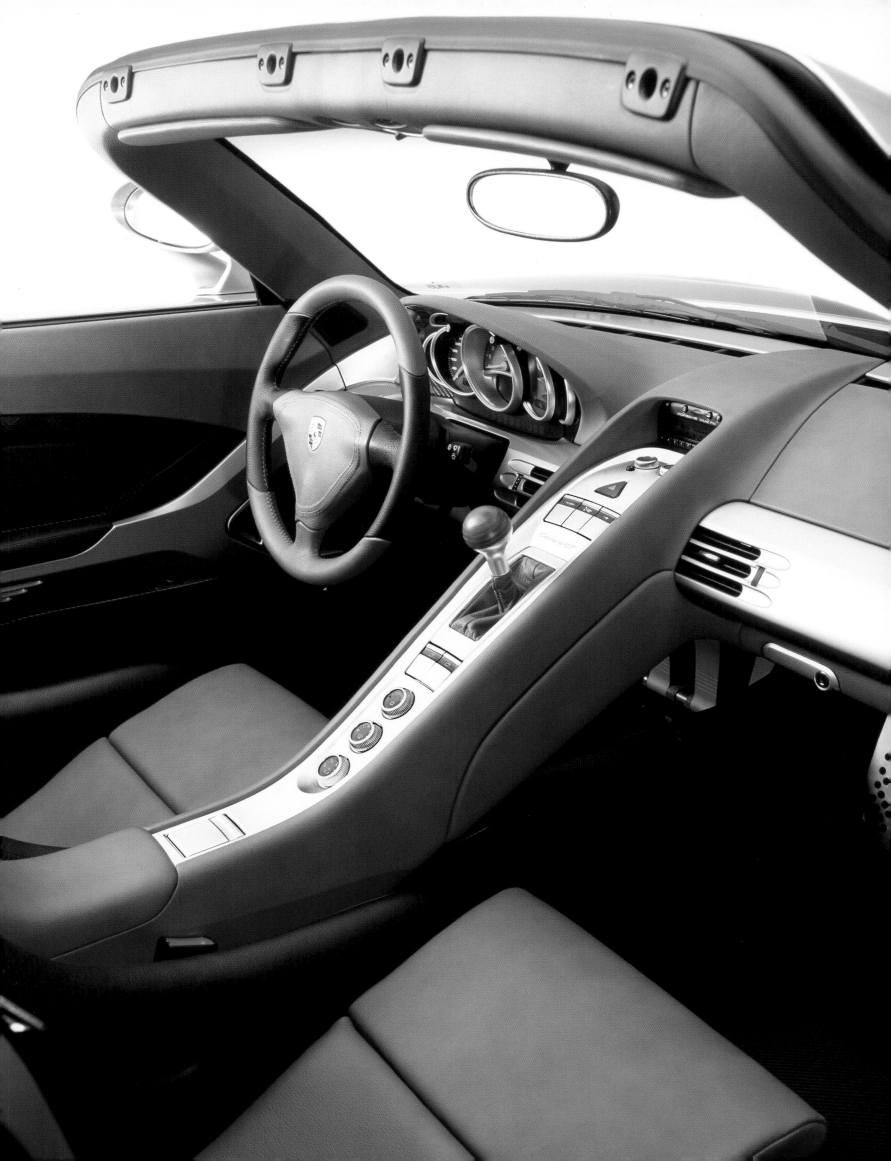

Lamborghini Murciélago Roadster

The new Lamborghini Murciélago's angular edges, air vents and posts lend this aggressively designed roadster an exclusive character.
Though the car's technology is based on that of the Murciélago Coupé, it differs from its forerunner in several key respects. The newly designed steel and carbon fiber components of the chassis, the latter's torsional stiffness, and the engine compartment's tubular frame lend the car additional stability.

Scharf geschnittene Kanten, Belüftungsöffnungen und Stege geben dem neuen Murciélago Roadster einen aggressiven und exklusiven Charakter.
Die Technik basiert auf dem Murciélago Coupé, unterscheidet sich aber in einigen wichtigen Details. So verbessern neu konzipierte Rahmenstrukturteile aus Stahl und Kohlefaser die Torsionssteifigkeit und ein Rohrrahmen im Motorraum liefert zusätzliche Stabilität.

Lignes franches et pures, ouies d'aérations et aileron confèrent à la Murciélago Roadster une stylistique agressive et exclusive qui la caractérise.
Les éléments techniques basés sur ceux du Coupé Murciélago, se différencient toutefois sur quelques points importants. Une nouvelle conception de structure renforcée en acier et fibres de carbone, améliore la rigidité du châssis. Une structure tubulaire autour du moteur confère une stabilité accrue.

Aristas de corte afilado, aberturas de ventilación y alerones confieren al nuevo Roadster murciélago un exclusivo y agresivo carácter.
Su técnica se basa en el Murciélago Coupé, pero con algunas diferencias importantes. La nueva concepción de las piezas del chasis en acero y fibra de carbono mejoran la rigidez en la de torsión, y un marco tubular en la zona del motor dota de estabilidad adicional.

Angoli vivi, aperture d'aerazione e listelli divisori conferiscono alla nuova Murciélago Roadster un carattere esclusivo ed aggressivo.
La tecnica costruttiva si ispira fortemente alla Murciélago Coupé, anche se alcuni importanti dettagli si differenziano dal modello originario. Nuove parti del telaio in acciaio e fibre di carbonio migliorano la resistenza a torsione e un telaio tubolare nel vano motore conferisce maggiore stabilità.

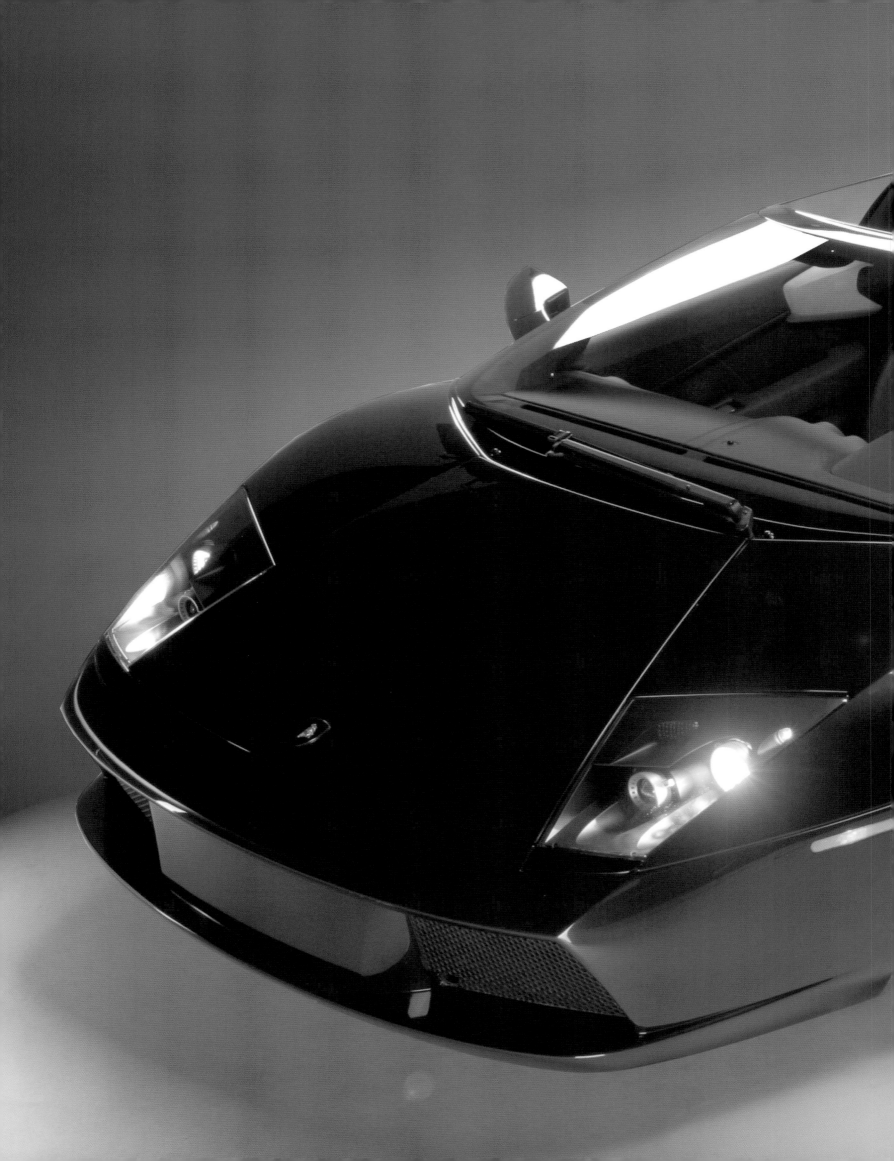

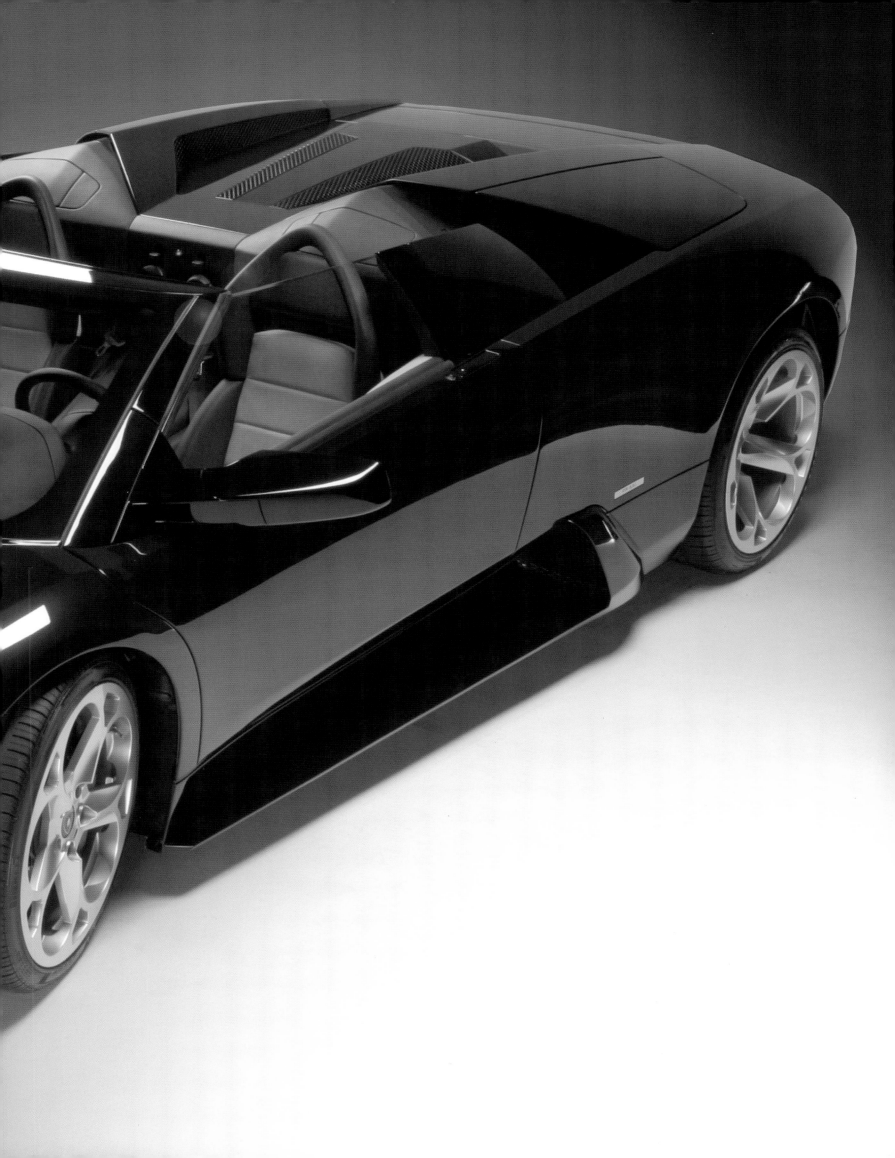

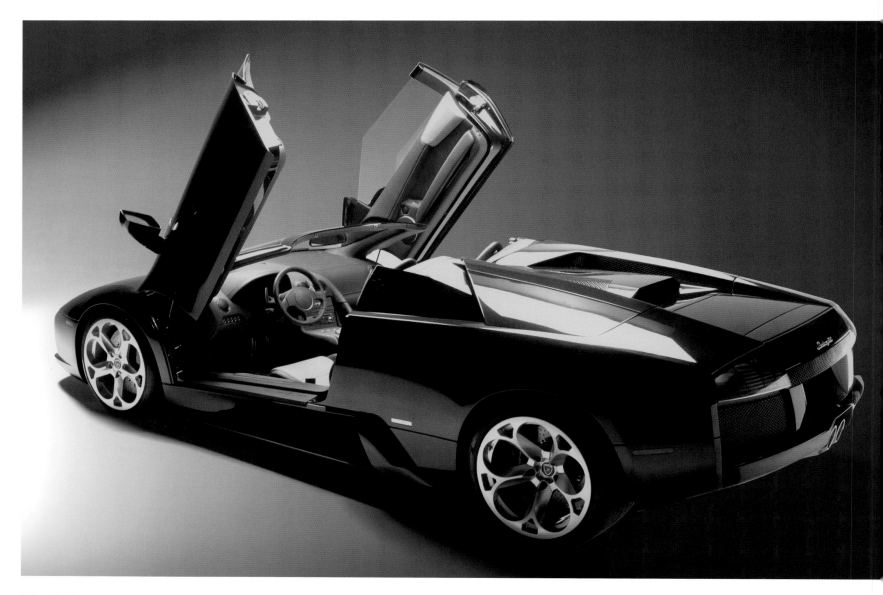

The designers went to great lengths to integrate state of the art driver safety features. For example, the Murciélago Roadster is outfitted with automatically extendable rollover bars. If the bars' controller detects a constellation of parameters indicating an imminent collision, the rollover bars extend from under the seats within a matter of milliseconds.

Besondere Sorgfalt wurde auf die Sicherheit des Fahrers gelegt. Der Murciélago Roadster verfügt über automatisch ausfahrenden Überrollbügel. Erkennt deren elektronische Steuerung eine entsprechend definierte Konstellation, schnellen die Überrollbügel innerhalb weniger Millisekunden hinter den Sitzen heraus.

Le plus grand soin a été apporté à la sécurité du conducteur. La Roadster Murciélago dispose d'un arceau de sécurité ou aileron qui se règle automatiquement par un système électronique qui déclenche en quelques millièmes de secondes la sortie de l'aileron derrière les sièges, selon des critères définis.

La seguridad del conductor ha cobrado gran importancia en el diseño de este coche. El Murciélago Roadster dispone de un arco de seguridad que se despliega automáticamente: si su sistema electrónico registra unas condiciones determinadas, los arcos de seguridad ocultos tras los asientos aparecen en pocos milésimas de segundo.

Durante la costruzione, si è dedicata molta attenzione alla sicurezza del veicolo. La Murciélago Roadster dispone infatti di barre di sicurezza automatiche: se il controllo elettronico riconosce delle particolari condizioni, le barre fuoriescono da dietro i sedili in pochi millisecondi.

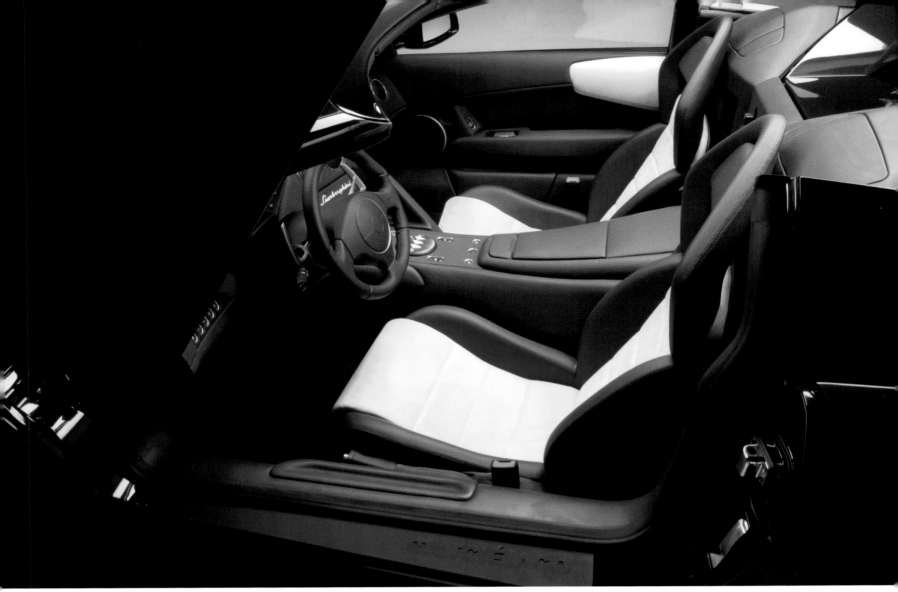

Photos: © Lamborghini

TECHNICAL SPECIFICATIONS

Manufacturer	Lamborghini
Price	€ 223,880
Contact	www.lamborghini.com
Engine /cylinders/valves per cylinder	V/12/4
Displacement	6.192 cc
Power output	580 hp
Top speed	330 km/h
Acceleration 0-100 km/h	3.8 sec.
Dimensions length, width, height	4,580 mm, 2,045 mm, 1,135 mm
Wheelbase	2,665 mm
Unloaded weight	1,652 kg
Transmission	6-speed, manual
Fuel feed	Multipoint sequential fuel injection
Fuel consumption city	31.3 l / 100 km/h

Ferrari Enzo

This new Ferrari sports car is named after the company's founder, Enzo Anselmo Ferrari, who died on August, 14th in 1988. This successor to the legendary F 50 is destined for an extremely select clientele, since only 349 examples are slated to roll off the company's Italian production line. The Ferrari Enzo has carbon fiber body panels, a Fomula 1-style suspension and doors that hinge upwards and forwards at the push of a button.

Zu Ehren des am 14.8.1988 verstorbenen Gründers Enzo Anselmo Ferrari wurde der neue Sportwagen dieser Edelmarke ganz kurz und knapp Enzo getauft. Der Nachfolger des legendären F 50 soll allerdings nur bestimmten Käuferschichten vorbehalten sein. So werden voraussichtlich genau 349 Enzos das Werksgelände in Italien verlassen. Der Ferrari Enzo ist ausgestattet mit einer Karbonfaserhaut, Formel 1- ähnlichen Radaufhängungen und Flügeltüren, die per Knopfdruck nach vorne geschwenkt werden.

C'est en hommage au créateur de la marque, Enzo Anselmo Ferrari, décédé le 14/08/1988, que la nouvelle sportive de cette noble marque a été baptisée Enzo. Successeur de la légendaire F 50, ce bolide restera réservé à une certaine couche d'acheteurs. Seuls 349 exemplaires de l'Enzo sortiront des ateliers italiens. La Ferrari Enzo est équipée d'une carrosserie en fibres de carbone, d'une suspension de roues comme pour la formule 1 et de portes en élytres, qui par simple pression sur un bouton basculent vers l'avant.

El nuevo deportivo de esta noble marca fue bautizado simplemente con el nombre de Enzo en honor al fundador de la firma, Enzo Anselmo Ferrari, fallecido el 14 de agosto de 1988. El sucesor del legendario F 50 se reserva a un grupo determinado de compradores. Con esta intención sólo un número limitado de Enzos, en concreto 349, saldrá de las plantas de producción italianas. El Ferrari Enzo está equipado con piel en fibra de carbono, suspensión en las ruedas similar a los vehículos de Fórmula 1 y puertas plegables que pivotan hacia adelante accionando un botón.

In memoria del fondatore Enzo Anselmo Ferrari morto il 14.08.1988, la nuova auto sportiva di questo nobile marchio è stata battezzata semplicemente Enzo. Il successore della leggendaria F 50 è stato destinato però a precisi gruppi di acquirenti. Per questo motivo, soltanto 349 Enzo usciranno dagli stabilimenti dell'azienda italiana. La Ferrari Enzo è provvista di un rivestimento in fibra di carbonio, sospensioni simili a quelle per la Formula 1 e portiere ad ali di gabbiano, che possono scivolare in avanti premendo un pulsante.

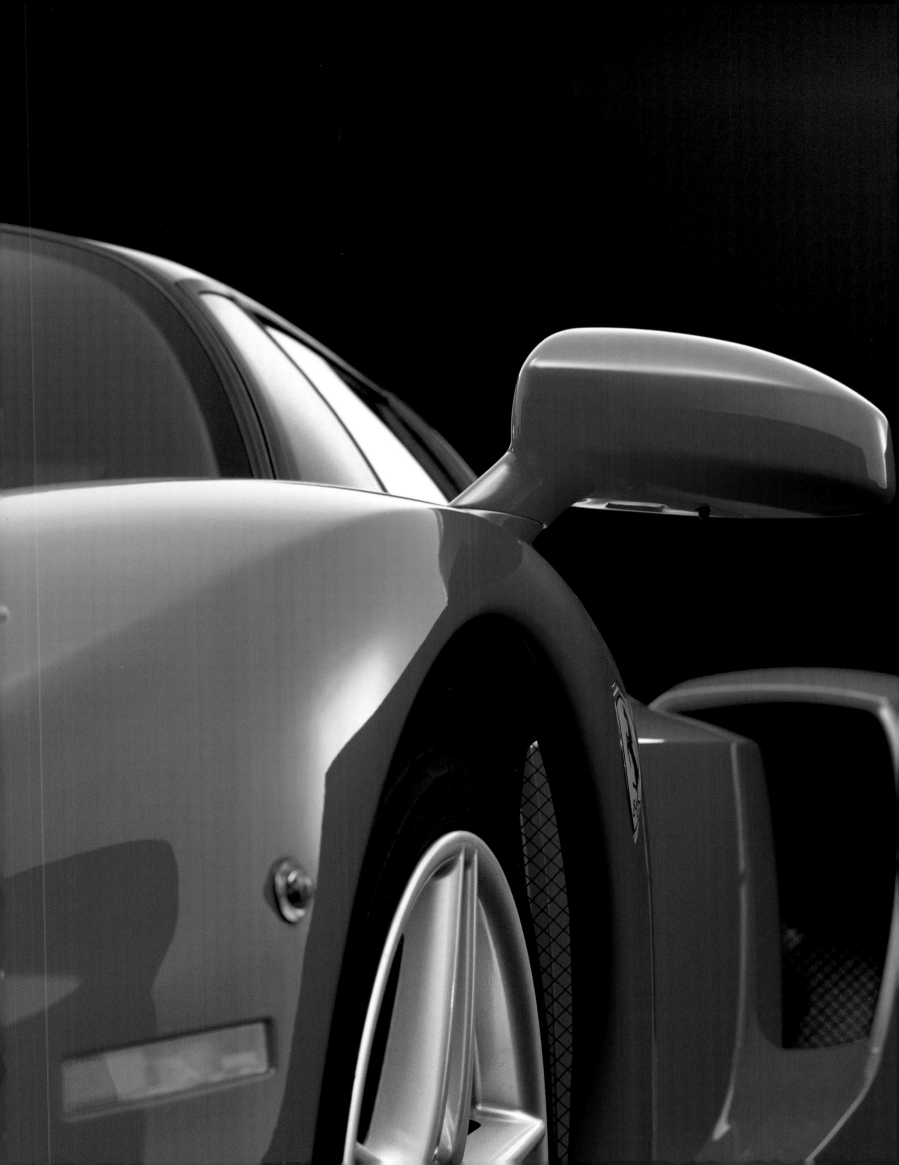

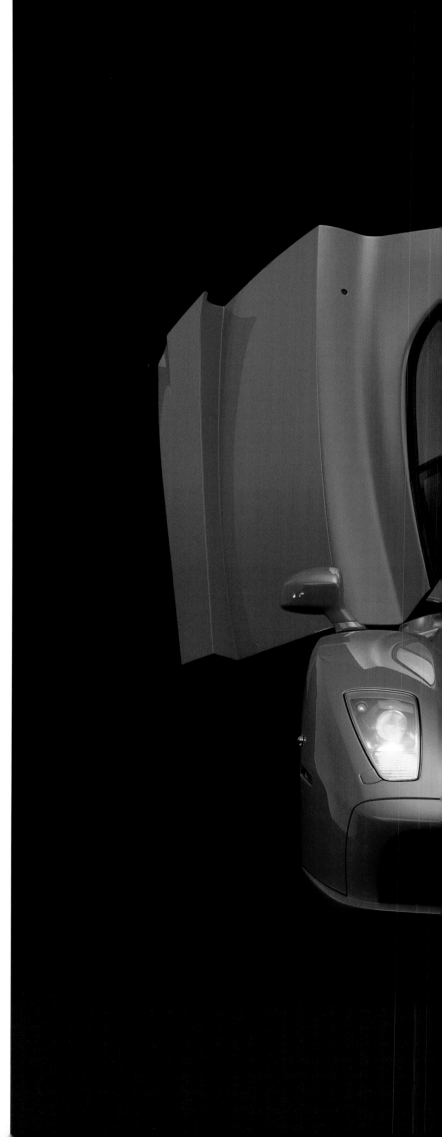

The Enzo's cabin eschews unnecessary luxury. There's just enough room for the steering wheel which has a built in blinker, gear shift and tachometer. This is one car in which you definitely won't find a joystick.

Im Innenraum verzichtet Ferrari auf unnötigen Luxus. Es gibt gerade einmal Platz für das Lenkrad, in dem Blinker und Schaltung sowie ein Drehzahlmesser untergebracht sind. Einen Schaltknüppel wird man in diesem Wagen vergeblich suchen.

Dans l'habitacle, Ferrari supprime tout luxe inutile. Il y a tout juste assez de place pour le volant. En effet, clignotant, changement de vitesse et tachymètre sont en dessous. Inutile de chercher des levier de vitesse dans ce véhicule, vous n'en trouverez pas.

En el interior, Ferrari renuncia a los lujos innecesarios. El espacio es el adecuado para el volante, bajo el cual se sitúan intermitentes y cambio de marchas así como un cuentarrevoluciones. Este coche no dispone de palanca de cambios.

Nell'abitacolo, la Ferrari rinuncia al lusso superfluo. C'è giusto lo spazio per il volante in cui sono inseriti gli indicatori di direzione, il cambio e il contagiri. Invano si cercherà una cloche in questa macchina.

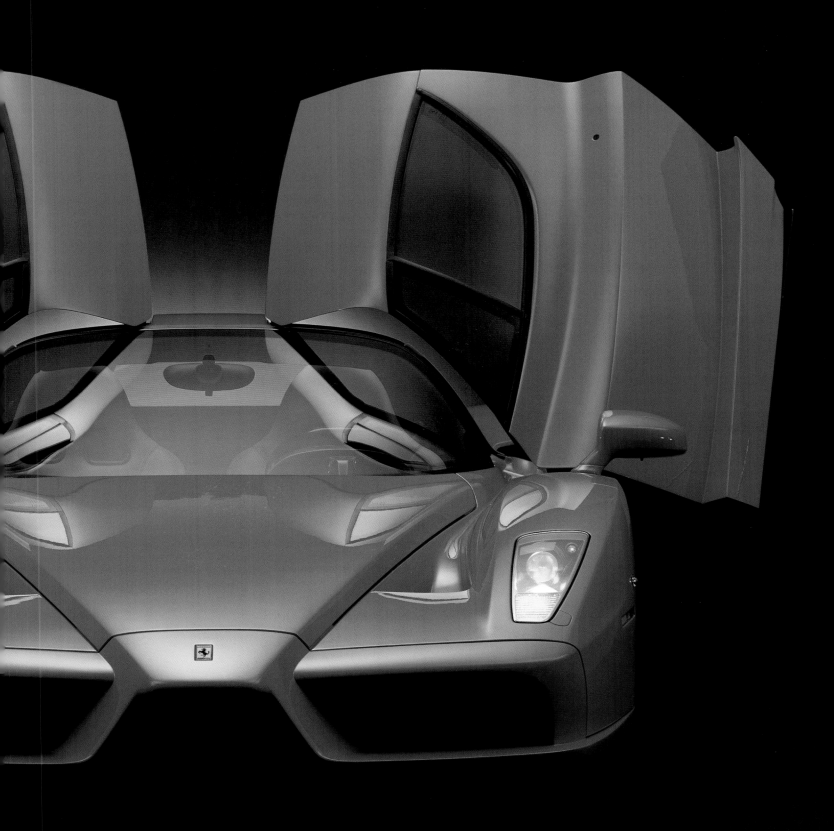

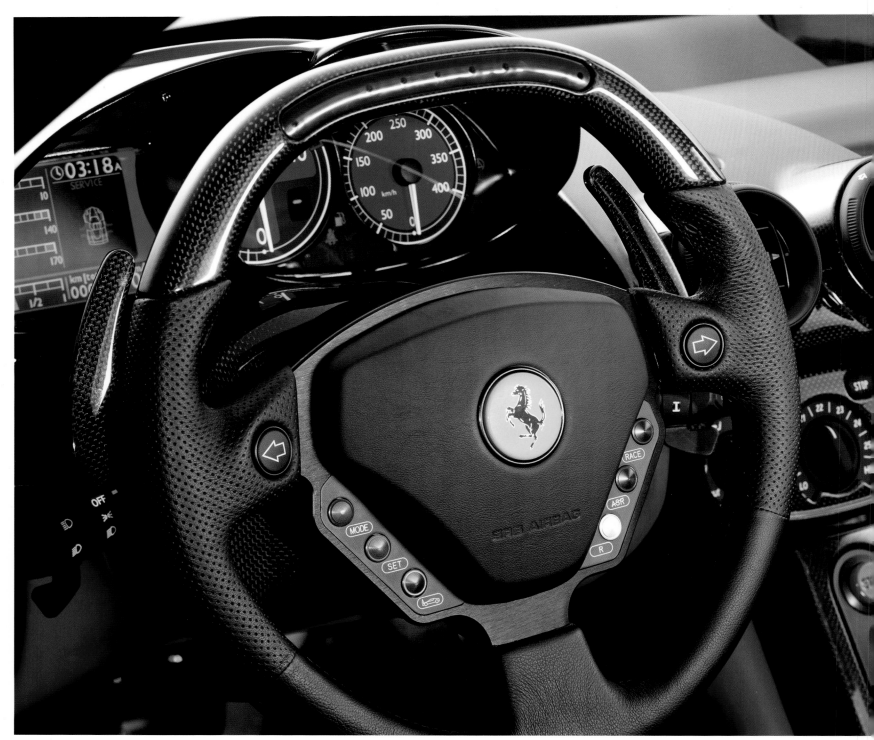

Photos: © Ferrari

TECHNICAL SPECIFICATIONS

Manufacturer	Ferrari
Price	€ 645,000
Contact	www.ferrariworld.com
Engine /cylinders/valves per cylinder	V/12/4
Displacement	5.998 cc
Power output	660 hp
Top speed	350 km/h
Acceleration 0-100 km/h	3.65 sec.
Dimensions length, width, height	4,702 mm, 2,035 mm, 1,147 mm
Wheelbase	2,650 mm
Unloaded weight	1,365 kg
Transmission	6-speed, manual
Fuel feed	Bosch Motronic ME7 fuel injection
Fuel consumption city	30.6 l / 100 km/h

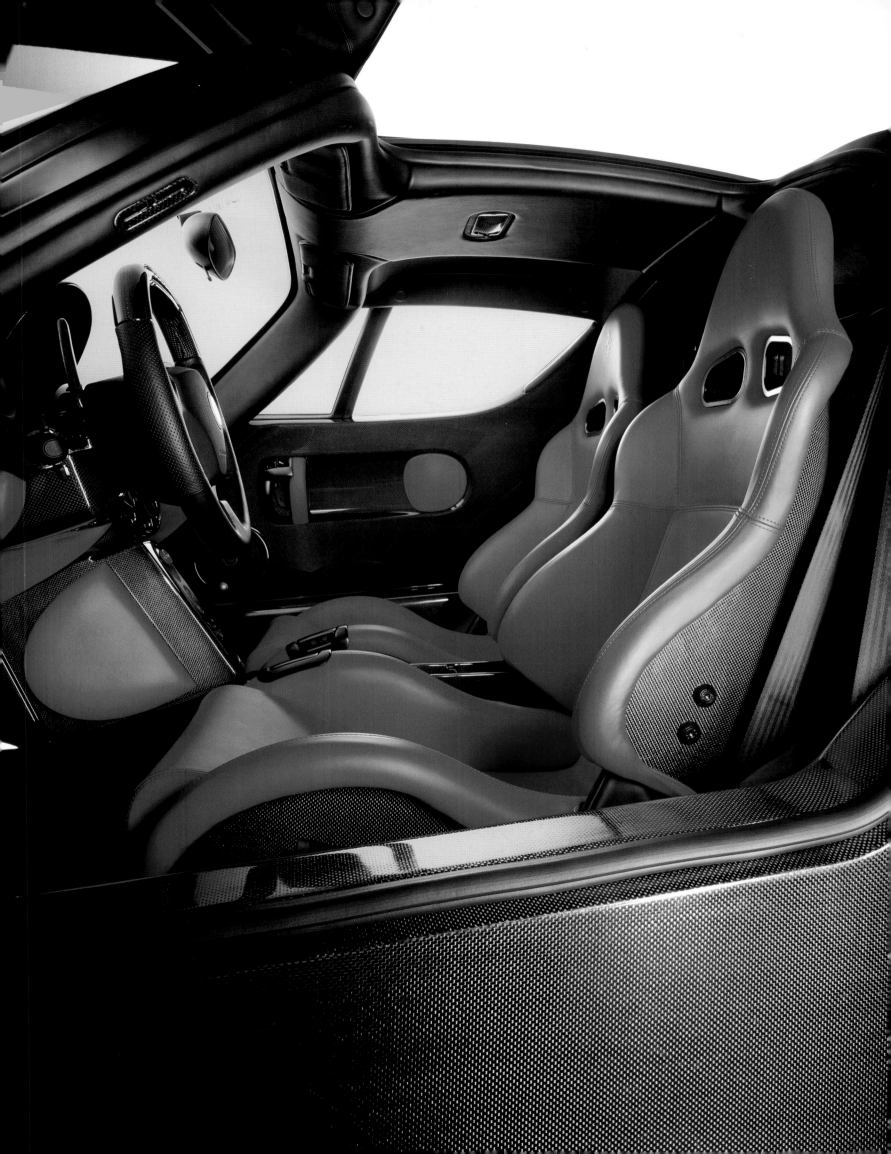

Jaguar XKR

Jaguar's new XKR convertible is a complete technical makeover of its previous version. Timeless though the design of Jaguar sports cars may be, the numerous improvements in the XKR—about 900 components were revamped—provide weighty evidence of the technical advances that have been integrated into the new model.
Thanks to the XKR's powerful, and super-charged 4.2-liter V8 engine, it has got plenty of output to spare, reaching an impressive figure of 400-horsepower.

Der neue XKR von Jaguar stellt eine technisch grundlegend überarbeitete Version seines Vorgängermodells dar. Mag der optische Reiz des sportlichen Jaguars zeitlos sein, so belegen die umfangreichen Verbesserungen – etwa 900 Bauteile wurden erneuert – eindrucksvoll die technische Weiterentwicklung.
Dank des leistungsstarken mit 4,2 Litern aufgeladenen V8-Motors kann der XKR aus üppigeren Leistungsreserven schöpfen und erreicht eine maximale Leistung von 400 PS.

Avec le nouveau Cabriolet XKR, Jaguar présente une version retravaillée, sur le plan technique, du modèle antérieur. Tout en gardant ses lignes éternellement fascinantes de voiture de sport, la Jaguar fortement améliorée par la rénovation de 900 pièces, est aussi au rendez-vous de la technique de pointe.
Grâce à un moteur V8 de 4.2 litres suralimenté, l'XKR peut puiser dans des réserves plus importantes qui atteint l'impressionnante chiffre de 400 CV.

El nuevo Jaguar XKR representa básicamente una generación técnicamente mejorada de su anterior versión. Incluso cuando el encanto óptico del Jaguar deportivo no pasa de moda, las numerosas mejoras –alrededor de 900 piezas de construcción han sido renovadas– atestiguan un impresionante desarrollo técnico.
Gracias a un eficaz motor V8 de 4.2 litros sobrealimentado, el XKR dispone de reservas de potencia más elevada que alcanzan los 400 caballos de potencia.

Il nuovo XKR di Jaguar rappresenta la nuova generazione, tecnicamente rielaborata, della sua anteriore versione. Anche se la magia estetica della Jaguar sportiva resta immutata, le numerose migliorie – sono stati modificati circa 900 pezzi costruttivi – contribuiscono in modo stupefacente al progresso tecnico del veicolo.
Grazie ad un motore V8 di 4.2 litri sovralimentatto, il XKR disporre di maggiore riserve di potenza raggiungendo l'impresionante cifra di 400 cavalli di potenza.

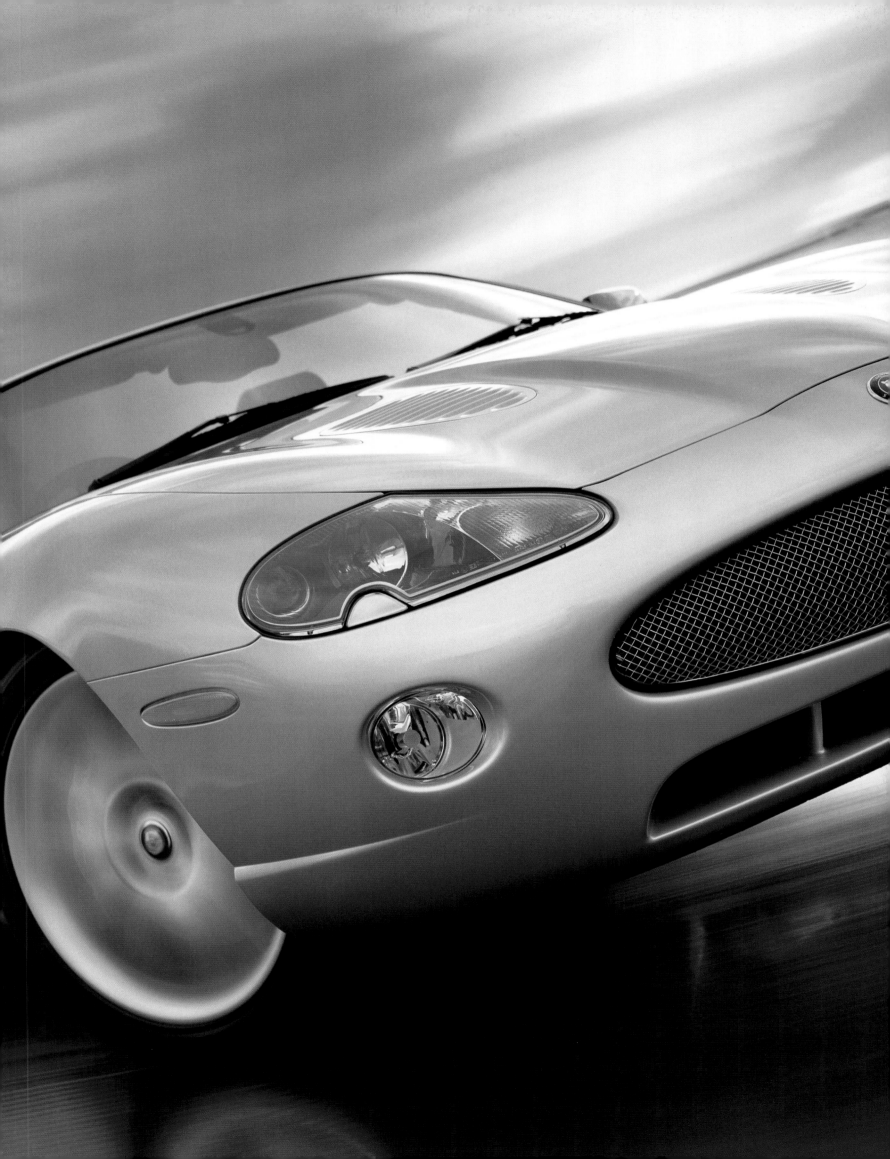

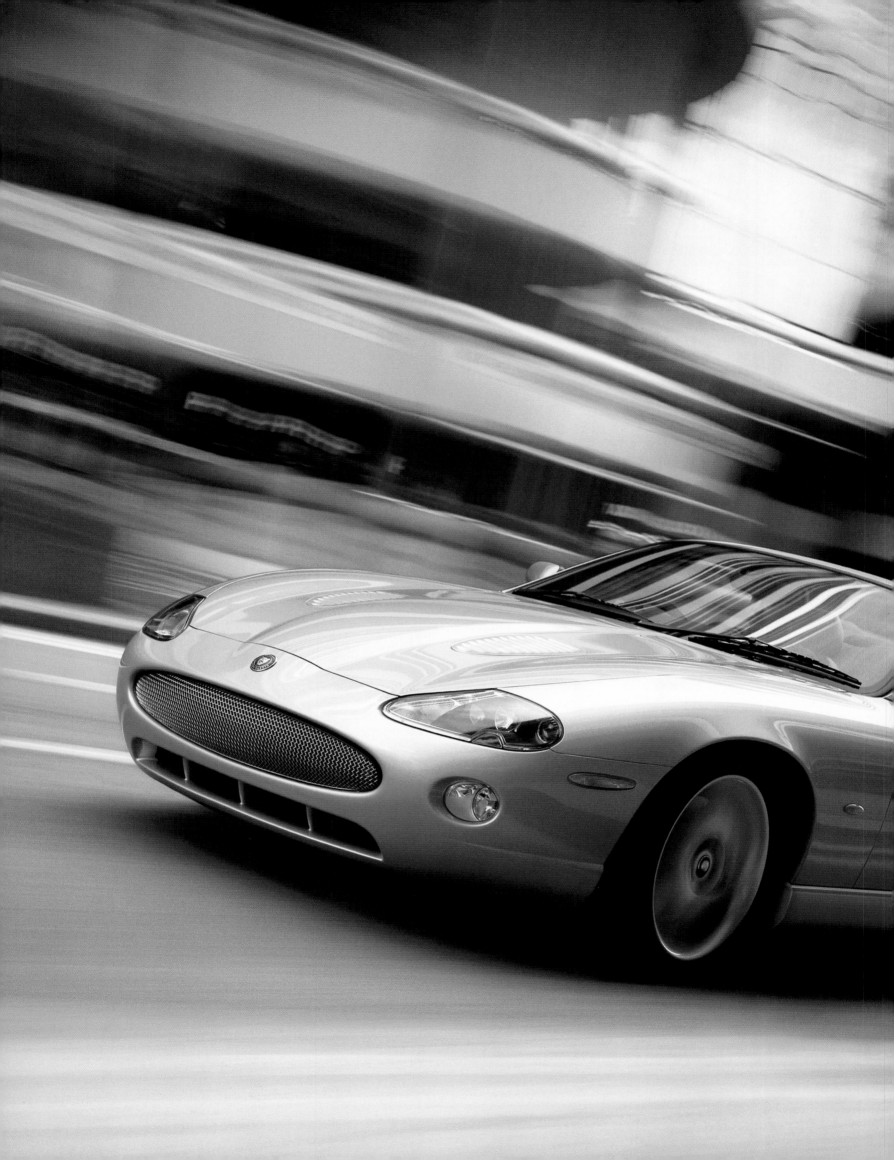

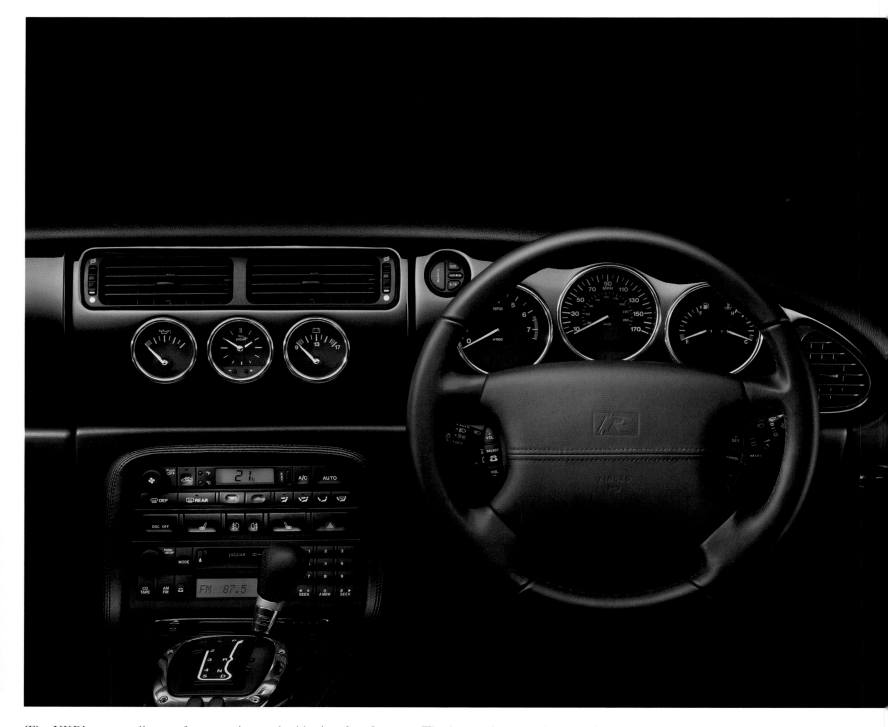

The XKR's outstanding performance is matched by it safety features. The innovative adaptive restraint system uses ultrasound sensors and a weight sensor to determine whether the passenger seat is occupied, how much the passenger weighs and their position in the seat at any time. On the basis of this information, the system then determines how much air the airbag needs in order to protect the passenger from the impact of a frontal collision.

Neben der Leistung, ist die Sicherheit einer der Hauptcharakterzüge des XKR. Das innovative Adaptive Rückhaltesystem misst mit Hilfe von Ultraschallsensoren und einem Gewichtssensor, ob der Beifahrersitz belegt ist, welche Position der Beifahrer gerade einnimmt und wie groß die betreffende Person ist. Anhand dieser Informationen errechnet das System, wie stark der Airbag aufgeblasen werden muss, um den Passagier bei einem Frontalaufprall optimal zu schützen.

Aux performances s'ajoute la sécurité, une des caractéristiques essentielles de la XKR. Un dispositif de sécurité modulable mesure à l'aide d'un détecteur à ultra-sons et d'un détecteur de poids, si le siège est occupé par un passager, sa position et son poids. Munis de ces informations, le dispositif calcule le volume de l'Airbag pour mieux protéger le passager en cas de choc frontal.

Junto a la potencia, la seguridad es uno de los rasgos característicos del XKR. El innovador sistema activo de retención mide con la ayuda de sensores de ultrasonido y un sensor de peso, si el asiento del copiloto está ocupado, en qué posición se encuentra el ocupante así como su estatura. Con esta información el sistema calcula con qué potencia debe ser hinchado el airbag para proteger de la mejor forma al pasajero en caso de una colisión frontal.

Oltre alle prestazioni, la sicurezza rimane una delle caratteristiche peculiari della XKR. L'innovativo sistema di ritenuta adattivo rileva con l'aiuto di sensori a ultrasuoni e sensori per il peso se il sedile del passeggero è occupato, in quale posizione si trova il passeggero e quanto è alto. Alla luce di queste informazioni, il sistema calcola con quale intensità gonfiare l'airbag per proteggere il passeggero in modo ottimale in caso di scontro frontale.

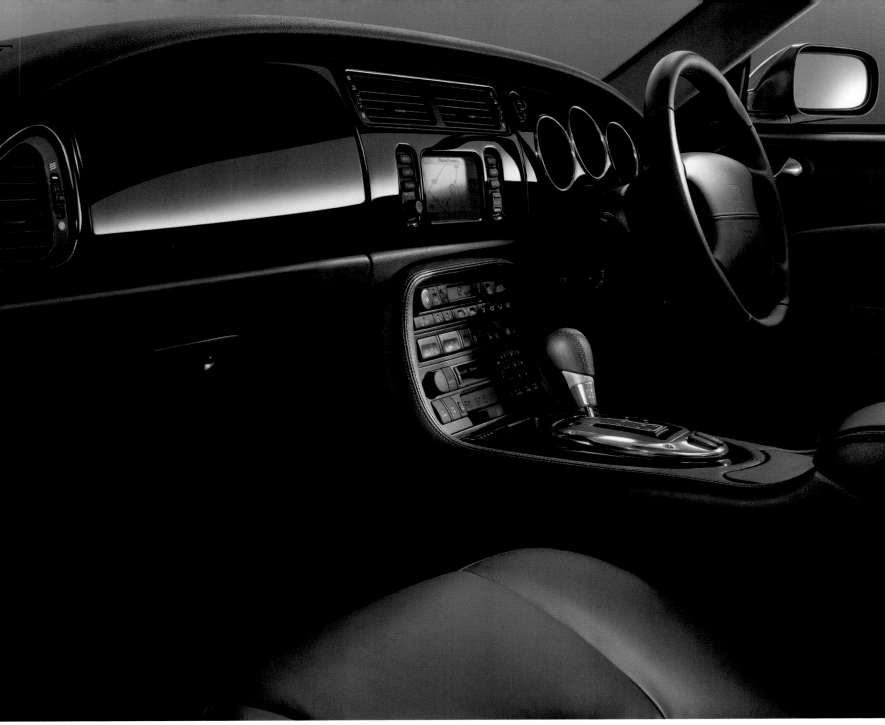

TECHNICAL SPECIFICATIONS

Manufacturer	Jaguar Cars
Price	€ 97,200
Contact	www.jaguar.com
Engine/cylinders/valves per cylinder	V/8/4
Displacement	4.196 cc
Power output	400 hp
Top speed	250 km/h limited
Acceleration 0-100 km/h	5.4 sec.
Dimensions length, width, height	4,760 mm, 1,829 mm, 1,306 mm
Wheelbase	2,588 mm
Unloaded weight	1,845 kg
Transmission	6-speed, automatic
Fuel feed	Direct injection
Fuel consumption city	18.1 l / 100 km/h

174

176

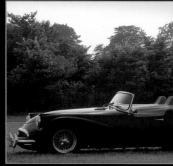

178

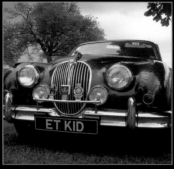

180

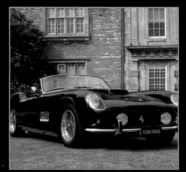

182

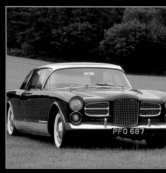

184

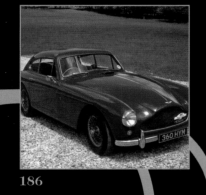

186

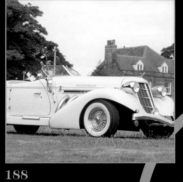

188

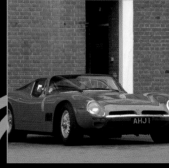

190

Rolls-Royce Phantom IV

The Phantom IV was the most exclusive Rolls-Royce ever built. Production was limited to exactly 18 examples, all of them destined for heads of state and member of various royal families.
The first Rolls-Royce Phantom IV was built in 1950 especially for the then-successor to the British throne, Princess Elizabeth and her husband Prince Philip, Duke of Edinburgh.

Der Phantom IV ist der exklusivste Wagen, der jemals in den Rolls-Royce Werkstätten gebaut wurde. Die strikte Beschränkung der Kundenliste auf Staatsoberhäupter und Mitglieder regierender Königshäuser limitierte die Produktion auf gerade 18 Automobile. Den ersten Rolls-Royce Phantom IV hatte die noble Manufaktur im Jahre 1950 speziell für das Thronfolgerpaar, I. K. H. Prinzessin Elisabeth und S. K. H. Prinz Philip, Herzog von Edinburgh, gebaut.

La Phantom IV est la plus exclusive des voitures jamais fabriquées dans les ateliers de Rolls-Royce. La liste des clients, strictement limitées aux chefs d'états et membres des familles royales actuelles réduit la production à 18 véhicules.
Les premières Rolls-Royce Phantom IV avaient été spécialement construites par la prestigieuse manufacture en 1950 pour le couple accédant au trône, Sa Majesté la Princesse Elisabeth et son Altesse Royale le Prince Philippe, Duc d'Edimbourg.

El Phantom IV es el vehículo más exclusivo construido en los talleres de Rolls-Royce. La lista de clientes se limita estrictamente a los más altos cargos de Estado y miembros de las monarquías Regentes, razón por la que se han construido únicamente 18 unidades hasta el momento.
Esta noble firma diseñó el primer Rolls-Royce Phantom para los sucesores al trono británico, la princesa Elisabeth y el príncipe Felipe, duques de Edimburgo.

La Phantom IV è il veicolo più esclusivo mai costruito negli stabilimenti Rolls-Royce. La lista dei clienti comprende esclusivamente capi di stato e membri delle case reali, consentendo di limitare la produzione a 18 esemplari.
La nobile azienda costruì la prima Rolls-Royce Phantom IV nel 1950 appositamente per i successori al trono, Sua Altezza Reale la Principessa Elisabeth e Sua Altezza Reale il Principe Philip, Duca di Edimburgo.

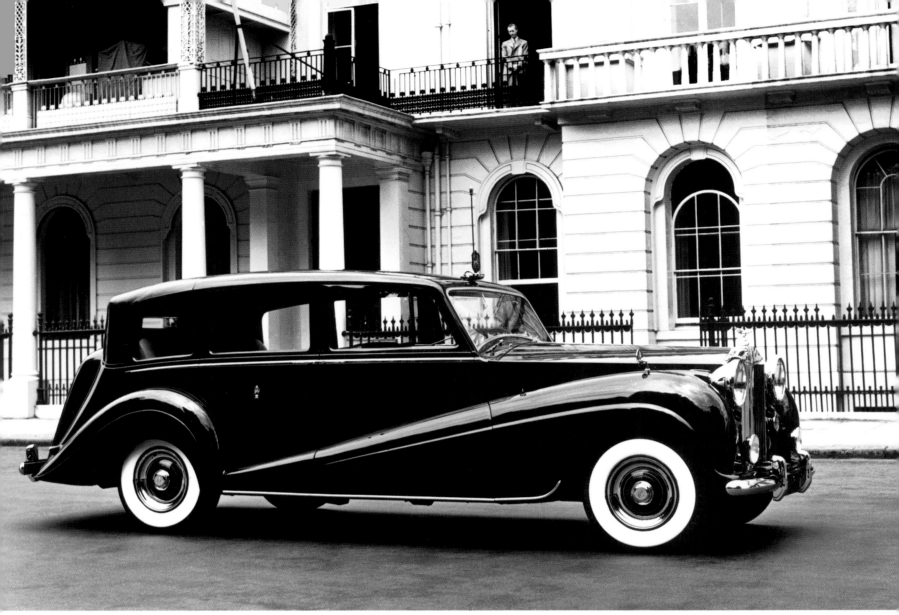

Photo: © Rolls Royce

TECHNICAL SPECIFICATIONS

Manufacturer	Rolls-Royce
Total made	18
Years in production	1950–1956
Engine/cylinders/valves per cylinder	S/8/2
Displacement	5.675 cc
Power output	166.3 hp
Top speed	163 km/h
Acceleration 0-100 km/h	n. i.
Dimensions length, width, height	5,766 mm, 1,956 mm, n. i.
Wheelbase	3,683 mm
Coolant	Water
Transmission	4-speed gearbox (from 1954, 4-speed automatic gearbox standard)
Engine alignment	Longitudinal
Engine location	Front

Bentley Continental R 1955

This car was carefully modified to suit the needs of a jaunty journey through the landscape and was outfitted with a tuned 4.6 liter engine.
The 207 examples produced were clothed with a light aerodynamically coupe structure by H. J. Mulliner. Wind tunnel tests had shown that the stability of the fastback saloon was improved by shaping the rear wings like fins.

Sorgfältig an die Bedürfnisse einer spritzigen Überlandtour angepasst, war der Bentley Continental R mit einem getunten 4,6 Liter Motor ausgestattet.
Die auf 207 limitierten Modelle des Bentley Continental R wurden mit leichten, aerodynamisch geformten Fließheckcoupéaufbauten von H. J. Mulliner versehen.
Windkanaluntersuchungen hatten ergeben, dass sich die Seitenempfindlichkeit des Fließheckcoupés mit flossenartig ausgeformten hinteren Kotflügeln verringern ließ.

Pour répondre parfaitement aux exigences d'une routière rapide et nerveuse, la Bentley Continental R était équipée d'un moteur poussé de 4.6 litres.
Le modèle de la Bentley Continental R, limité à 207 exemplaires, est pourvu d'un arrière profilé aux formes légèrement aérodynamiques, conçu par H. J. Mulliner.
Des études sur l'aérodynamisme avaient montré que l'arrière profilé du coupé était moins sensible après l'installation d'ailerons arrières en formes de nageoires.

Adaptado al detalle para hacer posibles las excursiones todo terreno en coche, el Bentley Continental R 1955 estaba equipado con un motor trucado de 4.6 litros.
La producción limitada de 207 modelos del Bentley Continental R se adornaron con una superestructura cupé de popa aerodinámica de H. J. Mulliner. Las pruebas en túneles aerodinámicos dieron como resultado que la sensibilidad lateral de la parte trasera tipo cupé disminuía gracias a los guardabarros en forma de aletas.

L'inizio della produzione della Bentley Continental R risale al 1952. Per soddisfare le esigenze di una frizzante gita fuori porta, la Bentley Continental R era fornita di motore a 4.6 litri.
La Bentley Continental R, limitata a 207 esemplari, presenta una carrozzeria coupé aerodinamica di H. J. Mulliner. Alcuni esperimenti nella galleria del vento avevano inoltre evidenziato che era possibile migliorare la resistenza alla forza trasversale del coupé a tre volumi con parafanghi posteriori piegati a pinna.

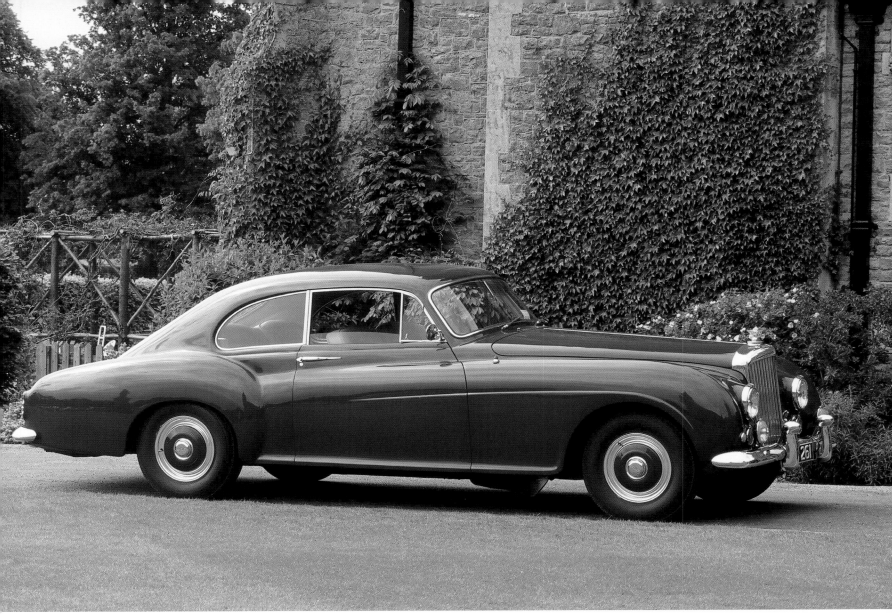

TECHNICAL SPECIFICATIONS

Manufacturer	Bentley
Total made	207
Years in production	1952–1955
Engine/cylinders/valves per cylinder	S/6/2
Displacement	4.566 cc
Power output	n. i.
Top speed	180 km/h
Acceleration 0-100 km/h	13 sec.
Dimensions length, width, height	5,245 mm, 1,816 mm, n. i.
Wheelbase	3,048 mm
Coolant	Water
Transmission	4-speed gearbox
	4-speed automatic gearbox optional
Engine alignment	Longitudinal
Engine location	Front

Daimler 250 SP

The Daimler 250 SP was developed by a Daimler project team in 1958. The chief engineer, who at the time was the top engineer in the auto industry, designed a new V8 engine with a hemispheric combustion chamber. The engine was originally air cooled, but this proved to be insufficient. To solve this problem, the Daimler engineering team devised a water jacket made of tubes that were mounted on the outside of the engine.

Der Daimler 250 SP wurde 1958 von einem Daimler Projektteam entwickelt. Der leitende Ingenieur, der in dieser Zeit zu den besten Ingenieuren der Automobilindustrie gehörte, entwarf einen für Daimler neuen V8 Motor mit hemisphärischer Verbrennung. Ursprünglich wurde dieser Motor mit Luftkühlung entworfen, jedoch reichte die Kühlung nicht aus. Um das Problem zu lösen, entwarf das Team eine Wasserjacke aus Schläuchen, die um die Außenseite des Motors geschlungen wurde.

La Daimler 250 SP fût conçue en 1958 par l'équipe d'ingénieurs de Daimler Benz. L'ingénieur en chef, le meilleur dans l'industrie de l'automobile de l'époque, développa pour Daimler un nouveau moteur V8 à combustion hémisphérique. A l'origine, ce moteur fût conçu avec un refroidissement à air. Toutefois, ce système de refroidissement s'avéra être insuffisant. Pour résoudre le problème, l'équipe mis au point une ceinture d'eau constituée de tuyaux qui entourait le côté extérieur du moteur.

El Daimler 250 SP fue desarrollado en 1958 por un equipo de proyecto de la Daimler. El ingeniero jefe, que pertenecía en aquella época a los mejores de la industria automovilística, diseñó para la Daimler un nuevo motor V8 con combustión hemisférica. Originalmente este motor fue diseñado con refrigeración por ventilación, pero resultaba insuficiente. Para resolver el problema, el equipo ideó una chaqueta de agua formada por manguitos que se acoplaba por la parte externa del motor.

La Daimler 250 SP, fu sviluppata nel 1958 da un team di progettisti della Daimler. L'ingegnere responsabile, che a quel tempo era uno dei migliori ingegneri dell'industria automobilistica, progettò per la Daimler un nuovo motore V8 con camera di combustione emisferica. Per il motore si concepì originariamente un raffreddamento ad aria, che si rivelò però insufficiente quando il motore venne collocato sotto il convogliatore dell'aria del radiatore. Per risolvere il problema, il team progettò una copertura composta da tubi per l'acqua che venne avvolta sul lato esterno del motore.

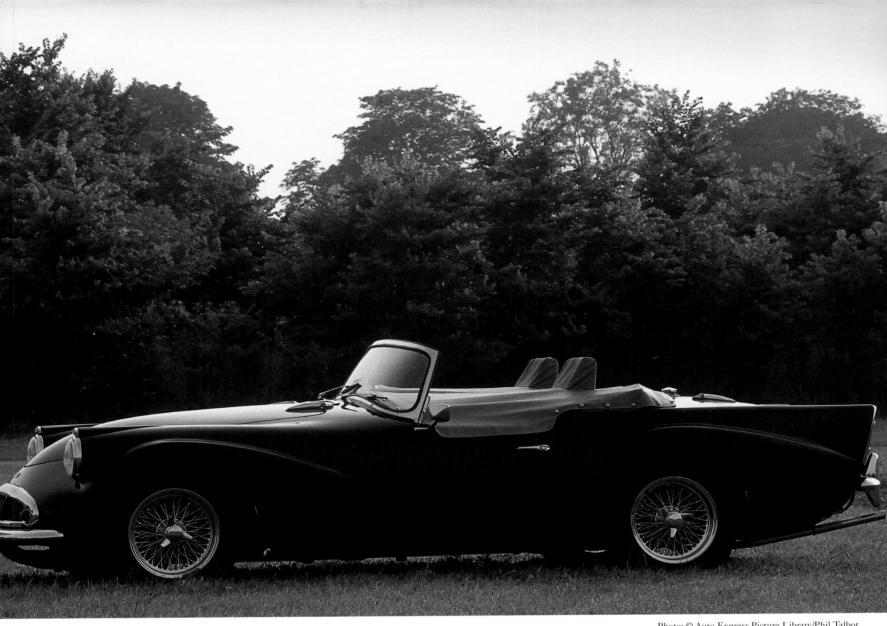

Photo: © Auto Express Picture Library/Phil Talbot

TECHNICAL SPECIFICATIONS

Manufacturer	Daimler
Total made	2,644
Years in production	1959–1961
Engine/cylinders/valves per cylinder	V/8/2
Displacement	2.547 cc
Power output	140 ph
Top speed	200 km/h
Acceleration 0-100 km/h	10.6 sec.
Dimensions length, width, height	4,066 mm, 1,533 mm, 1,270 mm
Wheelbase	2,337 mm
Coolant	Water
Transmission	4-speed
Engine alignment	Longitudinal
Engine location	Front

Jaguar MK II

In the 1960s, the Jaguar MK II was considered one of the world's fastest and most elegant series-produced limousines. Its uniquely harmonious design, exquisite leather and wood interior combined with a race track proven XK-engine, ensured this sporty limousine of worldwide success.

Der Jaguar MK II galt in den sechziger Jahren ohne Zweifel als eine der schnellsten und auch schönsten Serienlimousinen der Welt. Die einzigartige Symbiose aus harmonischem Design, gehobenem Interieur aus Leder und Holz sowie der rennerprobten XK-Maschine sicherten den weltweiten Erfolg dieser sportlichen Limousine.

Dans les années soixante, la Jaguar MK II était sans conteste la plus rapide et la plus belle des berlines de série au monde. L'unique symbiose entre l'harmonie du design, l'habitacle en bois et cuir et le moteur de course XK fit remporter à la berline sportive un succès mondial.

El Jaguar MK II estaba considerado en la década de 1960 sin duda alguna como la limusina de serie más rápida y bonita del mundo. La simbiosis única entre un diseño armónico, los elegantes interiores en piel y madera, y el motor XK, probado por profesionales del automovilismo, aseguran el éxito a escala mundial de esta limusina deportiva.

Negli anni sessanta, la Jaguar MK II era senza dubbio una delle limousine di serie più belle e veloci del mondo. La simbiosi unica tra le prestazioni del modello XK da gara e il design armonioso con interni sofisticati in pelle e legno assicurò a questa limousine sportiva un successo mondiale.

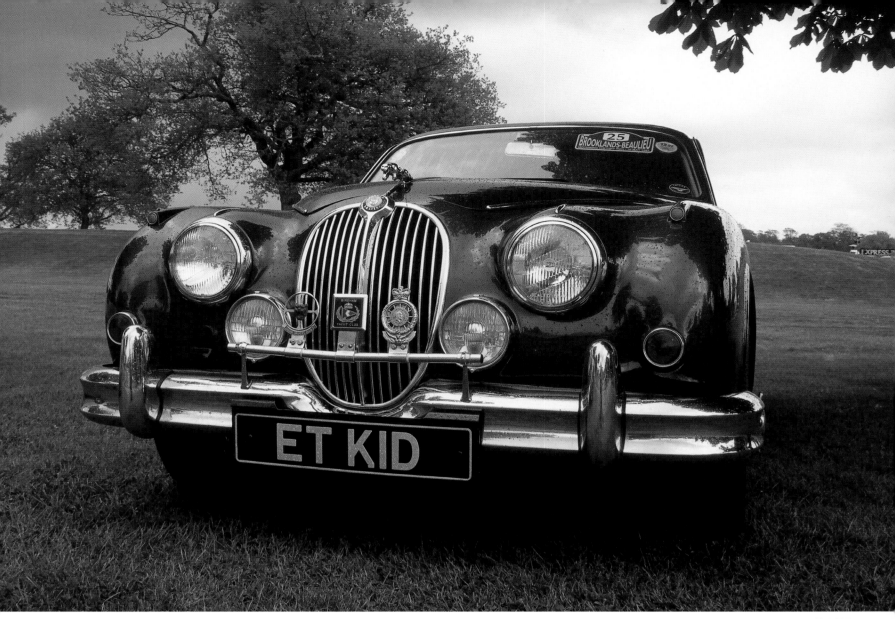

Photo: © Auto Express Picture Library/Phil Talbot

TECHNICAL SPECIFICATIONS

Manufacturer	Jaguar
Total made	123,000
Years in production	1959–1967
Engine /cylinders/valves per cylinder	S/6/2
Displacement	3.442 cc
Power output	168 hp
Top speed	193 km/h
Acceleration 0-100 km/h	8.6 sec.
Dimensions length, width, height	4,591 mm, 1,695 mm, 1,597 mm
Wheelbase	2,730 mm
Coolant	Water
Transmission	4-Speed, manual
Engine alignment	Longitudinal
Engine location	Front

Ferrari 250 California Spyder

At the urging of Ferrari's US importer Luigi Chinetti, the company decided to market an elegant convertible variant of the 250 GT. The car was christened Spyder California with its target group firmly in mind.
This extremely sporty model develops 260 hp and reaches a top speed of 240 km/h. In the interest of keeping the Spyder lean, the doors and hood were made of aluminum. Some panels were made solely of aluminum.

Auf Anregung von Ferraris US-Importeur Luigi Chinetti präsentierte die italienische Nobelmarke ein auf dem 250 GT basierendes elegantes Cabriolet. Mit Blick auf seine Zielgruppe wird der Wagen Spyder California genannt.
Dieses Modell setzt verstärkt auf Sportlichkeit. Mit 260 PS erreicht er eine Höchstgeschwindigkeit von 240 km/h. Um das Gewicht gering zu halten werden die Türen und Hauben aus Aluminium gefertigt. Einige Karosserien entstehen sogar komplett aus Aluminiumblechen.

A l'instigation de l'importateur américain de Ferrari, Luigi Chinetti, la fameuse marque italienne présenta un cabriolet basé sur la 250 GT. Cette automobile baptisée Spyder California, est un clin d'œil à sa future clientèle.
Ce modèle met l'accent sur le côté sportif. Forte de 260 ch elle atteint la vitesse de pointe de 240 km/h. Afin de réduire son poids au minimum, portes et capot sont en aluminium. Certaines carrosseries sont entièrement en aluminium.

Gracias al impulso del importador americano de Ferrari Luigi Chinetti, se presentó un elegante cabriolet basado en el 250 GT. Pensando en los destinatarios del vehículo, se le denominó Spyder California.
Este modelo apuesta por la deportividad. Posee 260 caballos de potencia y alcanza una velocidad de 240 km/h. El peso del coche es mínimo gracias a las puertas, el capó y el maletero fabricados en aluminio, e incluso algunas carrocerías están totalmente compuestas de chapa de este material.

Grazie all'impulso dato da Luigi Chinetti, importatore della Ferrari negli USA, l'esclusivo marchio italiano presentò un elegante cabriolet basato sulla 250 GT. In considerazione del target di riferimento, l'auto venne chiamata Spyder California.
Questo modello pone un forte accento sulla sportività. Grazie ai 260 CV, l'auto raggiunge infatti una velocità massima di 240 km/h. Per limitarne il peso, le porte e il cofano sono in alluminio; in alcuni casi, le carrozzerie sono composte esclusivamente da lamiere di alluminio.

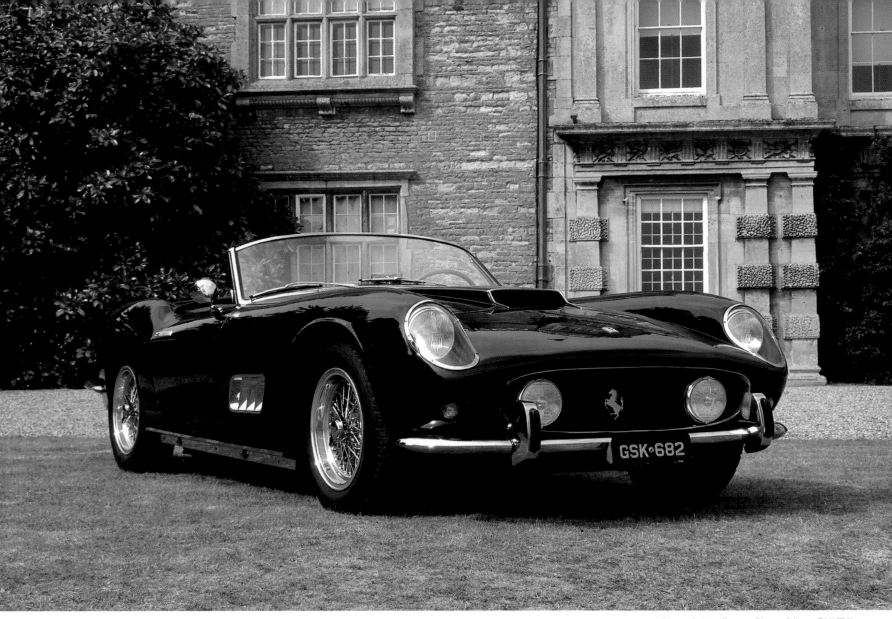

TECHNICAL SPECIFICATIONS

Manufacturer	Ferrari
Total made	55
Years in production	1958–1960
Engine/cylinders/valves per cylinder	V/12/2
Displacement	2.953 cc
Power output	260 hp
Top speed	240 km/h
Acceleration 0-100 km/h	7.5 sec.
Dimensions length, width, height	4,394 mm, 1,651 mm, 1,397 mm
Wheelbase	2,591 mm
Coolant	Water
Transmission	4-speed, manual
Engine alignment	Longitudinal
Engine location	Front

Facel Vega Excellence 1961

Before the first world war, Jean Daninos established a metal foundry known as "Les Forges et Ateliers de Construction de l'Eure et Loire", one of whose lines of business was the manufacture of auto body components. In the 1950s, Daninos decided to develop and build his own luxury automobile. The resulting coupe was then refined, resulting in the creation of the four-door limousine Excellence in 1957.
The unusual feature of this 5.23 m long luxury automobile was that it had four doors but no central pillar.

Vor dem Ersten Weltkrieg gründete Jean Daninos „Les Forges et Ateliers de Construction de l'Eure et Loire", das Konstruktionen technischer Art, darunter auch Karosserien, fertigte. In den fünfziger Jahren beschloss Daninos sein erstes, eigenständig gebautes Luxusauto zu entwickeln. 1957 wurde dieses Coupé weiter entwickelt und es entstand die viertürige Limousine Excellence.
Die Besonderheit des 5,23 m langen Luxuswagens waren die sich zueinander öffnenden Türen. Dadurch konnte man auf den Mittelposten verzichten.

Avant la première guerre mondiale, Jean Daninos créa « Les Forges et Ateliers de Construction de l'Eure et Loire », qui produisait des constructions techniques dont des carrosseries. Dans les années cinquante, Daninos décida de développer lui-même sa première voiture de luxe. En 1957, il améliora ce coupé pour aboutir à la berline Excellence de quatre portes.
Cette voiture de luxe longue de 5.23 m, avait une particularité : Les portes s'ouvraient en contraposition l'une de l'autre. On pouvait ainsi se passer de la barre médiane.

Con anterioridad a la Primera Guerra Mundial, Jean Daninos fundó "Les Forges et Ateliers de Construction de l'Eure et Loire", que llevaba a cabo construcciones de tipo técnico y también carrocerías. En la década de 1950, Daninos decidió desarrollar su primer y propio automóvil de lujo. En el año 1957 se perfeccionó este cupé del que después surgiría la limusina de cuatro puertas Excellence.
La particularidad en este vehículo de lujo de 5.23 metros de longitud son las puertas, de apertura diametralmente opuesta y que, de esta manera, permitió prescindir de la jamba central.

Prima della Prima Guerra Mondiale, Jean Daninos fondò "Les Forges et Ateliers de Construction de l'Eure et Loire", che effettuava costruzioni di tipo tecnico, tra cui anche carrozzerie. Negli anni '50, Daninos decise di produrre autonomamente la sua prima auto di lusso, che venne ulteriormente sviluppata nel 1957 diventando la limousine a quattro porte Excellence.
La particolarità di questa auto di lusso lunga 5.23 m erano le portiere che, aprendosi ad armadio, consentivano di guadagnare lo spazio intermedio.

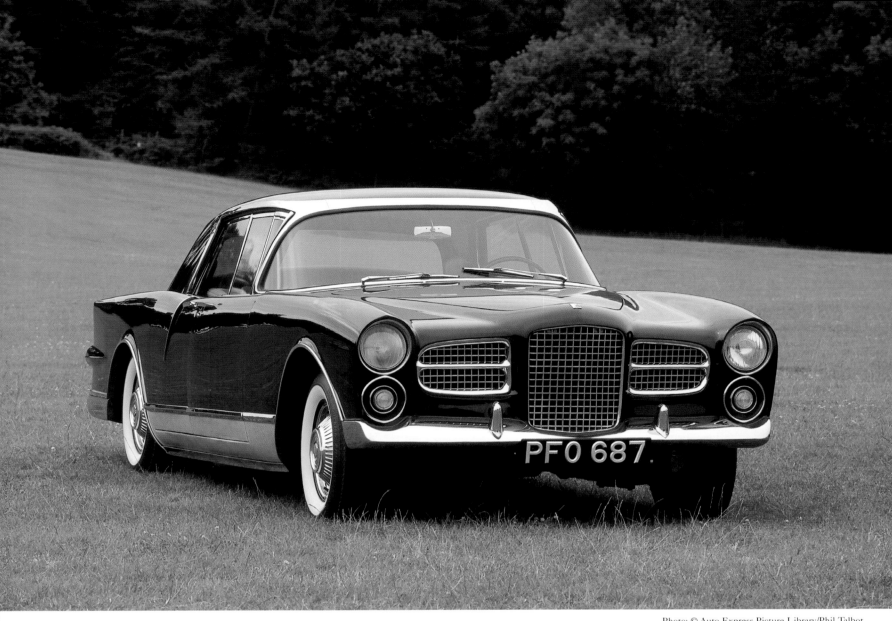

TECHNICAL SPECIFICATIONS

Manufacturer	Facel Vega
Total made	152
Years in production	1954–1962
Engine/cylinders/valves per cylinder	V/8/2
Displacement	4.940 cc
Power output	253 hp
Top speed	200 km/h
Acceleration 0-100 km/h	n. i.
Dimensions length, width, height	5,230 mm, 1,830 mm, 1,380 mm
Wheelbase	n. i.
Coolant	Water
Transmission	4-speed, manual
Engine alignment	Longitudinal
Engine location	Front

Aston Martin DB 2/4 MK III 1959

The Aston Martin DB 2/4 was an improved version of the DB 2 with 125 more horsepower than its predecessor, rear seats and an incorporated tailgate. The DB 2/4 was later outfitted with the 3-liter engine from the DB 3 racing version. It developed 142 horsepower and reached a top speed of over 200 km/h. In 1955 Aston Martin came out with a hatchback sports car known as the MK2. This handmade coupe was outfitted in 1957 with a revamped cylinder head that increased engine power to 164 horsepower. Since 1956 a convertible variant has also been available.

Bei dem Aston Martin DB 2/4 handelt es sich um eine um 125 PS verbesserte Version des DB 2. Zudem wurden zwei hintere Notsitze und eine Heckklappe eingebaut. Später wurde der DB 2/4 mit einem 3-Liter-Motor der Rennversion DB 3 ausgerüstet. Dieser leistete 142 PS und beschleunigte den Wagen auf über 200 km/h. Ende 1955 gab es den Sportwagen auch als MK 2 mit einem konventionellen Stufenheck. Das in Handarbeit gefertigte Coupé wurde 1957 mit einem überarbeiteten Zylinderkopf ausgestattet und konnte seine Leistung auf 164 PS erhöhen. Neben dem Coupé ist seit 1956 auch eine Cabriolet-Version erhältlich.

L'Aston Martin DB 2/4 est une version améliorée de la DB 2 avec un moteur passant à 125 ch. En outre, elle est dotée de deux sièges arrière de secours et d'un capot. Plus tard, la DB 2/4 sera équipée d'un moteur de 3 litres à l'instar de la version de course DB 3. Ce moteur déploie 142 ch et propulse la voiture à plus de 200 km/h. A la fin de 1955, la sportive fut aussi produite dans la version MK 2 dotée d'un béquet réglable conventionnel. Ce coupé, fabriqué à la main, fût équipé en 1957 d'une tête de cylindre plus puissante faisant passer la puissance à 164 ch. Depuis 1956, il est possible, outre le coupé, d'obtenir la version cabriolet.

El Aston Martin DB 2/4 es una versión aumentada en 125 caballos del DB 2. Además se añadieron dos asientos traseros supletorios y un portón trasero. Más tarde, el DB 2/4 se reforzó con un motor de tres litros de la versión de carreras DB 3. Este genera un 142 caballos de potencia y tiene una velocidad máxima de más de 200 km/h. A finales de 1955 salió como MK 2 con la parte trasera escalonada. En 1957 este cupé fabricado a mano se reforzó con cabezas de cilindro perfeccionadas, de esta manera pudo aumentar su rendimiento hasta 164 caballos de potencia. Junto con el cupé está disponible desde 1956 la versión cabriolet.

La Aston Martin DB 2/4 era una versione della DB2 con 125 CV, oltre a due nuovi sedili posteriori e a un coperchio della bagagliera. Successivamente la DB 2/4 venne equipaggiata con il motore 3 litri della versione da corsa DB 3, che forniva 142 CV e portava l'auto a oltre 200 km/h. Alla fine del 1955, venne prodotta anche una versione MK 2 dell'auto sportiva con una coda a sbalzo convenzionale. Il coupé fabbricato a mano venne dotato nel 1957 di una testa cilindri ripassata che gli permise di raggiungere i 164 CV. Accanto al coupé, nel 1956 venne lanciata anche una versione cabriolet.

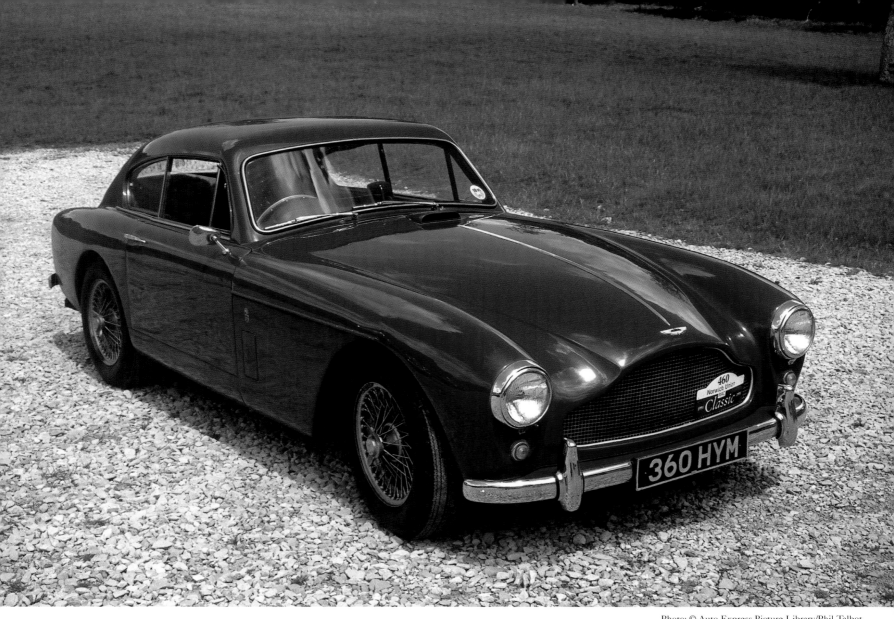

Photo: © Auto Express Picture Library/Phil Talbot

TECHNICAL SPECIFICATIONS

Manufacturer	Aston Martin
Total made	551
Years in production	1957–1959
Engine /cylinders/valves per cylinder	S/6/2
Displacement	2.580 cc
Power output	125 hp
Top speed	185 km/h
Acceleration 0-96 km/h	8.20 sec.
Dimensions length, width, height	4,356 mm, 1,651 mm, n. i.
Wheelbase	2,515 mm
Coolant	Water
Transmission	4-speed, manual
Engine alignment	Longitudinal
Engine location	Front

Cord L 29

The launch on the American market of the new automobile known as the Cord L 29 caused quite a stir owing to its striking design. The extensive work that went into the car's exterior paid off because in the ensuing years Cord enjoyed great success during beauty contests and famous Hollywood stars became Cord owners, which enhanced the brand's exclusive image. A second model went beyond mere aesthetic success and came to be regarded in the auto industry as the ultimate in car design.

Mit dem Cord L 29 kam eine neue Automarke auf den amerikanischen Markt, die besonders durch ausgefallenes Design für Wirbel in der Branche sorgte. Die intensive Arbeit am äußeren Erscheinungsbild zahlte sich aus, denn in den folgenden Jahren gehörte der Cord zu den erfolgreichsten Wagen bei Schönheitswettbewerben. Bekannte Hollywood-Schauspieler gehörten zu den Käufern und verhalfen der Marke so zu einem exklusiven Image. Eine zweite Version übertraf sogar noch den ästhetischen Erfolg und ging als Paradebeispiel gelungener Formgebung in die Geschichte des Industriedesigns ein.

La Cord L 29 marque l'entrée d'une nouvelle marque automobile sur le marché américain dont le design audacieux fit des remous dans ce secteur. Le travail minutieux consacré à l'aspect extérieur fut récompensé, car l'année suivante la Cord remporta de très grands succès dans les concours de beauté. Les grandes stars d'Hollywood figurèrent parmi les acquéreurs lui conférant ainsi son image de marque exclusive. La deuxième version dépassa le succès esthétique remporté par la première et fût citée en exemple, pour la réussite de ses formes, dans l'histoire du design industriel.

El Cord L 29 supuso la irrupción en el mercado americano de una nueva marca que, especialmente por su atrevido diseño, causó furor en el sector automovilístico. El intenso trabajo en la estética externa del coche se amortizó, ya que en los años que siguieron el Cord se convirtió en uno de los coches con más éxito en los concursos de belleza. Entre sus compradores se contaban conocidos actores de Hollywood lo que contribuyó a dotar a la firma de una imagen de exclusividad. Una segunda versión superó incluso el éxito estético y pasó a formar parte de la historia del diseño como paradigma del modelado perfecto.

La Cord L 29 segnò l'ingresso nel mercato americano di un nuovo marchio automobilistico che fece scalpore nel settore grazie all'originalità del design. L'attenzione particolare rivolta al lato estetico del veicolo ottenne un riconoscimento negli anni successivi, quando la Cord rientrò tra le auto maggiormente degne di nota in varie competizioni di bellezza. Famosi attori hollywoodiani divennero acquirenti della Cord, conferendo al marchio un'immagine di esclusività. Una seconda versione superò addirittura il successo estetico della prima, entrando di diritto nella storia del disegno industriale come esempio paradigmatico di un modello perfettamente riuscito.

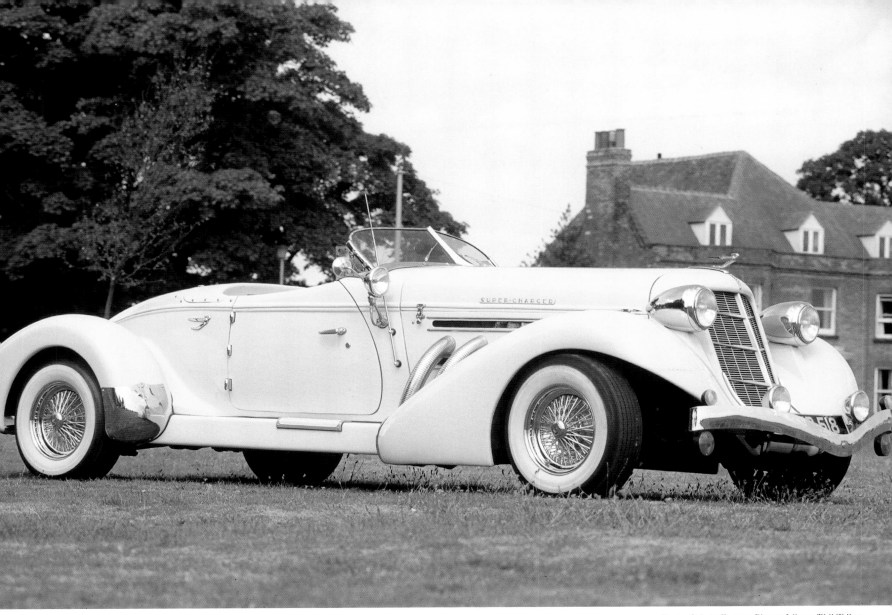

TECHNICAL SPECIFICATIONS

Manufacturer	Cord
Total made	5,000
Years in production	1929–1931
Engine/cylinders/valves per cylinder	8 in line
Displacement	4.893 cc
Power output	125 hp
Top speed	125 km/h
Acceleration 0-96 km/h	24 sec.
Dimensions length, width, height	n. i.
Wheelbase	3,492 mm
Coolant	Water
Transmission	3-speed, manual
Engine alignment	n. i.
Engine location	Front

Bizzarrini Strada GT 5300

The Bizzarini owes its existence to the passion for cars of the company's founder, professor Giotto Bizzarrini, who was a developer for Alfa Romeo, Ferrari and ATS Autos until going into business for himself in 1962. Bizzarini counted among his customers Lamborghini and Iso Rivolta. After leaving Iso Rivolta, Bizzarrini changed the name of the Iso Grifo to the Bizzarrini Strada GT.

Bizzarini verdankt seine Entstehung der Autoleidenschaft seines Gründers, des Professors Giotto Bizzarrini. Er entwickelte für Alfa Romeo, Ferrari und ATS Autos, bis er 1962 seine eigene Firma gründete. Zu seinen Kunden gehörten Lamborghini und Iso Rivolta. Nach dem Bruch mit Iso Rivolta änderte Bizzarrini den Namen des Iso-Grifo-Modells in Bizzarrini Strada GT um.

La Bizzarrini doit son existence à la passion automobile de son fondateur, le professeur Giotto Bizzarrini. Il concevait des voitures pour Alfa Romeo, Ferrari et ATS, jusqu'à ce qu'il fonde, en 1962, sa propre entreprise. Parmi ses clients, citons Lamborghini et Iso Rivolta. A la suite de sa rupture avec Iso Rivolta, Bizzarrini changea le nom du modèle Iso-Grifo en Bizzarrini Strada GT.

Bizzarini debe su nacimiento a la pasión por los coches de su fundador, el profesor Giotto Bizzarrini. Diseñó para Alfa Romeo, Ferrari y ATS Autos e incluso creó su propia marca en 1962. Entre sus clientes estaban Lamborghini e Iso Rivolta. Después de finalizar las relaciones con Iso Rivolta, Bizzarrinni cambió el nombre del modelo Iso-Grifo por el de Bizzarrinni Strada GT.

Bizzarini deve la sua nascita alla passione automobilistica del fondatore, il professore Giotto Bizzarrini. Dopo aver lavorato come sviluppatore per l'Alfa Romeo, la Ferrari e ATS Autos, il professore fondò la propria azienda nel 1962. Tra i clienti dell'epoca ricordiamo Lamborghini e Iso Rivolta. Dopo la rottura con Iso Rivolta, Bizzarrini cambiò però il nome del modello Iso Grifo in Bizzarrini Strada GT.

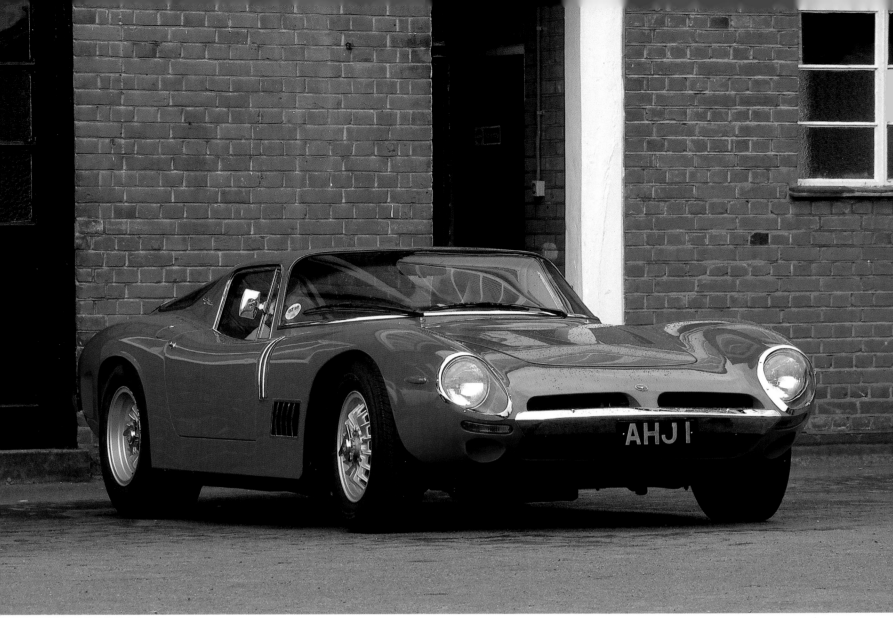

TECHNICAL SPECIFICATIONS

Manufacturer	Bizzarrini
Total Made	133
Years in production	1964–1968
Engine	V/8/2
Displacement	5.358 cc
Power Output	365 hp
Top Speed	260 km/h
Acceleration 0-100 km/h	6.7 sec.
Dimensions length, width, height	4,460 mm, 1,760 mm, 1,115 mm
Wheelbase	2,448 mm
Coolant	Water
Transmission	4-speed, manual
Engine alignment	n. i.
Engine location	Front

AIRPI

Business jets

194

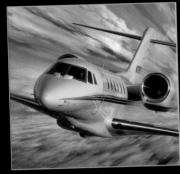

200

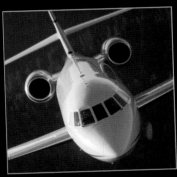

208

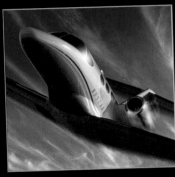

214

Gulfstream V

The Gulfstream has earned a reputation as the world's most reliable and comfortable long-haul business jet. With a range of 6,500 miles and a top speed of 900 km/h the Gulfstream V gets its passengers to their destination in record time.
This twin engine aircraft is extremely roomy and offers an unusual level of comfort. 14 extra large windows flood the cabin with natural light, thus enabling the aircraft's future owner to design the cabin to suit his own needs and taste.

Die Gulfstream genießt den Ruf, das zuverlässigste und komfortabelste Langstrecken-flugzeug der Welt zu sein. Mit einer Reichweite von 6.500 Meilen und einer Geschwindigkeit von 900 km/h erreicht die Gulfstream V gewünschte Ziele in Rekordgeschwindigkeit.
Dieses zweimotorige Langstrecken-Business-Jet legt dabei sehr viel Wert auf großzügige und komfortable Innenräume. 14 übergroße Fenster ermöglichen eine Beleuchtung der Kabinen mit natürlichem Licht. Dabei genießt der künftige Eigner die Freiheit, die Innenräume nach eigenen Bedürfnissen gestalten zu können.

Le Gulfstream jouit de la réputation d'être le long courrier le plus sûr et le plus confortable du monde. Le Gulfstream peut parcourir une distance de 6 500 miles à vitesse record de 900 km/h.
Ce jet d'affaires, long courrier biréacteur, attache également une grande importance à un intérieur de cabine très spacieux et confortable. Grâce à 14 fenêtres surdimensionnées, la cabine est dotée d'un éclairage naturel. Le futur propriétaire peut moduler librement l'espace intérieur en fonction de ses besoins personnels.

El Gulfstream tiene fama de ser el más noble y confortable avión de largo recorrido del mundo. Con un alcance de 6 500 millas y una velocidad de 900 km/h, el Gulfstream V puede alcanzar el destino deseado en un velocidad récord.
Este jet de negocios de largo recorrido bimotor otorga especial valor a la amplitud y la comodidad de los interiores. Dispone este vehículo de 14 ventanas de grandes dimensiones que permiten la iluminación natural de la cabina. Además, el potencial propietario dispone de la libertad de diseñar los interiores según sus necesidades.

Il Gulfstream gode la fama di essere l'aeroplano a grande autonomia più affidabile e confortevole del mondo. Con un raggio d'azione di 6 500 miglia e una velocità di 900 km/h , il Gulfstream V raggiunge gli obiettivi desiderati in tempo record.
Questo business-jet bimotore a grande autonomia è particolarmente confortevole e spazioso. 14 finestrini di notevoli dimensioni conferiscono alle cabine una generosa illuminazione naturale. Inoltre, il proprietario ha la possibilità di organizzare gli spazi interni secondo i propri desideri.

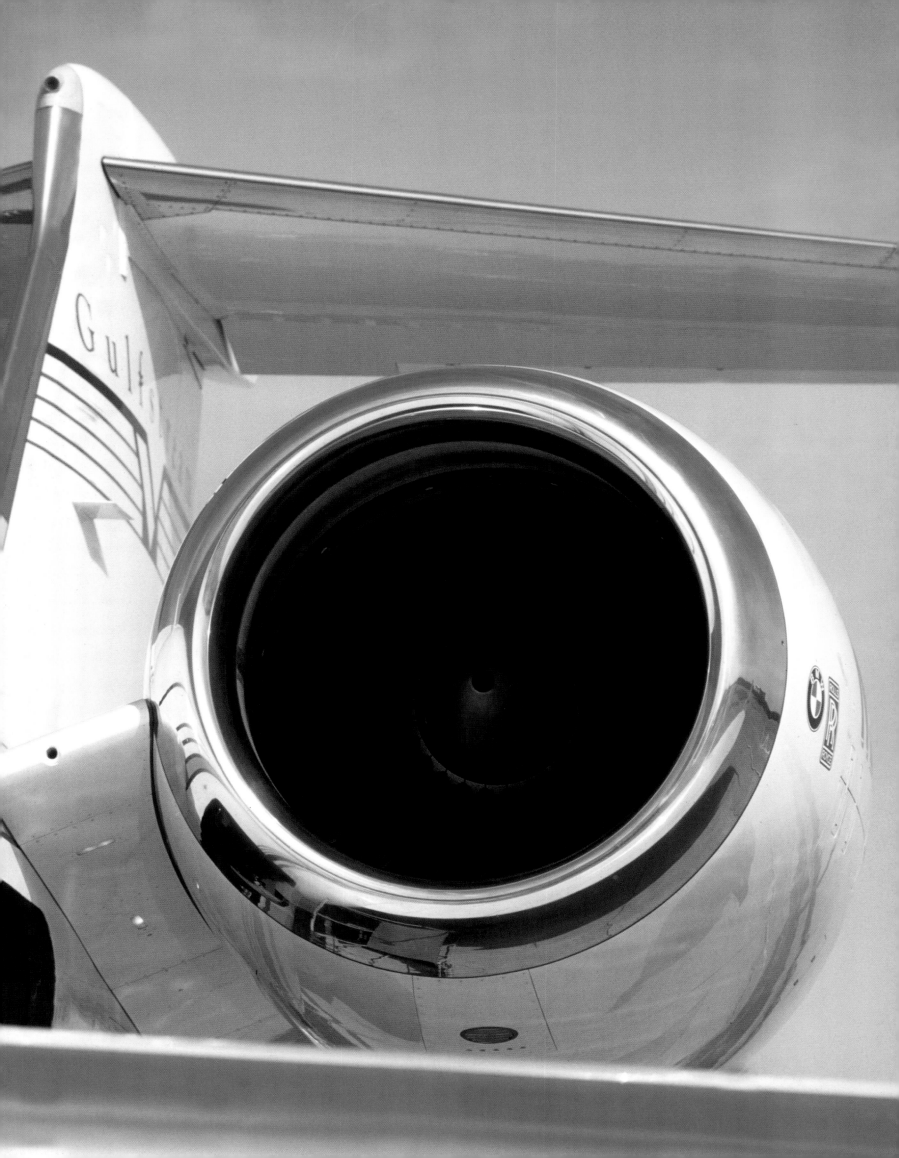

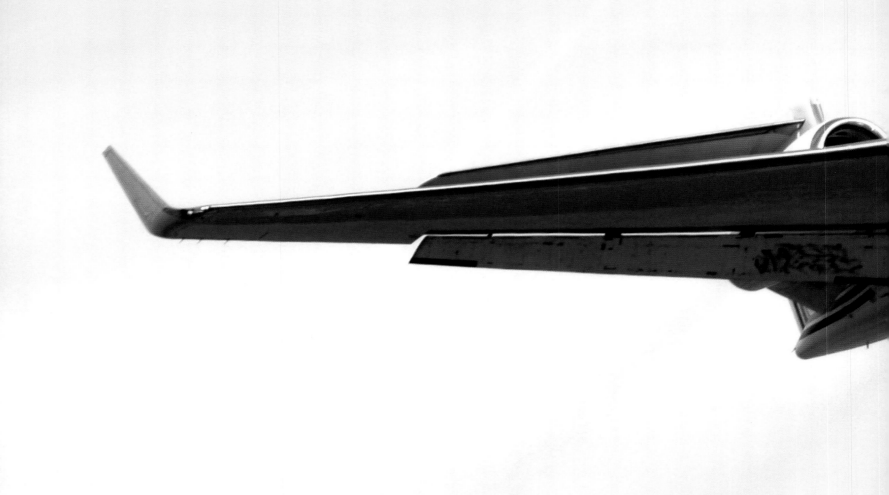

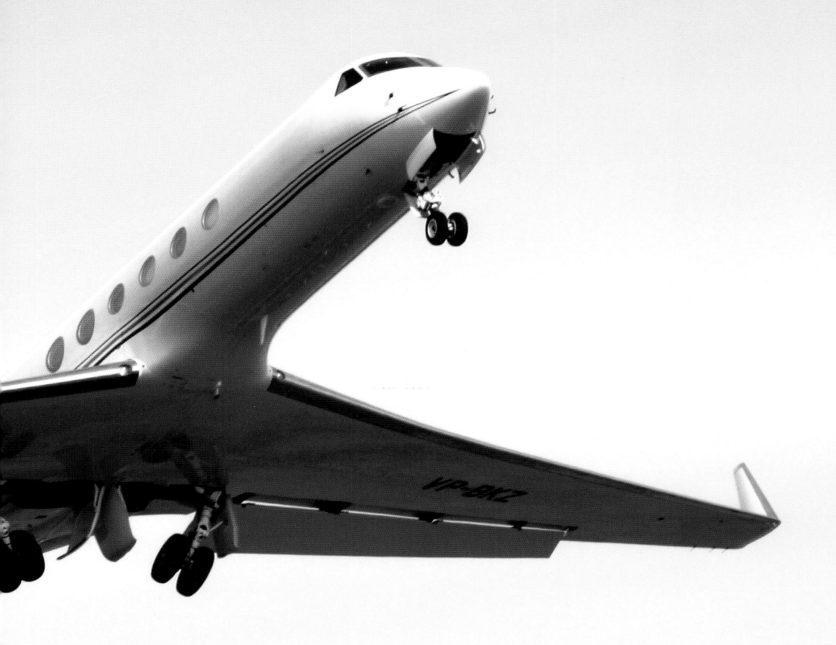

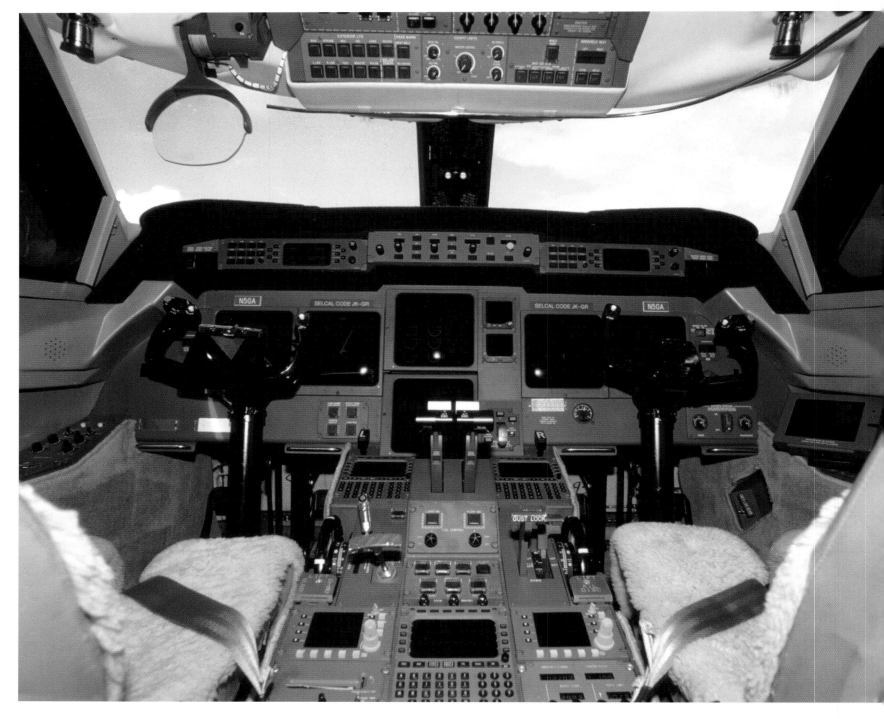

To meet the expectations of a mobile office and to make the stay as comfortable as possible, the Gulfstream V is outfitted with a satellite phone, direct TV, video screens, training bikes, bathrooms with showers, a full galley and and a sound system.

Um den Ansprüchen eines mobilen Büros gerecht zu werden und den Aufenthalt an Bord so angenehm wie möglich zu gestalten, ist die Gulfstream V mit Satelittentelefon, Direktfernsehen, Videoflachbildschirmen, Trainingsfahrrad, Bädern mit Dusche, einer Kochmöglichkeit und einem Soundsystem ausgestattet.

Pour répondre aux exigences d'un bureau mobile et rendre la vie à bord aussi agréable que possible, le Gulfstream V est équipé de téléphones satellites, de télévision en direct, d'écran plat vidéo, d'un vélo d'entraînement, de salles de bains avec douche, d'une niche de cuisson et d'un dispositif sonore.

Para cumplir con las exigencias de un despacho móvil y hacer de la estancia a bordo la más confortable posible, se ha equipado al Gulfstream V con teléfono por satélite, televisión en directo, pantallas planas de video, bicicleta estática, baños con ducha, posibilidad de cocinar y sistema de sonido.

Per soddisfare le esigenze di un ufficio mobile e rendere più piacevole il tempo trascorso a bordo, il Gulfstream V dispone di telefono satellitare, televisione diretta, schermi piatti, bagni con doccia, cucina e soundsystem.

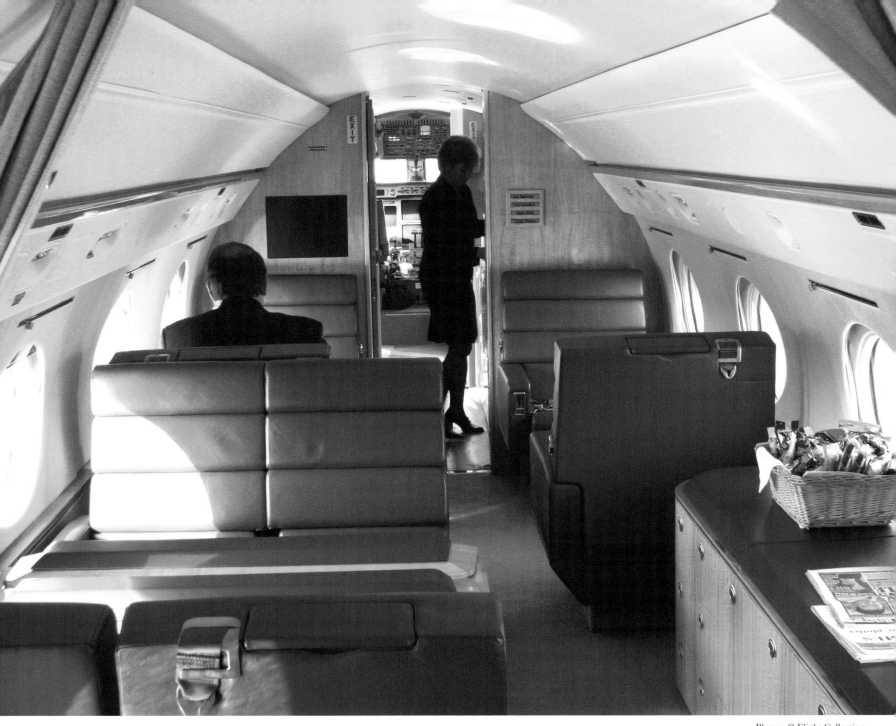

TECHNICAL SPECIFICATIONS

Manufacturer	Gulfstream Aerospace Corporation
Price	$ 36,000,000
Contact	www.gulfstream.com
Type	ultra-long range business jet
Passenger Capacity	12–15
Engines	Rolls-Royce BR 710
Range	12,046 km
Cruise Speed	851 km/h
Max. Cruise speed	930 km/h
Length	29.4 m
Height	7.9 m
Span	28.5 m
Baggage capacity	6.4 m^3
Empty Weight	42,130 Lbs

Cessna Citation X

With a top speed of over 960 km/h—mach 0.92 or nearly the speed of sound—the Citation X is the world's fastest business jet. The aircraft climbs to 43,000 feet immediately upon takeoff, is rated for a cruising altitude of 51,000 feet and has a range of more than 6,300 km. And even with this high level of performance, the Citation X is a remarkably efficient flying machine, one that uses less fuel, even for short hauls, than some slower jets. The Citation X also offers an extraordinary level of comfort. A typical configuration comprises space for nine passengers and up to 1.70 m of headroom in the center aisle.

Sie ist der schnellste Business-Jet, der je gebaut wurde. Knapp unterhalb der Schallgeschwindigkeit fliegt die Citation X mit Mach 0.92 über 960 km/h Sie steigt direkt auf 43.000 Fuß auf und ist für 51.000 Fuß zugelassen. Ohne zu tanken beträgt ihre Reichweite mehr als 6.300 km. Und bei all dieser Leistung ist die Citation X bemerkenswert effizient. Tatsächlich verbraucht sie weniger Treibstoff – auch bei Kurzstreckenflügen – als manch langsamerer Jet. Dabei ist diese Maschine in höchstem Maße komfortabel. In einer typischen Ausstattung ist Platz für neun Mitreisende, und in der gesamten Kabine kann man im Mittelgang bis zu einer Körpergröße von 1,70 m aufrecht stehen.

C'est le jet d'affaires le plus rapide construit jusqu'à présent. A peine en dessous de la vitesse du son, le Citation X vole avec une vitesse de Mach 0.92 ou de 960 km/h Il monte directement à 43 000 pieds et est certifié pour 51 000 pieds. Il peut couvrir une distance de 6 300 km sans se ravitailler. Fort de toutes ces performances, le Citation X est remarquablement efficace. Il utilise vraiment moins de carburant – même sur les vols courts – que le plus lent des jets. En outre, cet avion est d'un confort extrême. Il est normalement équipé de neuf places et dans l'espace cabine, il est possible d'être debout dans le couloir du milieu jusqu'à une hauteur de 1.70 m.

El Citation X es el jet de negocios más rápido jamás fabricado. El Citation X con 0.92 Mach roza la velocidad ultrasónica volando por encima de los 960 km/h. Alcanza directamente los 43 000 pies y está autorizado para llegar a los 51 000. Tiene una independencia de vuelo de 6 300 km y es de una eficiencia notable en todas sus prestaciones. Consume menos combustible –incluso en vuelos de corto recorrido– que algunos jets más lentos. Al mismo tiempo, es muy confortable. Con el equipamiento estándar hay espacio para nueve acompañantes y se puede estar cómodamente de pie en la zona del pasillo, a lo largo de toda la cabina, hasta una altura de 1.70 m.

Si tratta del business jet più veloce mai costruito. Il Citation X con Mach 0.92 raggiunge i 960 km/h, poco al di sotto della velocità del suono. Il jet sale direttamente a 43 000 piedi ed è progettato per raggiungere i 51 000 piedi. Senza fare il pieno, può volare per più di 6 300 km. E anche con queste prestazioni, il Citation X rimane sorprendentemente efficiente, consumando meno carburante – anche in tratte brevi – rispetto ad altri jet più lenti. Il velivolo è anche estremamente confortevole. Nella disposizione classica degli spazi, c'è posto per nove passeggeri e in tutta la cabina è possibile stare in piedi nel corridoio centrale fino a 1.70 m d'altezza.

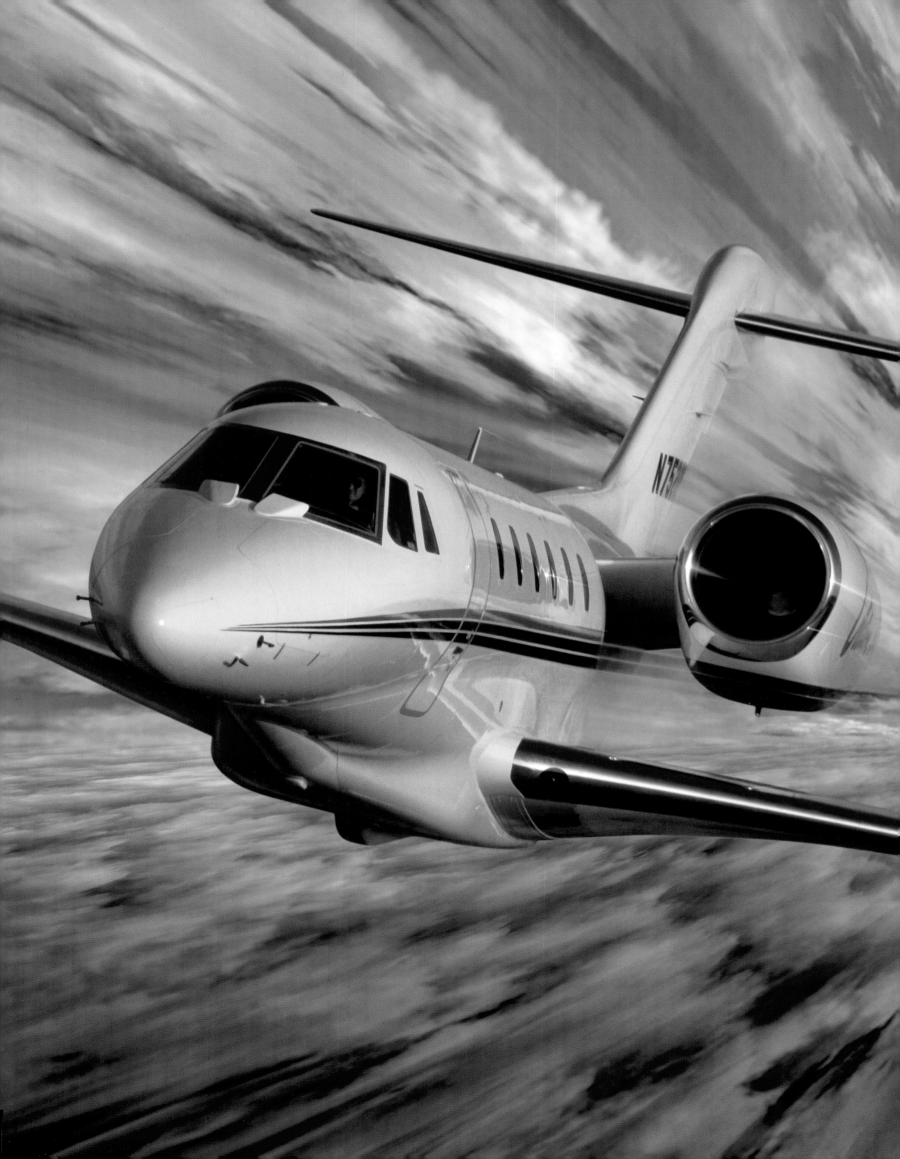

It is small wonder that both companies and private individuals all around the world use this Cessna top of the line jet. Golf legend Arnold Palmer was the first owner of this aircraft, which is also used by Daimler-Chrylser executives and by ex-Formula-1-world-champion Nelson Piquet. People who fly in a Citation X are generally frequent travelers who want to arrive at their destination as quickly and comfortably as possible.

Kein Wunder, dass rund um den Erdball sowohl Firmen als auch Einzelpersonen zu den Nutzern des Cessna-Topmodells gehören. Golflegende Arnold Palmer war der Erstkunde und im Daimler-Chrysler Konzern ist sie ebenso zuhause, wie in der Hand von Ex-Formel-1-Weltmeister Nelson Piquet. Wer Citation X fliegt, der muss viel reisen und dies möchte er schnell und komfortabel.

Il n'est pas étonnant que tout autour du globe, les entreprises comme les privés, utilisent le top modèle des Cessna. Arnold Palmer, golfeur de légende, fût son premier client et le groupe Daimler-Chrysler compte parmi ses habitués tout comme Nelson Piquet, l'ex champion mondial de la Formule 1. Voler en Citation X est le privilège réservé au voyageur affairé, en quête de rapidité et confort.

No es de extrañar, que tanto empresas como particulares de todo el mundo se encuentren entre los usuarios del modelo top de Cessna. La leyenda del golf Arnold Palmer fue el primer cliente, en el consorcio Daimler-Chrysler forma parte de la casa, al igual como para el ex campeón mundial de fórmula 1 Nelson Piquet. El piloto de un Citation X, es una persona que tiene que desplazarse con mucha frecuencia y desea hacerlo de manera rápida y confortable.

Non stupisce il fatto che aziende e privati di tutto il mondo utilizzino questo modello di punta del Cessna. La leggenda del golf Arnold Palmer fu il primo cliente, mentre alla Daimler-Chrysler il Citation X è di casa, così come dall'ex campione del mondo di Formula 1 Nelson Piquet. Chi vola su un Citation X, sceglie di farlo in modo veloce e comodo.

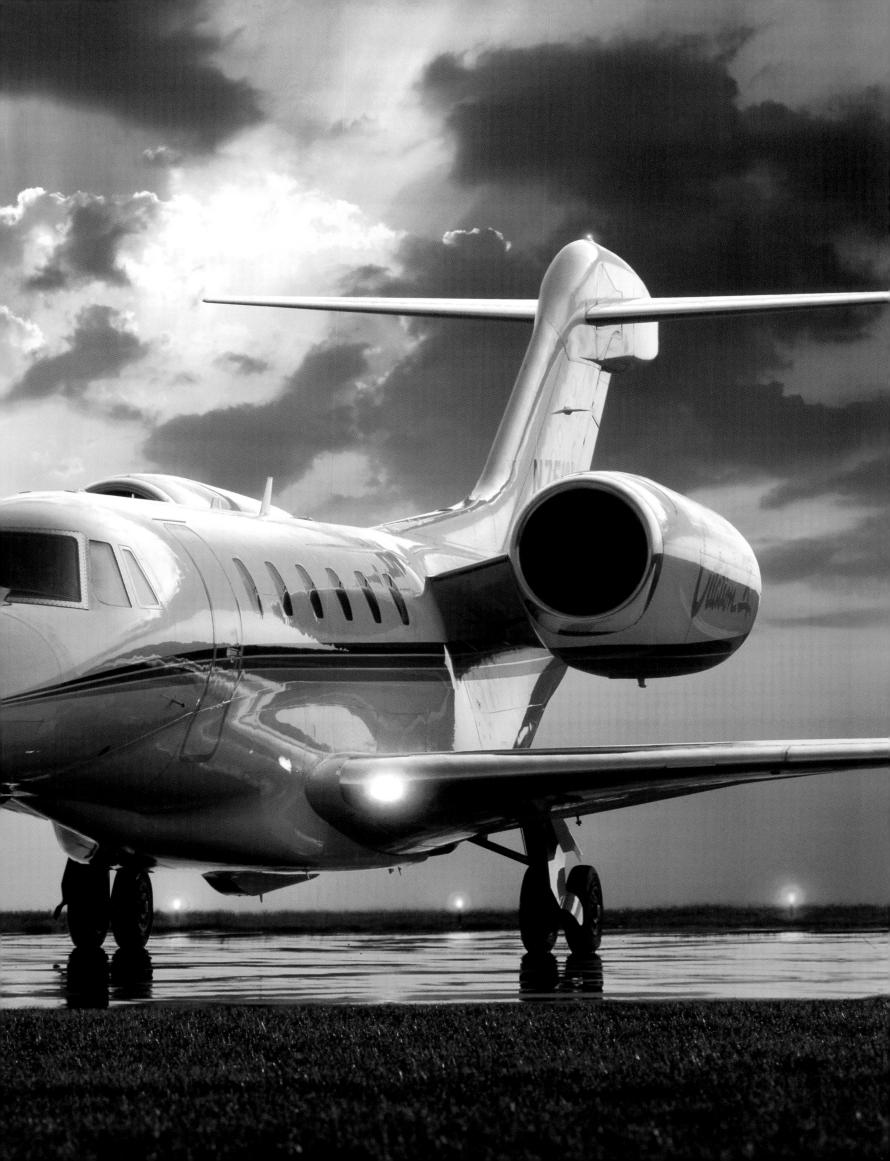

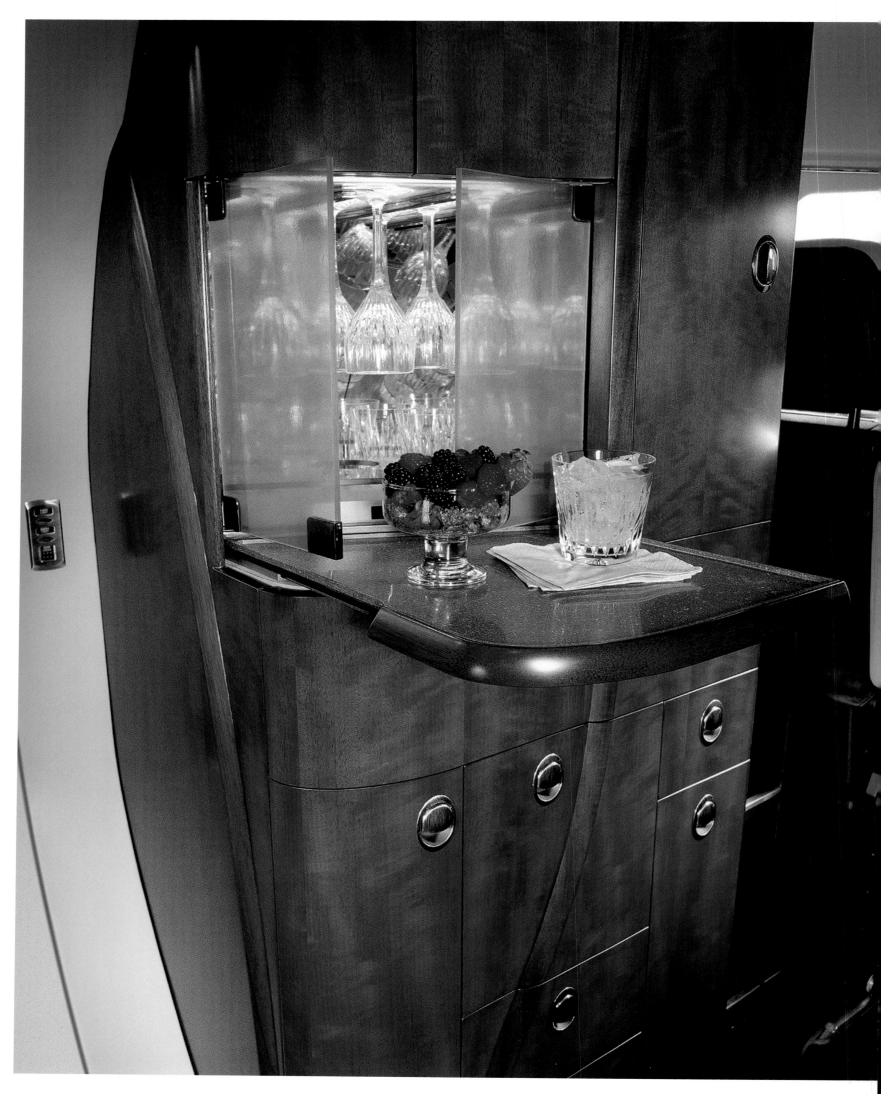

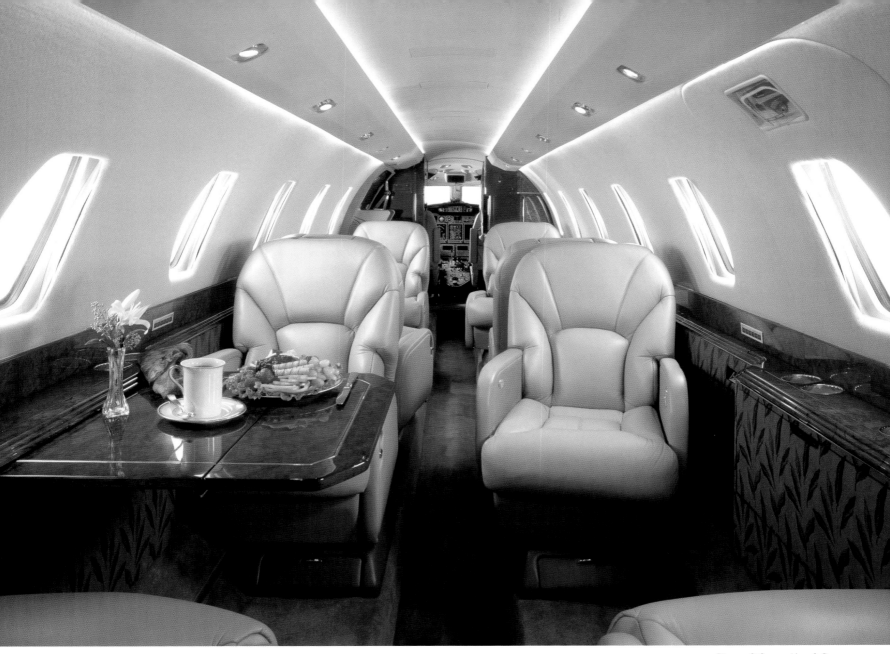

TECHNICAL SPECIFICATIONS

Manufacturer	Cessna Aircraft Company
Price	Price on request
Contact	http://citationx.cessna.com/
Type	medium-sized business jet
Passenger Capacity	12
Engines	2 x Rolls-Royce AE 3007C Turbofans
Range	6,020 km
Cruise Speed	0.90 Mach
Max. Cruise speed	0.92 Mach
Length	22.00 m
Height	5.77 m
Span	19.48 m
Baggage capacity	2.30 m³
Empty Weight	9,730 kg

Dassault Falcon 2000 EX

The 2000 EX is a 25% longer upgrade of previous already successfull 2000 jet. The aircraft accommodates up to six passengers and has a range of over 7,000 km, which means it can fly nonstop between Paris or London and the east coast of the US. Like the Falcon 900 EX, the Falcon 2000 EX is the second jet equipped with the new "EASy Cockpit system" which has four screens in lieu of classic cockpit instrumentation. Using Dassault's proprietary software, the pilots can simply click on the desired function, which greatly reduces their workload.

Der 2000 EX ist eine um 25% verlängerte Version des bereits erfolgreichen Businessjets 2000. Die 2000 EX befördert sechs Passagiere über eine Entfernung von mehr als 7.000 km. Das bedeutet Non-Stop-Flüge von Paris oder London zur Ostküste der Vereinigten Staaten. Die Falcon 2000 EX ist nach der Falcon 900 EX der zweite Dassault-Businessjet, der mit dem neuen „EASy-Cockpitsystem" ausgerüstet ist. Vier Bildschirmdisplays sollen die klassischen Instrumente ersetzen. Durch eine von Dassault entwickelte Software, können die einzelnen Funktionen per Mausklick aufgerufen werden. Damit soll die Arbeit der Piloten drastisch vereinfacht werden.

Le 2000 EX est 25% plus long que le jet d'affaires 2000, déjà couronné de succès . Le 2000 EX transporte six passagers à plus de 7 000 km. Il fait donc des vols directs de Paris ou de Londres à la côte Est des Etats-Unis. Le Falcon 2000 EX est, après le Falcon 900 EX, le deuxième jet d'affaires produit par Dassault équipé du nouveau concept de cockpit « EASy-Cockpitsystem ». Quatre écrans à affichage électronique sont sensés remplacer les instruments classiques. Grâce à un logiciel développé par Dassault, il suffit d'un clic sur la souris pour appeler chaque fonction. Cela simplifie considérablement le travail du pilote.

El 2000 EX es la versión un 25% más larga del exitoso jet de negocios 2000. El 2000 EX puede llevar a seis pasajeros a una distancia de más de 7 000 km. Ello significa que puede volar sin realizar paradas desde Paris o Londres hasta la costa este de Estados Unidos. El Falcon 2000 EX es, después del Falcon 900 EX, el segundo jet de negocios de Dassault equipado con el nuevo "EASy-Cockpitsystem". Cuatro pantallas sustituyen a los antiguos instrumentos. Cada función se puede ejecutar por separado a través de un ratón, gracias al software desarrollado por Dassault, con lo que se pretende facilitar drásticamente el trabajo de los pilotos.

Il 2000 EX è una versione del famoso business jet 2000 più lunga del 25% rispetto all'originale. Il 2000 EX trasporta fino a sei passeggeri su una tratta di oltre 7 000 km. Questo significa voli non-stop da Parigi o Londra fino alla costa orientale degli Stati Uniti. Il Falcon 2000 EX è dopo il Falcon 900 EX il secondo business jet della Dassault che dispone del nuovo "EASy-Cockpitsystem". Quattro schermi display sostituiscono la strumentazione classica; grazie a un software sviluppato dalla stessa Dassault, è possibile attivare le diverse funzioni con un semplice clic del mouse. In questo modo, anche il lavoro dei piloti risulta notevolmente semplificato.

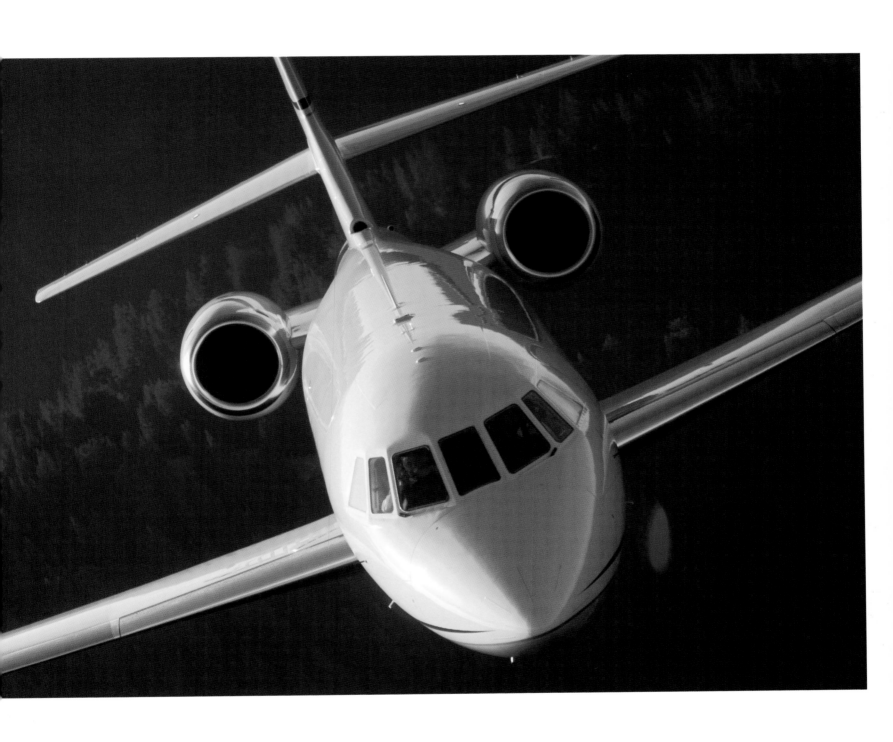

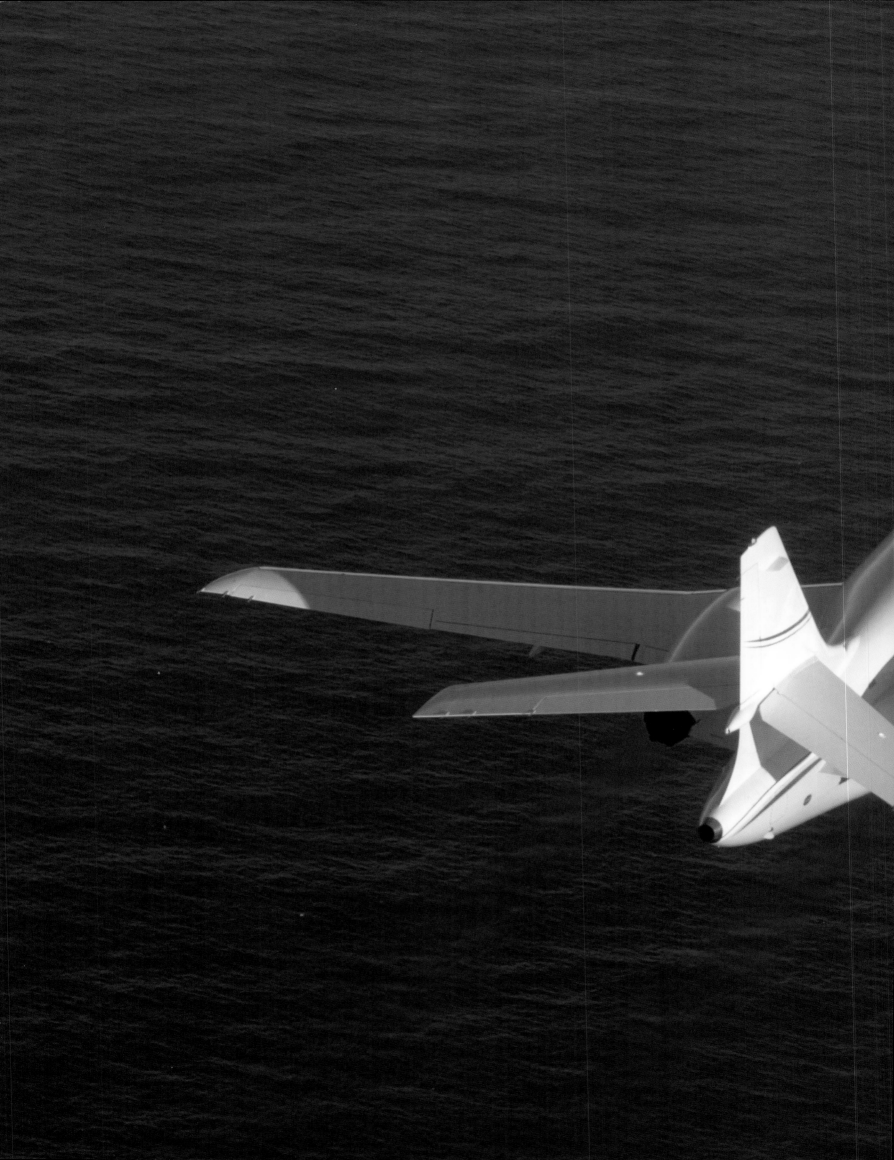

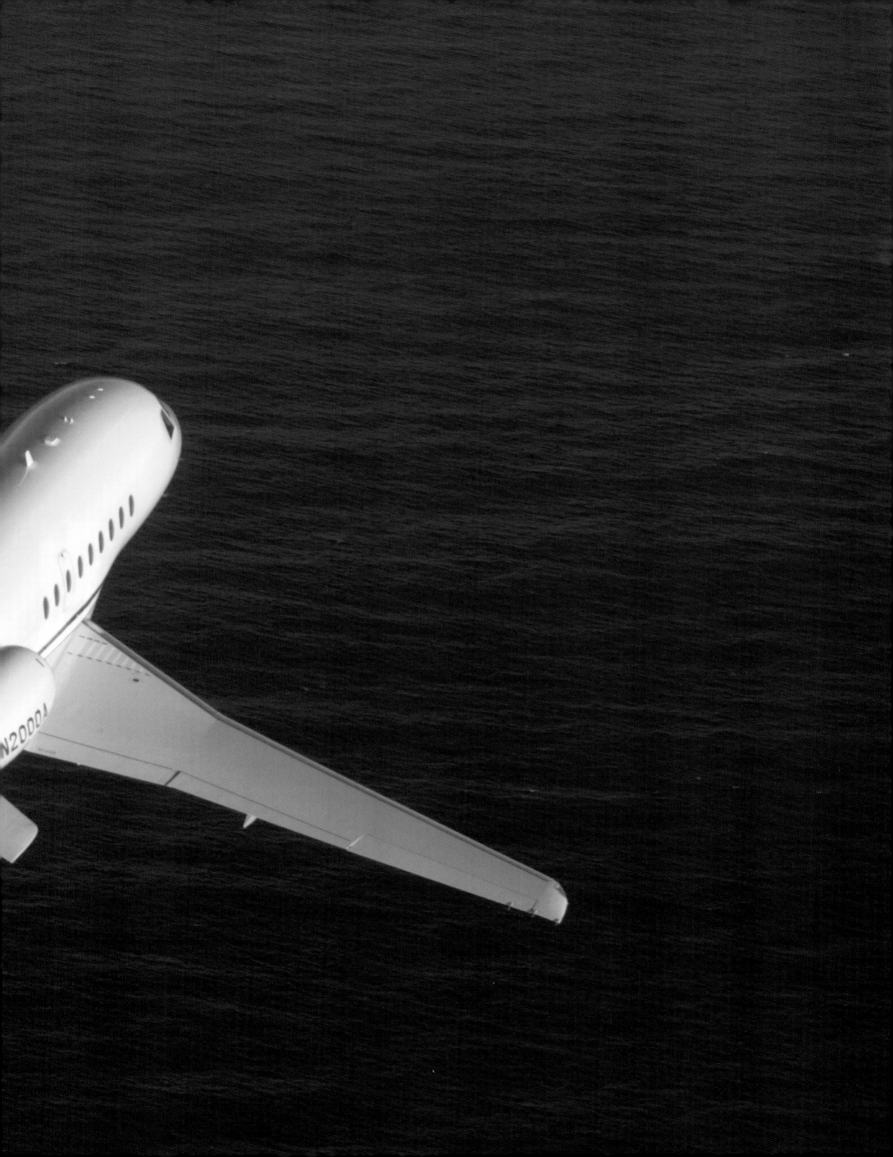

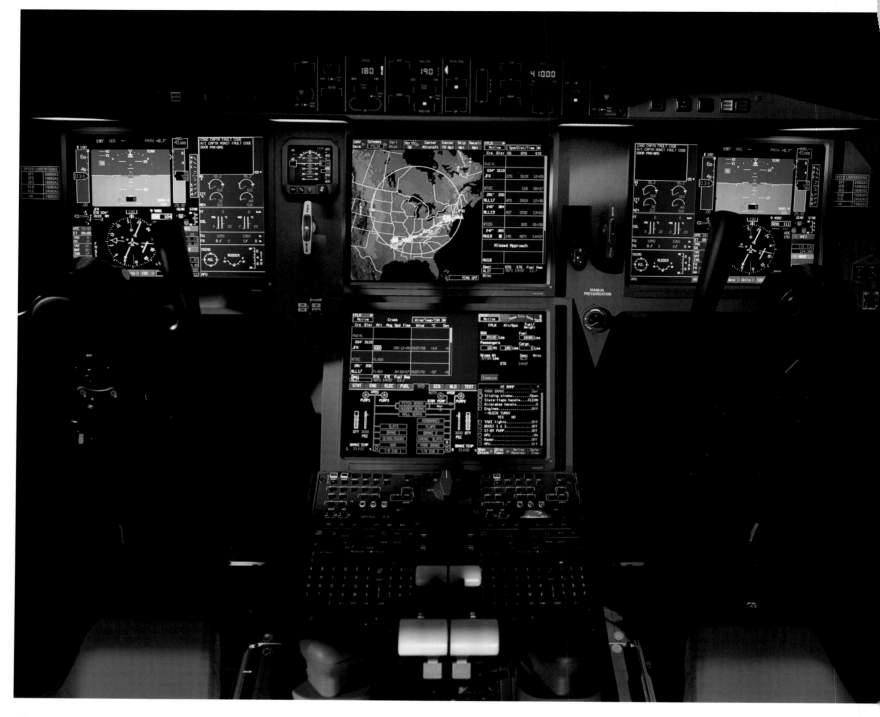

The 2000 EX cruises at an average speed of 0.80 mach, an improvement resulting from the use of the PW308C turbofan engine. The aircraft's fuel capacity has also been increased by 31% and cabin noise was substantially reduced by means of a complex design engineering and testing process.

Die durchschnittliche Reisegeschwindigkeit beträgt 0.80 Mach. Die verbesserte Leistung wurde durch die PW308C-Turbinen-Kreiselgebläse ermöglicht. Zudem ist die Kraftstoffkapazität um 31% erhöht. Mit Hilfe verschiedener Versuchsreihen gelang es auch, die Kabinengeräusche deutlich zu verringern.

La vitesse de croisière moyenne est de Mach 0.80. La puissance a été améliorée grâce aux turboréacteurs à ventilateur centrifuge PW308C. En outre, sa capacité de carburant est augmentée de 31%. Suite à une série de tests, les bruits en cabine ont été considérablement réduits.

La velocidad de crucero media es de 0.80 Mach. Se mejoró el rendimiento gracias a las turbinas PW308C de fuelles giroscópicos. Además se ha aumentado la capacidad del deposito de combustible en un 31%. Como resultado de diferentes tests se consiguió reducir notablemente el ruido en la cabina.

La velocità media di viaggio raggiunge gli 0.80 Mach. Prestazioni ottimali sono assicurate grazie dalla pompa centrifuga per gas a turbine PW308C. Inoltre, la capacità di carburante è incrementata del 31%. Grazie a diversi esperimenti, è stato possibile anche ridurre drasticamente i rumori nella cabina.

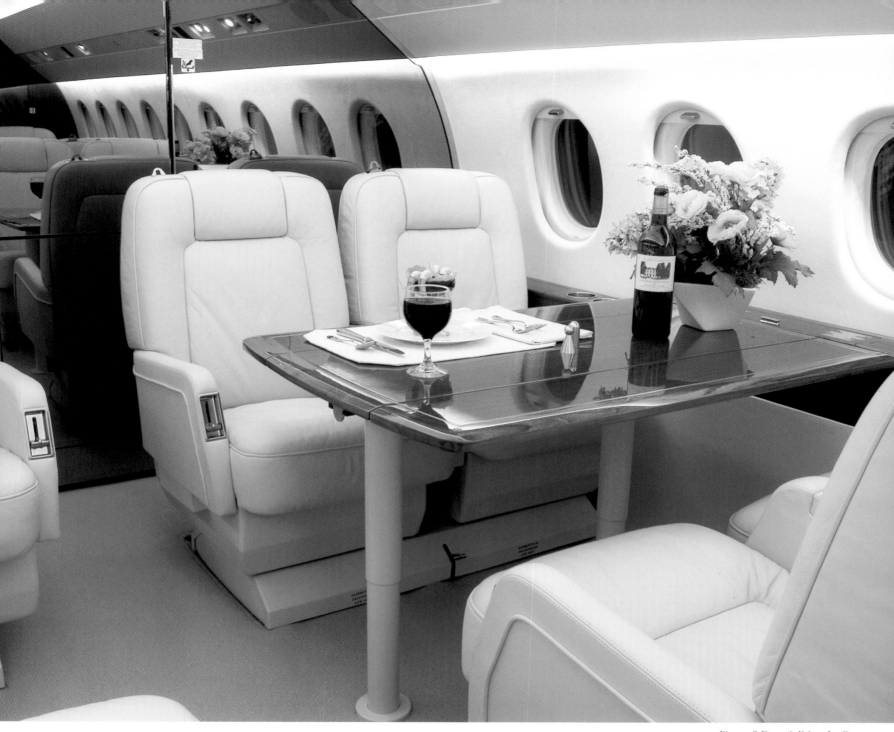

Photos: © Dassault Falcon Jet Corp.

TECHNICAL SPECIFICATIONS

Manufacturer	Dassault Falcon Jet Corp.
Price	$ 25,000,000
Contact	www.falconjet.com
Type	large wide-body business jet
Passenger Capacity	10
Engines	Two PW308C turbofans each rated at 7000 lb thrust
Range	7,037 km
Cruise Speed	0.80 Mach
Max. Cruise speed	n. i.
Length	20.21 m
Height	7.06 m
Span	19.33 m
Baggage capacity	3.70 m^3
Weight	n. i.

Cessna Mustang

Developed and built by the "Cessna Group II design development program", the Mustang represents Cessna's entry into the lightweight jet market. The Mustang costs 2.3 million dollar, accomodates four passengers and can be flown by its owner.

Bei dem Jet Mustang handelt es sich um den Einstieg Cessnas in den Leichtjetmarkt. Der Mustang ist von Grund auf neu vom „Cessna Group II Designentwicklungs-Programm" konstruiert worden. Der 2,3 Millionen Dollar teure Businessjet bietet Platz für vier Passagiere. Diese Maschine ist ein Jet, der vom Eigner selbst geflogen werden kann.

Avec le jet Mustang, Cessna entre sur le marché des jets privés légers. Le Mustang a fait peau neuve grâce au « programme de conception du design du Cessna Group II ». Ce jet d'affaires peut prendre quatre passagers à bord et coûte 2.3 millions de dollars. Il peut être piloté par son propriétaire.

El jet Mustang significó la entrada de Cessna en el mercado de los jets ligeros. El Mustang ha sido construido en su totalidad por el programa de desarrollo de diseño Cessna grupo II. Este jet de negocios de 2.3 millones de dólares da cabida a cuatro pasajeros e incluso puede ser pilotado por el propietario.

Questo Jet Mustang rappresenta l'entrata del Cessna nel mercato dei jet leggeri. Il Mustang è stato costruito interamente dal "Programma di Progettazione e Design Cessna Group II". Questo business jet da 2.3 milioni di dollari può ospitare quattro passeggeri e può venire pilotato dall'armatore stesso.

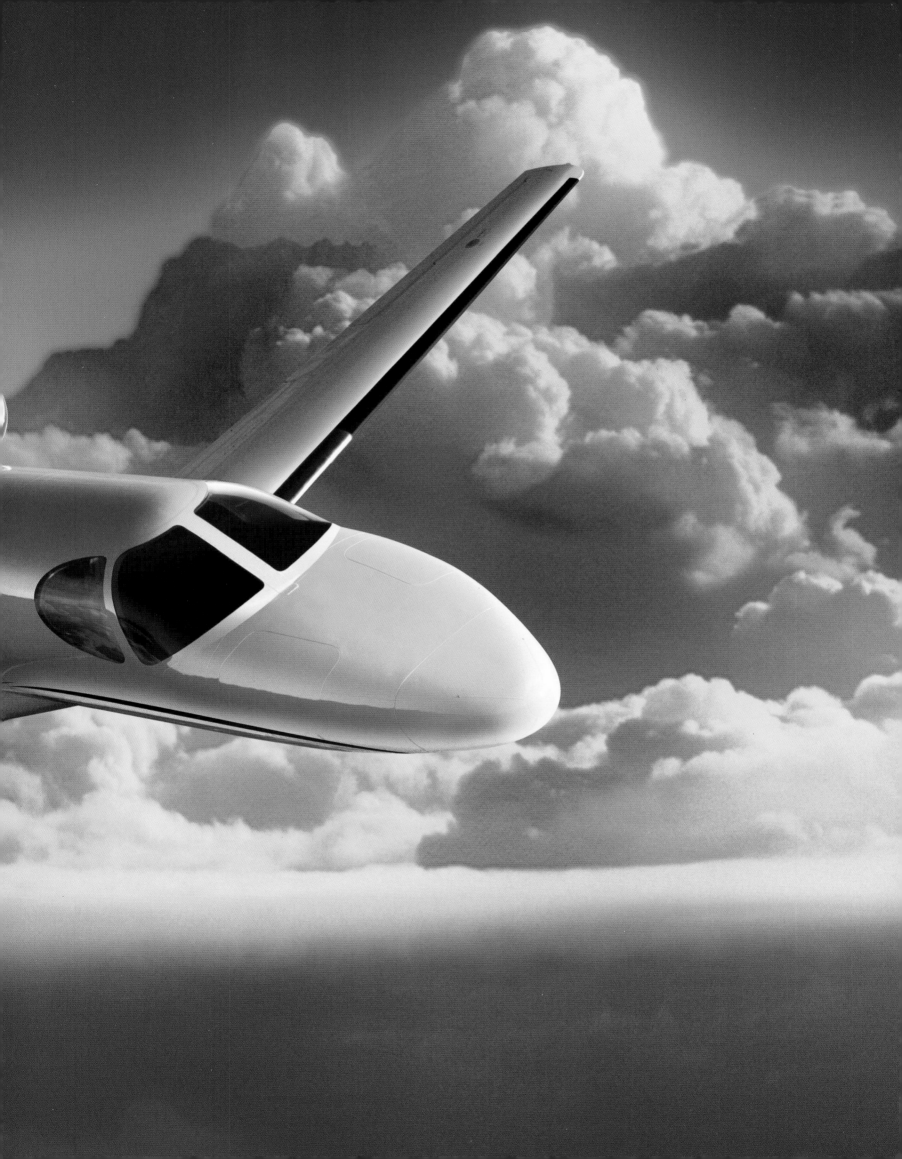

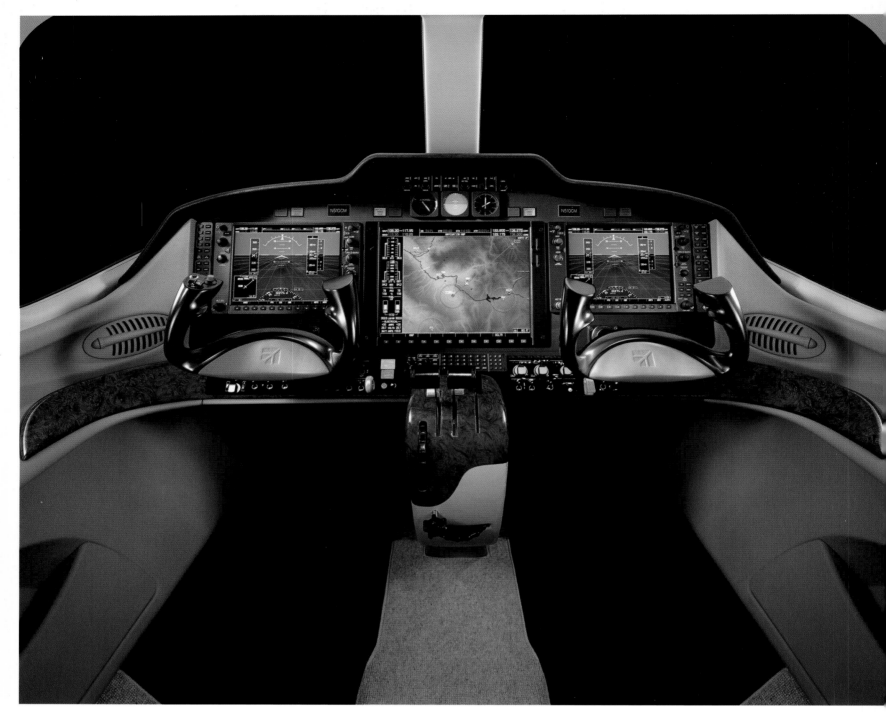

Numerous design options are available for the cabin. The basic setup is four passenger seats, a divan, and a bathroom.

Bei der Gestaltung der Interieurs gibt es die Möglichkeit zwischen verschiedenen Optionen auszuwählen. Die Grundausstattung besteht aus einer Sitzgruppe für vier Passagiere, einer Sitzcouch und einem Privatbad.

La conception intérieure offre des options modulables en fonction du client. L'équipement de base comprend un ensemble de sièges pour quatre personnes, un divan et une salle de bains privée.

El diseño de los interiores permite elegir entre diferentes opciones. El equipamiento básico consiste en un asiento para cuatro pasajeros, un sofá y un baño privado.

Nella suddivisione degli spazi interni è possibile scegliere tra diverse opzioni. L'arredamento di base prevede sedili per quattro passeggeri, un divano e un bagno privato.

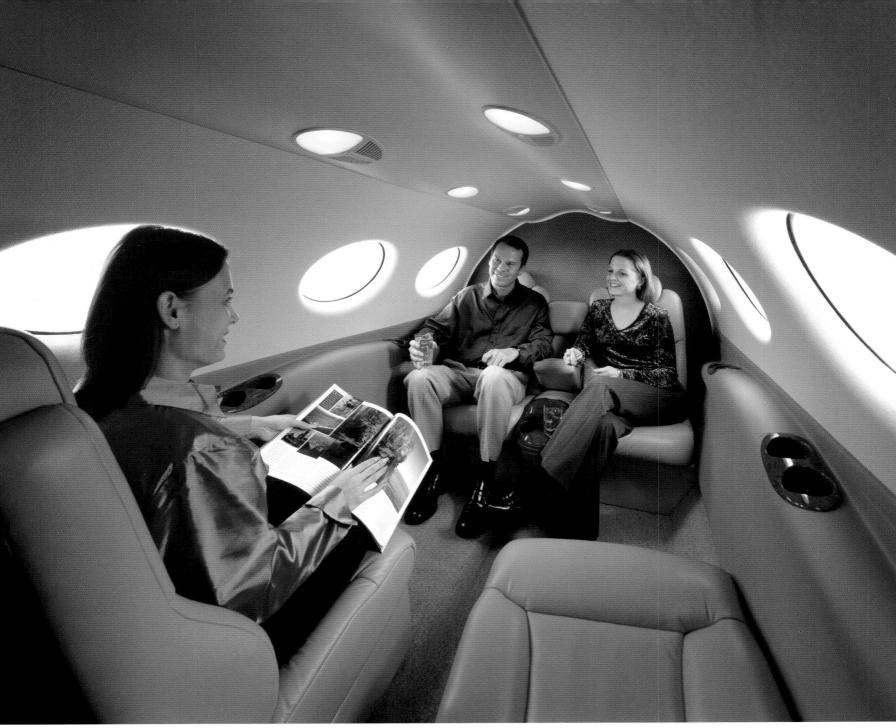

Photos: © Cessna Aircraft Company

TECHNICAL SPECIFICATIONS

Manufacturer	Cessna Aircraft Company
Price	$ 2,600,000
Contact	http://mustang.cessna.com
Type	Super light business jet
Passenger Capacity	4
Engines	Two Pratt & Whitney Canada PW615F
Range	2,408 km
Cruise Speed	603 km/h
Max. Cruise speed	815 km/h
Length	11.86 m
Height	4.19 m
Span	12.87 m
Baggage capacity	1.27 m^3
Empty Weight	n. i.